Nineteenth Annual Winterthur Conference, 1973

TECHNOLOGICAL INNOVATION AND THE DECORATIVE ARTS

Technological Innovation and the Decorative Arts

Edited by Ian M. G. Quimby
and Polly Anne Earl

Published for
The Henry Francis du Pont Winterthur Museum
Winterthur, Delaware

The University Press of Virginia
Charlottesville

Cover illustration: Machine printing wallpaper in the factory of Christy, Shepherd, and Garrett, New York, from Scientific American 43, no. 4 (July 24, 1880). (Photo, courtesy of the Science and Technology Research Center, New York Public Library, Astor, Lenox, and Tilden foundations.)

CONTENTS

INTRODUCTION

THE PURPOSE of the 1973 Winterthur Conference was to focus attention on a neglected aspect of the history of Anglo-American decorative arts: the close relationship between technological innovation during the eighteenth and nineteenth centuries and the development of home furnishings. This approach enabled the conference planners to bring together scholars who in the normal course of events would seldom be part of the same program. The podium was shared by historians of science and technology and museum curators of technology and decorative arts. The idea behind this juxtaposition of specialists from different fields was to illuminate the role of technology in creating domestic furnishings, many of which have historically been treated as works of art.

The conference planners were aware that the goals and methodologies of historians of technology often differ sharply from those of the museum curator. Where the historian starts from the process used in creating a product, the curator starts from the product itself. Most conferences of professional scholars find specialists in the same field talking to each other. This conference was an attempt to open the minds of scholars in two diverse fields and to show areas of common interest in the hope of shedding new light on a neglected problem. The decorative arts as a subject should provide the ideal meeting ground for historians and curators because the subject is uniquely receptive to interdisciplinary study. Certainly in the eighteenth and nineteenth centuries the decorative arts were closely connected with major technological changes and with the development of modern productive and distributive systems. Perhaps the ultimate reason we should all acknowledge the validity of interdisciplinary study in the decorative arts is their quality of combining utility and art in the service of human needs while offering each individual the opportunity to project that special vision of his own personality.

Early American decorative arts have long been celebrated as products of individual craftsmanship. There is a popular mythology surrounding this class of historical artifacts that can be defined as the cult of the colonial craftsman. The cult consists of a series of vague generalizations about the nature of production in a misty preindustrial past. Central to the cult is the image of a hard working, nonunion, independent craftsman who lavished infinite time and patience--not to mention the best of materials--on elegant goods, which of course he sold at low, noninflationary prices.

While no museum curator would subscribe uncritically to this view of the craftsman, museums and historic houses too often reinforce rather than correct the myth. Proof of this assertion can be found by trailing groups of visitors through museum galleries or historic houses and listening to their comments. While it may not be entirely fair to blame the curator for the simplistic generalizations of the unlearned visitor, it is impossible to avoid the charge of inept or inadequate interpretation in light of the widespread acceptance of the cult. There is a failure to understand decorative arts settings as products of a context of social attitudes reflected in styles and technological developments.

The most common mode of presenting the decorative arts of early America is through the period room. Except in rare instances where the original furnishings survive in situ, the period room is a very rough approximation, a kind of generalized statement of what could have been. In spite of intensive research to discover the type of furnishings appropriate to a room, the choice of period furnishings available is limited by the survival factor and the preferences of collectors over the years. Better quality items have a higher survival rate, and American collectors prefer American-made to foreign-made objects when there is a choice. Curators frequently succumb to the temptation of selecting the finest example for aesthetic rather than historical reasons.

Whatever the inaccuracies, however, the better examples are usually rooms that contain a representative selection of objects, rare and common, expensive and inexpensive, but more or less appropriate to the period. The problem is that

most visitors carry away the impression they have seen
exquisite examples of American hand craftsmanship. The
fact is that most of the objects they see are neither American
nor the product of a single craftsman. Except for the furniture
and possibly a few of the metals, most of the objects in these
rooms were made abroad, and most of them issued from a
complex structure of production and distribution extremely
remote from the cult of the colonial craftsman.

The list of goods imported from European sources is
considerable: all except the coarsest fabrics; nearly all the
porcelain and fine earthenwares; hardware, cutlery, jewelry,
and countless small metal objects for the house; glass for the
table, for chandeliers, and even much window glass; carpets
and other floor coverings; wallpaper and a multitude of graphics
for decorative or didactic purposes; pâpier maché and painted
tin; and the list could go on. Thus what we see most in these
reconstructed interiors is not the fruits of individual skill;
we see the products of the shops and factories of Birmingham,
Sheffield, the pottery towns of Staffordshire, and numerous
other centers where capital, technical skills, raw materials,
transportation, and marketing techniques had been put together
to create that historical phenomenon called the industrial
revolution. And when by the nineteenth century, more deco-
rative goods came to be made in America, we see the results
of the trans-Atlantic migration of innovations in machines and
human organization that contributed to the American industrial
revolution.

Any aggregation of period rooms purporting to show the
principal decorative styles of the past also reflects the
progress of technology. This is a point almost never made by
museums and historic houses when they display and interpret
decorative arts of the past. As the United States developed
its own industrial base in the nineteenth century, mechani-
zation accelerated the production of home furnishings. The
so-called American system of production, which relied on
machine production, division of labor, and sequential work
processes, created the abundance of material possessions
that is today a continuing hallmark of American culture. In
addition to portraying the increasing technological maturity

of the American nation, the decorative arts are a convenient index to any culture because they are so intimately related to the economic and social status of the people who used them. Besides their obvious utilitarian function, they have great symbolic value. They have the quality of making a statement because, among other reasons, they represent a selection from a variety of possible choices. There is no such thing as purely functional furniture.

Curators of decorative arts, since they are often trained as art historians, are to a large extent concerned with the development of style. It forms the principal basis for attributing museum objects to the correct time and place of manufacture. By itself style cannot answer all questions of attribution. The modern museum increasingly relies on the scientific examination of materials to isolate fakes and reproductions and to aid in proper care, preservation, and restoration. But style remains the curator's chief stock in trade, and its importance extends beyond the process of attribution.

Style is the way in which something is done, the character of the expression, and anything can be done in an infinite variety of styles. Any style is the sum of tradition and innovation. Nothing is completely new but neither is it exactly like all its forbears. Style is the special imprint an individual, a region, a tribe, or a state puts on all its cultural expressions from language and music to furniture and dress.

In the decorative arts the major styles of the past were usually international in scope while retaining unmistakable traces of their national origin. Chairs in the rococo style made in France, England, and the American colonies betray their national origins by such things as the degree of exuberance in the design, the treatment of decorative detail, as well as by types of woods or details of construction. Yet all such pieces share in common the concept of a specific style.

Style derives from so many complex factors that it be-comes nearly impossible to fully describe its origins. But we can isolate certain factors. The 1973 Winterthur

Conference sought to explore the relationship between style
and technology within the confines of Anglo-American
decorative arts. Implicit in any consideration of this subject
is the question of the extent to which style was influenced by
the rapidly changing technology of the nineteenth century.
Did the new techniques and materials create a new style? Or
were traditional forms adapted to the new technology? The
stylistic character of household furnishings altered dramatically
between 1750 and 1850, a condition that could easily be
attributed to burgeoning industrialization. On the other hand
there were equally startling changes between 1650 and 1750
in the appearance and variety of furnishings. Is one to
conclude that dramatic changes in style occur with or without
industrialization? What if anything did nineteenth-century
technology contribute to the decorative arts? There is no
simple answer to these questions, but some observations
emerged from the conference that suggest a pattern.

In spite of new materials and new techniques, the general
tendency was to repeat old forms--elaborated to be sure--but
tradition held among traditional forms. It is noteworthy that
nineteenth-century decorative arts are known for their
eclecticism; the past was ransacked for visual ideas to feed
the hunger for novelty. Specialization of function among home
furnishings, a trend since the Middle Ages, reached new
heights. Furniture and silver designed for every room and
every function became available in a bewildering variety of
styles, patterns, and prices. As the technical problems of
moving from handcraft to machine production were solved,
there was a tendency to display technical proficiency by
pushing novelty to the limit--very often at the expense of
aesthetic sensibility. Ultimately, however, the most profound
effect of technology on the decorative arts was to make them
available to a mass audience. The increasing ease of machine
replication created an abundance of material goods and perhaps
a delight in ornate designs that could now be executed without
the high cost of hand labor. Many shoddy goods were created
in the process, and possibly man's attitude toward his
furnishings was altered forever. As they became cheaper and
more abundant, home furnishings became, in effect, dis-
posable, and their owners became consumers in the modern sense.

The papers presented at the conference developed
different perspectives on the problem of how to interpret the
decorative arts in the context of the technical innovations of
the industrial revolution. Cyril Stanley Smith, in his keynote
address, discussed the exploitation of the principle of
electrolysis in the nineteenth century. Electrodeposition
of precious metals on base metals constituted a fundamental
change in materials technology while determining and
expanding decorative possibilities. Electrotypography
contributed to printing technology, but it also found wide
application as an inexpensive means for the mass replication
of decorative forms. Both applications were widely adopted,
which in turn stimulated development of better storage
batteries and ultimately the electric generator. Turning to a
detailed examination of the Birmingham segment of the early
trade in silverwares, Eric Robinson stressed managerial
innovations in research and labor organization that developed
along with new techniques. The transition from a craft to a
factory basis of labor organization was further elaborated in
Merritt Roe Smith's paper on Harper's Ferry. Guns, an
example of a useful object often decoratively enhanced by the
skilled workmanship of individual craftsmen, were assimilated
into a factory system of production at an early date due to
the rationalization of production under the supervision of
ordinance engineers. A key element in the successful transi-
tion was the adoption of the Blanchard lathe, whose tracing
principle of replication was widely applied throughout
American industry for shaping irregular forms that had previously
required laborious hand work. John D. Tyler traced how
changes in casting technology affected the form of iron pots
and the quality of decoration on iron stove plates. Refinements
in casting and molding technology in another material, glass,
gave rise to the new ornamental effects of pressed glass, an
original American invention. Kenneth Wilson analyzed the
sequence of technical and stylistic changes in American
pressed glass. Innovations in pressing and molding technology
were not confined to semifluid materials as Clare Vincent
showed in her discussion of the elaborate styles and ornamen-
tation made possible by John Henry Belter's patented wood-
working processes.

New machines, rather than innovations in materials technology, were the basis of the revolutionary developments in the nineteenth-century printing industry. Theodore Z. Penn investigated the process through which British calico printing machines were applied in America, and Florence Montgomery traced the sequence of stylistic developments in American printed cotton fabrics. Catherine Frangiamore's paper on the American wallpaper industry pinpointed the introduction of mechanized presses and the design changes that came with mechanization and the wide availability of low cost wallpaper. New machines and the adoption of steam power were crucial factors in the transition from craft to factory production in the furniture trades described in Polly Earl's paper.

Anthony Garvan, in a paper not completed for publication, speculated on the novel attitudes toward furnishings and moveables that have developed in the twentieth century. The conference closed with two papers examining museum attitudes toward technology and its products. Jay Cantor chronicled the Metropolitan Museum of Art's early efforts to support and improve industrial design, while George Basalla evaluated the romantic and unrealistic attitudes toward technology fostered by modern technical museums.

That no overarching reinterpretation of the interrelationships of technology and taste emerged from the conference proceedings is hardly surprising given the traditional lack of communication between the disciplines represented. What did emerge from the conference with some force was an indication of the need for further research and publication in this grey area between the aesthetic and the utilitarian aspects of culture. Several of the papers indicated that the industrial revolution in the realm of the decorative arts was not a sudden event but rather a phased process in which hand work remained important for many decades as the finishing touch applied to mass-produced objects. And although machine technology could be applied in the service of dissimilar stylistic ends--witness the different visual impacts of a piece of machine-produced Renaissance revival furniture and a piece of machine-produced Eastlake furniture--the technological innovations of the nineteenth century

undeniably altered the decorative landscape of domestic life
through the sheer abundance of goods now available to all.
The revolutionary effects of this new abundance in both
fulfilling and stimulating human desires for the good life
lead to the twentieth-century question of how conformity and
the greatest possible number of personal choices coexist in
our society?

The theme of the 1973 Winterthur Conference provided the
rare opportunity for a cooperative effort between the Winterthur
Museum and the Hagley Museum in cosponsoring an exhibit
bearing the same title as the conference. Under the direction
of Maureen O'Brien Quimby, graduate students from the
University of Delaware enrolled in the Winterthur Program in
Early American Culture, the Hagley Fellowship Program, and
the Museum Studies Program had the unique opportunity of
working on every stage of the exhibit from design through
installation. Pictures, objects, and text in the exhibit
reinforced the conference papers while providing many future
museum curators with invaluable experience. The exhibit was
supported by a grant from the National Endowment for the
Humanities. A permanent record of the exhibit is contained
in a catalogue published in 1973 by the Eleutherian Mills-
Hagley Foundation.

The editors wish to express their profound gratitude to the
numerous persons who made the conference possible. In
particular they would include the conference speakers whose
wisdom and counsel not only contributed to a successful
conference but an innovative exhibit. Eugene Ferguson, Cary
Carson, and Dwight Lanmon contributed their ideas as members
of the conference planning committee. Publication of the
conference papers was made possible through the generosity
of Mr. and Mrs. Henry S. McNeil.

<div align="right">

Ian M. G. Quimby
Polly Anne Earl
Conference Cochairmen

</div>

KEYNOTE ADDRESS

REFLECTIONS ON TECHNOLOGY AND THE DECORATIVE ARTS IN THE NINETEENTH CENTURY

Cyril Stanley Smith

Introduction

ART and technology have always been intimately linked;
indeed in their origins they were almost indistinguishable.
In an earlier paper, I discussed at some length the role of
aesthetic curiosity in leading to the discovery of various
classes of materials and processes for productive use in
engineering or industry.[1] Examples were cited dating from
prehistory through the late nineteenth century. In the
twentieth century art no longer precedes technology, for
invention has become more consciously purposeful, and art
enters at a late stage as package design, a marketing aid,
not as a conscious inspiration at the beginning. Yet,
discovery is an aesthetic activity even today, although its
patronage has changed and although for over a century art
has led to the discovery of fewer new phenomena than has
science. Nevertheless, it is worth pointing out that the
ingenuity involved in devising mass production itself began
as an urge to multiply pleasant objects, not just utilitarian
ones. The craftsman working for an elite trade is, of course,
mainly concerned with individual beauty, but many of the
eighteenth-century technologists who aimed at more production
for less cost were consciously concerned with what might
be called art for the masses.

 There are probably earlier expressions of this viewpoint
in the literature on printing and ceramics, but here let us
note the motive behind the metallurgical work of the
versatile French scientist R. A. F. de Réaumur. The second
part of his famous book, L'Art de Convertir le Fer Forgé en
Acier, published in 1722, is devoted to the art of making

cast iron malleable for the specifically stated purpose of
giving cheap cast ironwork a finish comparable to the
wrought iron used for elaborate door knockers and artistic
serrurerie (fine ironwork) in general. In his preface Réaumur
remarked, "It is the foremost duty of all of us to work for the
general good of society." His sixth memoir begins, "The
production of more beautiful work, without sacrifice of
quality and at lower cost, is the route to progress along
which we must endeavor to guide the arts." Later, "the
strikers, or knockers, on carriage gates and other entrances
are nowadays almost devoid of ornamentation but they cost
as much as quite ornate cast-iron door knockers will cost in
the future. . . . From now on, escutcheons, large and small
bolts, hinges--in other words, any ironwork pieces that are
not subject to strain--can be made most artistically and yet
will cost hardly more than the plain ones do today."

Réaumur, however, was worried about the effects of his
invention in cheapening art. Though it is important in
general to produce more refined, more decorative work, he
said,

> One might ask, however, what would be gained
> by the human race if the number of objects we
> call "beautiful," and which are simply beautiful,
> were increased beyond a certain limit. If we
> knew the secret of how to build palaces as
> cheaply and as quickly as cottages, if small
> houses were suddenly changed into magnificent
> buildings, we should be struck by the novelty
> of the spectacle. But soon it would be just as
> well if our common houses had remained unchanged.
> We should look with less pleasure and interest
> at the paintings of the great masters if daubers
> discovered how to paint similar ones. We can
> judge what we call "beautiful" only by comparison,
> but we can judge at all times the things directly
> connected with our occupation and decide whether
> they are good. There is always something with which
> to compare them.[2]

Against Réaumur's caution one can advance the view of an Englishman a little over a century later who, inspired by the superb "Berlin" castings, advocated the use of cast iron for sculpture "to supply the place of many less interesting but indispensable architectural and other supports: As the material is so cheap, its application in the way proposed might tend to increase the taste for, and thus foster the patronage of the arts of sculptural design with reference to our mortuary and other monuments."[3]

Réaumur also worked to improve the manufacture of tinplate and porcelain. In a paper read in 1740 to the Académie des Sciences, he stated:

> It is not by their masterpieces, by their rarest products, that [potters] are at their most useful to us, it is by their less perfect works that they provide for our ordinary need. The potter who gives us only glazed pots, made from the commonest and grossest clay, but who gives them to us for practically nothing, is more useful to us than a workman who would have us buy vases at a great price even though these rival in beauty the precious porcelain of China itself.

By using his new process of devitrifying glass, Réaumur said proudly, "There is no one who cannot transform all the bottles in his cellar into bottles of porcelain."[4] Réaumur's poor-man's porcelain never became an important product. Though often discussed by eighteenth-century scientists interested in crystallization, it was used mainly in laboratory vessels, and even this ceased before long.

Reflections on Replication

Another aspect of the relationship between art and technology is the way in which subtle properties of matter basically affect the quality of a work of art. Any artist knows that sensitive selection and treatment of materials is critical to the realization of his intent. In retrospect, I notice that

most of the examples I used in an earlier historical paper,
which discussed this point in some detail, were from the
decorative arts, not the "fine" arts.[5] This may reflect the
fact that the latter are less bound than the former to the
universal sensual qualities of shape, color, and texture and
are more directly concerned with suggesting human overtones
within a particular culture. Yet the decorative or useful
object in one culture may be regarded a very fine art in
another, as ceramics in particular show.

The fine arts are conscious and essentially individual in
tradition. Though the artist may make a number of attempts
before he is satisfied or satiated with his concept, he
usually aims at making a unique object, one in which the
material is subjugated to the idea and on which no amount of
labor is misplaced. His purpose is discovery and singular
statement. He will use existing materials, sometimes in
radically new ways. Though he may discover new materials,
such discoveries are incidental to his aim.

The quantitative and economic aspects of the decorative
arts, on the other hand, make them intrinsically repetitive.
Because of this, their aesthetic qualities have a very
intimate relationship to the technology of materials, and
their design is thereby basically affected. Does not the
discovery of symmetry lie in the decorative arts? Something
akin to knowledge of the nature of the crystal lattice
inevitably arises from experiments in which decorative
details are repeated as the simplest way of filling space.
This shows in simple form in Greek geometric pottery and,
much earlier, in the famous mosaic walls at Uruk. The same
property appears in block- or roller-printed fabrics, and it
is no accident that most introductory discussions of crystal
symmetry and space filling from Kelvin to the Braggs and
Weyl reproduce wallpaper designs.

The use of stamps in decorating clay tiles--most
delightfully in the early Han tombs of China (Fig. 1)--
prefigured both the printing press and the aesthetic value of
repetition with differences. From a design standpoint, the
complex repetitive patterns in Islamic tilework show how
small local variations can integrate into symmetry on

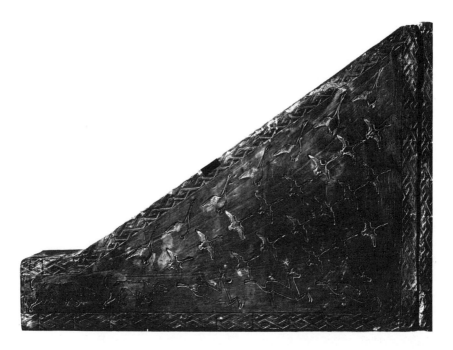

Fig. 1. Clay tiles from the wall of a tomb. Lo-yang, Honan Province, China, Han dynasty, 206 B.C.-A.D. 220. Note the symmetry arising from the repeated use of stamps. (Royal Ontario Museum, Toronto.)

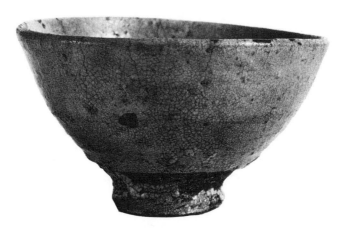

Fig. 2. Ceramic tea bowl, called <u>Kizaemon Ido</u> by Japanese tea masters. Korea, sixteenth century. H. 3 1/2". From Sōetsu Yanagi, <u>The Unknown Craftsman: A Japanese Insight into Beauty</u>, ed. and trans. Bernard Leach (Tokyo and Palo Alto: Kodansha, 1972), p. 11, pl. 1.

ever-larger scales. Even the superb Byzantine mosaics at
Ravenna and elsewhere rest on unit repetition in diverse
environments, involving tedious work of a kind that few self-
conscious artists today would be willing to do.

Repetition affects the selection of matter as well as
form. The shaping operations must not fight the material but
must conform naturally to it. Whether stone, metal, wood,
clay, or glaze, the physical properties and structure of the
material have their say in determining both surface finish and
overall shape. Nowhere does this show to better effect than
in folk art, especially in ceramics and above all in the
common wares of Korea and Japan (Fig. 2), where the "no-
mindedness" of the potter has led to the production of forms
with surface decoration of the simplest kind, and yet the
overall effect of superb beauty is based on a balance between
purpose, process, and the properties of the material.[6] There
is a natural relationship in the yielding of the aggregate of
clay particles to the micro and macro forces applied in
shaping, in the flow and adhesion of the glaze as it is
applied, and in the effects of fire in rendering the glaze
partly fluid while it shrinks and hardens the clay. The
Japanese tea masters of the seventeenth century knew this
intuitively, though there is doubt that they gave any thought
to the properties of thixotropy, surface tension, viscosity,
vitrification, nucleation, crystallization, and diffusion upon
which all these effects depend. The whole environment of
the tea ceremony is provided by simple natural surfaces of
wood, bamboo, lacquer, paper, cast iron, copper, carbon,
stone, plaster, clay, and vitreous glaze, almost as if to
present examples of classes of quantum-mechanical bonding
between atoms to illustrate a modern course in the science
of materials. When Oriental materials reached Europe in
the seventeenth and eighteenth centuries, they inspired many
attempts at duplication by manufacturers--not the least
Meissen and Wedgwood--as well as research on mineralogy,
chemical analysis, and high temperature reactions. The
effect of contact with the Orient was at least as great on
science as it was on the decorative arts.

In addition to the qualitative need for repetitive detail

in design, the decorative arts have a quantitative requirement,
namely the imperative of covering large areas or making large
numbers of individual objects. Historically, both of these
were strong incentives to mechanization. Covering the
expanse of plaster walls led to molded bricks and tiles. The
mechanical concept employed in the rotary drill for beadmaking
moved through the potter's wheel to the lathe; stamps for body
decoration in clay moved to punches for metalwork, dies for
coinage, Arentine relief-molded pottery, drop stamps for
pinheads and buttons, and eventually to power-driven presses
for nearly everything.

Consider also the development of mass production
methods involving the casting of molten metals. Though the
finest castings were made individually by the lost-wax
process, the majority of castings from the earliest days have
been designed expressly to facilitate molding. As with
punches and dies, most foundry processes have the charac-
teristic that the careful work of the master designer is
involved only once, whereafter replication takes over. A
lost-wax casting can be almost any shape the designer wants,
for the mold is destroyed each time. Repetitive casting, on
the other hand, requires either that a cheap plastic mold
material be quickly shaped by pressing against a permanent
model or that the mold itself remain intact for repeated use.
In either case the design of the object must be such as to
enable the model or the casting to be withdrawn cleanly from
the mold; i.e., there must be no undercuts or overhanging
features in at least two directions. Though more freedom can
be attained by making the mold in several pieces fitted
together, the two-piece mold is the simplest, and the
requirement of a parting line running around the object at its
maximum width to mark the surface of separation of the mold
confers a special quality to the design of anything made in
this way. Sometimes the parting line marks the equator of a
convex object, but it can also meander up and down irregularly.
It can be seen in the cast axes of the Early Bronze Age, in
terra-cotta figurines, toy soldiers, belt buckles, pressed
glass, plastic kitchenware, and a host of other objects. It
forms the undefined edge of early coins and becomes defined

and double in later coins and medals struck in retaining
rings. The rich low relief of coins and medallions provides
some of the finest examples of the relationship between
design and technique, for their dies are subject to the
geometrical limitations needed to allow the withdrawal of the
work even more stringently than in the case of molds for
castings, and the metal cannot flow laterally to a very large
extent.

The virtue of thin sheet metal in giving the greatest
glitter for a grain of gold was exploited in the earliest days
of metallurgy. However, before the days of rolled sheet and
drawn wire, most metal objects were made by hammering and
were basically three-dimensional in form. Theophilus, for
example, described the making of a chalice in the twelfth
century A.D. as involving a silver ingot worked out into a
thin disk, with a projection left in the middle, and the fully
rounded form then raised with offset hammer blows on a small
anvil called a stake.[7] Flutes were nearly as easy to produce
as rotational forms. The introduction of rolled sheet as a
starting material did not change the second stage of the
operation (as many beautifully hand-wrought silver objects
made today testify), but it did naturally invite a boxy form--
again fine if done straightforwardly.

Thin sheet metal, particularly gold, had been repetitively
shaped since very early times by simple pressing or hand
hammering against three-dimensional forms (dies) of wood,
stone, or metal (Fig. 3). Theophilus described the multiple
diestamping of saintly images with decorative borders in
sheet silver and gilded copper for use on caskets, book
covers, and the like.

Although water-driven hammers for rough forging were
used earlier, the mechanization of metal stamping begins with
Leonardo's wedge and screw press for striking coins; by the
seventeenth century the latter had become the rigid frame
press with heavy swinging arms bearing inert masses on their
ends, still to be seen in the mint at Paris. A smaller version,
the fly press, with a single swinging arm was then used for
cutting coin blanks; later this was adapted to precise
blanking, cupping, and forming operations. Flashier

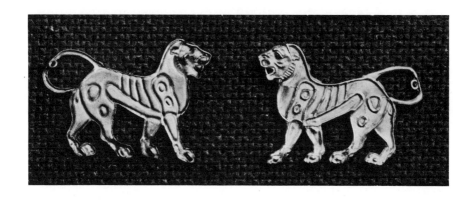

Fig. 3. Appliqué dress ornaments. Iran, fourth century B.C. Thin sheet gold shaped by pressing against a die; W. 1 1/2". The photograph shows both obverse and reverse. (Oriental Institute, University of Chicago.)

decorative work in thin metal was done in the simpler drop
press. All these devices can be seen in André Félibien's
engraving of 1676 (Fig. 4). The advantage of the screw press
for precise work was not immediately obvious, and coins were
also struck in engraved rolls for some time, for example, in
Sweden.

The drop hammer falling between vertical guides was used
for pile driving at least as early as the fifteenth century. Its
use with two dies to shape metal seems to be a seventeenth-
century innovation for shaping the solid heads of pins and
nails. A 1769 British patent describes a guided falling hammer
with a lead face--later called the force--used to strike thin
sheet metal against a single die, "more especially to be
used in the production of coffin furniture." The process soon
spread to stamping buttons and all kinds of brummagem ware
from thin sheet metal, and it partially displaced casting for
the formation of cheap three-dimensional contoured surfaces.[8]
Look at the simple drop press (Fig. 5)--its unmodulated blow
striking in a single direction symbolizes much of nineteenth-
century mechanized production. To make multiple stampings,
stacks of very thin metal sheets were superimposed under
the hammer, and the final profile with moderately high relief
was gradually achieved as finished sheets were removed from
the bottom and new ones added at the top (Fig. 6). A corner-
cutting operator could remove two or three at a time, sacri-
ficing detail for quantity.

W. C. Aitken described the process in 1865 with rather
perceptive remarks on its effect upon design.[9] It was an
ideally cheap means for the multiplication of surfaces in low
or medium relief. Innumerable decorated objects stamped of
sheet metal in poorly cut or worn dies formed a characteristic
feature of Victorian decoration, and these inferior examples
brought stamping to a disrepute that the technique per se
does not deserve. (One might remark that most handwork was
and is extremely sloppy; only the best survives or is noticed,
and the worst is forgotten.)

The coining press working on blanks of thick metal fitted
well into traditional design. But when the drop press was
used to shape large areas of thin sheet metal, the aesthetic

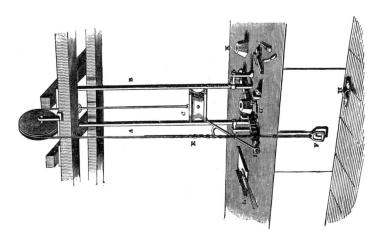

Fig. 4. Presses for the manufacture of coins and medals. From André Félibien, Principles de l'Architecture . . . (Paris: J. B. Coignard, 1676). (University of Chicago Library.)

Fig. 5. Simple drop press for use with lead "force." This type of press was used mainly for cheap stamped metalwork in the nineteenth century. From [John Holland], A Treatise on the Progressive Improvement and Present State of the Manufactures in Metal, 3 vols. (London: Longman, Rees, 1834), 3:220.

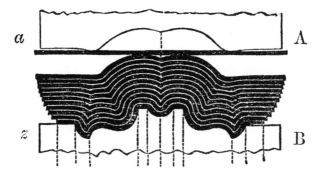

Fig. 6. Diagram of stack of metal sheets being stamped in a press like that
shown in figure 5. From Charles Holtzapffel, Turning and Mechanical
Manipulation, 5 vols. (London: Holtzapffel & Co., 1846-84), 1:409.

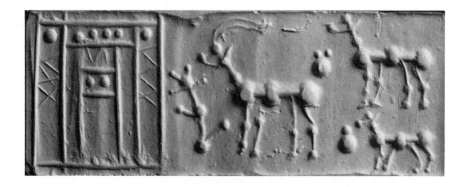

Fig. 7. Impression of a cylinder seal. Sumerian, ca. 3200 B.C. Note the
relief details of the design, which are inversions of the intaglio shapes that
arise naturally from the use of gravers and rotary drills. H. 1 1/4". (Museum
of Fine Arts, Boston, H. O. Cruft Fund 34.192.)

qualities of the surface became divorced from the underlying
substance, and decoration became independent of the body
needed to support it. In any object there is natural relation-
ship between the surface and the bulk, i.e., between its
one-, two-, and three-dimensional aspects. The fakery
involved in applying gold or silver plating on a solid copper
object is quite different from the deception of an ornately
stamped piece of thin sheet brass. Compare a magnificent
ormolu furniture fitting or even a gilded plaster picture frame
with a cheap lamp base embossed in thin sheet brass. In
the former the surface is simply and honestly applied for its
optical effect alone; in the latter the fakery is fundamental
for it is dimensionally misleading.

Objects in relief designed to be shaped by replicative
processes of any kind have yin-yang overtones arising from
the spatial inversions involved. The matching convexity
and concavity of the dual die/coin relationship or the triple
pattern/mold/casting sequence profoundly influence the
appearance of small details of the object. A narrow channel
cut into a broad surface differs from the equivalent projection
not only in its strength but also in the quality of imprecision
resulting from tool movement and the rounding of edges caused
both by tool wear and by limitations of material flow. A line
in intaglio can be a first, single cut; one in relief is what
remains as the terminus of many cuts. The aesthetic over-
tones of both the manner in which surfaces join and the
texture of surface details shaped by the craftsman's tool are
profoundly different when inverted. The scratch yields a
projection; the punch mark becomes a positive replica of the
sharp edges of the punch, not a sharp-bottomed concavity
with rounded metal flow leading into it. An external
projection subject to rounding cannot be the same as a cut
intaglio groove. Of course a good diesinker will avoid these
effects in finishing his work, but if tool marks remain, the
inversion looks unreal, for the eye remembers that a tool
can only approach a surface from the outside and senses
discrepancies that are hard to define (Fig. 7). The effect is
related to the perceptual figure-ground inversion in two
dimensions that has been used by artists, most notably by

Fig. 8. Child's pinafore with design formed by stencil-printing a resist and subsequently dyeing in indigo. Modern. From Chai Fei et al., <u>Indigo Prints of China</u> (Peking: Foreign Languages Press, 1956).

Maurits Escher, and has led to many interesting experiments
on the psychology of perception. In decoration consider a
stenciled resist-dyed fabric (Fig. 8). One's first reaction
is to expect the color to be applied in the cutout areas of
the stencil, and there is a faint tension when color covers
the areas of the stencil itself, still joined rather than
separated by the little supporting strips.

The graphic arts abound with examples of inversion. In
the West most xylographers' blocks are made to follow closely
the positive lines of an artist's sketch, which calls for
extremely precise and intricate cutting. However, some
artists (notably Paul Gauguin) work simply and directly on
the block, the tool forming blank spaces on the print between
larger variable areas of ink coming from the residual un-
touched block. From the beginning, Japanese wood-block
prints made much use of subtly varying line width, and by
the late seventeenth century they were using large areas of
block surface. In many modern Japanese color prints (hanga)
the grained texture of the block itself is proudly replicated.

In intaglio printing processes such as etching and
engraving, the artist working on the plate makes a negative
line directly to carry the ink, and the only inversion on
printing is chiral, not that of figure and ground. The quality
of the print nevertheless depends intimately on the depth,
width, and edge sharpness of the lines as well as on their
spacings, crossings, and junctions, permitting an infinity of
effects.

The Dimensionality of Hand- and Machine-shaping Processes

There is an essential difference between handcrafted and
machine-made objects that is based on dimensionality. The
manual worker can apply his tool to the material in any
direction, with any force, on any part, in any sequence.
Though the basic movement of a hand tool is unidimensional,
the three-dimensional shapes resulting from the integral
effect of many motions are unlimited. Machine operations,
conversely, are essentially one-dimensional or, at most,
combine a very few sequential motions. (Computer-controlled

machines may well void this limitation, for they allow
complete three-dimensional freedom if the working tool
itself is small. Intermediate examples of the products of
machine-controlled combined motion are the guilloche
snuff boxes of eighteenth-century France and the Lissajous
figures engraved on bank notes and bond certificates.)

The very essence of nineteenth-century ornamental work
in metal and other materials lies in shapes that are generated
by one-dimensional translation of a tool with an extended
working surface, geometrically either simple or complex.
The drawbench, the rolling mill, and the extrusion press all
give shapes that are swept out by the simple linear
translation of the profile of the working surface. Pressed
and stamped work marks the end point of the one-dimensional
advance of the three-dimensional contoured surface of the
die, or it may be (as in lithographic printing) a transfer of
locally different surface qualities that are three-dimensional
only on a microscopic scale. The requirements are similar
to those of easily made castings discussed above, and indeed,
all mass production methods suffer similar dimensional
restrictions. There is a philosophical similarity between the
reduction to essentials needed for mechanical production and
the exclusion of extraneous factors in a good scientific
theory; by invoking a sufficient number of variables and
motions anything can be duplicated, but in practice, economy
of both thought and motion leads to dimensional simplification.
Only if the abstraction is sensitively done will the product
be intellectually satisfying and beautiful to behold.

This distinction between "the workmanship of chance"
and "the workmanship of precision" is the basic theme of the
excellent little book by David Pye.[10] And materials are
central to the difference. The craftsman can compensate for
differences in the qualities of his material, for he can adjust
the precise strength and pattern of application of his tools
to the material's local vagaries. Conversely, the constant
motion of a machine requires constant materials. The gradual
standardization of shapes and sizes of prefabricated
materials as well as the control of their composition, internal
structure, and properties was second only to quantity and

cost of production among the principle themes of nineteenth-century metallurgy.

The machine, of course, also froze design, very often with unsatisfactory results because the designer improperly copied features appropriate to earlier techniques. Fifteenth-century typographic printing is one of the very few examples of a satisfactory close imitation of a handmade product by mechanical means, and it was possible only because the surface being shaped was purely two-dimensional; simple replication was possible without deformation or inversion of concavity and convexity. As one surveys the history of printing and the graphic arts, it is impossible to claim that replication is necessarily the enemy of aesthetics.

The quality of design imposed by machine inversion of relief decoration permeated the Victorian environment, or at least the popular vision of it today. Consider the molded terra-cotta facings for municipal buildings; the cast-iron fluted columns on warehouses or the more elaborate molded iron details affixed to the outside of department stores and domestic stoves; the innumerable stamped or cast parts of brass for the newly flourishing gas or electric lighting industries; or the molded panels in terneplate ceilings or pressed-wood furniture. Such designs are usually too exuberant to be beautiful by today's aesthetic standards, but it can be noticed that their unpleasant aspects lie less in the overall form than in the details. These were not designed from the beginning with a replicative process in mind but modified from the rich hand-carved profusion of eighteenth-century metalwork just enough to allow withdrawal from mold or die. The same process of die stamping that produced Victorian horrors also produced superb coins and medals. The nineteenth-century stampings were usually made from thin sheet metal locally stretched and bent to conform to the die, while the coins were of heavy metal and underwent volumetric flow. The thin sheet could neither accommodate sharp changes in surface contour, except uncomplicated bending in a single direction, nor draw smoothly to yield high local relief. There was a return to the rather unpleasant quality of some of the earliest sheet-metal work

shaped over forms, such as the so-called mask of
Agamemnon in the Athens museum in which the malleability
of gold is exploited to get a large area of glitter at the cost
of unpleasant folding, quite different from more careful
repoussé work in thicker metal such as the mask of
Tutankhamen. The differences in design required for
repoussé work in sheet as compared with stamping are not
great; nevertheless, they influence the whole quality of the
work.

When it had to be made by hammering, thin sheet metal
in any material was too expensive to be widely employed;
the introduction of rolling mills of sufficient power and pre-
cision made sheet metal one of the cheapest ways of
covering exterior surfaces of commercial buildings as well
as making common utensils for the home. Thin sheet iron,
whether tinned, galvanized, oxidized ("Russia iron"),
japanned, or just painted, lends itself remarkably well to
making objects of simple design using the cylindrical, conical,
or planar surfaces that naturally arise from the cutting,
bending in a single direction, and joining sheet metal to
form objects such as boxes, buckets, lanterns, funnels,
and trays that can be most appealing in their geometric
restraint (Fig. 9).[11]

Totally different in spirit are works raised from sheet
metal by hand hammering. In these, carefully offset local
hammer blows integrate to give three-dimensional changes of
shape, slowly forming the necessary curvatures while
maintaining nearly uniform thickness. This process, which
gives almost infinite freedom of shape, is an old and
beautiful one and still a favorite method of the silversmith
(Fig. 10) but very time-consuming and highly demanding of
skill. In quantity production it has been largely displaced
either by stamping or deep-drawing sheet metal between
dies or by spinning, in which a disk of sheet metal is
pushed by a burnishing tool until it conforms to the surface
of a wooden form mounted on a lathe head and revolving
at high speed. Spinning, which is subject to less geometric
restraint than drawing, first became important early in the
nineteenth century, when it was widely used to shape

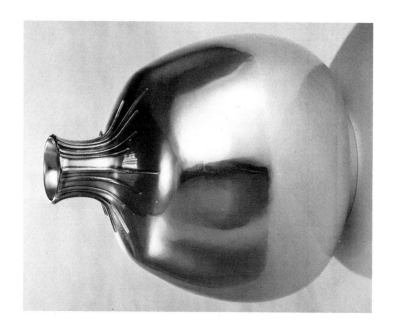

Fig. 10. Frederick A. Miller, silver bottle. Cleveland, Ohio, 1972. Made by raising from sheet silver. H. 6 1/2". (Frederick A. Miller: Photo, John Paul Miller.)

Fig. 9. Covered pail. America, 1800-1850. Sheet tin joined by soldering; H. 7". (Winterthur 58.3029.)

objects from the tin-antimony alloy known as Britannia metal.
It resulted in a revival in popularity of objects made of solid
tin, following a century of neglect of pewter, which had been
displaced by the availability of cheap but attractive ceramics
and glassware.

Good design in the decorative arts must take account of
the properties and the prefabricated shape of the material
as well as the limitations imposed by the replication process
on tool shape and tool motion. Though in principle it might
be possible to make by mechanical means an exact copy of
any individual work of art with all its nuances, the process
would need to have the same sensitivity as the original
handwork to the locally variable responses of the material,
and to achieve this requires a method of reproduction with
resolving power, response, and control on a microscopic
scale. The success of a mechanic's, or a machine's,
reproduction of a thing depends on his, or its, sensitivity to
whatever qualities are important, just as the skill of the
designer lies in the proper appreciation of surface qualities
in terms of structure and shape variation that come from the
intended means of production.

Decorative Textures

The process by which an object is finished affects its
appearance mainly by changing the microcontours of the
surface and hence the visual clues that arise in the
variations of light reflected at different angles from different
parts of the surface. However, mechanical preparation of
surfaces may change the structure of the immediately under-
lying material, and if there is subsequent coloring by
chemical treatment, it can cause even greater changes in
surface quality. The unmatched beauty of some Japanese
metal finishes, notably on the alloy shibuichi, depends on
the preservation of a discrete though almost invisible micro-
structure that burnishing would entirely destroy--as indeed
it did on European metal surfaces, none of which revealed
their underlying rich texture to the scientist's microscope.[12]
The coarser crystals in tinplate were decoratively used in

the ware called <u>moire metallique</u> that was briefly the rage
early in nineteenth-century Europe and later appeared in
America (Fig. 11). The preferred finish for a metal seems
usually to have been a highly burnished reflective surface,
but finely tooled or abrasively scratched lines to give
unexpected reflections have been and are popular. Chemical
treatment may give color by producing superficial layers of
carbonates, oxides, sulphides, and the like, with a texture,
if visible at all, not much related to the underlying structure
of the metal. From the sixteenth century on, innumerable
western publications of the practical handbook type include
recipes for pickling solutions of various types to give such
effects.

On Materials in the Nineteenth Century

Material innovation in the nineteenth century lay mainly
in the province of the organic chemist. Bleaching textiles
with newly discovered chlorine and dyeing with synthetic
dyes permitted all classes of people to have some of the show
of color that, at least in Europe, had previously been
limited to the rich. For centuries organic materials such as
bone and various pasty mixtures had been softened by
moisture and heat and molded by pressure into buttons, knife
handles, and the like, but the nineteenth century saw a
transition toward a quite new type of material. Rubber and
gutta-percha were first used in more or less their natural
states; then came rubber changed by sulphur cross-linking
into both elastic and hard forms, the latter called vulcanite
and pressure-molded to shape. The first fully artificial
polymer was celluloid or xylonite cellulose nitrate
stabilized with camphor. This was introduced in 1862 by
Alexander Parkes, an English metallurgist, and provided a
kind of synthetic ivory that could be shaped either by
pressing or by cutting. Parkes's firm failed, but an improved
version of the material offered in the early 1870s by John
Hyatt, of Albany, New York, quickly established a stable
market. Billiard balls and piano keys were its first large
applications, but celluloid was widely used in innumerable

Fig. 11. Painted tin tray. Possibly Stevens Plains, Maine, 1874. The center area (L. 8", H. 4") is of moire metallique, a pattern formed by the controlled crystallization in tin, subsequently developed by etching in acid. OL. 12 3/8". (Winterthur 65.1717.)

Fig. 12. Zinc chimney pots. Drawing attributed to Punch, reproduced from J. H. Pepper, Playbook of Metals (London: George Routledge, 1866), p. 498.

small die-molded objects. As the first artificial thermo-
plastic material, it clearly foreshadowed the synthetic
polymer industry of the twentieth century.[13] Among
nonmetallic inorganic materials, that vastly important
material cement was beginning to modify architecture, and
moldable synthetic stone had some vogue in the arts. The
production of glass was mechanized to some extent, but
its nature remained basically unchanged except in glass for
optical and laboratory use. The ceramics industry also was
mainly concerned with exploiting the changes of the
eighteenth century rather than seeking new compositions.

In metals, the nineteenth century saw great changes in
shaping methods (mainly the introduction of machinery to
reduce labor costs, often fiercely resisted by the older
workers). Slight changes in old alloys were accompanied by
new names, but on the whole the only sign of the new science
was in the better control of composition and the introduction
of electroplating. There was, however, a change in the
pattern of use of the old metals. The alloy paktong, previously
imported from China, became cheaper and more available
when manufactured in Europe under the name German silver
or nickel silver. Metallic zinc moved from a laboratory
curiosity or a component in brass to a place of importance in
its own right.

Tin took on renewed importance in the form of Britannia
metal, an alloy of tin with about 4 to 8 percent antimony and
1 to 2 percent copper. This alloy is not only brighter and
more tarnish-resistant than pewter but is nontoxic, harder,
and has the resonance expected of a metal. Moreover, it
has superlative working properties, and though easily cast
to shape, objects, which weigh and cost less than cast
ones, can also be formed out of rolled sheet. Though tin-
antimony alloys had been used sporadically on the continent
long before, the industry really began to develop in Sheffield
around 1770. Innumerable objects imitating both the glitter
and the form of the best silverware appeared in the second
half of the nineteenth century, but even before this the alloy
itself had found widespread use. Writing in 1834, John
Holland remarked, "Although . . . almost every article

manufactured in silver now has its counterpart in Britannia
metal, the greater part of the material used is in the
production of candlesticks, tea pots, coffee-biggins and all
kinds of measures for liquids."[14] The sheet metal was soft
enough to be shaped easily on cast-iron dies, cheaply made
from plaster of paris molds simply formed on fine silver
objects. Britannia metalware is particularly associated with
spinning, a process using simple dies of wood or other soft
material that do not need elaborate diesinking operations in
steel as do the tools for most competitive processes.
Britannia metal as a poor-man's silver came into competition
with nickel silver, and in one of the many unpredictable
interactions that have so strongly influenced the development
of technology, both of these white alloys were later to
provide an excellent base for electroplated silverware, which
will be discussed in the next section.

Zinc needs attention here as an old metal that took on
new life in the nineteenth century. It was, of course, a
component of brass, which had been made by cementation of
copper with zinc oxide for centuries before the metal itself
was discovered. Zinc had been imported into Europe from
the Orient to some extent from the seventeenth century on,
but its extensive use dates from the early nineteenth century
when industrial methods of rolling it into sheet were
introduced. (The coarsely crystalline cast metal is brittle
and needs to be heated to between about 100 to 150° C.
before it can be extensively deformed.) The sheet metal came
to be widely used in both Europe and America for roofing,
gutters, chimneys (Fig. 12), cisterns, dairy utensils, and
the like. Embossed zinc sheets for ceilings and external
sheathing for buildings were common. Alfred S. Bolles in
1879 extolled sheet zinc: "It is so cheap, too, that it has
brought handsome cornices within the means of all; and the
invention has really been the means of improving the
architectural appearance of our formerly exceedingly plain
business-streets, as well as their security."[15]

Castings of zinc alloyed with 3 to 4 percent of copper,
known as bidri metal, were widely used in India for
decorative objects. Pickling gave bidri an attractive black

matte finish to contrast with the usual silver inlay. The
Topkapi museum contains two roomfuls of cast zinc objects
elaborately inlaid and encrusted with gold, diamonds, rubies,
and emeralds. Nevertheless the use of zinc alloys for
casting was slow to develop in the West until the 1930s,
when the making of die castings of alloys stabilized against
corrosion became a large industry. Before this, commercially
pure zinc was used in making cheap ornamental hardware,
statuettes, and the like by the process of slush casting, but
the principal use of the metal had been as a minor constituent
in alloys or as rolled sheet. Zinc played an invisible but
essential role in electroplating and a too visible but important
one in galvanized sheet iron.

The Beginnings of Electrometallurgy

 Most of the developments in nineteenth-century
materials production involved analytical chemistry, which
revealed new sources of raw materials and identified
impurities responsible for undesirable properties in the
products. It gave the better control of smelting and refining
operations that was necessary for the increased scale of
operation, but chemistry did not directly produce major
changes in the working of materials--these came from the
mechanical approach, mainly the application of power to the
processing of raw materials and their final shaping. The new
methods of chemical analysis did disclose previously unknown
elements that had lain hidden in unrecognized minerals or
invisibly present in minor amounts in common ones, and
they led inevitably to the discovery of the quantitative laws
of combination between atoms.
 The discoveries of nickel and aluminum (new metals that
were to become most important in the decorative arts) were
thus a natural outcome of the old chemistry. But a new route
to discovery--indeed a newly found aspect of nature that
would change society more than all the social revolutions of
history--was coming out of the physics laboratory. Just
before 1800 voltaic electricity was discovered. It opened
to study innumerable properties of matter of which there had

been almost no hint in earlier science, still less in the
decorative or useful arts. The transition from the discovery
of electricity to its useful application was relatively slow,
occurring first in the fields of the electric telegraph and
electroplating, both in the same year, 1837.

Much had been written about the development of the
telegraph, whose utility and profitability was obvious enough
from the beginning; electroplating was less spectacular, but
it played a greater role in spreading knowledge of electricity.
It was both pleasant and democratic. While the telegraph
enlisted the interest of governments and mammoth corporations,
electroplating was at first only a popular hobby, a means of
copying art objects and printing pretty pictures. The
decorative arts did not lead to the discovery of electricity
or electrodeposition, and indeed, these uses followed
Michael Faraday's establishment of the scientific laws, but
it was nevertheless the decorative applications of plating
with electricity that inspired the first major steps toward
today's industry. The arc light followed close behind plating,
and in time the incandescent light would certainly have
developed its own generator if suitable ones had not existed,
but the fact remains that much of the prehistory of the
electrical power industry actually lay in the development of
generators for electroplating operations.

The earliest records of electrochemical phenomena relate
to copper mines, where it had been found that iron immersed
in cupriferous mine waters would become coated with copper.
While this at first served mainly to support alchemical
speculations regarding transmutation, it was also used in
producing copper on an industrial scale in the seventeenth
and eighteenth centuries. Delightful small cups and dishes
of distinctive design were made at Herrengrund in the
Erzgebirge from this copper.[16] Similar replacement of silver
and lead by mercury or zinc gave beautiful dendritic crystals
in many chemical demonstrations from the seventeenth
century on.

Assayers knew in the eighteenth century that zinc, iron,
copper, and silver were capable of sequentially replacing
each other from solution--a listing incorporated in the

earliest tables of chemical affinities, and which today we call the electrochemical series. The accelerated decay of dissimilar metals in seawater when in contact with each other was painfully known to the British navy and to the hopeful purveyors of rolled sheet lead in the seventeenth century.[17] Within six months after Volta's "pile" had turned the metals responsible for Galvani's spasmodic physiological effects into a continuous battery, Nicholson had begun electrochemistry by decomposing water, and his discovery was followed by several studies in which many kinds of salt solutions were decomposed and metal depositions observed. The first decades of the nineteenth century were of immense scientific importance for the development of the basic principles of electricity, and perhaps even more for laying the groundwork for the eventual merging of physical and chemical theory. It was an exciting period in science, with Davy discovering new chemical possibilities based on electricity (including the reduction of the alkali and alkaline earth metals), Ohm establishing the basis of circuit theory, Oersted discovering the magnetic field associated with a current, and Faraday both the association of moving electrical and magnetic fields and the laws of electrolysis.

William Wollaston in 1801 observed the plating of an adherent copper layer on silver, and two silver medals were electrogilt by Luigi Brugnatelli in Padua in 1805. Shirley Bury in her fine book on Victorian Electroplate[18] showed a small but impressive "galvanic goblet" in the royal collections that was made of silver and electrolytically gilded in 1814 by the English firm of Rundell, Bridge, and Rundell. But such findings were far from the ordinary concerns of inventors, and no one seriously sought practical application for almost four decades. Practical electrometallurgy became inevitable after the introduction in 1836 of the two-compartment copper-depolarized cell devised by J. F. Daniell, for anyone using it could not help but notice that copper is deposited from the copper sulphate solution on the copper cathode whenever current is drawn from the cell, although the utility of this fact still had to be realized. W. de la Rue, who used an electrochemically naive cell of his own

devising, seems to have been the first to notice that such
copper reproduced every detail of the underlying surface.[19]

Even before this, Antoine Becquerel, suspecting the role
of electrolysis in geology, had used a cell with two electro-
lytes divided à cloison by a compact layer of unfired clay to
study mineral formation.[20] He successfully made crystalline
deposits of several oxides and sulphides, but he was
uninterested in metal formation. Becquerel and Daniell
together formed the background for the work in 1837 of
Golding Bird who used a porous layer of plaster of paris to
separate two compartments of a cell containing zinc and
platinum electrodes immersed in solutions of salt and of the
material to be electrolyzed. Bird successfully produced
metallic copper, iron, tin, zinc, bismuth, antimony, lead,
and silver from solutions of their chlorides or nitrates; he
noted that hydrogen was evolved if the metal was not easily
reduced and that the deposits were crystalline, often
beautifully so. His copper matched the finest specimens of
native copper in hardness and malleability; silver formed
needles of snowy, dazzling whiteness; and the deposition of
nickel, though externally black, was of silvery luster where
it was in contact with the electrode. Bird reduced silicon
from silicon tetrafluoride solution in alcohol and electrolytically
made amalgams of potassium, sodium, and even ammonium.
Although he himself did not follow up any of the practical
applications, his paper was published in Philosophical
Transactions and abstracted in lesser journals where it could
be widely noticed. At their 1836 meeting, the members of
the British Association were entertained by a gentleman named
R. W. Fox who displayed a pot containing water, clay, zinc,
and copper "by which humble means he imitated one of the
most secret and wonderful processes of nature, the mode of
making metallic veins."[21]

Science had laid the groundwork. The next stages were
practical. Two Englishmen, C. J. Jordan and Thomas Spencer,
independently saw the utility of electrodeposition in 1837,
but neither had published anything when in October 1838 an
announcement was made in St. Petersburg of the use of
electrolysis to copy engravers' plates. Thereafter practical

electrometallurgy caught the popular imagination, and three
rather distinct uses were developed with great rapidity.[22]
The first two of these--electrotyping plates for the printer
and copying three-dimensional objets d'art--involved making
negative replicas separable from their molds, while the
third, electroplating, required tight adherence of the deposit.

The first public announcement of the utility of electrolysis
was the account of the reproduction of line engravings read
by the Russian physicist Moritz Hermann von Jacobi before
the Academy of Science in St. Petersburg on October 5, 1838.
Jacobi had previously done imaginative work on electric
motors, and had even driven a small boat on the Neva with
one. He outlined his process in a letter dated June 21, 1839,
which he sent to Michael Faraday accompanied by three
electrotype plates (one stuck irremovably to the original)
and concluded "Artists should be very grateful to galvanism
for having opened this new road to them." Jacobi published a
slim book on galvanoplastics, as it was called on the
continent, in April 1840.[23] He was optimistic about his
process, predicting that casting or stamping might be
entirely superseded as methods of shaping metals, suggesting
electrotyping as a means of duplicating molds for relief-
decorated pottery and printing surfaces of all kinds, and even
predicting that buildings would be adorned "with cheap and
numerous copies of the finest specimens of ancient bronzes."

On March 2, 1840, a letter from Jacobi was read to the
Académie des Sciences in Paris, and three large copper bas-
reliefs made by him were displayed.[24] By that time, however,
the process was widely known, and at the same meeting of
the academy D. F. J. Arago showed medals made in Frankfurt
by one Vogel, while Becquerel produced others by a man named
Boquillon of the Pris Conservatoire, who sent engravings and
prints from electrotype clichés to the next meeting. The
preceding year had been an active one, especially in England
where the first announcement of Jacobi's invention had
appeared in the form of a note by Julian Guggsworth published
in the March 1839 issue of William Sturgeon's Annals of
Electricity:

I have just learned that Professor Jacobi is
occupying himself with a discovery which may,
if in the end successful, prove of far more use
than Daguerre's. He observed that the copper
deposited by galvanic action on his plates of
copper could, by certain precautions, be removed
from these plates in perfect sheets which presented
in relief most accurately every accidental
indentation on the original plate. Following
up this research, he employed an engraved
copper plate for his battery, caused the deposit
to be formed on it, removed it by some means
or other, he found that the engraving was printed
thereon in relief (like a wood cut), and sharp
enough to print from. Whether a repetition of
the process from this galvanically formed block
will furnish, in its turn, a copper plate from which
impressions can be thrown off, is not yet
established.[25]

Guggsworth was a frequent contributor of notes regarding
continental electrical experiments in Sturgeon's Annals. A
later note in the more widely read London Athenaeum for
May 4, 1839, flushed two men who claimed to have developed
the process previously and independently. Neither was a
professional scientist, and in fact, the subsequent develop-
ment of the practical art owed very little to any but
rudimentary science. If anything the debt was in the other
direction, for the demand for wire, insulators, binding posts,
and chemicals provided a useful support for the more esoteric
business of laboratory supply houses.

The first to publish was a printer named C. J. Jordan who
briefly but clearly described the copying of engraved plates,
set type, coins, and medals in a letter dated May 22, 1839,
printed in the issue of the London Mechanics Magazine for
June 8, 1839.[26] The second was Thomas Spencer of Liverpool
who in May 1839 had offered a paper to the British Association
that was rejected as unoriginal and did not become public
until he read it on September 12, 1839, before the Liverpool

Polytechnic Society.[27] Spencer said his purpose was "to
point out a means by which I hope practical men may be
enabled to apply a great and universal principle of Nature to
the useful and ornamental purposes of life." He said that
he hit upon the method in September 1837 when he noticed
that the usual deposition of copper on the cathode in a
simple battery had been locally prevented by some drops of
varnish. Seeing that he could "guide the metallic
deposition in any shape or form" he chose, he proceeded to
produce relief printing surfaces by depositing copper in
lines engraved through a coating of soft cement on a metal
plate. A second and, Spencer believed, more generally
useful application of electrolysis was in the duplication of
objects such as coins. He said that this idea came to him
when he observed the minute replication of a copper penny
that, lacking copper sheet, he had used as a battery electrode
in a demonstration of the electrolytic origin of metallic ores.
By the time he published, he had prepared "stereotype" plates
from both wood blocks and copperplate engravings and had
made duplicates of three-dimensional models in clay or
plaster of paris, whose surfaces were rendered conducting
with bronze powder or gold leaf. A drawing of Spencer's
cell (Fig. 13), was printed from a relief electrotype and
seems to be the first electrotype print ever to be regularly
published.

It seems probable that all three men, Jacobi, Jordan, and
Spencer, made the discovery independently. Jordan's letter
went virtually unnoticed until Napier rediscovered it in 1851,
but Spencer's paper immediately excited popular interest.
The English scientific community remained somewhat aloof
since there was no new theory involved, but entrepreneurs
quickly developed many profitable applications--all of which
were in fields related in some way to the arts. It should be
noted that each of the three original inventors was concerned
with the reproduction of surfaces with details in relief or
intaglio features, and that all three mentioned the graphic
arts. The reproduction of plates for printing provided the
basis for an enormous growth in illustrated books and
magazines. The Illustrated London News (1842),

DESCRIPTION (AND ACCOMPANYING VIEW) OF THE APPARATUS.

FIGURE 1.

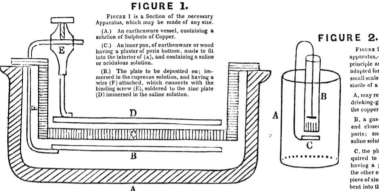

FIGURE 1 is a Section of the necessary Apparatus, which may be made of any size.

(A.) An earthenware vessel, containing a solution of Sulphate of Copper.

(C.) An inner pan, of earthenware or wood having a plaster of paris bottom, made to fit into the interior of (A), and containing a saline or acidulous solution.

(B.) The plate to be deposited on; immersed in the cupreous solution, and having a wire (F) attached, which connects with the binding screw (E), soldered to the zinc plate (D) immersed in the saline solution.

FIGURE 2.

FIGURE 2 is a more simple apparatus,--but on the same principle as Fig. 1. This is adapted for experiments on a small scale; or to take a facsimile of a single medal.

A, may represent a common drinking-glass, containing the copper solution.

B, a gas-glass, having one end closed with plaster of paris; and containing the saline solution.

C, the plate or medal, required to be deposited on, having a plate attached, to the other end of which is a piece of zinc,--the wire being bent into the requisite form

₄ The above engraving has been produced (in relief) by the Electro-chemical Process described in the preceding pages ;—and is the first result of that process appearing in print.

It is however by no means a fair specimen of what *may* be done by it.—The lines were originally cut in a sheet of soft lead, hastily, and without reference to ornamental beauty of execution. The want of a tool properly adapted to cut the lead, accurately, in the required manner, has made the lines less regular in formation than they would otherwise have been. The letters were punched into the lead, with types. The lead, thus prepared, was then put into the apparatus it illustrates, and a plate of copper deposited, the lines being in relief,—which is here printed off, accompanying the pages of the treatise.

Fig. 13. The first published print from an electrotype plate, showing the cell used to produce the plate. From Thomas Spencer, "An account of some experiments . . . ," Annals of Electricity 4 (Jan. 4, 1840): unnumbered page. (Courtesy Burndy Library.)

L'Illustration (1843), Scientific American (1845), and
Harper's Weekly (1856) all date from this period.

A major book on practical metallurgy (and one that
introduced the word to the language) was Elements of Electro
Metallurgy by Alfred Smee. With a preface dated November
2, 1840, it was published early in 1841 by E. Palmer, a
Londoner who ran an imaginative business in scientific
apparatus and later offered a complete electrotyping service
for artists. Palmer's 1840 catalog illustrated kits for electro-
typing with a two-compartment cell of the simple horizontal
type described by Jacob and Spencer, for sale at prices
between 5/ and 10/6. In 1839, Smee had invented a voltaic
cell with a platinum black cathode.[28] Among other occupations
he acted as surgeon to the Bank of England and later, in 1845,
supervised the printing of bank notes from relief electrotype
plates. The April 1840 issue of the Philosophical Magazine
contains a short article by him on electrotyping, illustrated
by an excellent impression from an electrotype of an engraved
plate, which Smee claimed was the first ever to yield more
than one thousand impressions.[29] In his book, however, he
does not mention this, giving priority instead to an electro-
type in the issue of the London Journal of Arts and Sciences
for the same month. This sketch, reproduced in figure 14, is
an amateur etching after a figure by Rembrandt. The original
plate bears the initials W. N., undoubtedly those of the
enterprising editor of the journal, William Newton, who
supplied a note on its production. The only visible difference
between the impressions of the original etched plate and the
electrotype is the disappearance of these initials.

Suspecting that professional engravers would oppose the
new process for fear of technological unemployment, Smee
assured them in his book that they

> need be under no apprehension, for not only will
> [the engraver's] talents be more required but he
> will be called upon to execute more splendid
> specimens of art; for as these can be multiplied
> ad infinitum, a large circulation will render it
> worthwhile for any publisher to pay a very high

price for an original, which he conceives
will meet with general public approbation.
The publisher, in the same way, could lessen
the price of engravings from our finest works
of art, so as to bring them within the means
of every person; and there is no doubt that he
who first engages in the business upon the above
liberal and well-known principles, will realize
for himself a large fortune, and contribute
greatly to the benefit of society.

Smee suggested the use of electrolysis for the reduction
of metals from their ores, for the making of electrotype
plates for calico printing, and for transfer printing in the
decoration of pottery. Fearing that the trinkets produced by
electrometallurgy might "appear to many to be trifling, as
they contribute only to embellish the drawing and gratify the
eye," he admonished his readers to "remember that if private
persons engage in the manufactures of these little trifles it
will lead to a knowledge, and a practical knowledge too, of
the effects of one of the most important and universal agents
operating in nature." The final paragraph in Smee's 1841
book shows a clear sense of what might happen from growing
applications of electricity:

Doubtless the galvanic fluid will, before long,
be as important to the manufacturer as the heat
of a furnace. At present a person may enter a
room by a door having finger-plates of the most
costly device, made by the agency of the electric
fluid; the walls of a room may be covered with
engravings, printed from plates originally etched
by galvanism, and multiplied by the same fluid.
. . . At dinner the plates may have devices given
by electrotype engravings, and his salt spoons gilt
by the galvanic fluid. . . . Although great and
glorious are the triumphs of science detailed in
this work, yet the prospect of obtaining a power
which shall supersede steam, exceeds in value

all these applications. For to cross the seas,
to traverse the roads, and to work machinery
by galvanism, or rather electro-magnetism, will
certainly, when executed, be the most noble
acheivement [sic] ever obtained by man.[30]

Smee's prediction of work and travel by electromagnetic
means was not original but simply reflected the "electric
euphoria" of the period. It could not have been fulfilled if
the necessary electrical energy had had to come from voltaic
sources. Even using the efficient Daniell cell, 1.1 kilograms
of zinc were needed for each kilowatt-hour produced, in
addition to 1.6 kilograms of sulphuric acid and 2.9 kilograms
of copper sulphate. There was also a formidable disposal or
recycling problem involving 2.7 kilograms of zinc sulphate
and 1.1 kilograms of metallic copper. The early electrical
enthusiasts were misled by the force of the electromagnet
into thoughts of almost unlimited power. As it happened,
however, the needs of electrotypers and electroplaters
specifically led to the development of the generator and so
to industries far beyond even Smee's imagination.

Electrotype and Galvanoplastics

In the second edition of Smee's book, published in 1843,
the author remarked that "there is not a town in England that
I have happened to visit, and scarcely a street of this
metropolis [London], where prepared plasters are not exposed
to view for the purpose of alluring persons to follow the
delightful recreation afforded by the practice of electro-
metallurgy."[31] Somewhat later, in 1868, Alexander Watt put
it even better.

So great was the interest felt in this country--
nay, almost all over the civilised world, when
this beautiful discovery was made known, that
persons of every grade in life devoted their
attention to it. The student, the mechanic,
the artist, the nobleman and the chemist, with

equal zeal, though with different views, deposited
copper from its solution by electrochemical
agency. Every one had his set of electrotyping
apparatus, and his bath of sulphate of copper.
Even among the fair sex would be found many
a skilful manipulator, and in such hands, how
could the art fail to give beautiful results!
Everywhere this art was in vogue, and whilst
it was being studied as an amusement by some,
others were turning their attention to its
commercial value, with a view to making it
subservient to the useful purposes of life. So
that in a very short time this country was well
stocked with a new class of competitors--
electrotypists, stereotypists, electro-platers,
gilders, &c., &c.; and now that the electro-
mania has subsided, it has settled itself down
into a very comfortable, highly lucrative and
legitimate business.[32]

Later Watt emphasized the deeper influence on men's minds.

It is not to be wondered at that an art so
fascinating should have produced more than
an ephemeral effect upon the minds of some
of those who pursued it. Indeed, it is within
our own knowledge that many a youth whose
first introduction to chemical manipulation was
the electro-deposition of copper upon a sealing-
wax impression of a signet-ring or other small
object, acquired therefrom a taste for a more
extended study of scientific matters, which
eventually led up to his devoting himself to
chemical pursuits for the remainder of his days.[33]

Within a decade after Jacobi's announcement, many
patents had been taken out for a variety of applications,
almost all of them concerned with either printing or with
decorative trinkets. In 1842 an artist named Thomas

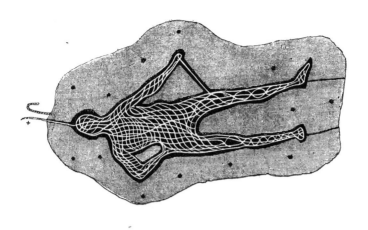

Fig. 14. Print from an electrotyped copy of an etched plate, signed W. N. From the London Journal of Arts and Sciences 16 (Apr. 1840): pl. 7. (Boston Public Library.)

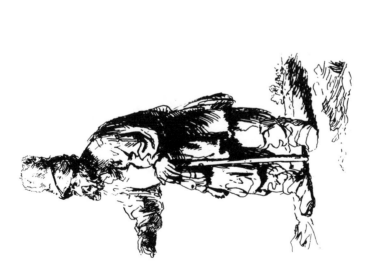

Fig. 15. Arrangement of an internal, insoluble anode wire, with insulating spacers, to enable the production of full-round sculpture without joints. From Alfred Roseleur, Manipulations Hydroplastiques, Guide Practique du Doreur, de l'Argenteur et du Galvanoplaste (Paris: Deval & Pascalis, 1883).

Fig. 16. Copper plaques and busts made by electrodeposition on gutta-percha molds by the Pellecat process. From Émile Bouant, La Galvanoplastie (Paris: Bailliere, 1894).

Sampson, working with E. Palmer, published a little booklet on what he called "electrotint," with illustrations of various ways of getting texture in plates for both relief and intaglio printing.[34] Another process of Palmer's, closely related to this, was glyphography, in which the artist cut the lines of his design through a 1/30-inch thick white ground on a blackened copperplate, a relief printing surface then being deposited on it in electrotype. Palmer advertised copperplates prepared with the appropriate ground and a custom electroforming service to finish them. He made the electrotypes to illustrate the second edition of Smee's book and offered prints on various subjects to the public.

There followed a spate of publications, highly practical in approach, giving details of battery and cell construction, the materials to be used, and especially methods of making molds in plaster, gelatin, and simple thermoplastic materials. Though applied to a new field, these molding techniques strongly resembled those used in copying sculptors' models in art bronze foundries and the long tradition of cheap molded duplicates of art objects.

In the United States the first printed technical account of electrotyping was a rather curious review of Spencer's paper by Benjamin Silliman, Jr., in his father's American Journal of Science.[35] The copying of engraved copperplates had already become important, and a footnote to Silliman's review cites illustrations in Mape's American Repository for July 1840 and the Westminster Review for September. Much better information appears in the Manual of Magnetism written by the Boston instrument maker Daniel Davis and published by him in August 1842.[36] The book contains a fine early print from an electrotype and one of the earliest descriptions of electrochemical effects produced by current from a magneto-electric machine. The account of practical electrotyping is adequate, though Davis's aim was more to provide instruction in science than to aid the artisan. The American practitioner was well served nine years later with the reprinting in full of James Napier's Manual of Electro-Metallurgy.[37]

The possibility of forming an adherent plate of one metal

upon another by electrolysis was noticed by the early
workers mentioned above, but most of them were more
interested in producing deposits that were to be stripped
from the cathode surface, i.e., plates for printing and more
impressive three-dimensional objects. Smee's April 1840
paper mentions that Karl A. Steinheil in Munich was using
the process to duplicate a large sculpture of the labors of
Hercules containing 140 figures. In August of the same year,
a French electrotyper named Soyez offered to produce the
elephant for the Place de la Bastille for a quarter the cost of
casting in bronze. The firms of Elkington in Birmingham and
Christofle in Paris, both famous in the 1840s for electroplated
silverware, developed large businesses in the duplication of
metallic antiquities by electrodeposition and were soon
producing original sculptures by this method. The process
was to make a mold, if necessary divided into pieces, of
plaster or gutta-percha shaped directly against the artist's
original, to render the mold surface conductive by brushing
on graphite, and then to deposit copper on it electrolytically
(Fig. 15). Elkington often made the mold itself by electro-
deposition on the sculptor's model, which was destroyed in
cutting off the negative. At first the finished work was made
by joining together open pieces easily accessible to the
electrolyte; later some were made by the use of an internal
insoluble anode that permitted almost the entire surface of a
full-round statue to be continuously coated (Fig. 16). This
was the invention of E. Lenoir, better known as the inventor
of the first internal combustion engine to be brought into
practical use.

Some very large pieces of sculpture were made by
electrodeposition, with deposits of copper sometimes more
than three-eighths of an inch thick. Aitken in a description
of the Birmingham hardware industry written for the British
Association meeting of 1865 listed twenty-two statues over
6 feet high that had been made by Elkington in the preceding
five years.[38] Baths were in use as large as 15 feet long, 8
feet wide, and 9 feet deep, holding 6,680 gallons of electro-
lyte. The statue of Lord Lieutenant Eglington in Dublin was
13 1/2 feet high and weighed three tons. The 10 1/2-foot high

Fig. 17. Memorial of the Great Exhibition of 1851, London. The central statue of Prince Albert (H. 10 1/2') and the four flanking figures of the continents are electrotypes made in 1863 by Elkington and Company. From the Illustrated London News 42 (June 27, 1863): 696. (Massachusetts Institute of Technology.)

statue of Prince Albert and the four flanking figures
symbolizing the continents in the memorial monument to the
Great Exhibition of 1851 and its founder (Fig. 17), all took
shape in a bath of cold electrolyte, not in the traditional
fiery mold of the bronze foundry . Even larger items
were made in France: one of the statues representing the
Muses made by Christofle for the Opera House in Paris was
19 1/2 feet high.

Many American museums and art schools began their
collections with plaster casts of European sculptures. Every
art school boasted of its casts. Less conspicuous but
equally valuable for study were electrotype copies of metallic
objects, many of which show almost perfect fidelity to their
original down to the most minute toolmarks and accidental
scratches. The production of these was an important business
in the nineteenth century and persists in a minor way to this
day. A series of fine reproductions mainly of objects in the
Louvre was made for the South Kensington Museum (now the
Victoria and Albert Museum) by the Elkington firm, which
published a special catalog in 1855.[39] In 1864 the
leadership of Henry Cole, head of the South Kensington
Museum, culminated in a "Convention for Promoting
Universally Reproductions of Works of Art for the Benefit of
Museums of All Countries," signed by princes of the reigning
families of Europe. In 1872 the museum issued priced
catalogs of reproductions of objects then available, some
five hundred in number.[40] Despite some trouble at the
Kremlin, museums seem to have been remarkably willing to
allow their treasures to be copied, and fortunately few
objects were damaged in the molding operation.

A similar list of reproductions of objects from Vienna
and elsewhere, made for the Musée des Arts Décoratifs, was
issued by the French firm of Christofle in 1887. From this
comes figure 18, showing pieces of the armor plate of Henri
II, copied in copper and iron and costing between 75 and
345 francs. The largest of all electrotypes was the copy of
Trajan's column, built up of six hundred bas-relief sections
each a meter square, made for the Gallo-Roman Museum in
Saint-Germain-en-Laye. These large objects were matched

by copies of Roman goldsmiths' work of exquisite quality,
including the Hildesheim treasure discovered by Prussian
soldiers in 1868, which was copied in Paris by Christofle
and Henri Bouilhet before being taken to Germany.

I do not know why electrolysis is no longer used in
making large sculpture. Some hint of the reason may,
perhaps, be found in a lecture by Bouilhet printed in the
Christofle catalog of 1887. Concluding that it is not enough
to be a skilled workman, it is also necessary to be a
conscientious one, Bouilhet said that the ease with which
extremely thin objects can be produced by galvanoplastics
had led to flooding the market with innumerable pieces of
some artistry that were so thin they had no durability. "The
public, failing to take into account the fact that the lack of
solidarity arises in the greed of the maker, not in the nature
of the process, has wrongfully come to disapprove the
process. But this, surely, can happen with any process,
especially those in the decorative arts."[41]

The electrotyping of small objects continues, and there
is growing interest in it at the present time on the part of
both amateur and professional craftsmen. No less an object
than the crown used at the investiture of the Prince of Wales
on July 1, 1969, was made by electroforming in gold.[42]
The use of electroforming for bas-relief plaques is increasing,
and perhaps larger sculpture will return if electrotypers can
improve the mechanical properties of their material. In the
meantime, electrochemistry plays an enormous role in industry.
Today virtually all aluminum is reduced in an electrolytic
cell, and almost all copper is electrolytically refined.
Electrodeposition provides both conductors in integrated
microcircuits for the most advanced computers and intricately
shaped waveguides for microwave equipment for scientific
and military purposes; electroforming shapes searchlight
mirrors, molds for high-fidelity disk records, and automobile
trim. Rocket nozzles are electroformed of refractory cobalt-
nickel-tungsten alloys, and hard-to-machine metals are
electrolytically milled to shape in a bath with reversed
polarity. In the decorative arts, however, the use of
electrolysis in plating objects shaped by other, cheaper

methods has far outstripped the earlier use in electroforming.

Electroplating

It was for plating, not shaping, that the main industrial development of electrolysis took place. Historically, the modification for decorative reasons of the composition and structure of surfaces was probably contemporary with the earliest uses of any material. It is done sometimes because the natural surface of a material with good bulk properties is not visually interesting, sometimes to confer corrosion resistance or watertightness as in the case of paint or ceramic glaze, sometimes--perhaps most frequently--to confer on a cheap material, for legitimate or fraudulent purposes, the appearances of a more expensive one. Ceramics were slipcoated very early. Bronze was given a silvery appearance by coating with arsenic in the third millenium B.C. The overlay of cheaper materials with gold or silver foil appears in virtually every civilization. Some of the most intriguing history of the chemistry and physics of materials lies in processes for the enrichment of the precious metal in the surfaces of dilute alloys of gold and silver. The coloring or dyeing of metal, stone, glass, or cloth makes up most of the content of the surviving collections of workshop recipes from the Leyden Papyrus through to the end of the nineteenth century.[43]

The coating of iron with molten tin was used to some extent in Roman times, and Theophilus described the process in the early twelfth century. Chemical or "electroless" tin-plating of bronze (probably from an alkaline tartrate solution) also seems to be Roman. It was in common use in the seventeenth century and after for finishing brass pins and other small items. Silver plating by rubbing with a mixture of silver chloride and chalk and gold plating by simply rubbing finely divided gold onto the object to be plated are ancient. Gilding by the decomposition of a solution of gold chloride in alcohol or ether first found its way into recipe books in the eighteenth century.[44]

Amalgamation as a means of getting a gold surface on

bronze or silver is Roman, or perhaps earlier in Han China. Ormolu fastenings of cast bronze chiseled to shape and gilded by the amalgam process made up much of the glitter of a Louis XVI salon and caused the early death of many a workman. The avoidance of mercury posoning was a strong conscious motive in the development of alternative processes.

The mechanical application of thin sheet gold on locally roughened surfaces of finished objects of iron is at least medieval. In the eighteenth and early nineteenth centuries a large amount of steel cutlery was sold completely covered, after shaping, with thin silver leaf secured by soldering. This close-plating, as it was called, was remarkably permanent, as the application of a magnet to old "silver" knives will not infrequently show.

The best plated ware was that shaped from sheets of composite metal made by soldering a thin plate of a precious metal onto a thicker slab of a compatible cheap one and working the composite down. Both Theophilus and Vannoccio Biringuccio (1540) described the manufacture of gold-clad silver in this way, and the latter told of silver-clad copper, which was later the basis of the famous Sheffield plate. In Sheffield plate a cast copper slab to which silver sheets were soldered was reduced by extensive rolling with inter-mediate annealing to a composite sheet, which was then fashioned into various objects by appropriate shaping and joining methods. Fine detail had to be separately made and joined by soldering. The copper core was exposed at any cut edges and silver had to be affixed to hide it. Areas to be engraved needed local application of thicker silver.[45]

All these constraints imposed by the nature of the material led to a simplicity of design that is very attractive today, but in the mid-nineteenth century it was the greater ease of elaboration that made for the enthusiastic reception of electroplating when it appeared. James Napier remarked that "the advantages offered to the plater by the electro-process are many, arising from the fact of the articles being plated after, instead of before, being manufactured. This at once entirely removed all those restrictions on taste and

Fig. 18. Electrotype reproductions of the armor of Henri II offered for sale.
From Charles Christofle et Cie, <u>Catalogue Spécial des Reproductions
Galvanoplastiques des Objets d'Art Destinés au Musée des Arts Decoratifs</u>
(Paris, 1887). (Metropolitan Museum of Art Library.)

Fig. 19. Electroplated silverware. From Elkington, Mason and Company,
<u>Silverplate</u> (Birmingham, 1847). (Massachusetts Institute of Technology.)

design under which the plater was forced, by the nature of his process, to labour."[46]

Though plating by electrolytic means was developed later than electrotyping, it soon greatly surpassed electrotyping in commercial importance. The later-to-be-famous firm of Elkington in Birmingham was carrying out experiments on the plating of "inferior metals" with gold and silver by chemical methods in 1836, and when Jacobi's and Spencer's announcements suggested an improved route to the end result, Elkington quickly patented the use of the battery with its solutions. The Swiss chemist August de la Rive published an account of gilding and silver plating of brass by electrochemical means in April 1840.[47] Elkington's first deposits were not satisfactorily coherent and smooth, but with the introduction in 1840 of cyanide electrolytes by John Wright (who knew of cyanides from the work of the Swedish chemist Karl Wilhelm Scheele in 1786) and the addition in 1847 of carbon bisulphide to prevent frostiness by an observant workman in the Elkington shop named William Millard, the stage was set for a very rapid development of the new techniques.[48]

In an 1844 pamphlet outlining the techniques of electro-plating, Elkington mentioned that its first extensive order was for flatware for the Royal Main Steam Packet Company in 1841.[49] Their product withstood the hard service very well and was a point of pride in the firm's 1847 catalog of flat and hollow ware, which included illustrations of the elaborate pieces of silver intended to grace the sideboards of the impoverished nobility or aspiring gentry (Fig. 19). They were not cheap. A 24-inch venison dish cost £21, a simple cream pitcher £2.5, and table forks from £3 to £5 per dozen depending on quality and design.[50]

Several pieces were shown in the 1851 London exhibition, but they received unfavorable official notice. The jury (which included Robert Garrard of the Goldsmiths Company, W. T. Brande of the Mint and of the Royal Institution, and the metallurgical chemists Percival Johnson and George Matthey) specifically stated that they desired to "guard against being considered as expressing an opinion on the

merit of the application of the electro process of silver
plating to objects of domestic use. They desire only to
commend the artistic application of this discovery, to which
alone they think it adapted. At the same time they
acknowledge that the application of gold by this process is a
highly meritorious invention."[51] The gilded and silvered
electrotypes of symbolic sculpture displayed by Elkington were
indeed impressive, and it is hard to understand the blindness
of the members of the jury (all prominent and experienced
men) to the value of the accompanying tableware, which had
already proved itself and was eventually to become by far
the most conspicuous application of electrometallurgy.

On the continent, the firm of Charles Christofle et Cie
played a role remarkably parallel to that of Elkington in
England, whose patents Christofle had purchased after some
wrangling, involving a chemist, Henri de Ruolz, whose
claims to priority were expensively defeated.[52] In 1894
Emile Bouant reported that since its founding in 1842
Christofle et Cie had deposited no less than 250,000
kilograms of silver, an estimated 80 hectares (200 acres) of
plated surface! In 1881 alone the whole French plating
industry consumed 125,000 kilograms of silver.[53]

As with any technological development, electroplating
had quite unanticipated effects on many other industries.
The world consumption of zinc increased from 29,000 tons
in 1845 to 70,000 tons in 1855, but zinc for batteries was a
minor item compared with the growing use of zinc in sheet
form and for galvanized iron and for brass. Electroplating
did have dominating influence on another metallurgical
industry, that of nickel, and, via the generator, on the
future of the entire electrical industry.

The Chinese alloy paktong or pakfong (pai-thung, white
copper) had been imported into Europe since the seventeenth
century and was used to some extent for candlesticks, fire-
places, and other objects.[54] Paktong was a fine white
alloy, as workable as brass though somewhat harder. It was
a nickel-brass but its composition was not known until
1776, twenty-five years after nickel itself had been discovered
in some refractory German copper ores. The alloy was

commercially made in Europe in the 1820s and, under the name German silver, was used to a small extent for cutlery, buckles, candlesticks, and the like. In 1831 its use was patented as an intermediate layer between the silver surface and the copper base in Sheffield plate, so that the color contrast would not be so noticeable when the silver layer disappeared in places subject to excessive wear.[55] The hardness of the metal proved unacceptable to the Sheffield plate workers (who by that time had learned to apply extra plating locally to the parts of highest wear), but knowledge of this use of the alloy in silverware may have suggested its use by Elkington as a base for its silver plating. EPNS--"electroplate on nickel silver"--was soon brightening the homes of thousands who could not have afforded sterling, and nickel had found its first considerable market.

The use of nickel, first in alloys to be plated upon and later as an electroplate itself, provided the incentive to develop the mining and smelting of its ores to a point where the industry could easily expand to produce the larger amounts of metal demanded for alloy steels by the armament and automobile industries at the very end of the century.[56] Even as early as 1837, Bird had shown that nickel could give a bright electrodeposit. Although the principal deposits responsible for the first development of the plating industry were those of the precious metals gold and silver, nickel later became a popular corrosion-resistant surface for more mundane objects like brass plumbing fixtures and innumerable machine parts and machine-made objects of iron and steel.

On Lecture Demonstrations, Electroplating, and the Electrical Generator

Most writers on the history of the development of the electric power industry treat the development of the generator at first as a source for the arc light, then for the incandescent filament lamp, and finally as the core of a convenient means of power distribution. These stages were, of course, conspicuous in the quantitative growth of the

Fig. 20. Hippolyte Pixii, machine built to demonstrate magnetoelectricity. Paris, 1832. The apparatus incorporates a cam-operated reversing switch to yield unidirectional current. (Smithsonian Institution.)

industry. Certainly these were the applications that provided both the promise of profit for investors and the carrot urging on inventors of the advanced machinery needed in the 1870s and later to couple with the ever-increasing efficiency of generation of power from coal via steam. However, in the critical decades, 1840 to 1870, it was electroplating and electrotyping, initially depending on current from batteries, that provided a market for electrical machinery that was clearly potentially profitable.

For some time the most reliable competitor to the voltaic cell in electroplating was the thermopile, several forms of which were commercially available between 1850 and 1880. Like the battery, it was eventually displaced by the more efficient mechanical generator. The first clear steps toward the generation of electricity for industrial purposes occurred nearly simultaneously in Europe and America--a generator specifically for commercial gilding in Birmingham and a machine in Boston used for lecture demonstrations of electrochemical effects, including electroplating and electrotyping.

Before this, Faraday's discoveries of the relationship between motion, magnetism, and electricity had inspired the little hand-driven alternating current generator demonstrated in Paris before the Académie des Sciences on September 23, 1832, by Hippolyte Pixii. Soon, probably following a suggestion of André Ampère, Pixii added a cam-operated reversing switch to his machine so that it produced intermittent direct current (Fig. 20). A more practical form of commutation was described by E. M. Clarke, self-styled "magnetician," in 1835, and this was still further improved by Daniel Davis, a philosophical instrument maker in Boston, Massachusetts, with advice from the inventor-physicist C. C. Page.[57]

Davis, who was well known to New England scientists, was the first to use mechanically generated current for sustained experiments in electrochemistry. At the second exhibition of the Massachusetts Charitable Mechanic Association, held in Faneuil Hall, Boston, in September 1839, he received the jury's high praise for understanding the

Fig. 21. Daniel Davis, hand-driven electromagnetic machine used for electrochemical experiments. Boston, 1842. Davis's machine was modified by the addition of a commutator devised by C. C. Page. From Davis, <u>Manual of Magnetism</u> (Boston: by the author, 1842), p. 163.

theory of the instruments that he manufactured and a more
tangible gold medal for "a large variety of Electro-magnetic
and magneto-electric apparatus," including "two Electro-
magnetic Engines . . . worthy of high commendation as
beautiful, ingenious inventions."[58] In his Manual of
Magnetism, published in 1842, Davis devoted some six
pages to detailing the use of his machine (Fig. 21) for
plating and other electrolytic experiments. In August of the
same year, J. F. Woolrich in England obtained a patent on
the combination of an electromagnetic machine and some
specific electrolytes for use in silvering, gilding, and
coppering.

The industrial development of the generator occurred
slowly. The initial period was one in which the improvement
and production of such machines was done by men with
little concern either for research or for industrial use. They
were, instead, making apparatus for lecture demonstrations
in the teaching of scientific principles. Despite the example
of James Watt and his tinkering with the demonstration model
of a Newcomen engine, this branch of the history of
technology has not been much studied. Because of the
diversity of effects involved (many of which were near the
forefront of science) and the ingenuity of the displays, these
demonstration devices provided a natural contact between
advanced ideas and practical realization at a playful level
where stringent demands of realistic economics were not
allowed to extinguish enthusiasm for an ingenious but
immature idea. E. Palmer, for instance, offered a model
electrically driven sawmill in 1840, hardly practical at the
time but likely to plant an idea in a youthful mind that could
later bear fruit, while his polarized light displays would be
quite at home in a 1970s art exhibition.[59] These lecture
demonstrations were, indeed, a form of art.[60]

Woolrich's machine was used to some extent for
industrial plating. The leading metallurgist of the time,
John Percy, took Michael Faraday and his wife to see Thomas
Prime's plant in Birmingham in 1845, where "for the first
time that great philosopher saw his discovery of the magneto-
electric current applied to the electro-deposition of silver.

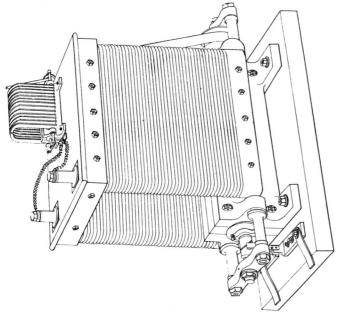

Fig. 23. Henry Wilde, generator for electroplating, 1866. This was the earliest commercially available generator using an electromagnetic field, in this case produced by a separate generator with permanent magnets. From Henry Wilde, "Experimental Researches in Electricity," Philosophical Transaction 157 (1867): pl. 6. (Massachusetts Institute of Technology.)

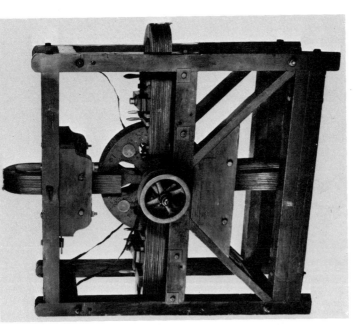

Fig. 22. John Stephen Woolrich (designer, 1842), magnetoelectric machine for commercial electroplating. Thomas Prime and Sons (builder), Birmingham, England, 1844. H. 62 1/2". (Museum of Science and Industry, Birmingham: Photo, courtesy, N. W. Bertenshaw.)

I shall never forget the sparkling delight which he manifested
on seeing this result of his purely scientific labors and its
subservience to a beautiful art."[61] The actual machine,
built by Prime to Woolrich's design, still exists (Fig. 22).

The permanent-magnet machines were soon abandoned,
for they were both unreliable and inefficient. Cells using
consumable zinc anodes powered the main development of
the industry until generator design was improved by the
replacement of the permanent magnets used to provide the
field with electromagnets, at first externally excited, then
using current generated by the machine itself. The latter
was clearly described by Wilhelm J. Sinsteden in Germany
in 1851, but his paper attracted no notice. Twelve years
passed before Henry Wilde produced a generator using a
separate small generator to power its electromagnets (Fig.
23), followed by the fully self-excited machines of S. A.
Varley and E. W. von Siemens.[62] Wilde's machines were
used in several plating works. Elkington used them for
plating and galvanoplastics and also in its first large-scale
electrolytic refinery for copper built at Swansea in 1865.
Slightly over five hundred pounds of copper were said to have
been deposited per day (this would require about twenty
kilowatts, a current of about eight thousand amperes unless
the cells were arranged in series at a higher generator voltage).

In 1870 Zénobe Gramme introduced a considerably improved
design of armature. A second-generation Gramme machine
was built specifically for use in Christofle's works. When
described early in December 1872, the machine had been
operating for four months.[63] It was designed to deposit 600
grams of silver per hour, running at 300 r.p.m. and consuming
about one horsepower, and it did just that. The Wilde
machine earlier installed in the Christofle plant, running at
2,800 r.p.m. and using far more power, deposited from 423
to 480 grams per hour.

Gramme also described a machine designed to produce
current at higher tension, equivalent to 105 Bunsen cells in
comparison with the two-Bunsen-cell voltage of the plating
machine. This was specifically for lighting, and it was in
this direction that the maturing generator was destined to

find greater opportunities for service to society. It was the
decorative arts, however, that had nurtured its childhood.

NOTES

 1. Smith, "Art, Technology and Science: Notes on
Their Historical Interaction," Technology and Culture 11,
no. 4 (Oct. 1970): 493-549, reprinted in Perspectives in the
History of Science and Technology, ed. Duane H. Roller
(Norman: University of Oklahoma Press, 1971), pp. 129-65.
 2. Réaumur, L'Art de Convertir le Fer Forgé en Acier,
et l'Art d'Adoucir le Fer Fondu ou de Faire des Ouvrages de
Fer Fondu Aussi Finis que de Fer Forgé (Paris: Michel Brunet,
1722); English trans. Anneliese Grünhaldt Sisco (Chicago:
University of Chicago Press, 1956), pp. 340, 342, 344, 352.
 3. [John Holland], A Treatise on the Progressive
Improvement and Present State of the Manufactures in Metal,
ed. D. Lardner, 3 vols. (London: Longman, Rees, 1831-34),
3:210.
 4. Réaumur, "L'Art de Faire une Nouvelle Sorte de
Porcelaine, . . . ou de Transformer le Verre en Porcelaine,"
Mémoires de l'Académie Royale des Sciences, 1739
(published 1741), pp. 370-88.
 5. Smith, "Metallurgical Footnotes to the History
of Art," Proceedings of the American Philosophical Society
116 (1972): 97-135.
 6. Sōetsu Yanagi, The Unknown Craftsman: A Japanese
Insight into Beauty, ed. and trans. Bernard Leach (Tokyo and
Palo Alto: Kodansha, 1972).
 7. Theophilus, De Diversis Artibus, manuscript
treatise, ca. A.D. 1125; Latin text and trans. C. R. Dodwell
(New York: Thomas Nelson, 1961); trans. with technical
notes by J. G. Hawthorne and C. S. Smith (Chicago:
University of Chicago Press, 1963).
 8. Holland, Treatise, 3:218-24.

9. Aitken, "Brass and Brass Manufactures," in The Resources, Products, and Industrial History of Birmingham and the Midland Hardware District, ed. Samuel Timmins (London: Robert Hardwicke, 1866), pp. 225-380. Also issued as a separate publication with its own pagination.

10. Pye, The Nature and Art of Workmanship (Cambridge: At the University Press, 1968).

11. Good discussions of sheet-metal work can be found in Oliver Byrne, Practical Metal-Workers Assistant (Philadelphia: H. C. Baird, 1851); Charles Holtzapffel, Materials; . . . Various Modes of Working Them without Cutting Tools, vol. 1 of Turning and Mechanical Manipulation, 5 vols. (London: Holtzapffel & Co., 1846-84); and in Joseph K. Little, The Tinsmith's Pattern Manual (Chicago: American Artisan Press, 1894).

12. On Oriental textured metal see Smith, "Metallurgical Footnotes." On the scientific importance of texture (microstructure) see Smith, A History of Metallography (Chicago: University of Chicago Press, 1960).

13. M. Kaufmann, The First Century of Plastics (London: Plastics Institute, 1963).

14. Holland, Treatise, 3:104. See also "Pewter and Britannia Metal Trade," in Timmins, Resources, Products, and Industrial History of Birmingham, pp. 617-23.

15. Alfred S. Bolles, The Industrial History of the United States (Norwich, Conn.: H. Bill Publishing Co., 1879), p. 368.

16. Gustav Alexander, Herrengrunder Kupfergefässe (Vienna: Julius Springer, 1927). Early references to this ware are in G. B. Porta, Magiae Naturalis (Naples: Horatius Salvianus, 1589); English trans. (London: Thomas Young, 1658), pp. 168-69; and Edward Browne, Travels in Divers Parts of Europe (2d ed.; London: Benjamin Tooke, 1685). For details of manufacture of cement copper in Germany and Hungary, see Christoph Andreas Schlüter, Gründlicher Unterricht von Hütte-Werken (Braunschweig: F. W. Meyer, 1738), pp. 461-71.

17. Samuel Pepys, "Naval Minutes [1680-83]," Publications of the Naval Record Society 60 (1926): 115;

[Thomas Hale], <u>The New Invention of Mill'd Lead for the Sheathing of Ships against the Worm</u> (London, 1691).

18. Bury, <u>Victorian Electroplate</u> (London: Country Life, 1971), p. 7.

19. de la Rue, "On Voltaic Electricity and on the Effects of a Battery Charged with Sulphate of Copper," <u>Philosophical Magazine</u> 9 (1836): 484-87.

20. Beginning in 1824, Becquerel published many papers on electrochemistry. He treated the role of electrolysis in mineral formation in <u>Annales des Mines</u> 7 (1830): 393-422, and, after 1835, in several notes in <u>Comptes Rendus</u>. See especially <u>Comptes Rendus</u> 10 (1840): 75-86, and 12 (1842): 121-47. His work in this field is summarized in <u>Elemens d'Électrochimie Appliquées aux Sciences Naturelles et aux Arts</u> (Paris: Didot, 1842).

21. Bird, "Observations on the Electrochemical Influence of Long Continued Electric Currents of Low Tension," <u>Philosophical Transactions</u> 35 (1837): 37-45. R. W. Fox, "On the Change and Minerals Induced by Galvanism," <u>Philosophical Magazine</u> 9 (1836): 228-29.

22. Among the many early publications on the subject, those of Smee (see n. 28-29), Napier (n. 37), Watt (n. 32 and below), and Gore go out of their way to discuss the priority of Spencer (n. 27) and Jordan (n. 26) at some length. They are, however, mainly plagiarizing the work of Henry Dircks (n. 26), and to this day, there has been no critical history of the subject that is international in scope. Leader (n. 48) discusses the origin of industrial silver plating with well-placed emphasis on the role of the firm on Elkington and Company, and Christofle's book (n. 52) provides many glimpses of the clashes of inventors' claims and commercial conflicts in France and reproduces at length many legal documents. The ingenious Henry Bessemer used electrolysis inadvertently and unknowingly as a boy of eighteen in 1832. In a reminiscing letter written in 1885 and published in Alexander Watt's <u>Electro-Deposition</u> (1886), see below, he describes his application of copper coatings to soft metal castings by immersing them in a copper sulphate solution, at first in earthenware dishes, then in iron, and best of all

in zinc trays. Other early publications of interest are:
William Sturgeon, Familiar Instructions in the Theory and
Practice of the Beautiful Art of Electro Gilding and
Silvering . . . (London, 1842), copy in Elkington Papers,
Victoria and Albert Museum, London; George Shaw, A Manual
of Electro-Metallurgy (1842 and 2d ed. enl.; London, 1844);
J. L. [N. P. Lerebours], Traite de Galvanoplastie (Paris:
by the author, 1843); Charles V. Walker, Electrotype
Manipulations . . . (26th ed.; London, 1852); George Gore,
Theory and Practice of Electro-deposition . . . (London:
Houlston & Stoneman, 1856); L. Oudry, Notice sur l'Électro-
metallurgie Appliquée au Cuivage Galvanique avec Forte
Épaisseur . . . (Paris: Lacroise, 1866); Alfred Roseleur,
Manipulations Hydroplastiques, Guide Practique du Doreur,
de l'Argenteur et du Galvanoplaste (2d ed.; Paris: by the
author, 1866); English translations of Roseleur's work were
issued by H. C. Baird of Philadelphia in 1872 and 1883;
George Gore, The Art of Electro-Metallurgy (London: D.
Appleton & Co., 1877); J. W. Urquhart, Electro-Typing, A
Practical Manual (London: Crosby Lockwood & Co., 1881);
Alexander Watt, Electro-deposition, A Practical Treatise
(London: Crosby Lockwood & Co., 1886); Watt's work was
revised and rewritten by Arnold Philip, under the title The
Electro-Plating and Electro-Refining of Metals (London:
Crosby Lockwood & Son, 1902).

23. Moritz Hermann van Jacobi (Boris Semenovich
Jacobi), "On the Method of Producing Copies of Engraved
Plates by Voltaic Action," Philosophical Magazine 15 (1839):
161-65; Jacobi, Die Galvanoplastik (St. Petersburg: Eggers
& Co., 1840). The original text in Russian was published
shortly after this German version, reprinted in Quedlinburg
the same year. See also Jacobi, Galvanoplastic; or the
Process of Cohering Copper into Plates, or Other Given Forms,
by Means of Galvanic Action on Copper Solutions, trans.
William Sturgeon (Manchester: Josiah Leicester, 1841).

24. Jacobi [Report of communication to the Académie des
Sciences, Mar. 2, 1840], Comptes Rendus 10 (1840): 375.

25. Guggsworth, Feb. 5, 1838, in [Sturgeon's] Annals
of Electricity 3 (Mar. 1839): 507-8.

26. Jordan, "Engraving by Galvanism," Mechanics Magazine (June 8, 1839). The full text is reprinted in Henry Dircks, Contributions toward a History of Electro-Metallurgy (London: Greenwich, 1863), and in James Napier, Manual of Electro-Metallurgy (London: Greenwich, 1851).

27. Spencer, An Account of Some Experiments Made for the Purpose of Ascertaining How Far Voltaic Electricity May Be Usefully Applied to the Purpose of Working in Metal (Liverpool: Mitchell & Co., 1839). Reprinted as "An Account of Some Experiments Made for the Purpose of Ascertaining How Far Voltaic Electricity May Be Usefully Applied for the Purpose of Working in Metal," Annals of Electricity 4 (Jan. 4, 1840): 258-76. This is followed by editorial comment on the British Association's treatment of Spencer and a note on his use of lead under pressure to produce electrotype molds from wood blocks. An enlarged version of Spencer's "Account" was later published as Instructions for the Multiplication of Works of Art in Metal by Voltaic Electricity, with an Introductory Chapter on Electro-Chemical Decomposition by Feeble Currents (Glasgow: Richard Griffin; London: Thomas Tegg; 1840).

28. Smee, Elements of Electro-Metallurgy, or the Art of Working in Metals by the Galvanic Fluid (London: E. Palmer, 1841).

29. Smee, "On the Production of Electrotypes," Philosophical Magazine 16 (Apr. 1840): 530-32.

30. Smee, Elements of Electro-Metallurgy, pp. 142-43, 147.

31. Smee, Elements of Electro-Metallurgy (2d ed.; London: E. Palmer, 1843), p. xxvi. After this paper was finished, a statement dramatically illustrating the popularity of electroplating was found in an anonymous article "Messrs. Elkington Mason & Co's Electroplate Works" in the Illustrated Exhibitor and Magazine of Art 1 (1852): 295-300. After a brief discussion of the nature of electrotyping and of its discovery, the article proceeds: "And if our readers made no experiments of the kind--of which, indeed, we can scarcely conceive--they will not fail to remember how eagerly, only a few years ago, their sons, or their younger

brothers were intent on taking impressions from coins, medals, casts, and a great variety of other objects, by means of some small battery which, at first, a few shillings, and sub- sequently a very trifle, would purchase."

32. Watt, Electro-Metallurgy Practically Treated (2d ed.; London, 1868), p. 2.

33. Watt, Electro-Plating and Electro-Refining of Metals, pp. 86-87.

34. Sampson, Electrotint or the Art of Making Paintings in such a Manner That Copper Plates and "Blocks" Can Be Taken from Them by Means of Voltaic Electricity (London: E. Palmer, 1842).

35. Benjamin Silliman, Jr., review of Instructions for the Multiplication of Works of Art in Metal by Voltaic Electricity, by Thomas Spencer, Silliman's American Journal of Science 40 (Oct.-Dec. 1840): 157-64.

36. Daniel Davis, Davis's Manual of Magnetism . . . with a Description of the Electrotype Process (Boston: by the author, 1842), see esp. pp. 199-210.

37. Napier, A Manual of Electro-Metallurgy (London, 1851). Many subsequent editions; reprinted without specific acknowledgment in Oliver Byrne, The Practical Metal Workers Assistant (Philadelphia: H. C. Baird, 1851), and under its own title (Philadelphia: H. C. Baird, 1853).

38. Aitken, "Brass Manufactures," p. 165.

39. South Kensington Museum, London, Illustrated Catalogue of Electrotype Reproductions of Works of Art . . . Made by . . . Elkington and Co. (London, 1855). Contains mounted photographic plates. Several later undated versions are also listed in the catalog of the library at the Metropolitan Museum of Art, New York City.

40. South Kensington Museum, London, Reproductions in Metal: A Classified and Priced List of Objects of Art Reproduced in Metal by Various Processes (London: Eyre & Spottisward, 1872); other editions 1876, 1881, and 1888.

41. Christofle et Cie, Catalogue Special des Repro- ductions Galvanoplastiques des Objets d'Art Destinés au Musée des Arts Décoratifs (Paris, 1887).

42. Oppi Untracht, Metal Techniques for Craftsmen

(Garden City, N.Y.: Doubleday, 1968), see chap. entitled
"Electroplating and Electroforming," pp. 379-91; David
Mason, "Electroforming a Crown," Electroplating and Metal
Finishing 22, no. 7 (July 1969): 26-28.

 43. C. S. Smith, "Historical Notes on the Coloring of
Metal." Paper presented at Second International Conference
on Solid State Physics, Cairo, Apr. 21-25, 1973 (in press).
For an important discussion of the coloring of metals in
relation to alchemy, see Joseph Needham, Science and
Civilization, vol. 5, pt. 2 (in press).

 44. [Godfrey Smith], The Laboratory or School of Arts
(London: T. Coxe, 1720), p. 130.

 45. For good contemporary accounts of Sheffield plate
manufacture, see Holland, Treatise, 3:354-72; and William
Ryland, "The Plated Wares and Electro-Plating Trades," in
Timmins, Resources, Products, and Industrial History of
Birmingham, pp. 477-98.

 46. Napier, Manual of Electro-Metallurgy (London,
1876), p. 158.

 47. A. de la Rive, "Sur un Procédé Électrochimique
ayant pour Objet le Dorage de l'Argent et du Laiton," Comptes
Rendus 10 (1840): 578-82.

 48. Robert Leader, "History of Electroplate," Journal
of the Institute of Metals 22 (1919): 316. See also Leader,
"History of Elkington and Company," 1913-14, typescript,
British Museum.

 49. Elkington and Company, On the Application of
Electrometallurgy to the Arts (London: J. King, 1844).

 50. Elkington, Mason and Company, Patentees, Electro-
plate Works, Illustrated Catalogue of Silver Plate
(Birmingham: by the company, 1854).

 51. "Reports of the Juries," in The Industry of All
Nations, 2 vols. (London: George Virtue, 1851), 2:1120-21.

 52. A history of the French patent conflict with reprints
of all depositions and legal actions was given by Charles
Christofle in his Histoire de la Dorure et de l'Argenture
Électro-Chimiques (Paris, 1851). The work of Henri
Catherine Camille de Ruolz was presented in the "Rapport
sur les Nouveaux Procédés Introduits dans l'Art du Doreur

par M. M. Elkington et de Ruolz," read by J. B. Dumas to
the Académie des Sciences on Nov. 29, 1841. See Comptes
Rendus 13 (1841): 998-1021. M. de Ruolz had electro-
deposited gold, silver, platinum, copper, lead, tin, cobalt,
nickel, and zinc; he had used cyanide solutions for silver
and hence had conflicted with the Elkington patent. The
academy report is highly enthusiastic in tone and foresaw
great possibilities for silver plating in the arts and industry
and, surprisingly, for zinc. In 1842 de Ruolz shared the
Academy's prize with de la Rive and, equally, with
Elkington, but later it became clear that he had not inde-
pendently invented the cyanide electrolyte and Elkington was
awarded sole French patent rights.

53. Bouant, La Galvanoplastie (Paris: Bailliere, 1894),
pp. 59-60; Henry Bouilhet, "Conference sur les Procédés
Électrometallurgiques," Annals de Chimie et de Physique 24
(1881): 547-63.

54. Alfred Bonnin, Tutenag and Paktong, with Notes on
Other Alloys in Domestic Use During the Eighteenth Century
(Oxford: At the University Press, 1924).

55. Stephen Barker, "Nickel German Silver Manufacture,"
in Timmins, Resources, Products, and Industrial History of
Birmingham, pp. 671-75. See also the note on German silver
by A. S. Paterson in Timmins, pp. 497-98, and on its use by
the Elkingtons in Timmins, pp. 488-96.

56. F. B. Howard-White, Nickel, an Historical Review
(Princeton: Van Nostrand, 1963).

57. For good early accounts of the history of the
generator, see James Dredge, ed., Electric Illumination, 2
vols. (London: Office of Engineering, 1882-85), and
Sylvanus P. Thompson, Dynamo-Electric Machinery (London:
E. & F. N. Spon, 1884); Clarke, "Description of E. M.
Clarke's Magnetic Electrical Machinery," Philosophical
Magazine 9 (1836): 262-66; Davis, Manual of Magnetism,
pp. 165-70.

58. Massachusetts Charitable Mechanic Association,
Catalog of the Second Exhibition, Sept. 23, 1839 (Boston:
by the association, 1839), pp. 69-70.

59. E. Palmer, Palmer's New Catalogue with Three

Hundred Engravings of Apparatus (London: by the author, 1840), p. 48, fig. 194, captioned: "Model of a Saw Mill driven by electro-magnetism, consisting of a powerful electro-magnet on stand, with rotating armature, driving in its revolution, by means of cog wheels, a circular saw, £3.3s."

60. Many of the ingenious kinetic or optical devices built by artists today make use of just the same combination of physical principles and showmanship that was invoked in nineteenth-century lecture demonstrations mounted purely for the purpose of alluring the freshman into a study of science. They involve the same thrill of discovery for both the creator and the viewer, the same opportunity for display of skill and insight. The artist's motive, however, is different, and in the absence of explicatory labels and mathematical analysis the viewer's reactions are limited to sensual ones and his interest may decrease with repeated contact.

61. Percy, Metallurgy . . . Silver and Gold (London: John Murray, 1880), pp. 48-49.

62. Wilde, "Experimental Researches in Electricity," Philosophical Transactions 157 (1867): 89-107. Later improvements on generators for electroplating were described by Wilde in Philosophical Magazine 45 (1873): 439-50.

63. Gramme, "Sur les Machines Magnéto Électriques Appliquées à la Galvanoplastie," Comptes Rendus 75 (1872): 1497-1500.

PROBLEMS IN THE MECHANIZATION AND ORGANIZATION OF THE BIRMINGHAM JEWELRY AND SILVER TRADES, 1760-1800

Eric H. Robinson

THE Oxford English Dictionary defines the word "brummagem," a corruption of Brimingham or Birmingham, as "cheap, shoddy goods." The word was so used in the eighteenth century and has kept its associations until the present day though many of the artisans of the town, from that day to this, have resented the slur. It is worth noting that the use of the word, though it may have been reinforced by the industrial revolution, was in fact known before steam power was developed in Birmingham, long before electroplating was introduced, and well before there was any factory production of jewelry or "toys," in the old sense of gewgaws or trinkets. Birmingham had long specialized in the production of metal goods of all sorts, from muskets to mousetraps, but the jewelry and toy trades by themselves encompassed an immense variety of goods including personal jewelry for men and women, watches and watch chains, decorative boxes of all sorts, buttons and buckles, swords and sword hilts, vases, and tableware of every shape and size, manufactured in every kind of metal, common, semi-precious, and precious (Fig. 1). Though the greater part of this large production, much of which was reputedly for export, consisted of cheaper wares, some of the Birmingham goods, especially those in wrought silver and enameled ware, have earned high praise from connoisseurs of those arts, and many of the cheaper wares that have survived, such as enameled boxes, when they are attributable with certainty to Birmingham, are not without distinction and taste. Such common objects as buttons, produced in Birmingham by the millions, have become the subjects of

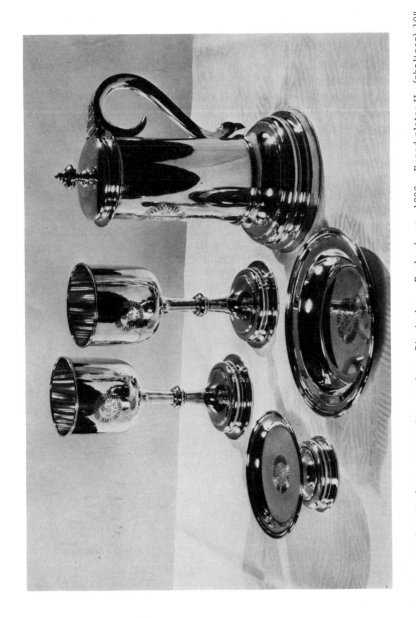

Fig. 1. Matthew Boulton, communion service. Birmingham, England, ca. 1800. Fused plate; H. (chalices) 10", (flagon) 12 1/2", (paten) 2 1/2"; Diam. (paten) 6", (plates) 8 3/4". (Minneapolis Institute of Arts, Gift of Mr. and Mrs. James Ford Bell.)

monographs and the objects of competitive search by collectors. Though continually threatened by international competitors, the Birmingham jewelry trade has survived to the present day, and the Birmingham Assay Office is still a very busy institution. The object of this paper is to describe and analyze some of the problems of mechanization and organization occurring in this trade during the later decades of the eighteenth century and, in so doing, perhaps to diminish some of the slurs under which "brummagem" has long suffered.

If one of the most important characteristics of industrialization has been, as Adam Smith showed, the division of labor, then it should be recalled that Birmingham was the center of the most advanced division of labor in manufacture known to the eighteenth-century world, and Smith recognized it as such:

> In the works of cutters and locksmiths, in all the toys which are made in the coarser metals, and in all those goods which are commonly known by the name of Birmingham and Sheffield ware, there has been during the same period, a very great reduction of price, though not altogether so great as in watch-work. It has, however, been sufficient to astonish the workmen of every other part of Europe, who in many cases acknowledge that they can produce no work of equal goodness for double, or even triple the price. There are perhaps no manufactures in which the division of labour can be carried further, or in which the machinery employed admits of a greater variety of improvements, than the one of which the materials are the coarser metals.[1]

Pin manufacture and button manufacture, Smith's archetypes for the division of labor in manufactures, were both Birmingham industries, and as early as 1766 when Lady Shelburne visited the town, this characteristic was well

known, as she noted in her diary,

> Another thing quickly followed, instead of
> employing the same hand to finish a button
> or any other thing, they subdivide it into
> as many different hands as possible, finding
> beyond doubt that the human faculties by
> being confined to a repetition of the same
> thing become more expeditious and more to
> be depended on than when obliged or suffered
> to pass from one to another. Thus a button
> passes through fifty hands, and each hand
> perhaps passes a thousand in a day; likewise,
> by this means, the work becomes so simple
> that, five times in six, children of six or
> eight years old do it as well as men, and earn
> from ten pence to eight shillings a week.[2]

If the presumptive dating of the year 1765-66 for this diary
is correct, Smith was only recognizing what was an estab-
lished view of the button industry and a characteristic facet
of its organization, which had important consequences for
its mechanization and its labor force.

The principal mechanical processes followed in button
making were rolling, stamping, and piercing. The 1785 act
against the exportation of tools and the emigration of
artisans provides a valuable idea of the tools employed.
That act was one of those pieces of mercantilist legislation
by which Britain vainly attempted to protect its industrial
secrets from the nascent industrial nations of the West, and
Birmingham manufacturers had been active in promoting its
passage through their leaders Samuel Garbett, Matthew
Boulton, and others.[3]

On July 25, 1785, Aris's Birmingham Gazatte listed the
tools most significant for Birmingham manufacturers whose
export was prohibited. They included:

In Iron, Steel, or other metal.
 Hand stamps
 Dog head stamps
 Stamps of all sorts
 Hammers and anvils for stamps
 Screws for stamps
 Iron rods for stamps
 Presses of all sorts
 N. B. <u>Such as are used for giving</u>
 <u>impressions to metal; or any</u>
 <u>parts of these several things.</u>
Presses of all sorts, called <u>cutting-out presses</u>
beds and punches to be used therewith.
Piercing presses of all sorts; beds and punches
to be used therewith.
 Either in part, or pieces, or fitted together.

Iron or steel dies to be used in stamps or presses,
either with or without impressions on them. Cast
iron, wrought iron, and steel rollers, for rolling of
metal, and frames for such. Flasks or casting moulds,
and boards used therewith. Lathes of all sorts for
turning, burnishing, or polishing, the whole together,
or separate parts thereof. Engines for making button
shanks. Scoring or shading engines. Laps of all
sorts. Presses for horn buttons, and dies for horn
buttons. Sheers for cutting of metals. Rolled steel,
rolled metal with silver thereon, parts of buttons not
fitted up into buttons, or in an unfinished state.
Engines for chasing. Stocks for casting buttons and
buckles, and rings. Cast-iron anvils, and hammers
for forging mills, for drawing or plating iron, or
copper. Die-sinking tools of all sorts. Rolls,
slitters, pillars and frames for slitting mills. Drilling
engines. Tools for pinching glass. Engines for
covering of whips. Bars of metal covered in part,
or wholly covered with gold or silver.
Such then were the tools principally employed in the trade.

Adding to them the various sources of power available--horse
mills, water mills, and, to a minimal extent before 1800,
steam engines--and the chemical processes for assaying,
refining, and recovering metals gives the broad outlines of
the technology employed in the Birmingham toy trade in the
later part of the eighteenth century. With these resources,
Birmingham and the villages of the Black Country poured out
millions of objects for consumption in every known country
of the world as well as for the satisfaction of Britain's own
rapidly growing domestic market.

Lady Shelburne, no doubt writing upon the basis of in-
formation given to her by her host, Samuel Garbett, observed
another salient fact about Birmingham's increasing produc-
tion: "The discovery of mixed metal so mollient or ductile
as easily to suffer stamping, the consequence of which is
they do buttons, buckles, toys and everything in the
hardware way by stamping machines which were before
obliged to be performed by human labor."[4] Cyril Stanley
Smith, in two distinguished papers, has drawn attention to
the interactions of art and technology, suggesting, on the
one hand, the variety of new ways of handling material that
have arisen in the course of creative play and, on the other,
the ways in which the properties of materials contribute to
the aesthetic appeal of art objects.[5] In Birmingham records
the variety of metals referred to is remarkable: Bath metal,
tutenag, Keir's metal, pinchbeck, gilt, platina, silver-plated
copper, iron, steel, brass, spelter, copper, gold, and
silver as well as a number of alloys not clearly specified but
kept as trade secrets by manufacturers. Constant
experimentation was going on, and it is surely reasonable
to suggest a relationship between the experimentation in
fashion objects and the experimentation in engineering for
both of which Birmingham became famous. A search for
adaptation and novelty in the world of fashion may
predispose the mind toward innovation in technology or
toward greater flexibility in intellectual attitudes generally.

The importance of new alloys to the Birmingham trades
was appreciated by chemists and others interested in

metallurgy who wished to sell their secrets to Birmingham
manufacturers such as Matthew Boulton. Thus Dr. Bryan
Higgins, the London chemist and lecturer, wrote to Boulton
with a proposition:

> It will be equally inconvenient to you and me, to
> loose a day in making the Tuteneg, if we are not
> likely to be joint proprietors of it. For this reason,
> and because you desired that I would declare my
> terms; I take the liberty to inform you, that I expect
> to be paid, in consideration of my expenses, five
> hundred pounds for an equal partnership; and will
> neither take less, nor sell the property altogether.[6]

H. W. Dickinson has told the story of Keir's metal, which
he sees as an anticipation of Muntz's metal, and of the
various uses made of it in Birmingham by Boulton and others,
and in another paper I have given an account of Boulton's
search for the secrets of French ormolu work.[7] In this latter
quest he was so successful that by 1771 he was in a position
to refuse the services of a German worker in ormolu on the
grounds that the process was already well known in Britain,
although Boulton was still interested in the materials used in
France for common gilding and the methods by which the
French obtained the high finish in their work. Sometimes the
suppliers of familiar metals had to be prodded into greater
efficiency. Thus in 1771 Boulton wrote to Robert Hurst of
Cheadle, one of his suppliers of brass, first asking the
company to make its brass more ductile and then recommending
to its brass rollers greater cleanliness in their work because
dirt rolled into the metal was a great inconvenience to the
purchaser.[8] He even reproved the great Benjamin Huntsman,
the Sheffield steelmaker, for want of toughness in his steel,
though Huntsman long continued to be one of Boulton's
principal suppliers of steel for dies, as well as the source
of the steel rolls employed by Boulton and John Fothergill in
their work. Robert Erskine, a Birmingham artisan,
described conversations he had enjoyed with Dr. William
Small about pig iron manufacture and declared that Small

and Boulton had been engaged in various experiments upon
iron.[9]

The notebooks of Boulton, James Watt, and their sons
are packed with observations on metal manufactures either
gleaned from published books and papers or from their own
observations. Their alertness to the potentialities of new
metals also extended to other materials like Blue John spar
(Fig. 2), ceramic cameos, tortoiseshell, papier-mâché,
mother-of-pearl, and indeed anything else that could con-
ceivably be used in the jewelry business. Since novelty was
one of the dominant factors in the jewelry trade, guaran-
teeing a firm's source of supply for an unusual material or
ensuring that it was always of a constant quality were
matters of regular concern. Overpurchase of some raw
material that did not stay in fashion could be a serious
liability. Variation in price of raw materials might affect
cost estimates to customers at the secondary stage of manu-
facture. A fault in steel could affect the tools used to
manufacture the salable products. Boulton wrote Huntsman:

> In answer to yours respecting the Rolls, we can
> dress them; but as we have been unfortunate in
> all our Tryalls in hardening your Steel, never have
> been able to make it, without some cloudy or
> soft places appearing when finished, we therefore
> wish you would polish and harden them as fine as
> possible, as the purpose we want them for,
> requires the greatest perfection, being for Gold
> Lace.[10]

I suggest therefore that in most studies insufficient attention
has been paid to the problems of raw materials, especially
at the stage when the decorative arts were in a transition
from handicraft to mechanized production.

The variety of tools developed for the Birmingham
jewelry trade was extensive, and though it is not always
possible to chart with accuracy the detailed improvements
in them over the decades, it is clear that steady evolution

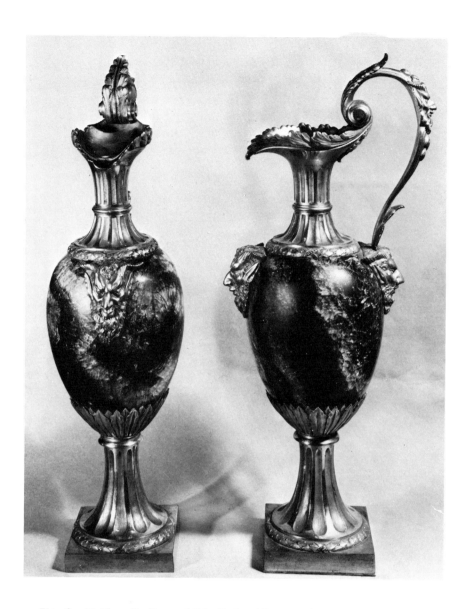

Fig. 2. Matthew Boulton and John Fothergill, pair of ewers. Birmingham, England, ca. 1772. Blue John spar and ormolu; H. 19", bases 4" square. (Birmingham City Museum and Art Gallery.)

took place. Twenty years after Boulton complained to Hunts-
man about the difficulty of dressing rolls, he seems to have
long overcome this problem. He received an inquiry from
the firm of Thiele and Steinert at Freiburg in Saxony about
special steel rollers of the type "made in Birmingham."[11]
To a similar inquiry two years earlier, Boulton had replied:

> In regard to Rolls: I use such as other people do in
> Birmingham, and which are Cast by any and all the
> Iron Founders. But for my Finishing Rolls I have tryd
> various means of obtaining them of a fine pollish such
> as making them of cast steel as well as making them
> of Cast Iron Case Hardend and pollished upon a Lap
> as I do my other fine Steel work and for that purpose
> I invented and Executed at the Expence of 2 or 300 [£]
> many Years ago a Machine which from that time to
> the present is fixt in an underground Building called
> the Bastile and always kept secret. However there
> are sundry persons in Birmingham who make a trade
> of dressing and pollishing Rolls for Mills and they
> do them very fine, but I must own I do not wish
> them to pollish them quite so well as my self, be-
> cause by my superiority I am able to keep my Mill
> employd and when it is fully employd it yields a
> profit, and when not, a loss, as the Rent and Labour
> is the same.[12]

This tendency to secrecy, noted by Lady Shelburne in her
diary, "there are besides an infinity of smaller improvements
which each workman has and sedulously keeps from the
rest,"[13] was the subject of constant comment by other
visitors to Birmingham during the period. It must have been
some obstruction to the advance of technology, but the
possibilities for bribing workmen were so many that it was
extraordinarily difficult to keep improvements from others,
as Boulton readily confessed on other occasions.
 Other standard tools in the trade were referred to in a
contemporary directory of the Birmingham area,[14] which

stressed three tools: the press, the stamp, and the engine for turning the mold. "The first gives the form to the Button, and the second, the objects represented thereupon; but the Engine, which was the invention of a man [probably Baddeley, the lathemaker] of great mechanical knowledge, was perhaps not the least acquaintance of the three." This opinion is confirmed by G. C. Allen in Industrial Development and the Black Country, 1860-1927, showing that a century later these basic tools retained their primacy:

> In the production of finished metal-goods the two machines common to most of the local industries were the press and the stamp, and in the lighter trades these were almost always operated by manual power. In the pen trade, for instance, the actual manufacture of nibs from steel strip was undertaken mainly on the hand-press. The most typical of the tools employed in Birmingham itself, this was found not only in pen manufacture, but in the production of gilt jewellery, certain kinds of buttons, needles, small chains and countless other metal smallwares. The power-press, on the other hand, had a much less extensive application in the lighter trades, though it was used in the manufacture of coins, brass chain links and door knobs.[15]

Allen continued: "The only other machine which was common to a wide variety of local industries was the lathe. This was still simple in design, and even in the larger factories the substitution of power for the treadle-lathe was by no means complete."[16]

These three tools were employed in an almost unbelievable variety of manufactures. The fly press, for example, which gives a hard, accurate, and perpendicular blow, was "not only employed in punching holes, and cutting out numerous articles from sheets of metal and other materials, but also in moulding, stamping, bending or raising thin metals into a variety of shapes, and likewise

in impressing others with devices as in medals and coins."[17]
It was used in the Sheffield-plate industry, a Birmingham as
well as a Sheffield trade, because it overcame the problem
of piercing without exposing the copper as a fretsaw would
have done. The force of the blow given by the fly press
turned the silver over both sides of the cut so that the
copper was not disclosed.[18] It was used in shaping
tortoiseshell boxes out of the heated tortoiseshell in one
blow against a mold.[19] When reinforced by steam power,
it was the basis of Boulton's coining business. Wherever
exact duplication was required, the fly press was essential.
It therefore can be seen as a tool essentially linked with
one of the characteristics of industrialization--the standard-
ization of parts. If no further assembly work or finishing
was required, mass production was thus already present.
Hence Dr. Samuel Johnson's comment on a visit to Boulton's
Soho manufactory: "We then went to Boulton's who with
great civility, led us through his shops. I could not dis-
tinctly see his enginery. Twelve dozen of buttons for three
shillings. Spoons struck at once! (Tuesday, 20 September
1774)."[20] Using the fly press thousands of candlestick
parts or innumerable stamped leaves and flowers for the
ornamentation of baskets, bowls, or boxes could be struck.

The problems created by standardization and mass
production were considerable. One effect was to drive prices
for some articles down so low that a manufacturer who
respected the quality of his output would be forced either to
abandon his principles or go out of business. As early as
1757, Boulton wrote to Timothy Hollis:

> As to the Coat Vest and Link Buttons I am at a
> stand what to do about the price of them and
> shall therefore take it as a particular favour
> if you would give me your advice whether you
> think lowering the price to that of others will
> be for or against that article or what will be
> the Best Method to take to keep up the Spirit
> of that Business and to prevent its being run

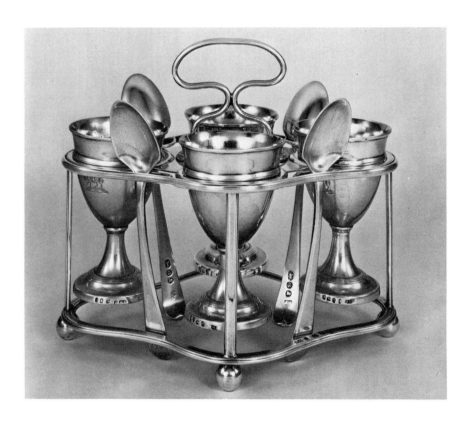

Fig. 3. Matthew Boulton, eggcup stand. Birmingham, England, 1802. Sterling silver; H. 5", L. 6". (Birmingham Assay Office, Matthew Boulton Collection.)

down in price and Quality till it becomes no
Business at all.[21]

At first Boulton seems to have tried to avoid competition in
the cheapest silver articles--"such as quite plain Spoons,
Tankards, Muggs &c which are sold very low in London and
other places"--but he did not consistently follow this policy.
In any event he was forced to compete in the mass production
market by improving his mechanical devices, cutting out the
middleman's profit, extending better credit terms to the shop-
keepers, and keeping himself well informed on fashion trends.
Yet despite advice from all his associates--James Watt, John
Fothergill, and Jonathan Scale--Boulton continually wavered
between producing common articles for the mass market and
manufacturing expensive and elegant objects for the luxury
market (Fig. 3). Thus his adventures in wrought silver,
ormolu, mechanical pictures, and elegant clocks tended to
lose money rather than establish the profitability of his
business.[22]

Raised ornamentation on a basic shape might be carried
out by hand raising or might be incorporated in the original
die, depending on the material, the style of ornament, and
the number of articles with identical ornament ordered by the
customer (Fig. 4). Customers were sometimes told that an
order had been omitted because the number required did not
justify sinking new dies, or else they were advised to have
dies made for their personal crests so that future orders
could be made from the same dies.[23] If a new fashion could
be anticipated new dies might be sunk: "We begin to think
the World gets tired of Pillar Candlesticks for which reason
we have put in hand some Dyes of such new patterns that we
imagine would [be] likely to please."[24] Robert Michael
Hirt's manuscript account of "The Founders of the Silver
and Plated Establishments in Sheffield" lays stress on the
importance of diesinkers and die turners for the silver
trades and remarks that "Nearly all the parts of a Candle-
stick are formed in Steel and cast-metal Dies."[25] The
importance to Boulton of dies and diesinkers both in his
toy manufacture and his coinage work is inescapable, and

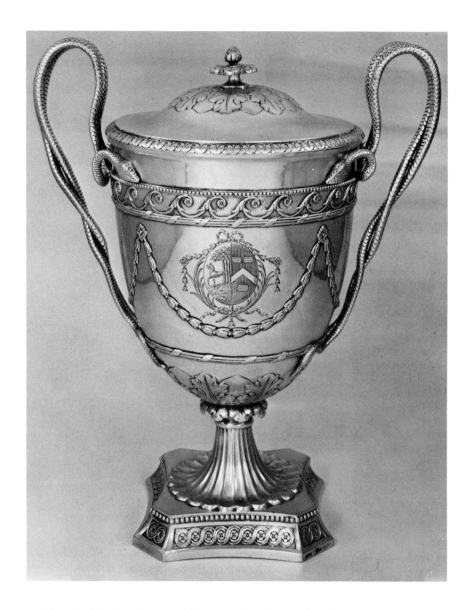

Fig. 4. Matthew Boulton and John Fothergill, two-handled cup with cover. Birmingham, England, 1777. Sterling silver; H. 12". (Birmingham Assay Office, Matthew Boulton Collection.)

for this reason I am inclined to except him from Judith
Banister's generalization that stamping was not widely
practiced as a method of producing silverware until the
mid-nineteenth century.[26] He certainly employed stamping
for candlesticks:

> We have always used Silver worth 6/- for light
> Stamped Candlesticks as it is better to Stamp.
> As Silver Candlesticks amount to a larger sum
> of Money than plated ones, although no more
> work in making them, and there being some
> trouble and expence in making, and as a Mans
> profit should bear some proportion to his return
> of money we have for these reasons always
> charged the fashion exactly the same without
> Discount as we charge the plated ones of the
> same pattern viz £7"17"6 and at that price there
> is less profit P Cent than upon the plated ones.[27]

From the beginning of his plated manufacture Boulton had
specialized in candlesticks and had described them to
Woolley and Heming, the London jewelers, as an article
"in which it will be our constant ambition to excell."[28]

The use of lathes for turning designs on metalwares was
a specialty of the Birmingham area, and if we are to judge
from Josiah Wedgwood's experience, the use of engine
turning was introduced into pottery manufacture from
metalwork. One of the early references to lathes in the
Boulton archives is in an estimate from Thomas Lightowller
dated August 31, 1758, in which he says: "I promise and
agree to and with Mr. Mathew Bolton to make him a Machine,
called a Mosaick Engine for the Sum of Twenty Guineas to
perform the following sort of work viz: Plain, round, Oval,
Rose work, frett work, Basket work of any pattern or form
the said Machine shall be capable of." The small Birming-
ham firm of Messrs. Boswell and Meers, Summer Lane, who
described themselves as button chasers, engravers, gilders,
silverers, and painters, advertised in Aris's Birmingham
Gazette in 1789:

> A very capital engine lathe by Wallace entirely
> new for the purpose of chasing, engraving,
> scoring and drilling in circles, stars, eccentric
> and across, prime cost 80 guineas. Another
> engine lathe almost new for chasing and engine
> cutting stars, eccentric circles and ovals by the
> same maker, prime cost 6 guineas. Also another
> in good condition for scoring and circling only,
> prime cost 12 guineas. A button stampe with
> two wrought iron hammers.[29]

The secondhand price of the lathe by Wallace suggests the
costliness and intricacy of this machinery. When Wedgwood
wanted advice on such lathes, he turned to Boulton and to
John Taylor of Birmingham.

Our effort so far has been only to outline the basic sorts
of tools employed in the Birmingham jewelry trade. Boulton,
in addition, sent to France for gilding tools and to London
for braziers tools. A silversmith hired by Boulton was told
to bring some large Bohemia stones with him for his own
use.[30] In 1772 Boulton and Fothergill wrote to one of their
retailers, Solomon Hyman, in Paris:

> There are a certain sort of Wire drawer plates
> made at Lyons of such steel as we have none
> of in this Country, they are made use of, fit
> to draw the Wire for Gold Lace, and have
> Holes, adapted to the purpose, we believe
> there is a possibility of getting 'em at Paris,
> in which Case we should be glad if you would
> procure us one or two of 'em, we should like
> to have 'em with the Holes, but if you cannot
> get 'em so, let us have 'em without the Holes
> being made in them.--We are also in want of
> half a dozen of Burnishing Stones call'd in
> french pierre Sanguines but they must be good
> in their Quality, and proper for the burnishing
> of Or Moulu. The half Dozen must consist of
> 2 large ones and 4 less ones in proportion, we

suppose the large ones will cost about 30 Livres
and less ones from 10 to 24: say [blank] Livres
p[er] piece. We beg you to procure them as soon
as possible. They are to be bought--Chez Mr.
Carpentier, Maitre doreur, rue de four, fauxbourg
St. Germain à coté de la rue de L'Egout.[31]

In order to complete an order for a silver table weighing 334
ounces to be presented to Sir Watkin Lewis by subscribers
in Worcester, Boulton had to have a new rolling mill "for
the purpose of laminating so large a piece of plate." It is
clear that the enterprising Birmingham manufacturer was
accustomed to recruiting workers from abroad and also to
searching for the specific tools used by foreign artisans,
some of which, in reciprocity for Britain's protective legis-
lation, were prohibited for export. Moreover, men like
Boulton, who ordered from his London bookseller, Peter
Elmsley, Plumier's L'Art du Tourneur and the Traité Mécanique
et Pratique sur l' Horlogerie,[32] purchased foreign manuals in
order to advance their own techniques.
 Basic to much of this mechanical progress was the use
of animal, water, or steam power, though apart from Boul-
ton's works there was little application of steam power in
Birmingham during the eighteenth century. On his first visit
to Soho, James Watt was much impressed by the use of water-
power in Boulton's Soho works:

I was introduced at Soho by Dr. Small in 1767 but
Mr. Boulton was then absent; Mr. Fothergill his
partner and Dr. Small showed me the works. The
goods then manufactured there were steel gilt and
fancy buttons, steel watch chains and sword hilts,
plated wares, ornamental works in Or Moulu, Tortoise
shell snuff boxes, Bath metal buttons inlaid with
steel and various other articles which I have now
forgot. A mill with a water wheel was employed in
Laminating metal for the buttons, plated goods etc.
and to turn the laps for grinding and polishing steel
work and I was informed that Mr. Boulton was the

first Inventor of the inlaid buttons, and the first who
had applied a mill to turn the laps. Mr. B. at that
[time] also carried on a very considerable trade in
the manufacture of buckle chapes, in the making
of which he had made several very ingenious im-
provements. Besides the laps in the mill, I saw
an ingenious lap turned by a handwheel for cutting
and polishing the steel studs for ornamenting
buttons, chains, sword hilts etc. and a shaking
box put in motion by the mill for scowering button
blanks and other small pieces of metal which was
also a thought of Mr. B.[33]

But waterpower at Soho, derived from the small Hockley
Brook, was a constant source of embarrassment. An exten-
sive correspondence with Thomas Gilbert, a member of
Parliament in 1771, reveals that the cutting of the Birmingham
canal seriously affected water levels in the brook; at other
times the pool dam was badly flooded.[34] No wonder that
Boulton complained:

I have laid out upon my Stream Twenty Thousand
Pounds in Buildings Machines and Tools--I have
700 people employed in my Manufactory and more
in consequence of it--Do but for a Moment Think
of my Summer Situation, when I have no Water,
my work people standing still Murmuring--My
Orders not executed, my foreign Friends complaining
and countermanding their orders--Think what a
distracting situation, what a reward is this for
my labours and hazards.[35]

For these reasons Boulton was anxious to install a
Watt engine at his mill. In 1767 Boulton and Fothergill
had been "obliged to employ from 6 to 10 Horses to work
the Mill which were necessary to be paid high and cost 5
or 6 Guineas per Week."[36] He wrote many letters
apologizing to customers for delays caused by lack of
water. Though he might boast of the high productivity of

his workers, assisted as they were "by the many mechanical
contrivances and extensive apparatus which we are
possess'd of," he was constantly faced by mechanical and
power failures, not to speak of difficulties with the work-
ers themselves.[37]

It has been stated often that eighteenth-century artisans
were often drunken and unreliable in timekeeping and atten-
dance. Eighteenth-century business records make such
facts inescapable, though there were, of course, many
reasons for this behavior. One does not have to be a
"lackey of the bourgeoisie" to see that employers had severe
problems with their workers. Of particular interest here are
the difficulties in creating and retaining a skilled work
force in the Birmingham jewelry trade.

In a letter to John Herman Ebbinghaus who advised him
to contract his scale of business, Boulton retorted:

> It may be very easy for people who only buy and
> sell goods to suddenly contract and lessen their
> dealings but that cannot so conveniently be done
> in a Manufactory like ours without Loss of Mony
> and danger of Credit.
>
> I cannot say to the workmen go your ways and
> come again twelve months hence. I assure you
> it hath been no small trouble and expence to
> collect such a sett of work folks as we have now
> employed in our Manufactory.[38]

Boulton indeed spared no pains to recruit skilled workers.
Among the most significant was William Hancock of
Sheffield, who was persuaded to bring with him two or three
Sheffield workmen and "to undertake the management of a
shop to make plated Candlesticks, Cruet frames, and sundry
other Articles in that Branch." In return Boulton promised:
"I will find you shops, Dies, and sundry other Tools
necessary for the manufactory as much as may make it
worth your while coming; provide[d] you can deliver them
compleatly finished at such prices as will enable me to
sell upon the same terms they do in Sheffield."[39] This

intermediate stage between outwork and true factory
operation is worthy of attention. In a similar letter to
James Watt, the silversmith (not to be confused with the
engineer), Boulton said that on William Wyon's recommenda-
tion he was approaching Watt to invite him to work at Soho.
He would pay Watt a guinea per week, his London wages,
with a present of five guineas as an annual Christmas gift.
Watt, if he joined Boulton, might expect to

> live in peace and Tranquillity all the days of
> your life as I have several Workmen that have
> been with my father and me all the days of my
> life. . . . As to your Workshop I promise you
> that you shall have one to your self and no body
> shall be admitted into it but such as you shall
> chuse for Assistants and if when you are settled
> you should like working piece work of other
> workmen I will make it your interest to prefer
> any such changes / as we have many sorts of
> Employments suitable for Women if any of them
> are found Agreeable to your Wife I shall be
> inclined to give her a Choice. If you know of
> any suitable Assistants in London that you should
> like to work with you and can agree with him
> for such wages as you think he will merit I
> commission you to agree with him and to bring
> him down. [40]

In the 1782 inventory of the Boulton and Fothergill
works, many of the workshops are listed under the names
of specific artisans--John Scale's Little Room, Will
Dawson's shop, John Jerom's Stamping Shop, John Vale's
Stamping Shop, Mrs. Callow's Cutting-Out Shop, Robert
Kimnel's Mill, G. Thickbroom's Shops, John Ottley's
Burnishing Shop. It is more than possible that these shops
were organized on the same basis as those described above
for James Watt and William Hancock. Even female workers
might be carefully courted to join Boulton's enterprise.

Thus Boulton's manager wrote to a female button worker:

> The Letter which you addressed to Mr. Swinney
> hath been sent to us as the Advertiser for a
> female Assistant in the Button business. The
> Mints you seem to possess would be quite
> sufficient for our purpose if we would perswade
> ourselv's that purpose was deserving of 'em
> and that the limits we are in some respects
> obliged to allow ourselves with respect to terms
> were also not inadequate to 'em. Such however
> is the nature of our business that we have never
> given any more than five shillings a Week to
> the most useful Woman we have, though we
> should not hesitate to make Some Extraordinary
> annual allowance to one of greater abilities.
> The employment for the person we want would
> be in the delivery and Receipt of every Article
> in a very Extensive Button Manufactory Regard
> being had to the Necessity of keeping debtor
> and Creditor of the Value of Such Articles. This
> Employment is in many cases dirty for the Hands
> but that perhaps may be obviated by the Con-
> sideration of every undertaking having something
> disagreeable in it. As to age, We Should prefer
> one whose Maturity as yours appears to be would
> ensure that trust and dependence which arise
> from cares assiduity and justice. Such are the
> requisites we Coud Wish in the person we take
> and Such are our terms--We wish we could flatter
> Ourselves that they may be agreeable to you. We
> beg the favour of an answer

> B & F

> Chas. Wyatt.[41]

Skilled workers, male or female, clearly had to be wooed
and, once assembled, persuaded to settle. Andreas Kern,

a German inlayer of gold and silver recruited by Boulton, was handled with kid gloves on more than one occasion.[42] Alexandre Tournant, a French gilder, was treated with every politeness and consideration. Such people were essential to the business and to the quality of the product.

There was always a competitor anxious to lure them away. To another Birmingham toymaker Boulton wrote:

> You, or your agent, employed Jonathan Deakin
> whilest he was my hired servant although I gave
> you notice of his being so hired, also Samuel
> Taylor was hired by your said Agent at Michael-
> mas 1767 to come to work at your plated work at
> the expiration of his agreement with me, which
> was not untill three Months after he was so
> hired by you. Also Benjamin Fletcher your said
> Agent enticed away from my work and now employs,
> although he was then an articled Servant to one
> of my articled men, those things you was informed
> of by one of our Clerks and by my self, but without
> effect. And finding myself ill used by Callons
> he being engaged by you, before I had any
> intimation of his leving me, I must own that in
> consequence thereof I did upon the principle of
> retaliation give Robinson some encouragement
> and I here declare that Robinson is the only man
> I in any way ever seduced from you. . . .
> Now Sir if you please we will consider this
> account Ballanced and proceed hereafter upon a
> more Gentleman-like plan which I am convinced
> will conduce more to our mutual intrest pleasuer
> reputation good neighbourhood etc. etc. than the
> Shabby Custom of secretly seducing each others
> Servants.[43]

And if it was not a local competitor who worked to steal away the artisans, it was some Austrian, German, or Frenchman, or their respective representatives who enticed the men to go abroad. Samuel Garbett reported, for

example, that Robert Hickman of Vienna had been employing people in Birmingham to seduce Thomas Bennet to go abroad by offering him £500 in ready money, £100 a year to be settled on him and his wife, and a house worth £40 a year. Such occurrences were common.[44]

Silversmiths, chasers, engravers, braziers, enamelers, designers, and so forth were recruited carefully by following up personal recommendations from other people in the trade. Union practices, even strikes on occasion, had to be tolerated; bad timekeeping and extended holidays, liquor and licentiousness were all overlooked from time to time provided the man was sufficiently skilled and difficult to replace. Nor would Boulton take on skilled artisans until he knew that there were reasonable steady prospects for a certain line of manufacture. Thus he wrote to the architect and designer James "Athenian" Stuart about a terrine being made for the Admirality:

> I promise you faithfully that the Workmen
> employed about it shall not touch any other
> thing untill it is completed but it's impossible
> to set many hands about it as it is but one
> thing. besides I have not many hand[s] that
> are qualified to work at such a thing nor dare
> I venture to encumber myself with many proper
> workmen for such things untill I see whether
> Parliament will permit me to be a Silversmith
> by establishing a marking office at Birmingham.[45]

The variation in the quality and quantity of workmanship done by artisans was apparently very large. On one occasion when Boulton received some new braziers and silversmiths recruited in London, he commented to his agent: "We hope we shall find them very usefull as they offer already to do the same work for 5/3 that we have paid 21/- for to our Drunken rascals." Good workmen had to be individually selected:

> We this day received a Letter from old Kelly

by which we find he has made a great rout
among the Silver Smith[s] and also got
himself out of Place by it--he gives us an
account of the under mention'd names that
he hath spoke to. Benson--Worked last for
Mr. Gardener St. James Street. A middling
hand at raising and mounting. John Right
a German. M. Duff (a very good hand at
mounting and raising but wants 1 1/2 guineas
per week which is too much 25/- is quite
enough.). . . Cornack with Horsley (A
Working Smith and a good Character) Wakesmith
a German with Horsley (a Raiser) Stross a
German with Mr. Momack (a Raiser and Mounter)
Hankle works with Mr. Hemming (M. B. wishes
to have him) Sibel at Du Mee's (send a note
to him in french but don't go to him) Heckford--
he has already been with you.[46]

Shortages of workers in inlay work, in making steel belt
locks, in brazier's work, and other specialties are mentioned
from time to time, and skilled workmen had no difficulty in
moving from one master to another:

Respecting Burn we hear that he is very feeble
minded in roving about from place to place and
that his abilities as a Workman are but indifferent,
nevertheless if he will come down [from London
to Birmingham] and make a piece of work as a
tryall of his skill, and if we find him a tollerable
good hand we will then agree upon any terms that
he may chuse and further pay his passage here.[47]

These were some of the labor problems faced by an
eminent Birmingham jeweler with extensive lines of
influence. The difficulties encountered by smaller masters
were presumably of a different order, but their records have
not survived. One thing is certain--a sober, industrious,
and competent workman could expect to be articled to

Boulton and Fothergill with guaranteed salary increases built
into his articles. Skilled workmen were in demand.

Perhaps one of the most challenging problems in the
mechanization and organization of the Birmingham jewelry
and silver trades was fashion and how to keep in touch with
it. This important subject requires separate and fuller
treatment, but no paper on Birmingham would be complete
without some reference to it. Since Birmingham jewelry was
usually made of nonprecious or semiprecious metals, it was
much more susceptible to rapid fashion changes than very
expensive jewelry. It could reflect the quirks of every
season, even the month-to-month fashion changes that were
taking place by the mid-eighteenth century. Boulton was
very much a man of the world--friend of David Garrick and
Sara Siddons, promoter of the Theatre Royal in Birmingham,
admirer of Lady Hamilton and all beautiful, fashionable
women, habitué of the coffeehouses and the clubs, jeweler
to lords and ladies and to the royal family itself, which still
remained a fashion leader even during the supposedly dowdy
Hanoverian period. In April 1780, for example, Boulton had
an audience with King George III, something that had
occurred several times in previous years:

> I yesterday morning received, by Lord Dartmouth,
> his Majestys commands to attend him at the Queen[s]
> house at 5 o Clock, which I punctually obeyed. I
> was most graciously and even friendly receiv'd.
> I found their Majestys drinking Coffee with the
> prince of Wales the Bishop the Young Sailour and
> two of the Princeses. I was kept upon the full
> stretch in Conversation from 5 to near half past
> 7 o Clock.[48]

When some article was required by a member of the royal
family--a vase, a clock (Fig. 5), a sword hilt, a medal, or
a set of buttons--Boulton was frequently called upon to
fulfill the order.

Boulton and other Birmingham jewelers constantly
sought to keep abreast of fashion and to preserve their

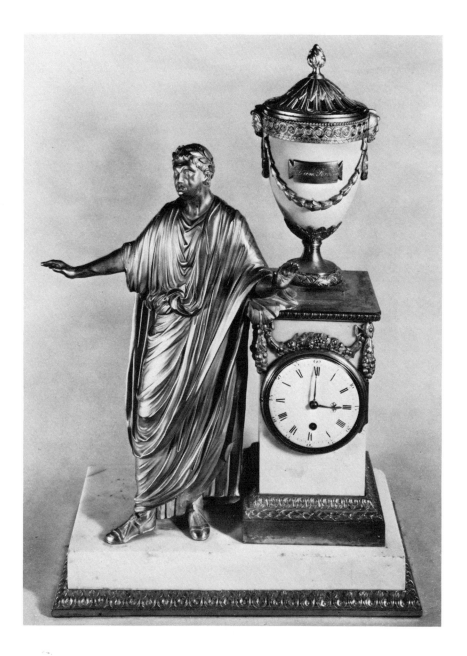

Fig. 5. Matthew Boulton and John Fothergill, mantel clock with figure of Roman emperor Titus. Birmingham, England, ca. 1778. White marble and ormolu; H. 16 1/2", W. 11". Movement by Caillard of Paris. (Birmingham City Museum and Art Gallery.)

lines of communication.[49] It was necessary to consult
retailers, to keep an eye on competitors' designs, to talk
with people of fashion, and to obtain information from
travelers both at home and abroad. Thomas Pownall wrote,
giving advice to Boulton:

> I have inquired amongst those who have nothing
> to do but to copy or invent new modes of Luxury
> and magnificence, and who have lived amongst
> the French, who understand these things best of
> any nation, about the idea we had conceived of
> a Service for a Dissert--à la grec--but I find that
> China only or perhaps in some instances Glass,
> is thought proper for fruit and confectionary and
> that nothing of metal, as we though of, wou'd
> be conformable to the present whim of Tast.
> But it was agreed that very elegant Vases etc.
> might be made for Ice-potts.
> The Things to which it was agreed that the
> Manufactory might be applyed with most success
> in things of Taste--Wou'd [be]--Clock-Cases--
> of which there [are] a Thousand Fancies, for
> Chimney peices and just now these fancied clock-
> Cases of the Or-mullie, inlaid enamell'd etc.
> are all the Mode-Francoise which they sett on
> tables bracketts toiletts chimney peices.
> Inkstands for Ladies toiletts and Escrutoires
> in every mode of elegance and fancy of the same
> work are also much in vogue and would be in
> great request--[50]

Boulton almost immediately went into the manufacture of
such articles. On another occasion Boulton and Fothergill
inquired of John Wyatt, the cousin of James Wyatt, the
architect: "Do you see nothing new neither in price,
quality nor fashion, in all the Articles Manufactord at Soho
we want Orders for tortoise work and dod says he his in-
formed that great quantities of small bottle cases are made
of different patterns have You seen any of them."[51]

Amos Green, the painter, sent suggestions from Bath; P. J. Wendler sent models and ideas from Italy; Lady Dartmouth was consulted on Wedgwood cameos; Thomas Hope showed John Philp, one of Boulton's designers, the collection of antique ornaments in his house; and royal patronage was used to advertise buckles (Fig. 6) in Europe:

> I am desirous of supplying all the great Citys
> in Europe with them and though the Edict is not
> repeald you must find some means of supplying
> Daser and Co [of St. Petersburgh] with a large
> quantity for I am confident of their Sale. all
> our Royal Family are pleased with them and tho
> the English Ladys wear Slippers without Buckles
> yet our princesses are determined to bring them
> into Fashion and I am making some of them for
> the Prince of Wales.[52]

Boulton's nephew, Zaccheaus Walter, wrote from Paris sending designs of earrings, necklaces, bracelets, sword hilts, and furniture ornaments.[53] It was Boulton's intention to design for the taste of all countries, and he spared no pains to obtain the requisite information. Moreover, he tried to create fashion, to synchronize production with royal celebrations and national events at home and abroad, and generally to vary and modify his offerings in order to provide a wide range of choice of the most fashionable productions. He cajoled his customers, puffed his wares in newspapers, and talked, talked, talked in fashionable drawing rooms. As in all fashion trades, a mistake meant dead stock or loss of sales. Though little evidence remains outside the Boulton and Wedgwood papers of the activities of hundreds of smaller manufacturers, except in the objects produced, which often cannot be attributed to a particular producer, there is reason to believe that on a lesser scale smaller firms were also keenly aware of the necessity of keeping up with fashion trends.

The Birmingham jewelry and silver trades have been rather neglected by economic historians in comparison with

Fig. 6. Matthew Boulton and James Smith, pair of shoe buckles. Birmingham, England, ca. 1800. Sterling silver and leather; H. 2 7/8", L. 2 1/2". (Birmingham Assay Office, Matthew Boulton Collection.)

the cotton, woolen, iron and steel manufactures, but they were a significant part of England's manufacturing production and export trade in the latter decades of the eighteenth century. They formed the basis for manufacturing skills that were later applied to automobile and bicycle manufacture and their auxiliary trades. Birmingham is still one of the greatest industrial centers of Britain and has diversified in a thousand ways. The best of its toys and silverware from this earlier period bear comparison with the best from other cities, and its artisans helped to promote jewelry manufacture in many cities from Vienna to Philadelphia. Birmingham can be said to have been the classical model for the division and specialization of labor, and nowhere more than in its jewelry trades. Artisans from all parts of Europe were recruited and brought there, while Birmingham products sold in large quantities in the great continental fairs and in all the major cities of Europe and America. Standardization, mass production, and cheapness of production characterized Birmingham's products, though there was still much high quality handicraftwork. The power sources were water power, and animal power, demonstrating once again that steam power was not a sine qua non of industrialization. The skilled labor force was probably as prosperous as that of any other city in the world in the later half of the eighteenth century, and the city's leading manufacturer, Matthew Boulton, was perhaps the greatest and the most imaginative of the entrepreneurs of his age.

The problems Boulton faced in achieving his ambitions reflect closely the stage of commercial and industrial development attained by Birmingham in the later eighteenth century. Difficulties arose of a managerial character, often connected with the organization of a highly specialized work force. Constant changes in the materials used in the trade, allied to unreliable power sources, created many headaches, but the severest problems may have arisen from the dependence of the jewelry and toy trades on the vagaries of fashion and the fluctuations of foreign policy that injured a production largely destined for export. The commercial and mechanical ingenuity of its

leading citizens allowed the city to continue its growth even during the Revolutionary and Napoleonic wars, to recover from the death of the shoe buckle, and to prosper on the basis of a wide variety of manufactures. The expertise in handling alloys, in mass production, and in standardization surely contributed to that successful adaptation.

NOTES

1. Smith, <u>An Inquiry into the Nature and Causes of the Wealth of Nations</u>, 2 vols., ed. E. Cannan (6th ed.; London: Methuen-University Paperbacks, 1961), 1:270.

2. Lord Edmond Fitzmaurice, <u>Life of William, Earl of Shelburne, afterwards First Marquess of Lansdowne</u>, 2 vols. (London: Macmillan and Co., 1875), 1:274-75.

3. See particularly the Lansdowne-Garbett correspondence at the Birmingham Reference Library.

4. Fitzmaurice, <u>Life of William, Earl of Shelburne</u>, 1:274.

5. Smith, "Art, Technology, and Science: Notes on Their Historical Interaction," <u>Technology and Culture</u> 11, no. 4 (Oct. 1970): 493-549, reprinted in <u>Perspectives in the History of Science and Technology</u>, ed. Duane H. Roller (Norman: University of Oklahoma Press, 1971), pp. 129-65; C. S. Smith, "Metallurgical Footnotes to the History of Art," <u>Proceedings of the American Philosophical Society</u> 116, no. 2 (Apr. 1972): 97-135.

6. Higgins to Boulton, Feb. 28, 1773. Unless otherwise noted, all of the Boulton and Fothergill papers, manuscripts, and letter books referred to in the text or footnotes are on deposit in the Assay Office Library, Birmingham.

7. H. W. Dickinson, <u>Matthew Boulton</u> (Cambridge: At the University Press, 1937), pp. 101-3; see also Eliza Meteyard, <u>The Life of Josiah Wedgwood</u>, 2 vols. (London: Hurst and Blackett, 1865), 2:26; Eric Robinson, "The International Exchange of Men and Machines, 1750-1800," <u>Business History</u> 1, no. 1 (Dec. 1958): 3-15, reprinted in A. E. Musson and Eric Robinson, <u>Science and Technology in the Industrial Revolution</u> (Manchester and Toronto: University of Manchester Press, 1969).

8. Boulton and Fothergill to M. Diemar, Sept. 28, 1771, Letter Book, 1771-73, fol. 202; Boulton and Fothergill to R. Hurst, Jan. 26, 1771, fol. 23; Feb. 23, 1771, fol. 54.

9. Boulton and Fothergill Letter Book, 1757–65, fol. 2: Boulton and Fothergill to Huntsman, Jan. 19, 1765; Erskine (Brimingham [sic]) to R. Atkinson, Oct. 11, 1770, Erskine MSS., Library of the New Jersey Historical Society, Newark.

10. Boulton and Fothergill to Huntsman, Feb. 23, 1775, Letter Book, 1774–77, fol. 26.

11. See under Komarzewski, Thiele and Steinert to Boulton, Apr. 1796.

12. Boulton to John Edwards, Oct. 3, 1794.

13. Fitzmaurice, Life of William, Earl of Shelburne, 1:275.

14. The Birmingham, Wolverhampton, Walsall, Dudley, Bilston and Willenhall Directory (Birmingham: Pearson and Rollason, 1780).

15. Allen, The Industrial Development of Birmingham and the Black Country, 1860–1927 (London: Allen and Unwin, 1929), p. 106, quoting "Birmingham and Her Manufactures" in The Leisure Hour, Feb. 3, 1853.

16. Allen, Industrial Development, p. 107, referring to "Newspaper Cuttings on Birmingham Industries", vol. 1, p. 22, Birmingham Reference Library.

17. Charles Holtzapffel, Turning and Mechanical Manipulation, 6 vols. (London: Holtzapffel & Co., 1846–84), 1:934.

18. Robert Rowe, Adam Silver, 1765–1795 (London: Faber & Faber, 1965), pp. 53–54.

19. Holtzapffel, Turning and Mechanical Manipulation, 1:131.

20. E. L. McAdam, Jr., Donald Hyde, and Mary Hyde, eds., Samuel Johnson's Diaries, Prayers and Annals (New Haven: Yale University Press, 1958), p. 220.

21. Boulton to Hollis, Jan. 15, 1757.

22. See Eric Robinson, "Eighteenth-Century Commerce and Fashion: Matthew Boulton's Marketing Techniques," Economic History Review, 2d ser. 16, no. 1 (Aug. 1963): 39–60. See also E. Robinson and Keith R. Thompson, "Matthew Boulton's Mechanical Paintings," Burlington Magazine 112, no. 809 (Aug. 1970): 497–507.

23. Letter Book, 1771-73, fols. 263, 55.

24. Letter Book, 1774-77, fol. 402.

25. Sheffield City Libraries, acc. no. 33243, Special Collections (Bradbury Records 299). I am grateful to Mrs. Shirley Bury of the Victoria and Albert Museum for this reference.

26. Banister, Old English Silver (London: Evans Brothers, 1965), p. 25.

27. Boulton and Fothergill to Parker and Wakelin, Nov. 16, 1771, Letter Book, 1771-73.

28. Boulton and Fothergill to Woolley and Heming, Jan. 19, 1765, Letter Book, 1764-66.

29. Aris's Birmingham Gazette, June 15, 1789, as cited in Adrian Oswald and Faith Russell Smith, "Discovered: A Box of Buttons," Connoisseur 133, no. 536 (Apt. 1954): 105-6.

30. Boulton to Solomon Hyman, 1772, Letter Book, 1771-73; Boulton and Fothergill to William Matthews, June 15, 1771, Letter Book, 1771-73: "Two or three Years ago you sent us some Braziers Tools from one William Papps . . . 2 Kitchen Heads, 1 flatt and 1 Round--1 hollow tool with a shank to it for Necks--1 side-stake--2 small heads for Brown Kettls, 1 flatt Bullet stake--2 lip Tools for Turkey Pots--2 Neck tools or hollow tools for Turkey Pots--a Guage for Kitchin Covers--2 spout Tools for 3 Quart Kettles--1 Beck Iron, a small size for 3 Quart Kettls."

31. Boulton and Fothergill to Hyman, Mar. 7, 1772, Letter Book, 1771-73.

32. Boulton and Fothergill to Samuel Bradley, June 27, 1774, Letter Book, 1774-77; Boulton and Fothergill to Elmsley, Oct. 19, 20, 1771, Letter Book, 1771-73. See Musson and Robinson, Science and Technology in the Industrial Revolution, for a full examination of the impact of printed literature on British manufacturers.

33. Watt, "Memoir of Matthew Boulton," Assay Office Library, Birmingham.

34. Canal Box, Assay Office Library, Birmingham. See also Boulton to Gilbert, Feb. 2, 1773, Letter Book, 1768-73; Jonathan Scale to Boulton, May 27, 1773.

35. Boulton to Gilbert, Feb. 2, 1773, Letter Book, 1768-73.

36. Boulton memorandum, beginning "It is but just to observe," Fothergill Box.

37. Boulton to the Earl of Warwick, Dec. 30, 1770, Letter Book, 1771-73.

38. Boulton to Ebbinghaus, Sept. 1768.

39. Boulton to Hancock, Aug. 21, 1775, Letter Book, 1774-77. See also fol. 414-15, 427, 448, and 453.

40. Boulton and Fothergill to Watt, ca. Feb. 7, 1775, Letter Book, 1774-77.

41. C. Wyatt to Mrs. H. Halford at Atherstone, May 6, 1773, portions of a Boulton and Fothergill letter book, 1773, Birmingham Reference Library.

42. See, for example, Boulton and Fothergill to W. Matthews, Nov. 11, 1771, Letter Book, 1771-73: "As for Mr. Kern we can't say but it is natural for him rather to chuse living with people that he can talk to and be understood by, than with people whose language is unknow[n] to him and consequently we left it to his own choice and gave him the Letter for you for no other purpose but only that he might meet with a proper reception from you in Case he had chused to stay with you."

43. Boulton to John Taylor, Jan. 23, 1769, Matthew Boulton Letter Book, 1768-73.

44. Garbett to Boulton, July 30, 1785, Samuel Garbett Box I, Assay Office Library, Birmingham. See Lansdowne correspondence, Birmingham Reference Library.

45. Boulton to Stuart, Aug. 1, 1771, Letter Book, 1771-73.

46. Boulton to W. Matthews, June 17, 1771; Boulton and Fothergill to Matthews, July 6, 1771, Letter Book, 1771-73. On another occasion Boulton offered to engage Dumee's brother as a chaser; see fol. 10.

47. Boulton and Fothergill to W. Matthews, May 23, 1776, Letter Book, 1774-77.

48. Boulton to J. Watt, Apr. 23, 1780, Boulton and Watt Box 20, Birmingham Reference Library.

49. See Robinson, "Eighteenth-Century Commerce and Fashion."

50. Pownall to Boulton, Sept. 8, 1769.

51. Boulton and Fothergill to Wyatt, Sept. 10, 1776, Letter Book, 1774-77.

52. Green to Boulton, Oct. 30, 1769; Wendler to Boulton, Apr. 14, 1767; Lady Dartmouth to Boulton, Nov. 24, 1773; Hope to Boulton, Sept. 15, 1806; Boulton to Andrew Collins, Sept. 2, 1793.

53. Walker to Boulton, Nov. 24, 1802, Zaccheaus Walker, Jr., Box, Assay Office Library, Birmingham.

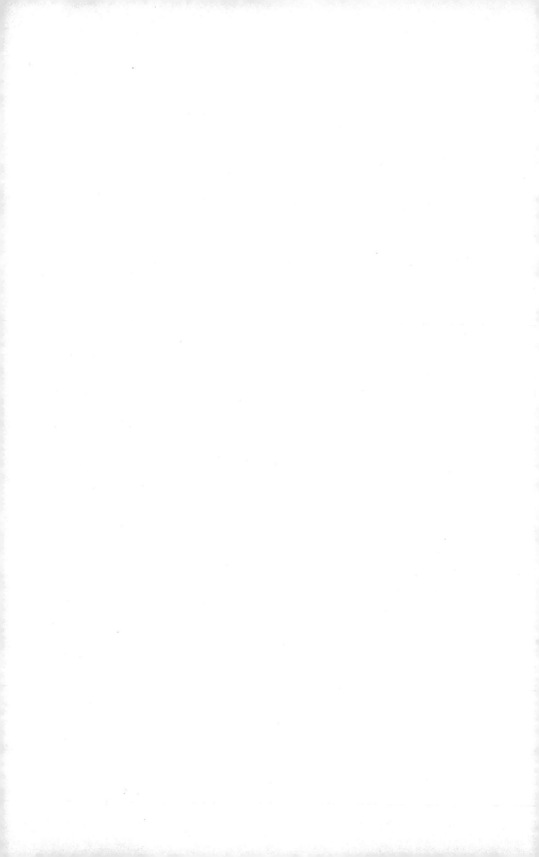

FROM CRAFTSMAN TO MECHANIC:
THE HARPERS FERRY EXPERIENCE, 1798-1854

Merritt Roe Smith

ANTEBELLUM America witnessed a spate of technological
innovations that appreciably altered the substance, quality,
and pace of everyday life. Between 1815 and 1850 new factories
began to dot the countryside, while mill towns and cities sprang
up around these complexes. During the same period steam began
to augment water as a primary source of power; canals, steam-
boats, and railways tapped vast hinterland markets; and the
electric telegraph began to span the continent, providing vastly
improved communications. With each stride toward a new
industrial society, colonial folkways receded further into the
historic past.

Over the years much has been written about the coming of
industrialization. Underlying this was a basic transformation
from craft to mechanical know-how--a complete reordering of
the modes and methods of production, which replaced the skill
of the hand with the precision of the machine and ultimately
altered the psychology of work itself. To probe this phenomenon
is to touch the very marrow of America's industrial revolution.
What follows is an attempt to explore the nature of this change
in the United States firearms industry. In particular the discus-
sion focuses on the transition from craftsman to mechanic at the
Harpers Ferry armory and the resultant responses to this trans-
formation. Insofar as old, craft-trained artisans frequently
became new, operative mechanics, the general implications of
this study may well extend beyond the narrow confines of arms
making to other sectors of the American economy.

One of two national armories sanctioned by act of Congress
in 1794, Harpers Ferry was located in Virginia's Northern Neck,
at the junction of the Potomac and Shenandoah rivers. Although
its sister institution at Springfield, Massachusetts, eventually

claimed the distinction, it was thought at the time of its
founding that Harpers Ferry would become the more important
of the two, the "Grand National Armory."[1] Several advantages
supported this expectation. From the very beginning the site
at Harpers Ferry had the undivided encouragement and support
of George Washington, who, as president and private citizen,
considered the armory essential to the economic development
of the Potomac Valley. Secondly, it was strategically located
about sixty miles up river from the nation's capital and lay in
the midst of numerous iron forges and lumber mills deemed
essential as sources of raw materials. Last but not least, it
commanded a contingent of very able gunsmiths.

Unlike the Springfield armory, which experienced much
difficulty in acquiring the services of skilled artisans, Harpers
Ferry had a ready-made work force.[2] This is not to say that
the Potomac Valley abounded with gunsmiths; far from it. Rather
the new armory profited from the fact that just prior to its
construction the War Department disbanded a federal arsenal at
New London, Virginia, and transferred its superintendent,
Joseph Perkin, to Harpers Ferry.

An Englishman by birth and a Moravian by conviction,
Perkin served an apprenticeship in the Birmingham gun trade
before emigrating to America around 1774. With the outbreak
of the Revolutionary War, he worked for John Strode, a well-known
businessman and manager of the Hunter Ironworks near Falmouth,
Stafford County, Virginia. Recognizing Perkin's ability as a
"usefull ingenious man," Strode "kept him chiefly at Gunlocks,"
a task assigned only to the most skilled armorers.[3] With the
termination of hostilities in 1781, Perkin left Falmouth and moved
to Philadelphia where he set up a small gun shop in partnership
with Samuel Coutty. There he remained, making arms for private
as well as public patrons and serving as a part-time inspector
for the intendant of military stores, until called upon to assume
supervision of the New London arsenal in 1792. Six years later,
at the summons of the War Department, he again packed his bags
and set out for Harpers Ferry.[4]

When Perkin arrived at the armory site in the fall of 1798,
he brought approximately fifteen New London workmen with him.
With the exception of three or four native Virginians, all of the

workmen had at one time or another resided in Philadelphia and
had been recruited there. Some, like John Miles, had "been
breed up among and . . . conducted some of the Principle Gun
& Pistol Manufactorys in Great Britain."[5] Others, such as
George Metts, Charles Williams, and Perkin's sons, Henry and
John, had trained under Philadelphia gun makers. Together they
represented Perkin's "principal dependance," a core group upon
whom he relied heavily in laying the foundations of the Harpers
Ferry armory.[6]

 With the initiation of construction in 1799 and the gradual
introduction of manufacturing operations thereafter, Perkin
sought to expand his labor force. Experiencing little success
finding qualified armorers in the immediate vicinity of Harpers
Ferry, he naturally began to look elsewhere for recruits. As in
the past, Philadelphia offered the best prospects. Its reputation
as the great center of craftsmanship and the disembarkation
point for newly arrived immigrants made it a natural reservoir for
skilled gunsmiths. Moreover, having resided in the city over
ten years, Perkin was thoroughly familiar with its commercial
environment and had many established contacts there. Relying
on this knowledge as well as his friendship with Samuel
Hodgdon, the intendant of military stores, Perkin succeeded in
attracting about ten workmen to Harpers Ferry between 1799 and
1801. Among them were Thomas Annely, a "compleat artificer"
in every respect and first master armorer at Harpers Ferry;
William Gardner, a highly skilled engraver; Miles Todd, an
experienced barrel forger; and James Greer, an able machinist
whom Perkin lured from Robert McCormick's Globe Mills armory
in the Northern Liberties section of the city.[7]

 Although Philadelphians undeniably exerted a strong influence
at Harpers Ferry between 1798 and 1816, other Pennsylvania-
trained artisans were also employed at the government works
during this period. It is clear that many of the highest paid and
most skilled workmen came from towns and hamlets lying beyond
the western reaches of the Quaker city. In fact, a collective
profile of early armory personnel reveals the existence of a
migratory pattern extending along the Great Wagon Road from
Philadelphia through Lancaster, York, Hanover, and Frederick
to the mouth of the Shenandoah River and the fertile valley beyond.

Just as scores of settlers moved westward over this busy trade
route throughout the eighteenth century, it became the main
thoroughfare on which workmen and their families made their
way to Harpers Ferry during the opening decade of the nineteenth
century.

To narrate the personal history of the armorers who followed
the Great Wagon Road to Harpers Ferry lies beyond the scope of
this paper. Suffice it to say that in 1816, the first year for
which there are sufficient records, thirty-three of eighty-four
armorers earning a monthly salary over forty dollars had either
worked or served apprenticeships in Pennsylvania and Maryland
gun shops prior to their employment at the national armory.[8]
Although this represents 39 percent of the skilled labor force at
Harpers Ferry, it is an extremely conservative estimate. For
one thing it includes only those armorers who are actually known
to have come from the Pennsylvania-Maryland arms industry.
For another, it excludes at least twenty-five men who may well
have come from the same craft-oriented background but who
cannot be included in the estimate at this time for lack of
positive evidence. Even taken alone, the 39 percent figure is
impressive, especially because it includes four of the five
shop foremen at Harpers Ferry in 1816.[9] Although subordinate
to the superintendent and master armorer, after 1808 these men
played an increasingly important role in armory affairs because
they not only oversaw production but often ruled on the adoption
of new techniques.

The roster of early armorers at Harpers Ferry reads like a
"Who's Who" of Pennsylvania gun making. Foreman John Resor,
for example, was the grandson of Matthias Roesser, one of the
earliest gunsmiths in Lancaster County. George Zorger learned
the trade while working under his father, Frederick, one of York
County's outstanding artisans. Michael Gumpf, Jacob and
George Hawken, John Kehler, and George Nunnemacker came
from similar family backgrounds. Others such as Martin
Breitenbaugh and Marine T. Wickham became craftsmen in
their own right after serving apprenticeships under prominent
Pennsylvania and Maryland craftsmen. In short, the careers
of all these men correspond to the extent that they reveal a
preponderant Pennsylvania arms-making influence.[10]

In addition to those armorers who trained in Pennsylvania and Maryland shops before their arrival at Harpers Ferry, a number of other workmen reflected a similar influence although in a more subtle manner. In this case, the vehicle of transmission was the armory's apprentice system. Through it Pennsylvania practices flowed from one generation to another and were thereby perpetuated at the government works.

Between 1800 and 1813 at least thirty boys served apprentice-ships at Harpers Ferry. Depending upon circumstances, the length of an indenture usually varied from five to seven years. During that time the youth worked along side his master and, through practical experience, learned the art or mystery of forging, filing, stocking, and finishing a well-crafted arm. George Malleory, for instance, served a six-year indenture under the watchful eyes of his father, William, and Joseph Perkin.[11] John Avis, on the other hand, spent only five years as an apprentice to Perkin's successor, James Stubblefield.[12] Unlike young Malleory, Avis left the armory. On his twenty-first birthday in 1813, he went to Philadelphia as an inspector of contract arms for the Commonwealth of Pennsylvania.[13]

Around 1809 the formal apprenticeship system gave way to a noncontractual training program at Harpers Ferry. Under the new arrangement, established armorers working as inside contractors assumed responsibility for selecting boys as helpers. Other than paying wages, no obligation existed on the armorer's part to feed, clothe, or educate his assistants. Nor, for that matter, was he obliged to teach them the secrets of the trade. For the most part, the degree of skill acquired under the new system depended solely upon the willingness of the master to impart it. In many cases, therefore, the development of expertise remained minimal, and this severely restricted a youth's mobility from one job to another.

More to the point is the fact that a lad's family connections often proved more essential to success than his aptitude or ability as an armorer. Boys whose fathers worked at the armory stood a far better chance of learning the trade and improving their lot than did those who came from different backgrounds. Indeed, to accomplished gunsmiths such as George Nunnemacker and George Zorger, skill represented a legacy as well as a means

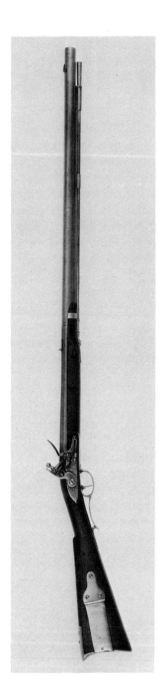

Fig. 1. U.S. rifle, Model 1803. Lockplate marked "Harpers Ferry 1803." 54 caliber; L. 49 1/2". (Winchester Gun Museum, New Haven, Conn.)

Fig. 2. U.S. rifle, Model 1814. Lockplate marked "Harpers Ferry 1815." 54 caliber; L. 49 1/2". (William C. Dodge Collection, Smithsonian Institution.)

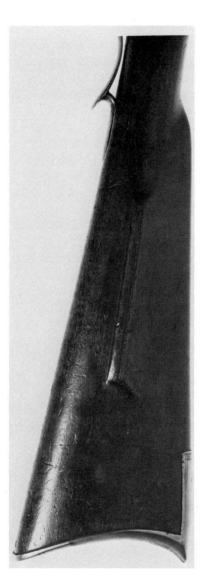

Fig. 3. Detail of cheek piece on Model 1814. (William C. Dodge Collection, Smithsonian Institution.)

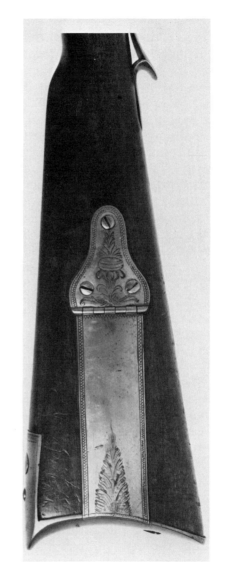

Fig. 4. Detail of patch box and butt plate on Model 1814 rifle. (William C. Dodge Collection, Smithsonian Institution.)

of livelihood. In many instances skill was the sole heritage a
man could impart to his male heirs. Accordingly, armorers
frequently hired their sons as helpers and, at the same time,
taught them the skills they would need to secure places in the
armory as full-fledged workmen. In this sense the apprentice
system never really ended at Harpers Ferry. Through it George
Zorger, Jr., John Malleory, Alexander Nunnemacker, and many
other young men got their start as gunsmiths. Moreover, it was
the means by which craft traditions as well as extended ties of
kinship became deeply embedded at the armory during the early
decades of the nineteenth century.[15]

The extent to which Pennsylvania-Maryland influences
prevailed at Harpers Ferry can be seen in the quality of its
earliest products. By 1806 the armory enjoyed a fairly widespread
reputation among military circles for the "superior workmanship"
of its firearms.[16] Outstanding in this respect is the Model 1803
"short" rifle (Fig. 1). There are many striking examples of the
use of three-dimensional artifacts as historical documents, but
few can surpass the Model 1803 in terms of clarity. Of all the
weapons produced at Harpers Ferry during its sixty-three-year
history, the Model 1803, manufactured with only minor alterations
through 1819, reflects the aesthetic preferences and style of its
makers with telling succinctness.

Figure 2 represents a specimen of this type dated 1815.
Originally designed and executed in 1803 under the supervision
of Joseph Perkin, it reveals distinct Pennsylvania-Maryland
gun-making influences.[17] The simple but elegant employment
of brass furniture, the well-defined comb of the butt stock with
its relatively narrow wrist, the high cheek piece, the large brass
patch box, the wide and slightly curved butt plate, the ornate
semigrip trigger guard, and the use of a retaining pin instead of
a band to secure the barrel to the stock--all these embellishments
give the rifle a character reminiscent of its famous Pennsylvania-
Kentucky prototype (Figs. 3, 4). Indeed, if one were to remove
the government markings, lengthen the barrel, substitute maple
for the walnut stock, and as a finishing touch, add some inlays,
distinguishing between the two would be difficult (Fig. 5).

Unlike the Pennsylvania-Kentucky long rifle, the Model 1803
was a composite product rather than the work of one person.

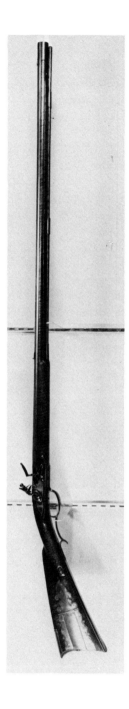

Fig. 5. Long rifle. Pennsylvania-Kentucky, ca. 1780-1800. 45 caliber; L. 58". (Fuller Gun Museum, Chickamauga and Chattanooga National Military Park, Fort Oglethorpe, Ga.)

While individual gunsmiths living along the Great Wagon Road
commonly fashioned rifles in their entirety, Joseph Perkin
adopted a pattern of production closely resembling traditional
European practices.[18] Under this arrangement individual
artisans made a particular part of each gun. In 1807, for
instance, the manufacture of rifles at Harpers Ferry involved
six separate branches of labor: barrelmaking, lock forging,
lock filing, brazing, stocking, and finishing. The completion
of each limb required not only different skills but also special
tools for each operation. As artisans completed their tasks,
they submitted their work to the master armorer, who in turn
sent the parts to another shop where a "finisher" filed and
fitted them and then assembled the completed weapon.[19] In
other words, each stand turned into store at Harpers Ferry
represented the work of several different hands. But, despite
the rudimentary division of labor involved in its manufacture,
the Harpers Ferry rifle remained essentially a handcrafted
product.

As a public institution whose fortunes necessarily
fluctuated with the course of political events, the Harpers
Ferry armory could not immunize itself against external forces
for change. No matter how tenaciously they resisted, neither
could the members of its craft-conscious labor force. This
became particularly evident after February 1815 when Congress
passed a bill placing both national armories under the immediate
jurisdiction of the Ordnance Department.[20] Until this time the
superintendent had been responsible only to the secretary of war.

Originally established in 1812 as an agency for the inspec-
tion and distribution of military supplies, the Ordnance Department
distinguished itself during the ensuing war years under the able
leadership of Colonel Decius Wadsworth. An experienced
administrator and a stickler for discipline, Wadsworth took his
job seriously--too seriously, in fact, for many at Harpers
Ferry--and within three years had molded a small but tightly
knit organization with a clear chain of command centered in
Washington, D.C. His motto, "Uniformity, Simplicity and
Solidarity," became the guiding principle in the formulation of
departmental policy, and he expected all who served under him
to live up to this precept or suffer the consequences--usually

transferal to less desirable duty.[21] Accordingly he surrounded himself with a group of bright, young engineering officers, the most able of whom was his chief assistant and ultimate successor, George Bomford. To Bomford, a West Point graduate, fell the responsibility of promoting greater system and efficiency at the national armories.[22]

Upon relieving the secretary of war in 1815 as the sole arbiter of armory affairs, Wadsworth and Bomford proceeded to draw up an agenda for Harpers Ferry and Springfield that went far beyond mere administrative reform. Because thousands of arms had been damaged and rendered virtually useless during the recent war with England, their immediate concern was the production of cheaper, more uniform weapons that could be repaired in the field by substituting new parts for those that had broken. The underlying principle was not new. It had been successfully introduced at several French armories during the 1770s and 1780s, publicized in the United States by Thomas Jefferson and Eli Whitney, and partially applied to the manufacture of pistols by Simeon North of Middletown, Connecticut, as early as 1813. Well aware of these developments, Wadsworth and Bomford appreciated their potential for eliminating the costly maintenance and repair problems that had plagued military authorities since the days of the Revolution. Intrigued, even transfixed, by the possibility of making arms with interchangeable parts, both men became zealous proponents of the uniformity system and relentlessly pursued the idea of introducing it at the national armories. But in order to do so, some means had to be found to eliminate the innumerable variations that inevitably crept into guns made by hand.

The first indication that the Ordnance Department intended to take action came in June 1815 when Colonel Wadsworth called a special meeting at New Haven, Connecticut, to discuss the feasibility of establishing interarmory criteria for the manufacture of more uniform muskets. In addition to the chief of ordnance, the participants included Superintendent Roswell Lee of the Springfield armory, James Stubblefield of Harpers Ferry, and Wadsworth's long-time friend and confidant, Eli Whitney. After several days of deliberation they agreed upon the adoption of a new model musket and decided that standardized pattern pieces

should be prepared and tested at the national armories.[23] If
the experiment proved successful, the participants concluded
that the program could be extended eventually to arms made by
private contractors.

Although the uniformity idea looked promising on paper,
neither acceptance nor success came easily. To some persons
the establishment of industrywide standards seemed fatuous
and beyond the bounds of administrative control. Because
manufacturing methods and inspection procedures differed
considerably from one armory to another, too many variables
had to be reckoned with.[24] One member of the military voiced
a common sentiment when he cautioned his superiors that "it is
the easiest thing in the world to change the pattern at Washington
and to make, in imagination, thousands of arms upon the new
pattern; but it is far otherwise in the practice."[25] Other critics
felt that the new system would be prohibitively expensive. It
would require not only the painstaking preparation of numerous
patterns and gauges but also the construction of special-purpose
fixtures and machine tools. Moreover, once built, these
machines had to be integrated with other units and coordinated
with the total production process. This factor alone presented
such a mind-boggling problem that even the dynamic and
resourceful Roswell Lee remained skeptical about finding any
quick technological solutions. "It is difficult . . . to please
every body," he reminded the chief of ordnance. "Faults will
realy exist & many imaginary ones will be pointed out. . . . It
must consequently take some time to bring about a uniformity of
the component parts of the Musket at both Establishments."[26]

Lee's pleas for "time, patience & perseverence" failed to
make much of an impression at the Ordnance Department.
Captivated by the engineering ideal of uniformity and convinced
of its urgency, George Bomford wanted results, not excuses,
and on more than one occasion made his feelings perfectly clear
to the Springfield superintendent.[27] Yet despite their differences,
both men realized that the two armories could coordinate their
efforts only through mutual cooperation. Otherwise all would be
lost. They also appreciated the fact that Harpers Ferry stood in
dire need of technical assistance. Owing to deeply rooted craft
influences, the armory's threshold for developing and assimilating

the new machine technology lay far below that at Springfield.
Although James Stubblefield had instituted the division of labor
and its adjunct, piecework, around 1808, no mechanical
innovations had originated at Harpers Ferry since its establish-
ment in 1798.[28] Its remoteness from other machine-using
factories prevented its armorers from comparing notes, sharing
information, and incorporating worthwhile improvements in their
own work. James Greer, since 1801 the sole machinist at the
Potomac works, had grown old and, at least in terms of know-how,
had lost touch with the times. Yet in 1816 Greer was expected
to cater to the mechanical needs of over two hundred workmen.[29]
Given these circumstances, it seemed unlikely that Harpers
Ferry would play an innovative role in the process of mechaniza-
tion. Coming from small-shop backgrounds, neither Stubblefield
nor his master armorer, Armistead Beckham, possessed the
ability or desire to do so.[30] To most observers one thing seemed
certain: the impetus to change had to come from some other
source than Harpers Ferry.

Promoting its cherished goal of uniformity, the Ordnance
Department stressed the importance of strong administrative
ties and closer technical collaboration between the national
armories. To his credit, Springfield's Roswell Lee needed little
prodding in this respect. Eagerly seizing the opportunity to
improve interarmory communications, he made a point to become
acquainted with Stubblefield and by the end of 1815 had established
an ongoing dialogue with the Harpers Ferry superintendent.[31]
Within a short time both men began to supplement their corres-
pondence with personal visits and the exchange of workmen.
Though everyone profited from the experience, the opening of
these channels particularly favored Harpers Ferry because fresh
technical information tended to flow from Massachusetts to
Virginia. Thereafter New England mechanics, many from
Springfield, not only carried new techniques to Harpers Ferry
but also played an increasingly important role in its daily affairs.

Between 1816 and 1829 Lee sent at least twenty-five work-
men to Harpers Ferry. Although most of them were conventional
armorers, Lee also loaned machinists, millwrights, and pattern-
makers to the Potomac armory on a temporary basis. Among the
first was Sylvester Nash, a Springfield employee, who in 1816

devised a machine for turning the exterior surfaces of gun
barrels. Since the 1790s numerous attempts had been made
to apply machinery to the finishing of barrels, but only Simeon
North of Middletown, Connecticut, had achieved any degree of
success. Hence, recognizing the importance of Nash's work,
Colonel Bomford instructed Lee to transfer Nash to Harpers
Ferry for the purpose of perfecting his model and assisting
Stubblefield with various technical problems associated with
the development of uniform production.[32]

Essentially Nash's improvement consisted of a rack-and-
pinion lathe fitted with a wrought-iron guide plate that regulated
the position of the cutting tool in relation to the desired contour
of the barrel (Fig. 6). To prevent the barrel from trembling and
springing out of position once the tool engaged its surface,
Nash attached a series of clamps that fit around the workpiece
and supported it between its bearings. When set in motion, a
slide rest carrying the cutting tool moved laterally along the
revolving barrel removing slivers of iron while producing a "true
and regular taper" (Fig. 7).[33]

The key words here are "true and regular," for the old method
of turning barrels against a revolving grindstone rarely produced
a uniform result. As in most handwork, rule-of-thumb procedures
prevailed. Consequently barrels often left the grinding shop
with weak spots where the bore ran eccentric to its outer
circumference. Further, the traditional method of grinding
barrels to their final dimensions was exhausting, hazardous,
and time-consuming. Because of the high number of losses at
the proof house, it also proved expensive. Nash's invention
helped to eliminate these problems. Though by no means perfect
in its operation, his lathe greatly reduced the inaccuracies
inherent in handwork and thereby increased the likelihood of
manufacturing arms with uniform parts. Equally noteworthy, his
twenty-month stay at Harpers Ferry signaled the beginning of a
slow but steadily growing reliance on Yankee know-how at the
government works.

Since gun barrels became flat and oval-shaped near the
breech, neither Nash's machine nor others like it could finish
their entire length. This meant that once the cylindrical portion
of the barrel had been turned, the breech section had to be

Fig. 6. Sylvester Nash, "Turning Musket Barrels." U.S. Patent no. 2939, Apr. 11, 1818. The letter h̲ marks the guide plate. (Photo, Frederick J. Wilson.)

Patented: 11 April: 1818. ✗

Fig. 7. Detail of sliding carriage (k), cutting tool (m), and wrought-iron guide plate (h) on Nash lathe. Record Group 241, Records of the Patent Office, National Archives. (Photo, Frederick J. Wilson.)

hand-filed in a jig at the loss of considerable time, uniformity, and expense. Numerous arms makers were aware of this problem, and several attempted to find a mechanical solution between 1816 and 1818. But only Thomas Blanchard, an obscure but obviously gifted inventor from Millbury, Massachusetts, succeeded.

While Nash was busy putting the finishing touches on his machine at Harpers Ferry in the spring of 1818, Blanchard had already begun to experiment with a lathe for turning the breech end of the barrel. Working at the Asa Waters armory near Millbury, he constructed a self-acting device featuring a cam motion for tracing a master pattern. This produced the desired result by guiding a cutter along the periphery of the barrel.[34] Upon learning of the machine from an inspector of contract arms, Lee invited Blanchard to demonstrate his principle at Springfield. Highly impressed by its performance, Lee signed a contract with the inventor for the construction of two machines, "one for turning the flats or squares & the other for draw grinding Barrels." When Blanchard completed the assignment toward the end of June 1818, the cooperative-minded Lee wrote Stubblefield of his latest technical coup and, with the Ordnance Department's approval, notified the Harpers Ferry superintendent that "I have advised him [Blanchard] to proceed to your works, not doubting you will be willing to encourage him in bringing forward those improvements which I am convinced will be useful to our Establishments."[35]

Arriving at Harpers Ferry in July 1818, Blanchard spent the better part of two months preparing a draw-grinding machine and an improved version of his gun-barrel lathe. Primary interest and attention focused on the latter. Whereas the lathe installed at Springfield turned only the short breech section of the barrel, the one built at Harpers Ferry turned its entire length, and as Blanchard described it, "changes from turning round to turning flat & oval of itself and turnes them so well that the draw grinding will grind them in 8 minutes."[36] Although initially skeptical, even the conservative Stubblefield joined the chorus of praise. "This machine," he wrote, "makes the barrels more complete than any thing ever set into operation to my knowledge."[37] In one fell swoop Thomas Blanchard had mechanized and integrated one of the most troublesome aspects of barrelmaking.

When Blanchard returned to Massachusetts in October 1818, he had already begun to ponder the possibility of applying the principle of eccentric turning to the manufacture of gunstocks. After several months of incessant labor he produced a model that "operated so well that a full-sized working machine was decided upon."[38] A familiar train of events followed. Even before completing the lathe at the Waters armory in February 1819, Blanchard received an invitation to demonstrate his invention at Springfield. Utterly fascinated by the machine's operation, Lee recommended its immediate trial to the Ordnance Department. Colonel Wadsworth consented, but instead of ordering its construction at Springfield, he notified Lee that Blanchard should carry out the experiment at Harpers Ferry.[39]

Completion of the lathe consumed most of April and all of May. But once set in motion it silenced those who scoffed at its ungainly appearance (Fig. 8). Indeed, its performance exceeded Stubblefield's fondest expectations. "It shews," he informed Colonel Wadsworth, "that Stocks can be turned in a Lathe, and I think it will be a great improvement in the Stocking of Muskets, and will also save expence, and insure uniformity in the stocks."[40]

Awkward-looking but amazingly proficient, Blanchard's lathe represented one of the most ingenious American contributions to a nineteenth-century technology. Its operating principle--tracing a master pattern and reproducing it--could be applied to the manufacture of all sorts of wooden articles with irregular shapes. Although the drawing Blanchard submitted to the Patent Office in 1819 depicted a machine for turning shoe lasts, it could have just as well been one for making ax helves, wheel spokes, or hat blocks (Fig. 9).[41] What is frequently overlooked is that, in addition to his eccentric lathe, Blanchard also designed and perfected thirteen different woodworking machines to facilitate the production of gunstocks. Built at the Springfield armory between 1819 and 1827, these machines completely mechanized the process of stocking and eliminated the need for skilled labor in one of the three major divisions of armory production. Rarely have the contributions of one person effected such a sweeping change in so short a time.

By November 1823 Blanchard had installed nine different

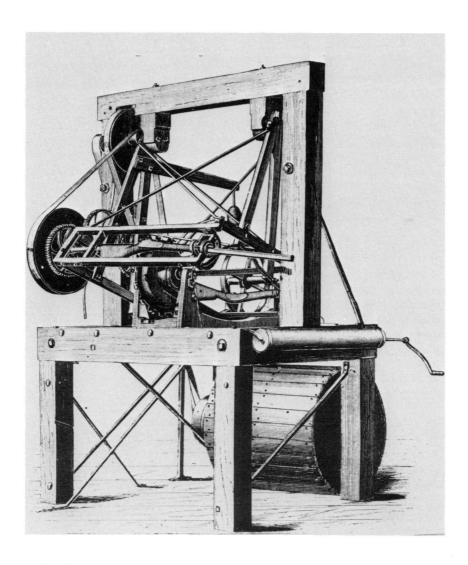

Fig. 8. Engraving of Thomas Blanchard's eccentric lathe for turning gun stocks. From Charles H. Fitch, Report on the Manufactures of Interchangeable Mechanism (Extra Census Bulletin, Washington, D.C.: Government Printing Office, 1883), fig. 9. (Photo, Frederick J. Wilson.)

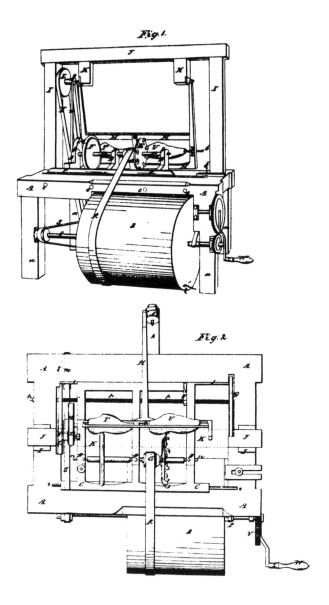

Fig. 9. Thomas Blanchard, lathe for turning irregular forms. U.S. Patent no. 3131, Sept. 6, 1819. Note the iron pattern (T), tracing wheel (F), cutter wheel (E), workpiece (V), swinging frame (H), and sliding carriage (C). (Photo, Frederick J. Wilson.)

machines at Springfield capable of carrying out major operations on the gunstock.[42] Yet Stubblefield seemed completely ambivalent about introducing them at Harpers Ferry. Part of his hesitancy undoubtedly stemmed from the fact that Blanchard demanded exorbitant fees for the use of his patented machinery, which tended to undercut any savings arising from their use. But Stubblefield was also influenced by a group of workmen, headed by his brother-in-law, master armorer Armistead Beckham, who expressed outspokenly hostile feelings toward "Yankee notions," no matter how useful or ingenious they might be. To skilled stockers, like Michael Gumpf, the introduction of Blanchard's machinery not only threatened to bastardize the art but also to lower monthly wages. Indeed, the very idea of becoming a mere tender of machines seemed demeaning. Confronted with these sentiments, Stubblefield steered clear of potential strife by maintaining strict silence concerning the adoption of Blanchard's improvements. Consequently the decision to install a complete set of stocking machinery was not made until Lee temporarily replaced Stubblefield as acting superintendent at Harpers Ferry in 1827.[43] In this case as in others, persons not permanently associated with the armory had to assume responsibility for introducing new mechanical techniques.

The reluctance to utilize Blanchard's machinery offers only one of many instances when the armory failed to avail itself of basic technical innovations. Another striking example was provided by the use of trip hammers to weld gun barrels. Although introduced by Asa Waters in 1808 and widely adopted by New England arms makers soon thereafter, over twenty-five years elapsed before similar water-powered equipment replaced less reliable hand-welding methods at Harpers Ferry.[44]

At least two factors help to account for this delay. First, tradition-bound artisans, such as George Malleory and George Zorger, tended to associate the introduction of laborsaving machinery with visionary schemes and charlatanism. Since these older men frequently held supervisory positions with the armory, their disenchantment with novelties influenced less skilled members of the labor force and fostered a curious sort of technological conservatism at Harpers Ferry. Second, close-knit kinship groups in and around the armory betrayed inbred

prejudices that held outsiders suspect and outside ideas alien
to customary practices. In 1816, for instance, superintendent
Stubblefield refused employment to an eminently qualified
German machinist for the simple reason that he was "a forener
and a Stranger."[45]

Over the years no one had more frustrating confrontations
with this attitude than Roswell Lee. On numerous occasions
he sent workmen to Harpers Ferry only to learn upon their return
to Springfield that they had been poorly treated by both the
townspeople and the armorers.[46] Even John H. Hall, a trans-
planted New Englander whose work with interchangeable parts
received widespread recognition during the 1820s and 1830s,
found himself ostracized by well-to-do members of society at
Harpers Ferry. To Stubblefield, Hall epitomized the money-
grubbing, opportunistic Yankee adventurer who "has not only
his hand, but his arm up to the shoulder (as the common phrase
is) in Uncle Sam's purse."[47]

Resentment of the man carried over to a denigration of his
machines.[48] Despite the fact that Hall's rifle factory stood
adjacent to the Harpers Ferry armory, few, if any, of his
innovations for forging, cutting, and gauging materials were
adopted at the latter establishment until the early 1840s. Prior
to that time the armory floundered in a mire of administrative
confusion, unable to close the technological gap between it
and the New England branch of the firearms industry. Upon
visiting the premises in 1832, a representative of the Ordnance
Department reported that "this armory is far behind the state of
manufacture elsewhere and the good quality of their work is
effected, at great disadvantage, by manual labor." Contrasting
Springfield with Harpers Ferry, he noted that "there is so little
machinery at the latter place that no fair comparison of prices
can be made." Four years later the same officer detected "a
great advance . . . in the introduction of new machinery."
"Nevertheless," he added, "much remains to be done to bring it
up to the point at which Springfield stood" in 1832.[49]

The person who ultimately presided over the transition from
craft to machine production at Harpers Ferry was Benjamin Moor,
a highly regarded and well-traveled alumnus of the Springfield
armory, who succeeded Armistead Beckham as master armorer in

May 1830. Upon his arrival from the Allegheny arsenal in
Pittsburgh, Moor found the armory in a "dilapidated state,"
the town inhospitable, and its inhabitants backward and
provincial. "Every way considered," he confided to a friend,
"there are customs and habits so interwoven with the very
fibers of things as in some respects to be almost hopelessly
remitless."[50] Confronted with ramshackle facilities, outmoded
techniques, and an undisciplined labor force, Moor recognized
the need for sweeping organizational changes. Most pressing
of all, in his opinion, was the need for complete mechanical
renovation. But burdened with the duties unfulfilled by an
absentee superintendent and beset with other responsibilities
imposed by the Ordnance Department, he found little time to
devote to these matters before 1838.[51]

Moor's commitment to the new technology exasperated
recalcitrant older artisans who branded him as "nothing more
than a theorist, with his head crammed full of whims, yankey
notions and useless machinery."[52] Yet, amid growls of humbug
and accusations of chicanery, he methodically proceeded to
strip the workshops of obsolete tools and machinery and replace
them with more up-to-date equipment embracing the entire process
of arms making. With the aid of newly recruited machinists such
as William Apsey, he succeeded in retooling the armory for
interchangeable manufacture by 1846. Considering the inherent
difficulties as well as the extent of the undertaking, the end
result denoted a truly impressive achievement.[53] Equally
impressive was the manner in which he carried the project
through to completion.

Although Moor undoubtedly made some inventive contributions
to the new stable of machinery erected at Harpers Ferry during
the 1830s and 1840s, his masterful ability to draw upon the
innovations of others and mold them into a workable system of
production overshadowed his aptitude as a machinist. Simeon
North, John H. Hall, and Thomas Warner had already applied
machinery to the manufacture of interchangeable firearms, and
Moor had the good sense to discern that much time, effort, and
expense could be saved by taking advantage of their improve-
ments. Hence, with encouragement and support from the Ordnance
Department, he proceeded to tap these sources of know-how.

From Hall, for example, he borrowed a sophisticated method
of gauging components and adapted it to the manufacture of
common muskets and rifles.[54] In like manner, he began sending
observers northward with instructions to scour the countryside
in search of useful mechanical improvements and other informa-
tion relevant to the manufacture of interchangeable parts.

The effort paid handsome dividends. Armory representatives
visited almost every important armory and machine shop in
New England. Without fail their primary rendezvous was the
Springfield armory.[55] There they examined machinery, compared
notes, and discussed common problems with such master mechanics
as Cyrus Buckland and Thomas Warner. After satisfying their
curiosity and determining their needs, they set out for other
manufacturing establishments where they either placed orders
for machinery or, if the job could be done at Harpers Ferry,
obtained drawings, patterns, and specifications to take back
to Virginia. All told, these excursions accounted for the
installation of well over 150 machines at Harpers Ferry between
1838 and 1854.[56] Covering a broad spectrum of mechanical
types, these machines revealed the extent to which Yankee
know-how had attenuated craft traditions at the government works.

When Benjamin Moor surrendered the duties of master armorer
in 1849, the physical facilities at Harpers Ferry contrasted
sharply with those he had encountered nineteen years earlier.
New, more spacious brick buildings had replaced earlier jerry-
built structures. Neatly situated along paved streets and
landscaped terraces, they completely altered the armory's
appearance. Within these shops could be heard the chattering
of machines that infinitely lightened the burdens of hand labor.
Men who formerly wielded hammers, cold chisels, and files
now stood by animated mechanical devices putting in and taking
out work, measuring finished dimensions against precision
gauges, and occasionally making necessary adjustments. Slowly
but perceptively the world of the craftsman was yielding to the
world of the mechanic.

At the same time younger men began to replace older artisans
as foremen, inspectors, and supervisors. Whether recruited or
trained during Moor's sojourn in office, they came primarily from
non-craft-oriented backgrounds and exhibited characteristics

that seemed strange and alien to elderly workmen like George
Zorger. Typical in this respect was James Henry Burton, a
native Virginian who came to Harpers Ferry in 1844 from a
Baltimore machine shop. In less than three years Burton moved
from machinist to foreman to inspector and, in November 1849,
succeeded Benjamin Moor as acting master armorer.[57] Although
they scaled the ladder of preferment at a slower pace, Armistead
M. Ball, Thomas K. Laley, and Jerome B. Young followed similar
patterns of development. Together they represented a new
generation of gifted master mechanics who carried on where
Moor left off. By 1854 they had placed Harpers Ferry on a more
or less equal technical footing with her sister armories in
New England.[58]

Even though mechanization took command during the 1840s,
it is noteworthy that old habits and preferences never completely
disappeared among certain members of the labor force. Indeed,
having dominated for well over thirty years, the craft ethos
continued to linger at Harpers Ferry until the Civil War. This is
particularly apparent in the quality and style of the Model 1841
rifle (Fig. 10), the most aesthetically appealing weapon to be
made at Harpers Ferry since the days of Joseph Perkin. Designed
under the supervision of Benjamin Moor and gauged for inter-
changeable manufacture, it bore a much closer resemblance to
the common military musket than to the classic Model 1803
rifle (Fig. 1).[59] Nonetheless traces of the old could still be
found in its .54-inch caliber, brass furniture, and large brass
patch box. That local residents recognized this affinity is
indicated by the fact that they dubbed it the Yaeger rifle, a term
of Germanic origin commonly used by Pennsylvania and Maryland
gunsmiths when referring to their handiwork.[60] Fourteen years
later the weight of tradition became fainter as a new pattern
rifle replaced Moor's model at Harpers Ferry (Fig. 11). Reflecting
similar though less pronounced influences, it retained the use of
brass mounting even though the bore of the barrel was enlarged
to .58 caliber. When finally perfected in 1859, iron fixtures
replaced those formerly made of brass. All that remained of the
bygone style was a small iron patch box that served little or no
functional purpose.

Just as decorative details on Harpers Ferry rifles became

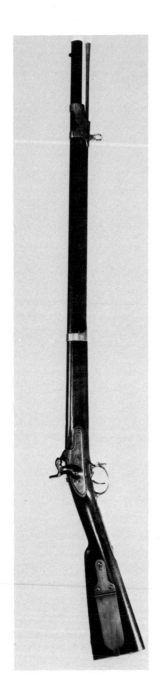

Fig. 10. U.S. pattern rifle, Model 1841. Lockplate marked "Harpers Ferry 1841." 54 caliber; L. 49". (Military Service Institute Collection, Smithsonian Institution.)

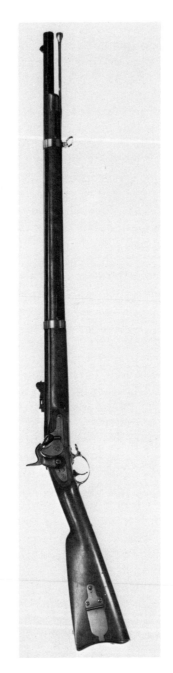

Fig. 11. U.S. pattern rifle, Model 1855. Lockplate marked "Harpers Ferry 1856." 58 caliber; L. 49". (War Department Collection, Smithsonian Institution.)

more superficial with the passage of time, so too did craft influences. It would be erroneous, however, to conclude that armorers of the old school simply shed their habits and assimilated the new machine technology straightway. In fact, as the pace of mechanization quickened during the late 1830s, a growing number of workmen became increasingly restive about the changes taking place. Some opposed the system out of mere cantankerousness and personal animosity against Moor. Others feared that they might be left jobless or, at best, face reductions in wages. Still others voiced concern over the threat to personal freedom they felt certain would ensue from the appointment in 1841 of an army officer as superintendent. Although Colonel Bomford attempted to allay these anxieties, the issue was joined on March 21, 1842, when the entire labor force, led by pieceworkers, walked off the job in protest over the installation of a clock and the establishment of a ten-hour day.[61]

To armorers long accustomed to coming and going from work whenever they pleased, the idea of a clocked day not only seemed repugnant but was an outrageous insult to their pride and respectability as dependable men. As the person primarily responsible for its introduction held the rank of major in the Ordnance Department, the clock reinforced already irritated feelings about the pernicious influence of outsiders--particularly military men--at Harpers Ferry. Moreover its ineluctable cadence served to emphasize the rigorous discipline, regularity, and specialization so often associated with the coming of the machine. In this sense, the clock not only kept time but also symbolically deprived armorers of the satisfaction of traditional craftwork. Every minute had to be accounted for, and each accounting fostered further discontent.[62]

The "clock strike" of 1842 represented an emotion-laden response to the consequences of rationalization, part and parcel of which was the introduction of laborsaving machinery. At no point, however, did Luddite impulses gain ascendancy; nor, for that matter, did the strikers resort to any form of physical violence. Yet, despite (or perhaps because of) their restraint, they utterly failed to wring any concessions from authorities in Washington. Other than promising that no retaliatory measures

would be taken against the "instigators and fomentors of the
outbreak," President John Tyler told them to "go home and
hammer out their own salvation."[63] This they did, but their
feelings about the system under which they worked did not
change substantially. Between 1842 and 1854 armorers at
Harpers Ferry learned to tolerate the machine but little more.

It is evident that the transition from craft to machine
production followed a long and circuitous path at Harpers Ferry.
From the armory's establishment in 1798 to roughly 1815, skilled
artisans plied their trade with little variation from familiar
techniques. Unmolested by higher authorities in Washington,
they also entrenched themselves in supervisory positions and,
as a result, virtually dominated every aspect of armory business.
Whether they came from the gun trade of Birmingham, the
arsenals of Deptford, or small country shops in Pennsylvania
and Maryland, these men were steeped in craft traditions, and
the early arms they fashioned clearly mirrored this influence.
Consequently when an engineering-oriented Ordnance Department
sought to introduce more uniformly made firearms based on
precision-machining techniques, managers as well as workmen
viewed the idea with suspicion. At no time between 1815 and
1830 did they participate energetically in the development of
novel manufacturing methods. Rather, the impetus to technolog-
ical change was provided by outsiders such as Roswell Lee,
Sylvester Nash, and Thomas Blanchard. Not until Benjamin
Moor and a younger breed of mechanics successfully retooled
the factory for interchangeable manufacture during the 1840s
did the basic stages of production begin to assume a decidedly
different character. Even then proponents of the system encoun-
tered much difficulty in inducing workmen to form new habits; and
notwithstanding the fact that functional emphases gradually
supplanted decorative details in weapons design, the lingering
influence of craft traditions continued to be felt well into the
1850s.

It is somewhat ironic that, upon touring the country in
1854, a team of British investigators extolled "the extreme
desire manifested by masters and workmen to adopt all labour-
saving appliances" and ranked Harpers Ferry among the five most
progressive factories of its type in the United States.[64] Little

did they appreciate the difficulties that accompanied the
adoption and acceptance of new techniques at the national
armory. Given the natural desire of factory managers to put
their best foot forward in the presence of foreign visitors, one
cannot help but wonder just how accurate similar assessments
of other manufacturing establishments were. Except for the
transient testimony of European observers, surprisingly little
is known about this aspect of industrialization. For example,
nothing is known about worker response to the mechanization
of clockmaking. The fact that interchangeable construction
of both clocks and firearms first flowered in New England
suggests that regional variations in customs and values had
much to do with the rapidity with which new techniques were
incorporated into the productive process. Yet, until more
research is conducted along these lines, oft-repeated statements
about the eagerness with which factory hands embraced the new
technology must remain tenuous.

NOTES

1. Roswell Lee to Col. Decius Wadsworth, Dec. 24, 1816, Letters Received, Record Group 156, Records of the Office of the Chief of Ordnance, National Archives, Washington, D.C. (hereafter RG 156, OCO); Bernard C. Steiner, The Life and Correspondence of James McHenry (Cleveland, Ohio: Burrows Brothers Co., 1907), pp. 401-2.

2. Joseph Williams to Samuel Hodgdon, Feb. 4, 1799, Hodgdon-Pickering Correspondence, Record Group 94, Records of the Adjutant General's Office, National Archives, Washington, D.C. (hereafter RG 94, AGO).

3. John Strode to Henry Dearborn, Feb. 12, 1807, Letters Received (Main Series), Record Group 107, Records of the Office of the Secretary of War, National Archives, Washington, D.C. (hereafter RG 107, OSW); Joseph Barry, The Strange Story of Harper's Ferry (3d ed.; Shepherdstown, W. Va.: Shepherdstown Register, 1959), pp. 15-16; Millard K. Bushong, A History of Jefferson County, West Virginia (Charlestown, W. Va.: Jefferson Publishing Co., 1941), pp. 56-57.

4. Perkin to Samuel Hodgdon, Jan. 5, 1793, Seth B. Wigginton to Hodgdon, Aug. 10, 1797, Hodgdon-Pickering Correspondence, RG 94, AGO; William Simmons to John Mackey, Dec. 20, 1799, Letter Book F, First Auditor's Accounts, Record Group 217, Records of the U.S. General Accounting Office, National Archives, Washington, D.C. (hereafter RG 217, GAO); Accountant's Office, War Department, Letter Book G, p. 63, First Auditor's Accounts, RG 217, GAO; John G. W. Dillin, The Kentucky Rifle (4th ed.; York, Pa.: Trimmer Printing, 1959), p. 149; Henry J. Kauffman, The Pennsylvania-Kentucky Rifle (Harrisburg, Pa.: Stackpole Books, 1960), p. 319.

5. Miles to Samuel Hodgdon, July 21, 1794, Hodgdon-Pickering Correspondence, RG 94, AGO.

6. Joseph Perkin to Samuel Hodgdon, Apr. 27, 1794, Armorers' Rough Articles, Nov. 22, 1798, Hodgdon-Pickering Correspondence, RG 94, AGO; William Simmons to John Mackey, Dec. 20, 1799, Letter Book F, First Auditor's Accounts, RG 217, GAO.

7. William Simmons to John Mackey, Dec. 20, 1799, Letter

Book F, First Auditor's Accounts, RG 217, GAO; Samuel Hodgdon to Samuel Annin, Sept. 1, 1800, Letters Sent by Samuel Hodgdon, Record Group 92, Records of the Office of the Quartermaster General, National Archives, Washington, D.C. (hereafter RG 92, OQG); Hodgdon to Annin, Oct. 10, 1800, Letters Sent by Samuel Hodgdon, RG 92, OQG; Henry Dearborn to Joseph Perkin, May 20, 1801, Dearborn to Perkin, June 2, 1801, Misc. Letters Sent, RG 107, OSW; James Greer to Col. Decius Wadsworth, Sept. 24, 1818, Letters Received, RG 156, OCO; Kauffman, Pennsylvania-Kentucky Rifle, p. 319; Arcadi Gluckman and L. D. Saterlee, American Gun Makers (Harrisburg, Pa.: Stackpole Co., 1953), p. 8; Robert E. Gardner, Small Arms Makers (New York: Bonanza Books, 1963), p. 7.

8. Payrolls and Accounts of Lloyd Beall, Harpers Ferry Armory, 1816, Second Auditor's Accounts, RG 217, GAO.

9. The four Pennsylvania-Maryland trained foremen were John Strickland, Frederick Oswan, John Resor, and Alexander Taylor. The fifth was George Malleory, the son of one of the New London armorers who accompanied Joseph Perkin to Harpers Ferry in 1798 and a product of the armory's apprentice system. See George Malleory to Henry Clay, Jan. 18, 1841, Letters Received, RG 156, OCO.

10. James Stubblefield to Henry Dearborn, June 20, 1808, "Friend" to William Eustis, July 26, 1809, Letters Received (Main Series), RG 107, OSW; William Simmons to Samuel Annin, Oct. 30, 1810, Letter Book Q, First Auditor's Accounts, RG 217, GAO; Stubblefield to Col. George Bomford, Apr. 7, 1815, Stubblefield to Bomford, Aug. 6, 1816, Letters Received, RG 156, OCO; Payrolls and Accounts of Lloyd Beall, Harpers Ferry Armory, 1816-17, Payrolls and Accounts of William McGuire, Harpers Ferry Armory, 1817-18, Second Auditor's Accounts, RG 217, GAO; Nahum W. Patch to Bomford, Jan. 25, 1826, Stubblefield to Bomford, July 11, 1829, Letters Received, RG 156, OCO; "Proceedings of a Board of Officers: Inspection of Harpers Ferry Armory, February 5 to 22, 1842," Special File, Reports of Inspections of Arsenals and Depots, RG 156, OCO; Martin Breitenbaugh to Col. George Talcott, Apr. 15, 1845, Letters Received, RG 156, OCO; Joe Kindig, Jr., Thoughts on the Kentucky Rifle in Its Golden Age (Wilmington, Del.: George N.

Hyatt, 1960), pp. 51, 286, 337–38; Henry J. Kauffman, Early American Gunsmiths, 1650–1850 (Harrisburg, Pa.: Stackpole Co., 1952), pp. xii–xiii, 12; Kauffman, Pennsylvania-Kentucky Rifle, pp. 246–48, 274, 329–31, 359–60, 367; Gluckman and Saterlee, American Gun Makers, p. 90.

11. George Malleory to Henry Clay, Jan. 18, 1841, Letters Received, RG 156, OCO; Col. George Bomford to Lewis Cass, July 2, 1836, Letters Sent to the Secretary of War, RG 156, OCO.

12. With Joseph Perkin's death in December 1806, Secretary of War Henry Dearborn offered the superintendency at Harpers Ferry to Eli Whitney of New Haven, Connecticut. When Whitney declined, Dearborn chose James Stubblefield, a gunsmith-planter from Stevensburg, Virginia. Stubblefield assumed command at Harpers Ferry on May 14, 1807, and continued as superintendent of the government works until Aug. 1, 1829.

13. Avis to Col. George Bomford, June 7, 1816, James Stubblefield to Bomford, July 11, 1816, Avis to Bomford, July 18, 1816, Letters Received, RG 156, OCO.

14. For a description of the inside contracting system, see Felicia J. Deyrup, "Arms Makers of the Connecticut Valley," Smith College Studies in History 13 (1948): 101.

15. Payrolls and Accounts of Lloyd Beall, Harpers Ferry Armory, 1816–17, Second Auditor's Accounts, RG 217, GAO; "Proceedings of a Board of Officers," Feb. 1842, Special File, Reports of Inspections of Arsenals and Depots, RG 156, OCO.

16. American State Papers: Military Affairs, 1:199; Henry Dearborn to Joseph Perkin, May 23, 1806, Misc. Letters Sent, RG 107, OSW.

17. Henry Dearborn to Joseph Perkin, May 25, 1803, quoted in James E. Hicks, Notes on United States Ordnance, 2 vols. (Mt. Vernon, N.Y.: by the author, 1940), 1:25; Perkin to Dearborn, June 6, 1803, Registers of Letters Received, RG 107, OSW; Dearborn to Perkin, Dec. 2, 1803, Misc. Letters Sent, RG 107, OSW; Perkin to Dearborn, Mar. 6, 1804, Registers of Letters Received, RG 107, OSW; Dillin, Kentucky Rifle, p. 107, pl. 24.

18. Kindig, Thoughts on the Kentucky Rifle, pp. 10–11; Deyrup, Arms Makers, pp. 19–21.

19. James Stubblefield to Henry Dearborn, Sept. 8, 1807,

Stubblefield to Dearborn, Oct. 1807, Letters Received (Main
Series), RG 107, OSW; Stubblefield to Col. George Bomford,
July 11, 1829, Letters Received, RG 156, OCO.

20. U.S., Statutes at Large, 3:204.

21. Wadsworth to Secretary of War, Aug. 8, 1812, Letters
Sent to the Secretary of War, RG 156, OCO.

22. For biographical information on Bomford, Chief of
Ordnance from June 1, 1821 to Feb. 1, 1842, see Military
Service Histories of Ordnance Officers, RG 156, OCO; Corra
Bacon-Foster, "The Story of Kalorama," Records of the Columbia
Historical Society 13 (1910): 98-118; G. W. Cullum, Biographical
Register of the Officers and Graduates of the U.S. Military
Academy, 6 vols. (New York: Houghton, Mifflin and Co., 1891),
1:58-59.

23. Wadsworth to Bomford, May 15, 1815, June 13, 1815,
Special File, Correspondence Relating to Inventions, RG 156, OCO.

24. Roswell Lee to James Stubblefield, Aug. 6, 1816, Lee to
Asa Waters, June 8, 1819, Letters Sent, Record Group 156,
Springfield Armory Records, National Archives, Washington, D.C.
(hereafter RG 156, SAR).

25. American State Papers: Military Affairs, 2:553.

26. Lee to Senior Officer of Ordnance, Nov. 20, 1817,
Letters Received, RG 156, OCO.

27. See, for example, Bomford to Roswell Lee, Sept. 3,
1821, Letters Sent, RG 156, OCO; Lee to Bomford, Sept. 11,
1821, Letters Sent, RG 156, SAR; Bomford to Lee, Sept. 21, 1821,
Letters Sent, RG 156, OCO.

28. Stubblefield to Bomford, July 11, 1829, Letters Received,
RG 156, OCO; Bomford to Stubblefield, Sept. 16, 1829, Letters
Sent, RG 156, OCO.

29. Payrolls and Accounts of Lloyd Beall, Harpers Ferry
Armory, 1816, Second Auditor's Accounts, RG 217, GAO.

30. John Strode to Henry Dearborn, Feb. 27, 1807, "Friend"
to William Eustis, July 26, 1809, Letters Received (Main Series),
RG 107, OSW.

31. Lee to Stubblefield, Nov. 4, 1815, Letters Sent,
RG 156, SAR; Stubblefield to Lee, Nov. 22, 1815, Letters Received,
RG 156, SAR.

32. Stubblefield to Lee, Feb. 28, 1817, Letters Received,

RG 156, SAR; Payrolls and Accounts of Lloyd Beall, Harpers
Ferry Armory, 1816-17, Second Auditor's Accounts, RG 217,
GAO; Stubblefield to Lee, Dec. 4, 1817, Letters Received,
RG 156, SAR; Stubblefield to Bomford, Feb. 28, 1818, Letters
Received, RG 156, OCO.

33. Patent specifications of Sylvester Nash, Harpers Ferry,
Apr. 11, 1818, Restored Patents, vol. 4, Record Group 241,
Records of the Patent Office, National Archives, Washington,
D.C. (hereafter RG 241, PO); Sylvester Nash, "Turning Musket
Barrels," Apr. 11, 1818, Restored Patent Drawings, RG 241, PO.

34. Asa H. Waters, "Thomas Blanchard, the Inventor,"
Harper's New Monthly Magazine 63, no. 374 (July 1881): 255.

35. Lee to Stubblefield, July 11, 1818, Letters Sent,
RG 156, SAR; Blanchard to Lee, June 2, 1818, Letters Received,
RG 156, SAR.

36. Blanchard to Lee, Oct. 13, 1818, Letters Received,
RG 156, SAR.

37. Stubblefield to Wadsworth, Sept. 30, 1818, Special
File, Correspondence and Reports Relating to Experiments,
RG 156, OCO; Wadsworth to Stubblefield, Oct. 7, 1818, Letters
Sent, RG 156, OCO; Stubblefield to Lee, Oct. 16, 1818, Letters
Received, RG 156, SAR.

38. Waters, "Thomas Blanchard," p. 255; Asa H. Waters,
Biographical Sketch of Thomas Blanchard and His Inventions
(Worcester, Mass.: Lucius P. Goddard, 1878), p. 7.

39. Blanchard to Lee, Feb. 5, 1819, Stubblefield to Lee,
Apr. 17, 1819, Letters Received, RG 156, SAR; Waters,
Biographical Sketch of Thomas Blanchard, pp. 7-9.

40. Stubblefield to Wadsworth, May 31, 1819, Special
File, Correspondence Relating to Experiments, RG 156, OCO.

41. Patent specifications of Thomas Blanchard, Jan. 20,
1820, Special File, Correspondence Relating to Inventions,
RG 156, OCO; Thomas Blanchard, "Turning Irregular Forms,"
Sept. 6, 1819, Restored Patent Drawings, RG 241, PO.

42. Blanchard to Capt. William Wade, Nov. 9, 1823,
RG 156, OCO; Thomas Blanchard, Feb. 1, 1828, Contract Book,
no. 1, pp. 321-23, RG 156, OCO.

43. Blanchard to Ordnance Department, Jan. 19, 1827,
Blanchard to Wade, May 25, 1827, Letters Received, RG 156,

OCO; Lee to Stubblefield, June 25, Sept. 11, 1827, Letters Sent, RG 156, SAR; Stubblefield to Lee, Sept. 14, 1827, Letters Received, RG 156, SAR; Bomford to George Rust, Jr., Nov. 3, 1830, Letters Sent, RG 156, OCO.

44. Waters to John C. Calhoun, Oct. 10, 1817, Special File, Correspondence Relating to Inventions, RG 156, OCO; Jonathan Leonard to Roswell Lee, June 26, 1818, Letters Received, RG 156, SAR; Charles S. Leonard, July 30, 1818, Letters Received, RG 156, OCO; Edward Lucas, Jr., to Col. George Talcott, Jan. 20, Mar. 19, 1840, Letters Received, RG 156, OCO.

45. Stubblefield to Bomford, Nov. 13, 1816, Letters Received, RG 156, OCO.

46. See, for example, Lee to Stubblefield, Mar. 22, 1817, Letters Sent, RG 156, SAR; James Carrington to Lee, Oct. 31, 1822, Letters Received, RG 156, SAR.

47. "A Mechanic" (Stubblefield) to Members of the Senate and House of Representatives, Apr. 12, 1830, Letters Received, RG 156, OCO; Hall to Mary Hall, Jan. 27, 1821, Hall-Marmion Letters, Harpers Ferry National Historical Park, Harpers Ferry, W. Va.

48. Edward Lucas, Jr., to John Cocke, Jan. 15, 1827, Stubblefield to Bomford, July 11, 1829, Letters Received, RG 156, OCO.

49. Maj. George Talcott, Inspection of the Harpers Ferry Armory, Dec. 15, 1832, Special File, Reports of Inspections of Arsenals and Depots, RG 156, OCO; Talcott and Maj. Henry K. Craig to Secretary of War, Apr. 9, 1833, Special File, Reports and Correspondence of Ordnance Boards, RG 156, OCO; Talcott, Inspection of the Harpers Ferry Armory, July 17-25, 1835, Special File, Reports of Inspections of Arsenals and Depots, RG 156, OCO.

50. Moor to Maj. Rufus L. Baker, May 5, 1831, Letters Received, Record Group 156, Allegheny Arsenal Records, National Archives, Washington, D.C.; Memorial of Benjamin Moor, n.d. (1837), Petitions for Compensation, 32A-H13.1, Record Group 46, Records of the U.S. Senate, National Archives, Washington, D.C.

51. Moor to Bomford, Sept. 29, 1830, June 25, 1831, Letters Received, RG 156, OCO; George Rust, Jr., to Bomford,

Mar. 3, 1832, Letters Received, RG 156, OCO; Maj. George Talcott and Maj. Henry K. Craig to Secretary of War, Apr. 9, 1833, Special File, Reports and Correspondence of Ordnance Boards, RG 156, OCO; Talcott, Inspection of the Harpers Ferry Armory, July 17-25, 1835, Special File, Reports of Inspections of Arsenals and Depots, RG 156, OCO.

52. Anon. (Carey Thompson) to War Department, June 27, 1841, Letters Received, RG 156, OCO.

53. James H. Burton to Charles H. Fitch, Nov. 27, 1882, Burton Papers, Yale University, New Haven, Conn. (hereafter YU).

54. Charles H. Fitch, "The Rise of a Mechanical Ideal," Magazine of American History 11, no. 6 (June 1884): 523.

55. See, for example, Maj. John Symington to Moor, Dec. 17, 1845, Second Auditor's Accounts, acct. no. 3502, RG 217, GAO.

56. Payrolls and Accounts of Richard Parker, Harpers Ferry Armory, 1839-47, Payrolls and Accounts of Edward Lucas, Jr., Harpers Ferry Armory, 1848-52, Second Auditor's Accounts, RG 217, GAO; Col. Henry K. Craig to John B. Floyd, Feb. 9, 1859, Letters Sent to the Secretary of War, RG 156, OCO.

57. Maj. John Symington to Burton, Apr. 20, 1846, Nov. 13, 1849; James H. Burton (1823-93), Obituary Notice, Oct. 19, 1894, Burton Papers, YU.

58. Payrolls and Accounts of Daniel Bedinger, Harpers Ferry Armory, 1830-38, Payrolls and Accounts of Richard Parker, Harpers Ferry Armory, 1839-47, Second Auditor's Accounts, RG 217, GAO; "Proceedings of a Board of Officers," Feb. 1842, Special File, Reports of Inspections of Arsenals and Depots, RG 156, OCO; Payrolls and Accounts of Edward Lucas, Jr., Harpers Ferry Armory, 1848-52, Second Auditor's Accounts, RG 217, GAO.

59. See, for example, Moor to Edward Lucas, Jr., Mar. 7, 1839, Correspondence and Reports Relating to Experiments, RG 156, OCO; Moor to Col. George Talcott, Dec. 31, 1840, Letters Received, RG 156, OCO.

60. Stuart E. Brown, Jr., The Guns of Harpers Ferry (Berryville, Va.: Virginia Book Co., 1968), p. 93; Robert M. Reilly, United States Military Small Arms, 1816-1865 (Baton Rouge, La.: Eagle Press, 1970), p. 35.

61. Col. Bomford to John C. Spencer, Dec. 20, 1841, Letters Sent to the Secretary of War, RG 156, OCO; "Proceedings of a Board of Officers," Feb. 1842, Special File, Reports of Inspections of Arsenals and Depots, RG 156, OCO; Talcott to Spencer, Mar. 11, 1842, Letters Sent to the Secretary of War, RG 156, OCO; Maj. Henry K. Craig to Talcott, Mar. 21, 22, 1842, Talcott to Spencer, May 17, 1842, Letters Received, RG 156, OCO.

62. Col. George Talcott to John C. Spencer, May 17, 1842, Maj. John Symington to Capt. William Maynadier, July 12, 1849, Letters Received, RG 156, OCO.

63. Maj. Henry K. Craig to Col. George Talcott, Mar. 21, 1842, Craig to John C. Spencer, Mar. 28, 1842, Craig to Talcott, Apr. 1, 1842, Letters Received, RG 156, OCO; Barry, The Strange Story of Harper's Ferry, p. 32.

64. Great Britain, House of Commons, "Report of the Committee on the Machinery of the United States of America," British Sessional Papers 50 (1854-55): 32; Nathan Rosenberg, ed., The American System of Manufactures (Edinburgh: Edinburgh University Press, 1969), pp. 128, 204, 387-88.

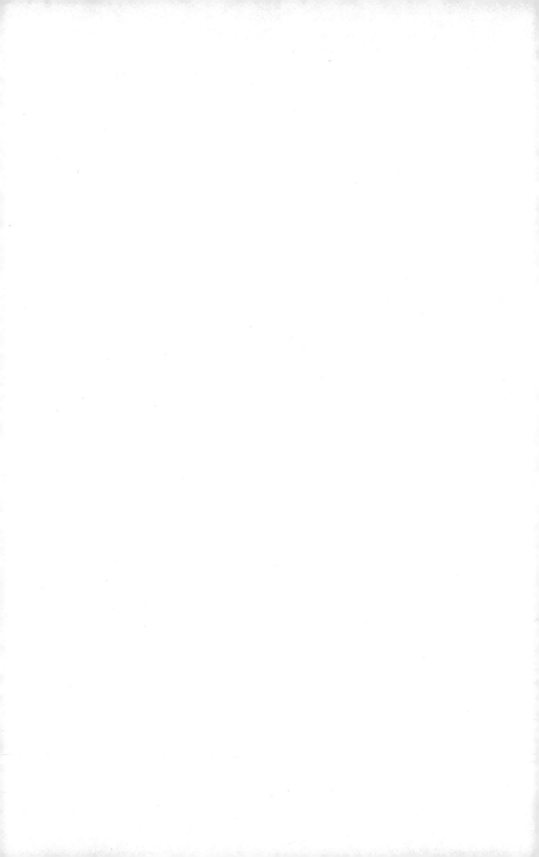

TECHNOLOGICAL DEVELOPMENT: AGENT OF CHANGE IN STYLE AND FORM OF DOMESTIC IRON CASTINGS

John D. Tyler

IN these times of intense interest in the artifacts of early American life, cast ironwares have not been given due consideration. This has not kept early pots, kettles, and stoves from becoming "collectibles," and the number available now is markedly slimmer than that of several years past. We tend to use the terms pot and kettle interchangeably today, but there is a basic difference between the two. Samuel Johnson's 1755 dictionary says: "In the kitchen the name of POT is given to the boiler that grows narrower towards the top, and of KETTLE to that which grows wider."[1] In view of the fact that few persons make any distinction between pot or kettle, English or American, it may be worthwhile to consider the technology of hollow ware manufacture and to explore the relationship of technological change to form and decoration. Did form influence technology? What changes were wrought by new innovations in manufacturing methods?

There were more problems involved in casting a pot than a kettle. The bulbous form of a pot meant that the mold had to be broken or split in half to remove the finished product. The body of a kettle could be cast in one piece simply by using an existing kettle as a pattern. Early pots were cast in molds of baked or fire-dried loam. At the completion of a cast, the core and ear molds had to be destroyed to free the pot from the mold, necessitating the renewal of a lengthy process in order to cast others.

The loam-molding process began with winding of rope or cord around a tapered spindle. When the rope had been built up to approximately the form of the pot's interior dimensions, the form was given a coat of moist loam or clay; shaved with a rotating wooden sweep pattern, or template, to the exact

shape required; baked; dusted with charcoal to prevent the
next layer from sticking; and coated with a second layer of
loam or clay. This second layer formed the actual wall
thickness of the vessel. It was shaped by the sweep
pattern, baked, dusted, and yet a third layer was applied in
the same fashion. At some time, probably prior to baking,
the third layer was split in half lengthwise as neatly as
possible. When the outer layer was removed and the inner
(second layer) scraped away, a cavity was left for the molten
iron. The spindle was removed and the hole it left in the
core was plugged and smoothed over with charcoal dust,
called blacking. The core, consisting of the rope and loam,
was then placed bottom up on a board. Feet and ear molds
were attached to the two halves of the outer mold, which was
then reunited around the core. The hole left in the outer
mold by the removal of the spindle served as a sprue, or
opening where the molten metal could be poured into the
mold.[2] This method involved the destruction of at least the
core, if not other parts of the mold, in order to remove the
finished pot. It was a very laborious and time-consuming
process.

Iron pots were cast in this fashion until Abraham Darby
began casting pots by an improved method in Shropshire
during the first decade of the eighteenth century. Loam-
molded vessels have a distinctive vertical seam running from
the rim down the side, under the bottom, and back to the rim
on the opposite side. This is the mark left by the two halves
of the mold. The distinctive round projection of the sprue
is also the mark of this type of early casting technique
(Fig. 1). However, the sprue appears to have been used
with later techniques, and when found on later pots it may
merely indicate the founder's preference for it over the gate,
an elongated narrow slot used from the mid-eighteenth century
on for the admission of molten iron to the mold.

The forms of early pots in both cast iron and bronze
followed similar trends in style. The earliest examples of
the fifteenth and sixteenth centuries tend to be spherical,
with round ears very much like those found on pots made late
in the nineteenth century. They had narrow lipped openings

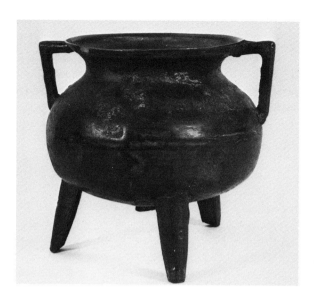

Fig. 1. Pot, probably England or Netherlands, 1600-1700. Bronze; H. 7 6/16", Diam. (rim) 6". Note traces of the vertical seam left by the two halves of the loam-mold process, indicative of pre-1707 casting procedures. Chamfered legs and angular ears also mark this as an early product. (Pennsylvania Historical and Museum Commission.)

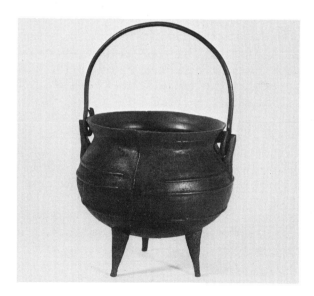

Fig. 2. Pot, probably England, 1750-1800. Cast iron; H. 6 1/2", Diam. (rim) 6 3/16". Note the triangular sectioned legs, more typical of English pots. A small sauce pot, this vessel has long legs to facilitate setting it over coals at one side of a cooking fire. Length of pot legs bears no relation to age or provenance and is merely a function of use. (Pennsylvania Historical and Museum Commission.)

and faceted legs. As time went on the largest part of the
vessel moved toward the bottom, the lip was widened, and
the pot resembled a pouch or bag.[3] A pot of this description
is illustrated in J. Seymour Lindsay, Iron and Brass Implements
of the English and American House, and is ascribed to the
fifteenth century.[4]

Different areas of Europe developed variations in this
basic pot form, and it is possible to ascribe provenance
for some of these surviving early vessels on the basis of
form. Eighteenth-century English forms seem to have followed
the Dutch, possibly due to the large numbers of pots imported
from the Low Countries. Dutch pots had short legs, triangular
in section, often merely stumps to keep the vessel from over-
turning, and very little ornamentation. Bronze or brass pots
were being cast in sand molds by the seventeenth century.[5]
Comparison of the typical eighteenth-century English pot with
earlier Dutch examples reveals how much the English owed to
the Low Country product. There are the same angular ears for
the handle, the same chunky triangular feet, and the same
bulbous form with its widest section toward the center (Fig. 2).[6]

Cast ironware appears to have come into general use in
England during the sixteenth century. Guns were being cast,
and there were references to flat castings, such as firebacks
and graveslabs, as early as 1547.[7] Beginning with the
sixteenth century, there was a limited amount of pot founding,
but even as late as mid-seventeenth century most pots and
kettles in use were imported from the Low Countries. British
founders had not been successful in the casting of thin, light
vessels; their products tended to be thick and heavy.[8]
R. A. F. de Réaumur's remarks in 1722 that cast-iron pots
were not favored in France due to their weight and roughness,
coupled with the brittle nature of cast iron, applied to the
English product as well. Nevertheless poor folk, as noted by
Réaumur, used iron pots because they could not afford more
costly and elegant bronze or copper vessels.[9]

To this point our discussion has centered on loam-molded
ware. In the first decade of the eighteenth century Abraham
Darby perfected significant innovations that rendered this
method obsolete. Darby had been apprenticed to Jonathan

Freeth in the iron trade at Birmingham. When he left his
apprenticeship in 1699, he went to Bristol intending to
manufacture malt mills. In 1704 he went to Holland to study
Dutch methods of casting in brass and returned with some
workmen he hoped would be able to cast pots in iron using
the same techniques normally applied to casting brass pots.[10]

Upon Darby's return to England with the workmen, he
tried to have them cast iron pots in sand molds, but with no
success. As the legend goes, John Thomas, a man on trial
to learn the trade of malt-mill manufacture, had an idea which
he and Darby tried one day after all the other workers had gone
home. They were successful in casting a pot "in a mold of
fine sand with a two-part flask, and with air holes for the
escape of steam."[11]

It is not known exactly what Darby's method entailed, but
it seems certain that he used the dry sand method in conjunc-
tion with multipart casting boxes or flasks.[12] The multipart
flask solved the problem of removing the pot without destroying
the mold, and the use of dry sand prevented the generation of
steam when the molten iron came into contact with the mold
material. Possibly the Dutch were using damp sand and a
two-part flask for brass, and Darby, with Thomas, hit upon
the use of dry sand so that the higher temperatures of molten
iron would not cause the formation of steam. On April 18,
1707, Darby was granted patent number 380 for

> a new way of casting iron bellied pots, and other
> iron bellied ware in sand only, without loam or
> clay, by which iron pots, and other ware may be
> cast fine and with more ease and expedition than
> they can be by the way commonly used, and in
> regard to their cheapness may be of great advantage
> to the poor of this our kingdome, who for the most
> part use such ware, and in all probability will
> prevent the merchants off England going to foreign
> markets for such ware, from whence great quantities
> are imported.

Four points in the wording of this preamble to the patent should

be noted: (1) pots made in the new way were to be "fine,"
that is, cast light and smooth, (2) they were to be cheap due
to the ease of the new method and its rapidity, (3) until this
time it was mainly the poor who used cast ironwares, bearing
out Réaumur's statement, (4) and previously most ironware was
imported into England.

Darby's partners in the malt-mill works did not share his
enthusiasm for iron pots; so in 1709/10 he withdrew from the
business and went to Coalbrookdale in Shropshire, where he
set up as an ironmaster. The demand for pots was increasing,
foreign importation was becoming more difficult, and, in
short, it seemed a good time to begin the production of a
much-wanted article.

In his work at Bristol, Darby had used charcoal as a fuel;
in Shropshire he was close to supplies of coal. This location
plus his prior experience in malting, in which coke had been
used since the mid-seventeenth century for drying, probably
suggested the use of coked coal in the blast furnace at
Coalbrookdale. The furnace accounts indicate use of coke
from the beginning. It was burned much as charcoal in heaps,
and later it was made in kilns similar to those familiar to
Darby from his malting days. The pig iron smelted with coke,
rather than charcoal, was found to be hard and intractible in
the forge but was perfect for the casting of small ware. Iron
smelted with coke was very fluid due to the higher smelting
temperatures necessary in coke furnaces and made thin, smooth,
lightweight pots.

Between 1707 and 1709 Darby sold pots locally at county
fairs for cash. By 1718, with the Coalbrookdale works in full
operation, orders were taken at fairs for future delivery. The
largest customer for pots was the Champion family of Bristol.
They purchased several hundred pounds worth annually, most
of which they exported. By 1730 Nehemiah Champion was
placing orders in amounts of thirty tons at a time. The
Champions dealt with American ironmasters and sold small
amounts of American pig iron to English firms. Other whole-
salers also bought from Darby, and it seems reasonable to
assume that a large number of Darby pots found their way to
America through exportation by wholesale merchants. For a

time the market for badly needed ironwares took all Darby could produce. The pots and kettles that poured from the Coalbrookdale works filled the needs of people who could not afford brass or copper wares.

In appearance the Darby product must have been smooth-surfaced and much lighter in weight than earlier pots. They retained the vestigal sprue on the bottom. Sweep-shaped, loam-molded cores were in use at Coalbrookdale, and a "loom" house is mentioned in the accounts. The molding of cores in loam with a sweep necessitated the use of a spindle, hence the survival of the central sprue. The accounts also indicate that cores were baked and that sand and loam were used together in the casting process.[13]

For exact details of the process, we must turn to an account of pot casting at the famous Carron Ironworks in Scotland at a somewhat later date. In 1869 Carron was still casting pots by a method that was probably very close to Darby's. Patterns for the pots consisted of nine pieces: two for the body, three for the feet, and two each for the two ears. The body pattern was formed by taking a completed pot, stripping it of feet and ears, and carefully cutting it in half. A close study of eighteenth- and early nineteenth-century pots reveals that this was indeed the method used. A very fine seam will be found to run under the bottom, much like that found on loam-molded pots. The seam was smoothed over before casting so as to render it barely visible. The molder took the two halves, placed the edges together, and laid them bottom up on a bench. He next enclosed the two patterns in a circular casing that was then filled with sand. The sand was rammed down around and over the pattern, and the feet and ear patterns inserted. A wooden plug was inserted to form a sprue or gate where molten iron was admitted to the mold. The box was then turned over and the inside of the pattern filled with sand. The circular casing was a three-part affair. The upper section of the casing was removed, exposing the impression of the bottom of the pot. Next the two sides were removed, leaving the body pattern in the clear. The patterns were lifted off, exposing the core. This surface was dusted with fine powdered charcoal and rubbed smooth so that

the pot interior would be smooth. The feet and ear patterns were withdrawn, and the casing was reassembled and fastened together. The gate was prepared by removing the wooden plug, the edges of the hole were rounded off, and the pot was cast.[14]

How can one tell an English from an American product? Eighteenth-century English pots were made from coke iron. American ironworks were not using coke in the smelting process until well into the nineteenth century; hence a pot that appears eighteenth century in form and that metallurgical analysis shows to have been made of coke iron will certainly be English, or at least not American. Since coke iron resulted in a light, smooth pot, it is reasonable to expect the American product to appear heavy and coarse compared to the Darby type of ware (compare Figs. 2 and 3).

Initial efforts at iron casting in America materialized with the inception of the well-known Saugus Ironworks at Saugus, Massachusetts, in the mid-seventeenth century. This was an up-to-date works for its time, the equal of any in England, consisting of a blast furnace, forges, and a slitting mill, which could produce bar as well as cast iron. It was in operation and casting some hollow ware by 1650. Other ironworks soon followed. By the 1650-60 period Thomas Clark and John Winthrop, Jr., had an ironworks in operation at New Haven, Connecticut, consisting of a blast furnace and refinery forge. A letter written by Winthrop in 1663 indicates that pots were among the products of this furnace.[15]

Indeed, hollow ware was a prime product of most of the early ironworks in America. By 1720 pots were being cast from pig metal at an air furnace at Massaponux, Virginia. Thus, in the same era as Darby's early efforts a progressive ironworks in America was utilizing the same reverberatory furnace techniques to produce finer cast wares. Hollow ware was being cast at Taunton, Massachusetts, beginning about 1725, "from the size of a pint kettle to a ten-pail cauldron."[16] The colonies early attempted to make themselves independent of importations of English ironwares, and the pots cast at local furnaces found ready sale in the surrounding countryside. Techniques of iron manufacture did not lag in America. In particular pot-founding methods soon followed the English practices.

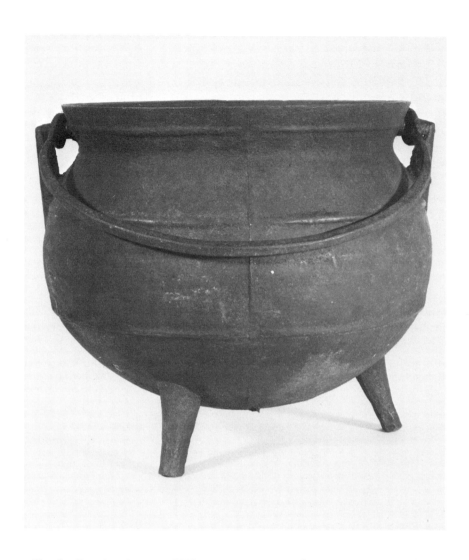

Fig. 3. Pot, America, ca. 1750. Cast iron; H. 9 7/8", Diam. (rim) 10 3/16". The full-bodied form and angular ears of this example are typical of eighteenth-century vessels. The rough exterior surface is more typical of charcoal blast furnace smelting techniques than of coke smelting, hence the designation as American. The rounded legs with a flat rear surface are also more often found on American examples than English. (Pennsylvania Historical and Museum Commission.)

The techniques used by Abraham Darby came into use in
America during the second quarter of the eighteenth century.
In 1739 Joseph Mallinson, owner of a blast furnace at Duxboro,
Massachusetts, memorialized the legislature for a grant of land
in consideration of the great benefit that had accrued to the
colony from the manufacture of hollow ware in sand molds, of
which he claimed to be the sole promoter. He went on to say
that the province might save some £20,000 annually by pro-
moting his product over that imported from England. Just when
the sand-molding method was first used by Mallinson is
unknown, but by 1739 he considered the technique far enough
advanced to warrant official notice. The introduction of casting
in sand molds has also been ascribed to Jeremy Florio, an
Englishman working at Kingston, Massachusetts, prior to his
death in 1755.[17] Regardless of who the originator was, the
molding of ironwares in sand was well established in New
England by the mid-eighteenth century. By 1750 that area,
according to reports, was producing cast wares cheaper than
those imported from England or Holland, and in 1794 two blast
furnaces at Stafford, Connecticut, made "sufficient hollow and
cast wares for the whole state."[18]

Ledgers relating to eighteenth-century iron manufacture
from the many iron furnaces of Pennsylvania reveal that this
state, rich in natural resources and chief of the early iron-
making districts, was a large producer of hollow ware. In
1769 pot patterns and flasks were advertised at the bankruptcy
sale of Martic Forge, indicating again the use of sand-molding
techniques. Likewise, the sale advertisement of Mount
Pleasant Furnace in 1796 listed flasks and patterns. But
despite the increase in production in the United States,
importation continued; 748,092 cast vessels were imported as
late as 1838.[19]

As with the identification of period furniture, determining
date and provenance of hollow wares depends greatly on form,
workmanship, and detail. Earlier English pots of the seven-
teenth century were heavy and thick-walled, shaped rather like
the pouch described earlier. Their widest diameter lay close
to the bottom, and they had almost straight sides. Pots of this
type exist in England and have been found in archaeological

contexts at Jamestown, Virginia. They were cast in halves
by the loam method.[20]

The Darby pot, modeled after the Low Country product,
was more spherical in form with its widest diameter close to
the midpoint of the side. Cast in a two- or three-part molding
box or flask, it bore three distinct mold marks, the marks of
the bottom and the two sides being clearly evident. Legs
appear to have little relevance in dating, save that the seven-
teenth-century and earlier pots often had chamfered legs, with
hooflike terminations. Eighteenth-century pots of English or
American origin have triangular sectioned legs, long if they
were meant to stand over coals or short if meant to hang from
a crane or lug pole. Many English pots have stubby, triangular
Dutch-type legs, while American products often have legs more
rounded in section with flat back surfaces (Figs. 2,3,6,7).

One of the best ways to date a pot, aside from the charac-
teristics of form, is to note the shape of the ears to which the
handle was attached. Pots of the early eighteenth century and
before have sharply angular ears that are round in horizontal
section (Fig. 1). By the mid-eighteenth century the vertical
piece of the ear began to flare a little at the base where it
joined the shoulder of the pot body (Fig. 3). By the late
eighteenth century the vertical piece was becoming triangular
in section, and by the early nineteenth century it had taken on
a triangular section with an inward curve to the inner surface
(Fig. 2). Pots from the second quarter of the nineteenth
century have an ear that curves uniformly inward (Fig. 4).
Mid- to late-nineteenth-century vessels have an ear that is
completely rounded, somewhat like a cow's horn (Fig. 5). The
examination of many examples indicates that a clear progression
can be seen, but lacking the proof of precisely dated hollow
ware the details of this progression are still a matter of theory.
Certainly there was a definite progression in the shape of the
ear from 1700 to 1900. The lag in time between the introduction
of a feature, say in imported pots, and its adaptation by a
rural furnace some years later makes pinpointing stylistic
changes almost impossible.

The change from the round sprue (Fig. 6) to the narrow
gate (Fig. 7) may have depended primarily on the preference

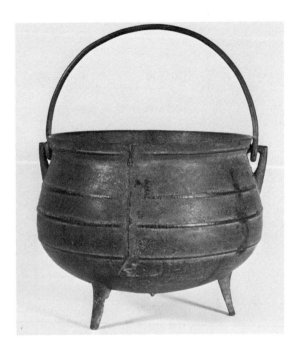

Fig. 4. Pot, America, 1800-1850. Cast iron; H. 8 1/4", Diam. (rim) 9 15/16". Note the rounded legs of the American product. The squashed shape of this vessel is typical of the early nineteenth century, and the ear has begun to curve by this time. (Pennsylvania Historical and Museum Commission.)

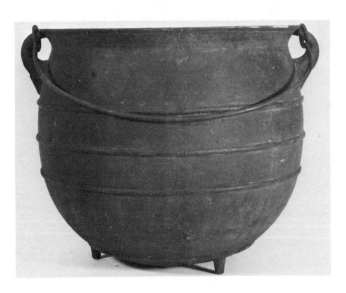

Fig. 5. Pot, America, 1830-70. Cast iron; H. 10 1/2", Diam. (rim) 11 3/4". By the third quarter of the nineteenth century the change in the shape of the pot ear is evident. It now resembles a cow's horn. Though large, this vessel is light for its size, another indication of later date. (Pennsylvania Historical and Museum Commission.)

of the molder. Individuals tended to use the techniques of
casting most familiar to them, and it is possible that an
English founder working in America would have preferred the
sprue at a time when co-workers were using the gate. The
gate was more practical because it could be broken off more
easily after casting, with less danger to the pot. A ten-plate
stove in the collections of the William Penn Museum at
Harrisburg, made in Lancaster County about 1840, has two
oven doors cast using a gate. The firebox door has a sprue.
Both types of doors involved identical casting procedures;
hence it must be inferred that the use of the sprue was due to
the founder's preference.

By mid-nineteenth century the charcoal blast furnace,
long the mainstay of the American cast-iron industry, had
given way to the coke-fueled furnace.[21] As a result, charcoal
furnaces were forced to find new markets and new products.
These small, rural furnaces abandoned the casting of hollow
ware, and by the time of the Civil War a majority of pots were
cast at foundries. The foundry, utilizing a cupola furnace
where pig iron from the blast furnace was remelted in small
amounts, specialized in a variety of small products requiring
elaborate casting techniques, such as pots and machine parts.
By the late 1830s the cupola furnace, simply a cylinder lined
with firebrick with tuyères for the blast below, was in use in
Pennsylvania, and soon foundries began to take the business
of "country castings," that is, cast ware sold locally, away
from charcoal furnaces.[22] The foundry's use of coke iron
meant that its products, among them the stove plates discussed
below, cast at higher temperatures, were more delicate and
smoother than those from charcoal furnaces where lower
smelting temperatures prevailed. Simpler forms were evolved
to speed the process of manufacture, as well as to harmonize
with a new development in cooking, the range.

Possibly the most important factor influencing the changes
that took place in late nineteenth-century pot forms was the
cookstove. By 1840 many householders had boarded up their
old wood-devouring fireplaces and were installing stoves. In
1870 the man who still allowed his wife to cook over the open
fire was regarded as a skinflint, or as desperately poor.[23]

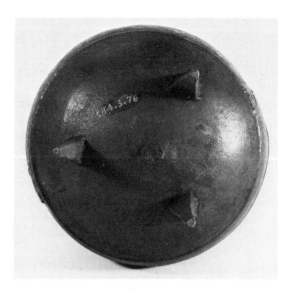

Fig. 6. Bottom of English pot shown in figure 2. Note the late survival of the sprue, indicating loam molding of cores in the British fashion, and the triangular shape of the legs. (Pennsylvania Historical and Museum Commission.)

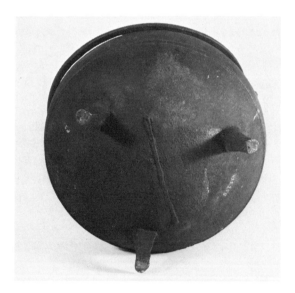

Fig. 7. Bottom of pot shown in figure 3. Note the American form of leg and the use of the gate rather than the sprue. The faint line running under the pot is a mold mark left from flask-casting procedures and should not be confused with the seam, which is always more obvious and results from loam-molding techniques. (Pennsylvania Historical and Museum Commission.)

There was little use for the bulbous pot with legs on the top of a range; consequently by 1850 the spherical shape tended to become cylindrical, with stubby legs only large enough to keep it from upsetting (Fig. 5). By 1870 a modern, straight-sided form had evolved with a recessed bottom that could be set within the holes on the top of the range. Later types (Figs. 5, 8), appeared in hardware catalogs as late as 1930, and many late forms of kettles are still being made today. A crude, squatty version of the bulbous pot also survived into the twentieth century. It had fully rounded ears and little, if any, traces of the bands cast into earlier examples.

The early bulbous pot owed its form to function--the inward curve served to keep moist vapors and rich juices within, adding to the character of the food. Ageless in basic design, it had been modified by different peoples in different ages. As evolved by the Dutch and made by Abraham Darby, it became pleasing to the eye and balanced in form. By the late nineteenth century its form had become subservient to ease of manufacture and the new use of the range. The newer forms lost the character given to older products by the individuality of the founders at each furnace. By 1880 they had taken on the sameness common to products of an industrial age.

The manufacture of stoves was a much simpler process of casting than that needed for pots and one in which technological change more directly affected the appearance of the product. Stove plates, unlike pots, were a flat casting requiring little specialized apparatus to manufacture. The earliest plates found in America are for the five-plate, or jamb, stove. Very heavily cast, these stoves extended into the room on the backside of the fireplace. They opened into the fireplace, but heated the room on the opposite side of the wall. They had no flue; the smoke simply escaped out into the hearth area and from thence, hopefully, up the chimney. Such stoves originated in Europe, particularly in Germany, whence the traditions of their use were brought to Pennsylvania by German settlers. Known as a Dutch stove among the Quaker ironmasters of early Pennsylvania, the jamb stove was largely the product of German molders working in ironworks owned and operated by Englishmen. They were being cast at Coalbrookdale as early as 1729.

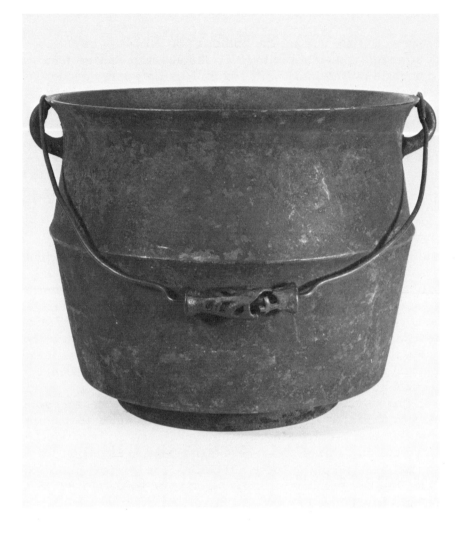

Fig. 8. Pot, America, ca. 1860-70. Cast iron; H. 10 3/4", Diam. (rim)
12 7/8". This pot is very light for its size and was probably made from
coke-smelted iron. It is a typical mass-produced foundry product. The
wire handle with cast-iron grip is original. (Pennsylvania Historical and
Museum Commission.)

Since they were intended for sale to German settlers, it is little wonder that the biblical scenes and fables cast into them reflected German preferences. Much has been written about these scenes, and it will suffice here to note that the mode of casting used was the most primitive sort, the open sand bed. This was essentially the same level of technology that had been utilized for casting firebacks and graveslabs in sixteenth-century England.[24]

A wooden pattern was used to form the impression or mold of the stove plate in the sand of the casting-house floor. Sometimes the design would be made up freehand, but usually patterns were employed. Once the mold had been made, molten iron was carried in a ladle from the furnace hearth and poured into the mold. Because the plates were flat and not curved, as were later stove plates, no complications were present in the process. The backs of plates made in open molds were generally rough and uneven, exactly the way they hardened in the sand bed. The use of flask casting for stove plates was not common until the nineteenth century, although, it was in use for hollow ware from the early eighteenth century.

The jamb stove was a warming stove; it did not supplant the fireplace. Likewise, the six-plate variety that followed was used mainly for heating. Like the five-plate, the six-plate stove was cast in open sand molds, but unlike the five-plate, it could stand in the center of a room, thus giving more heat at the price of increasing the danger of fire. Because it utilized a stovepipe, the draft was much improved over the jamb stove, with subsequent increases in heating capability. The biblical scenes so common on jamb stoves were replaced by rococo designs on six-plate types. The new stoves were known as early as 1744 in America, when Franklin described one. By the 1760s Warwick Furnace was marketing "Six Plate English Stoves." According to Henry C. Mercer, the six-plate stove made its way from Holland to England and then to America. If this is indeed so, then it presents a most interesting example of two transfers of technology, probably via the workmen involved, between Holland and England, and from thence to America. Both pot technology and stove innovation appear to have originated in the Low Countries.

A third type of stove, the ten-plate, came into use about 1760-70. It was much like the six-plate, with the addition of a small oven above the firebox where baking could be done. It was still essentially a heating device and was often used beside a fireplace, especially a large fireplace where little heat escaped into the room. Ten-plates were never as decorative as their predecessors since the oven doors took up much of the room formerly given over to design.[25]

Open sand castings were the rule throughout the eighteenth century, and the crude formation of the often complicated designs plus the irregular back surfaces are typical. A Pine Grove plate (Fig. 9) is a good example of a late survival of open sand casting applied to the manufacture of the six-plate stove. The classical feeling of the scrolls is balanced by the main subject, the crane, a common motif. Late eighteenth-century plates, such as that from Sally Ann Furnace (Fig. 10) often reflect the patriotic feeling of the years following the Revolution. The eagle, shield, and motto on a scrolled design are typical of the designs of the late eighteenth and early nineteenth centuries.

A major change took place in stove-casting technology with the introduction of flask casting for flat plates, which then led to curved plates and more finely executed decorative features. The new technique required the use of sand tightly rammed into wooden boxes, the same process used for making pots, although plates continued to be cast in open molds to as late as 1820. In fact, at some furnaces very primitive molding techniques continued to be used. In 1812 Cumberland Furnace in New Jersey was casting ten-plate stoves in open molds that had been modeled by hand in the same fashion as castings of the sixteenth century.[26]

Making a plate by the flask-casting method involved first placing the pattern in the flask, then ramming the sand around it, and finally removing the pattern. It was the process for pots all over again but without the complications of ears, legs, and bulbous cores. The patterns used were often traded among furnaces or sold to other ironworks. Consequently, there is a great deal of similarity among later stoves from different furnaces within a general area.[27]

Fig. 9. Stove plate, Pine Grove Furnace, Cumberland County, Pa., ca. 1790. Cast iron; L. 17 3/4", W. 25", thickness 1/2". Typical crudely cast plate for a six-plate stove. Made of charcoal iron. (Pennsylvania Historical and Museum Commission.)

Fig. 10. Stove plate, Sally Ann Furnace, Berks County, Pa., ca. 1800. Cast iron; L. 35 1/4", W. 26", thickness 1/2". Like the Pine Grove example this plate from an early ten-plate stove exhibits the same rough, crude surface typical of open sand bed casting. Both were molded from a wooden pattern, rather than by individual workmen in the manner of the early eighteenth century. (Pennsylvania Historical and Museum Commission.)

Fig. 11. Stove plate (rear view), D. & S. Hughes Furnace, Mt. Alto, Pa., ca. 1813–15. Cast iron; L. 33 1/4", W. 23 3/4", thickness 1/2". The rear of this flask-cast plate clearly shows the various parts of the wooden pattern used to form the mold. (Pennsylvania Historical and Museum Commission.)

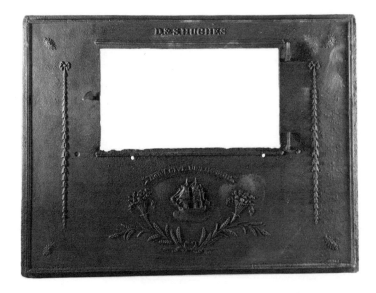

Fig. 12. Stove plate (front view of figure 11). Comparison of this plate with the Sally Ann or Pine Grove examples shows the improvement in quality and workmanship brought about by flask-casting methods at the cost of a loss of individuality. (Pennsylvania Historical and Museum Commission.)

Once the cast was completed the flask was opened and the plate was removed and taken to a finishing room where gates and flashes or rough edges, left where the two halves of the mold joined, were removed and the plate was filed and smoothed. Burned sand that adhered to the plate was removed and a visual inspection was made to determine if the product was suitable for sale.[28] The flashes where the halves of the flask joined were important, for they provided a vent where air trapped within the mold during the pouring of the molten iron could escape. If the air could not escape, bubbles would form within the mold, resulting in an imperfect or weakened casting. The Carron Ironworks account of the casting of pots mentions that the joints of the flasks burned and spouted flames during casting due to the escape of gases from within. This provision for the escape of gases may well have been one of the contributing factors to Darby's success in flask-casting pots.[29]

The typical flask-cast plate has a sprue or gate somewhere on its backside, as pots do on the bottom. In general, flask-cast plates are thinner, smoother, and more delicate in design. Partially this was due to innovations in blast machinery in the early years of the nineteenth century. Although still smelted with charcoal, iron was now more fluid due to hotter temperatures made possible by improved blast machinery and higher stacks, with the result that it flowed into the molds more evenly, filling every tiny crevice exactly. Backs as well as front surfaces show the marks of the mold (Fig. 11).

Design motifs on flask-cast plates range from sparse, Adamesque swags and ribbons, often found on stoves from the lower Cumberland Valley of Pennsylvania, to early Empire acanthus leaf designs. A stove with curved plates cast at Pine Grove about 1815 has sparse Adamesque ribbons with an eagle on both side plates. Corners are filled by rosettes typical of those found on fine Federal period furniture from Philadelphia or farther south.[30] Another plate (Fig. 12), cast at the neighboring furnace of D. and S. Hughes of Mt. Alto, Pennsylvania, bears the very same ribbons, rosettes, and olive branches, has flat, very heavy plates, and is typical of plates cast during the first decade of the nineteenth century.

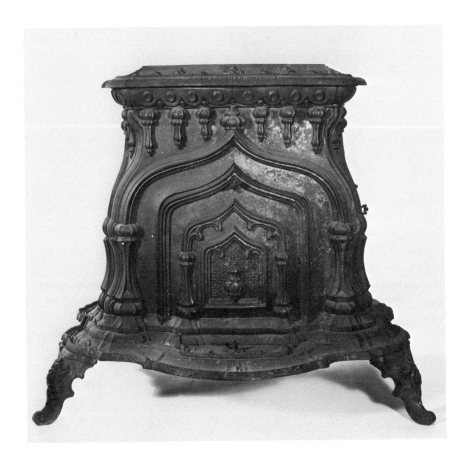

Fig. 13. Stove, America, ca. 1850. Cast iron; H. 28". Made of very thin (1/8" to 1/4") castings, this mid-nineteenth-century stove exemplifies the exuberance of the Gothic revival and the extent to which decoration with intricate designs could be employed through the use of coke iron. (Pennsylvania Historical and Museum Commission.)

It was made soon after the battle of the <u>Chesapeake</u> and the <u>Shannon</u> on June 1, 1813, for it bears a portion of the dying words of Commander James Lawrence: "Don't Give Up the Ship." Beneath the motto is a ship.

The ever-increasing use of coke iron, particularly after 1855, meant that thinner and more complicated castings could be made. Coke iron, smelted at a high temperature, was more fluid in the mold, resulting in very fine castings. The elaborate decoration typical of the early Victorian years made the most of this fluidity. By 1850 stoves were found in a bewildering variety of forms, some even resembling Gothic cathedrals (Fig. 13). In others floral designs ran riot. By 1860 thin embossed designs were used in efforts to conserve iron, but they were easily broken. As with pots, by the mid-century technology had the controlling hand, and designs as well as form became a function of what technology was able to perform most quickly and economically.

NOTES

1. James A. H. Murray, et al., eds., The Oxford
English Dictionary (Oxford: Clarendon Press, 1933), 5:680.
2. Raymond Lister, Decorative Cast Ironwork in Great
Britain (London: G. Bell and Sons, 1960), pp. 40-42.
3. Hanns-Ulrich Haedeke, Metalwork (New York:
Universe Books, 1970), p. 66.
4. Lindsay, Iron and Brass Implements of the English
and American House (Bass River, Mass.: Carl Jacobs, 1964),
figs. 114-15.
5. Haedeke, Metalwork, p. 67.
6. A. J. G. Verster, Brons in den Tijd (Amsterdam:
J. H. De Bussy, 1956), pl. 45.
7. H. R. Schubert, History of the British Iron and Steel
Industry (London: Routledge & Kegan Paul, 1957), p. 256.
8. Leslie Aitchison, A History of Metals, 2 vols.
(New York: Interscience Publishers, 1960), 2:437.
9. Réaumur, Memoirs on Steel and Iron, eds. Anneliese
Grunhaldt Sisco and Cyril Stanley Smith (Chicago: University
of Chicago Press, 1956), p. 351.
10. Arthur Raistrick, Dynasty of Iron Founders (London:
Longmans, Green, and Co., 1953), p. 19.
11. Edward H. Knight, Knight's Mechanical Dictionary,
3 vols. (New York: Hurd and Houghton, 1877), 1:499.
12. Schubert, British Iron and Steel, p. 269.
13. The discussion of Darby's techniques at Coalbrookdale
is based on Raistrick, Dynasty of Iron Founders, pp. 21-23,
36-37, 45-46, 55, 115.
14. David Bremner, The Industries of Scotland (1869;
reprint ed., Newton Abbot, Devon: David and Charles Reprints,
1969), pp. 44, 45.
15. E. N. Hartley, Ironworks on the Saugus (Norman:
University of Oklahoma Press, 1957), p. 144; James M. Swank,
History of the Manufacture of Iron in All Ages (1892; reprint ed.,
New York: Burt Franklin, 1968), p. 118.
16. J. Leander Bishop, A History of American Manufac-
tures from 1608 to 1860, 2 vols. (Philadelphia: Edward
Young & Co., 1861), 1:598; Swank, Iron in All Ages, p. 117.

17. Bishop, American Manufactures, p. 484.

18. Swank, Iron in All Ages, pp. 121, 131.

19. Henry C. Mercer, The Bible in Iron (3d ed.; Doyles-
town, Pa.: Bucks County Historical Society, 1961), p. 138;
Alfred Gemmell, The Charcoal Iron Industry in the Perkiomen
Valley (Allentown, Pa.: published by the author, 1949), p. 35;
Samuel Hazard, ed., Hazard's United States Commercial and
Statistical Register (Philadelphia: William F. Geddes, 1840),
p. 86.

20. John L. Cotter and J. Paul Hudson, New Discoveries
at Jamestown (1957; reprint ed., Washington, D.C.: National
Park Service, 1962), p. 30.

21. See John D. Tyler, "The Charcoal Iron Industry in
Decline" (M.A. thesis, University of Delaware, 1967).

22. Edwin T. Freedley, Philadelphia and Its Manufactures
(Philadelphia: Edward Young, 1858), p. 288; Gemmell,
Charcoal Iron Industry, p. 105.

23. Stevenson Whitcomb Fletcher, Pennsylvania Agriculture
and Country Life (Harrisburg: Pennsylvania Historical and
Museum Commission, 1950), p. 399.

24. Mercer, Bible in Iron, pp. 2, 29, 30; Aitchison,
History of Metals, 2:408.

25. Mercer, Bible in Iron, pp. 82, 84, 87, 132, 140.

26. Donald A. Crownover, Manufacturing and Marketing
of Iron Stoves at Hopewell Furnace, 1835-1844 (Washington,
D.C.: United States Park Service, 1970), pp. 59-65; Norton L.
Montgomery, "Early Furnaces and Forges of Berks County,
Pennsylvania," Pennsylvania Magazine of History and Biography 1
(1884): 73; Mercer, Bible in Iron, p. 138.

27. Crownover, Iron Stoves at Hopewell, p. 108.

28. Crownover, Iron Stoves at Hopewell, p. 73.

29. Bremner, Industries of Scotland, p. 45.

30. Charles F. Montgomery, American Furniture: The
Federal Period (New York: Viking Press, 1966), p. 473.

AMERICAN CONTRIBUTIONS TO THE DEVELOPMENT OF PRESSED GLASS

Kenneth M. Wilson

FROM the first feeble and futile beginnings in Jamestown until about 1900, English and Germanic traditions strongly influenced the development of the American glass industry. Hollow wares made here as by-products of window glass and bottle manufacture are closely related to the Waldglas ("forest glass" made of unrefined metal produced in the forest glasshouses of Germany, Central Europe, and the Lowlands in the fifteenth and sixteenth centuries. In the few American factories established before 1820 for the production of flint glassware, more sophisticated tablewares were strongly influenced by English glassmaking practices and styles. Mechanically pressed, or machine-pressed, glass developed relatively late. At first, in America, the traditional European method of hand pressing was employed, but this quickly developed into machine pressing, one of the most important innovations in glassmaking technology. To place this development in proper perspective it is necessary to look at the background of the technique.

From about 1780 or 1785, the bases of some salts, rummers, goblets, and compotes made in English, Irish, German, and Netherlandish glasshouses were formed by a hand-pressing technique using a pincerlike device with a two-part mold (Fig. 1). These molded elements were then applied to the body of a vessel while the glass was still hot. Except for the multipointed star, rosette, or "lemon squeezer" design in the underside of some of these bases, no attempt was made to utilize this simple and limited technique for pressing glass for decorative purposes. Nor was this technique, which I am convinced was used in America at least by 1813, and possibly much earlier, further developed in England or Europe during

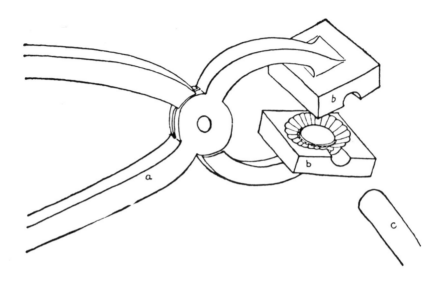

Fig. 1. Drawing of a hand-operated pressing device, or pliers. From
George S. and Helen McKearin, American Glass (New York: Crown
Publishers, 1941), fig. 15. (Photo, Corning Museum of Glass.)

the forty or forty-five years after its introduction. The
adaptation of this process and the invention of machine
pressing--a natural evolution from the hand press--apparently
did not take place until sometime in the early 1820s. The
invention of machine pressing, which is credited to American
glassmakers, was a revolutionary step in the production of
glass. Its effects were enormous and widespread; it was a
major contribution to glass technology--the next most
important technical development after the introduction of
glassblowing.

Although machine pressing is only about 150 years old,
forerunners of this technique date back to almost 1500 B.C.
Amulets of various shapes and figures were made in Egypt
at least as early as the eighteenth dynasty (1450-1330 B.C.).
These amulets of opaque white, yellow, blue, and red glass
were presumably formed by casting and pressing molten glass
in shallow molds or by placing powdered glass in molds in
which it was then fused and pressed. Figures and geometric
designs also produced in this manner were used as inlays in
boxes and furniture.

Medallions, or disks, or opaque light-blue glass, some-
times bearing radial images on their surfaces, have been
ascribed to Nuzi, in Mesopotamia, and are believed to have
been made about 1500 B.C. These, too, were undoubtedly
cast-pressed in molds in the same manner as the amulets made
in Egypt. During the Ptolemaic period (323-30 B.C.) vast
quantities of amulets and inlays were produced, many by
the cast-pressed technique. Numerous examples of cast-
pressed glass in the form of medallions bearing portraits,
representations of deities, and mythological scenes survive
from the Roman Empire (Fig. 2). Many of these were produced
during the first century A.D., even after the introduction of
the blowpipe, which may have occurred during the second half
of the first century B.C. The fine quality of the images on
many of these examples testifies to the skill of the ancient
Roman mold makers and the glassmakers who used the molds.
Glassmakers of the early Roman era probably utilized a form
of mold pressing to produce at least some of the pillar-molded
bowls of various forms, sizes, and colors represented in almost

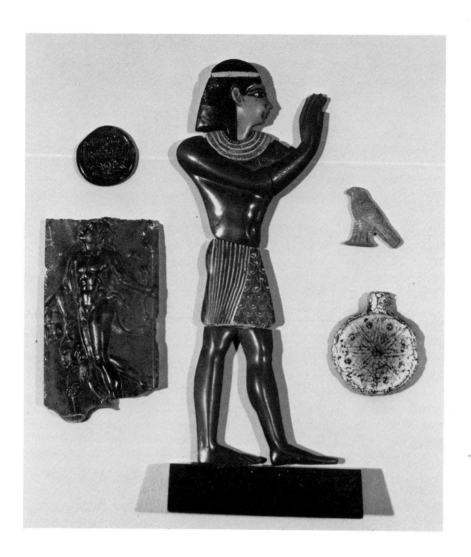

Fig. 2. Five cast-pressed glass objects: amulet in form of a bird,
Egyptian, probably eighteenth dynasty, 1450–1330 B.C.; pendant or
medallion, Mesopotamia, possibly Nuzi, probably the late fifteenth
century B.C.; figure of a man, Egyptian, probably Ptolemaic, ca. third-
first century B.C.; plaque, probably Hercules, Roman Empire, first
century B.C.-first century A.D.; weight, bearing an Arabic inscription,
ca. ninth century A.D. Height of Egyptian figure 8 1/4". (Corning
Museum of Glass: Photo, Raymond F. Errett.)

every collection of ancient Roman glass. In many instances these bowls were finished and sometimes decorated with incised lines, produced by turning on a lathe or other abrasive means, just as some of the medallions mentioned above were touched up or finished by cutting and polishing.

Casting or mold pressing of glass appears to have been largely abandoned as a means of producing decorative glasswares after the first or second century A.D., with some few exceptions, until near the end of the eighteenth century. One of these exceptions was the stamping, or pressing, of weights and seals by Islamic glassmakers (Fig. 2) and another was Islamic use of pincers to decorate cups, bowls, and even bottles with a variety of geometric and calligraphic designs, sometimes including the name of the maker. The latter form of glass pressing seems to be unique to Islamic glassmakers.

As previously mentioned, the use of a pliers or "hand press" (Fig. 1) to form stoppers for decanters and feet for salts, compotes, goblets, and rummers seems to have come into almost simultaneous use in England, Ireland, Germany, and Holland about 1780 or 1785. Deming Jarves in 1854 noted "fifty years back the writer imported from Holland salts made by being pressed in metallic moulds" and from England articles "with pressed square feet, rudely made, somewhat after the present mode of moulding glass."[1] The square, sometimes stepped, feet characteristic of goblets decorated with gold and schwarzlot portraits by Joseph S. Menzel of Bohemia evidence the use of this type of pressing there. Most of Menzel's hand-pressed work dates from about 1785 to 1800. The bases on most of these goblets have been finished by cutting and polishing to achieve a smooth surface, and some bear cut stars or rosettes on their undersides. At least a few, such as one in the Kunstmuseum der Stadt Düsseldorf, are decorated by large rosettes formed by pressing. Rummers and goblets of various sizes and forms, as well as candleholders, sugar bowls, sweetmeat dishes, and salts supported by square pressed feet of various designs--sometimes cut and polished--came into fashion in England about 1785 and continued in popularity until about 1820. Similar forms of goblets, adapted from English styles, were also produced in

German and other European glasshouses during roughly this
same period. The square feet on these European pieces were
also produced by hand presses and often contained rosettes
and lemon squeezer designs on their undersides.

Although the feet on some of these rummers and candle-
holders (Fig. 3) are fairly large, the most impressive
hand-pressed feet or bases are those found on round and
boat-shaped compotes produced in Irish and English glass-
houses from about 1785 to 1815. The feet on some of the
boat-shaped compotes measure 6 inches long by 4 1/2 inches
wide and have an overall height of 3 1/2 inches. Sometimes
the upper side of the foot has been decorated with ribbing or
with a shell-like pattern.

Bases like those on some of these compotes and candle-
holders, sometimes bearing pressed rosettes underneath,
are almost identical to several variations of pressed glass
bases found on lamps attributed to one of the South Boston
glasshouses operated by Thomas Cains or to the New England
Glass Company (Fig. 3). Cains leased the South Boston Flint
Glassworks from the Boston Glass Manufactory and operated
it from 1813 until about 1819, when he opened his own Phoenix
Glassworks across the street. There, too, he undoubtedly
continued to produce lamps of this form with pressed glass
bases made in hand presses as well as smaller chamber lamps
with pressed feet. Possibly a few other glasshouses, such
as the New York Glassworks established by John Fisher and
John Gilliland in Brooklyn in 1820, also produced whale-oil
lamps with hand-pressed bases of similar types.

The date of the invention of a machine for pressing glass
is not known. It seems likely that there were several stages
in the evolution from the hand press of plierlike form to the
machine for pressing glass illustrated by Apsley Pellatt in
1849 in his Curiosities of Glassmaking (Fig. 4).[2] Unfor-
tunately, because the 1836 Patent Office fire destroyed
patents prior to that date, knowledge of patents relating to
the pressing of glass before then is based on incomplete
references. The earliest known patent referring to the pressing
of glass was granted to John P. Bakewell of Bakewell, Page
and Bakewell Company of Pittsburgh on September 9, 1825.

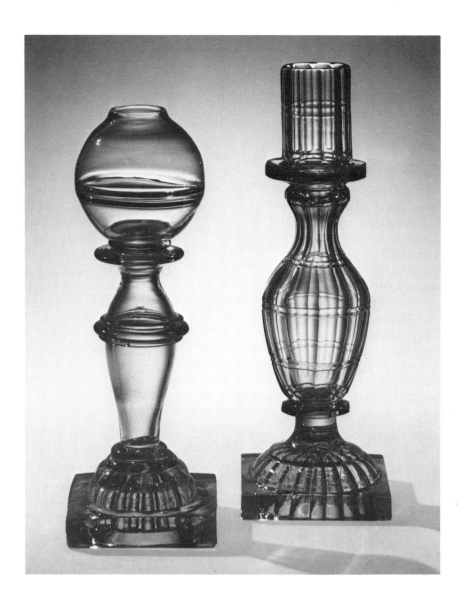

Fig. 3. <u>Left</u>: attributed to Thomas Cains's South Boston Flint Glassworks or to the New England Glass Company, whale-oil lamp. Boston or Cambridge, Mass., 1813-30. Colorless flint glass with free-blown and manipulated font and standard, supported on a pressed-glass foot; <u>Right</u>: candleholder, probably Ireland, ca. 1785-1800. Blown, tooled, and cut, supported on a pressed-glass base; H. 10". (Corning Museum of Glass: Photo, Raymond F. Errett.)

It was for "an improvement in making glass door knobs."[3]
The word improvement included in this reference may be
interpreted to mean that previous patents had been granted
for some manner of pressing glass. A spate of patents
followed; many of them were also for improvements in pressing
glass knobs for furniture. On November 4, 1826, Enoch
Robinson and Henry Whitney of the New England Glass
Company were granted such a patent. On October 6, 1827,
John Robinson, proprietor of the Stourbridge Flint Glassworks
in Pittsburgh, was granted a patent for "making press glass
door knobs." On October 16, 1827, Phineas C. Dummer, one
of the founders and proprietors of the Jersey Glass Company in
Jersey City, New Jersey, obtained a patent for "the
construction and use of moulds with a core, for pressing glass
into useful forms: called Dummer's scallop, or coverplate."
On the same day, he, along with his brother, George Dummer,
and James Maxwell, was also granted a patent "on forming
glass by the combination of moulds with mechanical powers."
On May 14, 1828, Thomas and John P. Bakewell, of Bakewell,
Page and Bakewell, obtained a patent "for making glass
furniture knobs or handles." On December 1, 1828, Deming
Jarves of the Boston and Sandwich Glass Company in Sand-
wich, Massachusetts, was granted a patent for "improvement
in the modes of pressing melted glass into moulds." He was
also granted a patent on June 13, 1829, for the "manufacture
of glass knobs and screws." In his design, a glass screw of
large diameter was part of the knob, necessitating a
correspondingly large hole in the wood (Fig. 5, right). In 1830,
he patented a mold in which a handled article could be pressed
in one operation. Additional patents for making glass door-
knobs were granted to Spencer Richards of Cambridge,
Massachusetts, on October 3, 1831, and to Theodore T.
Abbott, of Canton, Massachusetts, on November 19, 1833.

The machine press was a relatively simple thing; so
simple, in fact, that one wonders why it was so long in
appearing on the scene. The illustration of a machine press
(Fig. 4), published by Pellatt in his Curiosities of Glass-
making,[4] is essentially the same as that in Pellatt's
specifications accompanying his application for an English

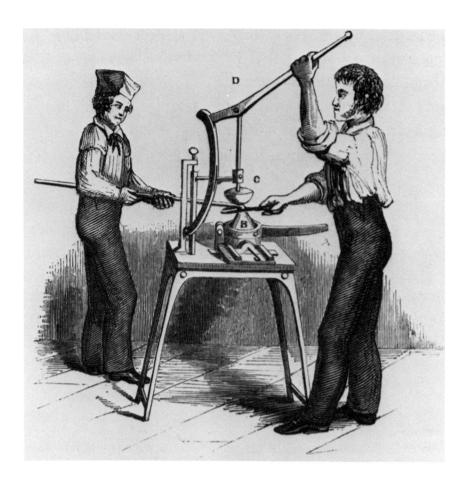

Fig. 4. Pressing glass by machine. From Apsley Pellatt, <u>Curiosities of</u>
<u>Glassmaking</u> (London: D. Bogue, 1849), p. 121. (Photo, Corning Museum
of Glass.)

patent for the machine. Pellatt credits Americans with the
invention of machine-pressed glass. His patent application,
dated March 9, 1831, bears the statement, "for a machine
for pressing glass by the mode lately introduced from America."
This indicates the rapidity with which this improvement in
producing glass was taken up abroad. It was also quickly
adopted by French and Belgian glasshouses, and later by
Bohemian and Scandinavian glassworks. The quality of early
American pressed glass, as well as its economic importance,
was recognized by several contemporary observers. James
Boardman, author of America, and the Americans, was so
favorably impressed by the glass exhibited at the fair of the
American Institute of the City of New York in 1829 that he
wrote: "The most novel article was the pressed glass; which
was far superior, both in design and execution to anything of
the kind I have ever seen in either London or elsewhere. The
merit of its invention is due to the Americans, and it is likely
to prove one of great national importance."[5] Anne Royall in
Mrs. Royall's Pennsylvania or Travels Continued in the United
States, written in 1828, noted after a visit to the Bakewell,
Page and Bakewell factory in Pittsburgh: "They have introduced
a new fashion of stamping figures on glass while it is warm,
also moulding glass, which is done mostly in the same way
metal is cast."[6]

After the invention of the basic machine for pressing glass,
glassmakers rapidly solved other problems in the pressing
process. A patent for an important improvement in pressing
decanters, bottles, and other glasswares with necks smaller
than the cavity or inside diameter of the vessel was granted
to Jonathan McGann, of Kensington, near Philadelphia, on
November 26, 1830. His ingenious method called for forming
the upper and lower sections of an object, such as a bottle
or decanter, in two molds. While the glass was still in a hot,
plastic state in the molds, the molds were turned over upon
one another to bring the edges of the glass into exact align-
ment. Then, with a slight pressure, they were joined together.
This patent preceded by almost two generations a similar
patent issued to William Leighton, Jr., on February 9, 1875.
During the second half of the nineteenth century, objects

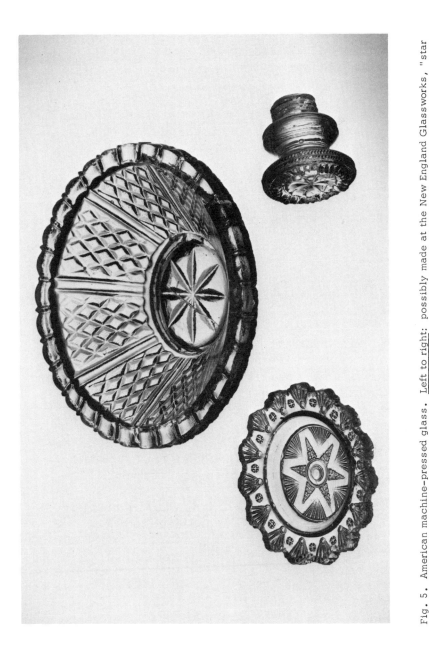

Fig. 5. American machine-pressed glass. Left to right: possibly made at the New England Glassworks, "star bottom" cup plate. Cambridge, Mass., ca. 1827-30; bowl, probably New England, ca. 1827-30. Geometric pattern imitating Anglo-Irish cut glass; max. diam. 5 5/8"; glass knob with screw shank of the form patented by Deming Jarves of the Boston and Sandwich Glass Company, June 13, 1829. (Corning Museum of Glass: Photo, Raymond F. Errett.)

having a smaller opening than their bodies were also pressed
by a process sometimes called today the shut and cut method.
Pieces pressed by this means were pressed upside down, with
an extra cylinder of glass, called a flap, extending above the
body of the vessel. This flap was immediately reheated after
the piece was removed from the mold, tooled shut to form the
base, and trimmed to remove the excess glass. The operation
usually left a swirled mark in the base, often mistaken as a
pontil mark.

As in the case of blown three-mold glass, the earliest
examples of machine-pressed glass closely imitated the
currently fashionable and more expensive Anglo-Irish cut
glass. Thus, patterns of diamond diapering, or strawberry
diamonds, fans, or splits, and similar geometric motifs, occur
on early pressed glass. The earliest machine-pressed glass,
dating from 1825 (or slightly earlier) to about 1830, is also
characterized by the extreme thickness of the glass (Fig. 5),
due to inexperience and a lack of control--problems solved
by the rapid development of pressing technology.

In addition to furniture knobs, mentioned in numerous
early patents, cup plates were among the earliest machine-
pressed objects. They are listed in records of the Boston and
Sandwich Glass Company on April 20, 1827.[7] And though they
are not specifically called cup plates, a bill of lading from
the New England Glass Company to William E. Mayhew and
Company, Baltimore, Maryland, dated July 26, 1828, listed
ten boxes containing 3 1/2- and 4-inch diameter plates.
Several patterns were represented in this shipment:

Box #1311	53 1/2 Doz.	3 1/2 in Star bott plates		$40.13
Box #1314	54 "	3 1/2 in Planet Bott	"	40.50
Box #1315	36 "	4 in Scollop	"	36.00
Box #1316	46 "	3 1/2 in " Star bott	"	34.50
Box #1317	40 "	4 in "	"	40.00
Box #1318	40 "	3 1/2 in "	"	30.00

It is difficult, of course, to identify surviving cup plates from
these brief descriptions, but it is possible that the six-pointed
star in the base of the cup plate in figure 5 may be one of the
patterns referred to on this invoice.

Two significant facts stand out in the following letter written on this bill of lading by H. Whitney, agent of the New England Glass Company, to William E. Mayhew and Company:

Gents

We hand you herewith invoice and b[ill of] lading for 45 packages ware per Brig Calo amount of same to you debit $1313.49. These goods with the exception of the 10 first packages [packages containing the 3 1/2- and 4-inch plates] are intended for exportation and these are equally well calculated for that market tho we have never sent or made any before--The plates we hope you will dispose of immediately as the So. Boston Co. have already copied our patterns and Mr. Jarves will do the same probably--very respectively.[8]

It would seem from the remark "we have never sent or made any before" that the New England Glass Company had just begun producing cup plates at this time. In addition, two other factors seem evident: cup plates were new and apparently in demand, and the market was very competitive. Competitors such as Thomas Cains's Phoenix Glass Works in South Boston and the Boston and Sandwich Glass Company, for which Deming Jarves was agent, did not hesitate to copy a popular pattern.

Less than two weeks later, on August 9, 1828, the New England Glass Company shipped to Mayhew eleven boxes of "Scollopd Plates," including three boxes of 3 1/2-inch plates with planet bottoms; five boxes of 3 1/2-inch star bottom plates; and three boxes of the star bottom pattern of the 4-inch size. Again, a letter by Whitney to Mayhew on the bill of lading is of interest in relation to the introduction and manufacture of these plates:

The first Package No. 33 in this Invoice contains chambers for the So. America market the remainder of the Invoice consists of Plates which we hope you will be able to dispose of before Mr. Jarves fills

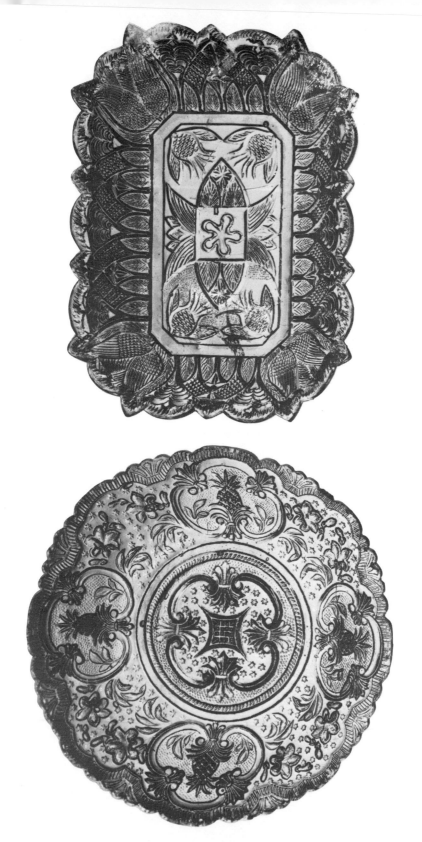

Fig. 6. Possibly made at the New England Glass Company, "lacy" pressed-glass dishes or shallow bowls. Cambridge, Mass., ca. 1829-40. Note the pineapple designs and Gothic arches; diam. of round bowl 6 3/4". (Corning Museum of Glass: Photo, Raymond F. Errett.)

> your market with them--if to do this you should
> think it expedient to reduce the price of the plates
> a little below the Inv. you had better do it--by so
> doing you may induce the Trade to take all you have
> immediately off.

This letter, too, indicates stiff competition among glasshouses
for business. Although none of the invoices refer to these
plates as pressed, and they do not specifically mention cup
plates, strong circumstantial evidence makes it almost certain
that these were cup plates. Two items on a New England
Glass Company invoice to Mayhew dated April 18, 1829, less
than a year later, tend to confirm this opinion. They refer to
"3 doz. 3 in Cup Plates $1.50" and "3 doz 3 1/2 in Cup
Plates $1.88." It is unfortunate that the pattern names were
omitted. The same invoice also lists several other items
that are undoubtedly in part or wholly pressed glass. These
include:

```
1/2 Doz. 7 in Pine Apple Dishes  $3.00
1/2  "    8 in   "      "      "      3.75
1/2  "    9 in   "      "      "      4.50

15 Doz. #1 Press. Furniture Knobs at $2.25  $33.75
15  "    "2  "               "       "       1.75   20.25
 4  "    "3  "               "       "       1.25    5.00

1/2 Doz. Sml. Sqr. foot Cyl. Lamps, round
shouldered at $4.50                                  2.25
2 pr. 3 sqr. foot bulb Lamps, Brass caps             3.50
```

Whether the square feet on these two different types of lamps
were machine- or hand-pressed cannot be determined. Nor
can the pineapple design on the 7-, 8-, and 9-inch dishes be
identified, but one can speculate that the dishes or shallow
bowls shown in figure 6, one bearing pineapples on its sides,
the other on its base, are like those referred to in the invoice.
If so, it is evident that the departure from simple geometric
designs of Anglo-Irish inspiration had begun at least by the
spring of 1829.

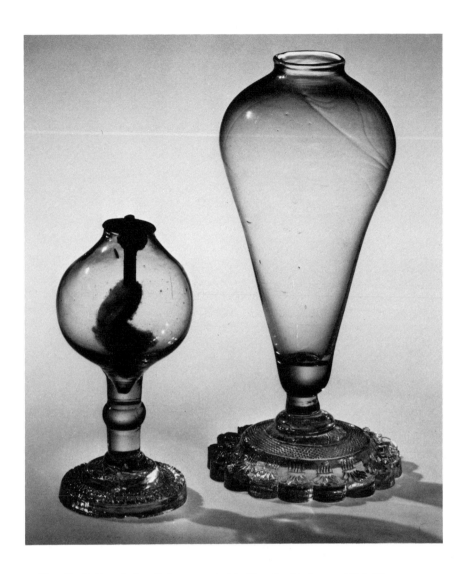

Fig. 7. <u>Left</u>: whale-oil lamp, probably New England, ca. 1813-30.
Supported on a hand-pressed base. <u>Right</u>: whale-oil lamp, New England,
ca. 1827-30. Free-blown font supported on an inverted cup plate for a
base; H. 6 7/8". (Corning Museum of Glass: Photo, Raymond F. Errett.)

In another of these invoices to Mayhew dated May 2, 1829,
3- and 3 1/2-inch cup plates are again listed, as are:

15 Doz.	2 3/8 in	Press.	Knobs at	$2.25	$33.75	
15 "	2 1/8 in	"	"	1.75	26.25	
4 "	1 3/8 in	"	"	1.25	5.00	

The invoice includes small square foot bulb lamps and glasses
and 7-, 8-, and 9-inch pineapple dishes. Of particular
interest is the listing "1/2 doz. Cup plate foot bulb Lamps at
$2.25 $1.12." Although not overly plentiful today, numerous
examples of whale-oil lamps with varying forms of fonts
supported on thick, inverted cup plates bearing various
geometric motifs can still be found. A cup-plate-base lamp
is shown in figure 7, along with a small whale-oil lamp on a
circular, hand-pressed base, to the left. At least one cup
plate design can be attributed to the Providence Flint Glass-
works, as the two following advertisements indicate. Both
appeared in the April 27, 1831, issue of the Manufacturers &
Farmers Journal and Providence and Pawtucket Advertiser:

> Providence Glass Ware. Edward Carlile, 53
> Cheapside, will open this morning a few cases
> Glass Ware, from the "Providence Glass Works,"
> consisting of Dishes, "Clay" cup plates, &c.
> Providence Glass Ware. Thomas Whitaker has
> received this morning from the "Providence Glass
> Works," an assortment of Glass Dishes. "Clay"
> Cup plates, &c. for sale on reasonable terms.

In addition to cup plates and furniture knobs, other early
machine-pressed glasswares included salts of many shapes
and patterns, a few of which were marked. Among the
manufacturers producing pressed glass salts were: the New
England Glass Company, the Jersey Glass Company, the
Providence Flint Glassworks, the Boston and Sandwich Glass
Company, and John Robinson's Stourbridge Flint Glassworks.
At least the Boston and Sandwich Glass Company and
Robinson's Stourbridge Flint Glassworks produced "Lafayet"

boat salts of almost identical design (Fig. 8). Because the
sterns of some of the Lafayet boat salts are marked "J.
Robinson & Son, Pittsburgh," it is possible to date them to
the period of 1829-30, when the firm bore this name. Likewise,
salts marked on the base "Providence" can be dated to 1831-
32, since the Providence Flint Glass Works was in business
only during these two years. Examination of a Providence
salt and the two boat salts illustrated shows the degree of
quality that had been achieved in pressing technology by that
time.

By 1830, and perhaps a little earlier, the production of
geometric pressed glass gave way, in large measure, to what
is called today by the generic term lacy pressed glass. The
general popularity of this type of glass lasted from about 1830
to about 1850. There are exceptions to this generalization,
for it is now evident either that some lacy glass continued to
be produced in the 1860s and 1870s or that this type of design
was revived during that period, as will be discussed later.
Though lacy glass designs often have considerable aesthetic
appeal, they resulted primarily from the desire and need to
overcome technical defects in the pressing process. Chief
among these were the scar, or shear mark, left on the upper
surface of the glass when the gather was cut off and dropped
into the mold and the surface dullness resulting from the
pressing operation. The plunger forcing the glass into the
mold spread the shear mark over a fairly large area of the
object being pressed. One solution to the problem was to
design patterns that concealed the defects. The brilliant
refraction of light resulting from covering the undersurface
(and sometimes portions of the upper surface) with a finely
stippled background surrounding the main elements of the
pattern minimized both the prominence of the shear mark and
the appearance of dullness. Fire polishing was also used,
with varying degrees of success, to overcome the surface
dullness caused by the contact of the plunger with the hot
glass.

The glassmaking industry in America was geographically
divided into two principal sections: the East, or seaboard,
and the Midwest, the area west of the Alleghenies where

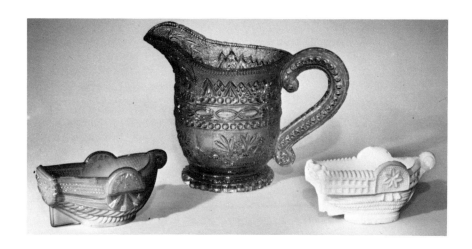

Fig. 8. Machine-pressed glass. Left to right: Boston and Sandwich Glass
Company, "Lafayet" boat salt. Sandwich, Mass., 1825-50. Opaque blue
glass marked on the stern "B. & S. Glass Co" and on the base "Sandwich";
Fort Pitt Glassworks, creamer. Pittsburgh, Pa., ca. 1831-34. Marked on
the base, "R. B. Curling & Sons Fort Pitt"; John Robinson's Stourbridge
Flint Glassworks, boat salt. Pittsburgh, Pa., ca. 1830. Opaque white
glass marked on the stern "J. Robinson & Son, Pittsburgh," H. 1 1/2".
(Corning Museum of Glass: Photo, Raymond F. Errett.)

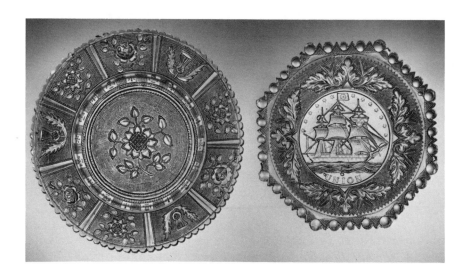

Fig. 9. Left: attributed to the Boston and Sandwich Glassworks, "lacy"
plate. Boston, Mass., ca. 1830-50. Thistle, rose, and sunflower motifs.
Right: octagonal plate. Probably Pittsburgh, Pa., 1830-50. Marked
"UNION"; W. 2 1/2". (Corning Museum of Glass: Photo, Raymond F. Errett.)

Pittsburgh was the glassmaking center. Stylistic differences
in the production of lacy pressed glass, as well as in pattern-
molded, free-blown, and engraved wares, developed in these
two areas. In the production of lacy pressed glass, two
principal characteristics generally distinguish the products of
the Eastern and Midwestern factories: the stippling in the
background of the lacy designs produced in the Midwest is
generally coarser than that encountered in Eastern examples;
and the borders of cup plates, plates, and bowls produced in
Midwestern factories are generally much bolder than those on
Eastern examples (Fig. 9). Midwestern borders often consisted
of large scallops superimposed with bold "bull's eyes,"
whereas the borders of Eastern counterparts were usually
smaller, less bold, and seldom, if ever, featured bull's-eye
decoration. Relatively few examples of lacy pressed glass
bear the names of their manufacturers, but those that do
support these observations.

The cream pitcher illustrated in figure 8 is one of the
best-known marked lacy pressed-glass pieces. It was
produced in Curling's Fort Pitt Glassworks in Pittsburgh and
is marked on the base "R. B. Curling & Sons Fort Pitt." This
factory was established by Curling and Price in 1827 and
continued in operation under various managements until about
1900. In 1828 the firm became R. B. Curling and Company.
By 1831 it had become known as R. B. Curling and Sons, and
by 1834, when Morgan Robertson entered the firm, it was
known as Curling, Robertson and Company. Thus, the mold
for this cream pitcher was made between 1831 and 1834, and
the early production from it occurred during these years,
though it may, of course, have been continued in use for a
number of years after the change of the firm name. The mold
is another indication that by 1831, at the latest, lacy designs
were well established. A comparison of the bold stippling on
the background of this pitcher with examples of lacy pressed
glass attributed to such factories as the Boston and Sandwich
Glassworks bears out the observation that, in general, the
stippling on Midwestern lacy pressed glass is coarser than
that found on pieces produced by Eastern glasshouses.

Selection of different pattern motifs can also be a

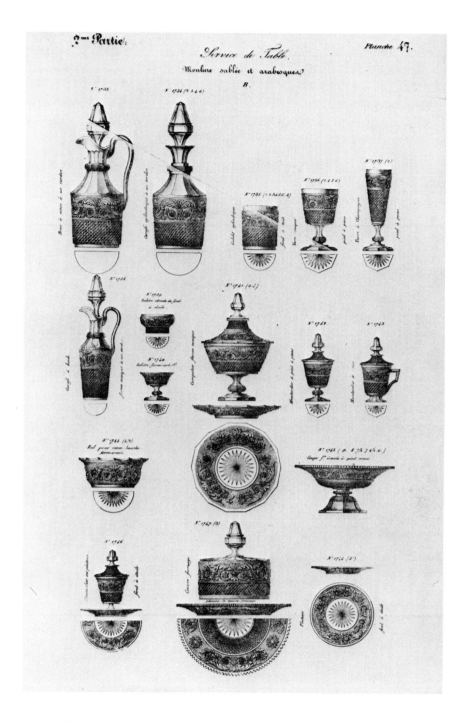

Fig. 10. Lacy glass. From Catalog of Launay, Hautin & Cie (Paris, 1840), pl. 47. (Corning Museum of Glass.)

distinguishing regional characteristic of pressed glass. For example, the use of Greek Revival motifs, such as the acanthus leaf, is much more prevalent on Eastern lacy pressed glass. The appearance of these motifs on glass parallels their use as architectural elements during the Greek Revival movement, which was very strong in New England and the East beginning about 1830. Gothic motifs, which did not appear in American architecture until about 1840, seem to have appeared at an earlier date on some glass. On the basis of large numbers of fragments found at the site of the factory, numerous sugar bowls of various colors of glass bearing Gothic arch motifs have been attributed to the Boston and Sandwich Glassworks. Midwestern firms, such as Ihmsen and Company, also produced sugar bowls with these motifs. They also appear on the rectangular pressed glass dish shown in figure 6, which may be like those referred to in the New England Glass Company invoices to William Mayhew, dated May 2, 1829. Gothic arch motifs are also found on "caskets," or rectangular dishes with covers and trays, produced in both Midwestern and Eastern glasshouses. It is difficult, however, to date the manufacture of most of these pieces, other than probably between about 1830 and 1850.

As noted earlier, the technique of machine pressing of glass was rapidly introduced in England and on the Continent, but judging from the remaining objects, relatively little lacy glass seems to have been produced in Britain during the period 1830-50. A toddy plate bearing likenesses of Victoria and Albert is characteristic of English lacy pressed glass. The Baccarat and St. Louis glasshouses in France and Val St. Lambert in Belgium produced a wide variety of brilliant, well-designed lacy glass, which is illustrated in the catalog of Launay Hautin,[9] a wholesale distributor of glass for these three factories (Fig. 10).

It seems generally accepted that the production of lacy glass designs requiring elaborate, detailed (and therefore very expensive) molds, began to wane about 1840 and was superseded by designs of simpler and broader elements, which required less expensive molds. It is also generally accepted that by 1850 lacy pressed-glass production had all but ceased.

A close examination of two catalogs from the firms of McKee
and Brother and Bakewell, Pears and Bakewell in Pittsburgh
presents some evidence to the contrary. The McKee catalog,[10]
though undated, has been traced to 1859; the Bakewell catalog
may be dated to about 1875, since it contains illustrations
of double glass for which the Bakewell firm obtained a patent
in 1874. The McKee catalog illustrates a number of "rayed
base" glasswares including a 7-inch nappy (a serving dish)
and a butter dish. Despite the fact that the illustrations are
small and elementary rather than sophisticated and detailed,
the form of the 7-inch nappy and (to a large degree) the design
of "peacock eyes," diamond diapering within circles and
diamonds, and the rayed base are very closely associated
with, if not identical to, the 7 1/4-inch bowl bearing the
peacock-eye motif shown in figure 11. The relationship is
close enough to permit a cautious suggestion that the bowl
was a product of the McKee company and was probably made
there during the 1860s. Even more positive identification of
the covered, footed bowl with lacy designs, shown in figure
12, right, can be made with the five bowls of various sizes
bearing the "Rochelle" design, shown in a page of the Bake-
well, Pears and Bakewell catalog, reproduced by Ruth Webb
Lee in Early American Pressed Glass.[11]

It is evident from these two examples that at least at
some factories lacy pressed-glass designs either continued
well beyond the usually accepted terminal date of 1850, or
were revived on occasion. Another covered bowl of the same
form as the Rochelle pattern bowl is illustrated in figure 12.
It bears a lacy design of peacock eyes and has the same
finely ribbed design on the foot. It seems likely that this
bowl was also a product of Bakewell, Pears and Bakewell and
that it was produced in the 1870s. Undoubtedly numerous
other similar lacy glass tablewares that have been generally
attributed to the 1830-50 era were made in this later period.
It is necessary on the basis of this evidence to review the
dating of some of these American lacy glass pieces.

In Europe the popularity of lacy pressed-glass designs
apparently continued throughout much of the century. Several
pages from a catalog[12] of the firm of Meyr-Neffen of Bohemia,

Fig. 11. Probably McKee and Brother, "rayed-base" bowl. Pittsburgh, Pa., ca. 1860. Max. diam. 6 1/2". (Corning Museum of Glass: Photo, Raymond F. Errett.)

Fig. 12. Left: probably made by Bakewell, Pears and Bakewell, pressed-glass covered bowl. Pittsburgh, Pa., ca. 1870-80. "Peacock-eye" or "comet" design; max. diam. 6". Right: "lacy" pressed-glass covered bowl bearing the "Rochelle" design, which appears in a Bakewell, Pears and Bakewell Company catalog published ca. 1875. (Corning Museum of Glass: Photo, Raymond F. Errett.)

Fig. 13. <u>Left to right</u>: all attributed to the Boston and Sandwich Glassworks, Boston, Mass., ca. 1840-55. Machine-pressed candleholder of translucent light-blue glass; machine-pressed whale-oil or fluid-burning lamp of light translucent green and white glass; machine-pressed candleholder of translucent blue and white glass; H. lamp 12 1/8". (Corning Museum of Glass: Photo, Raymond F. Errett.)

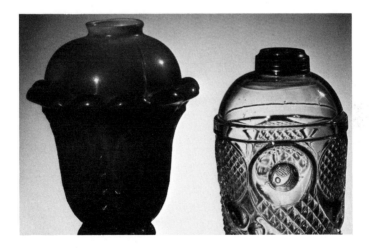

Fig. 14. Detail of two pressed-glass lamp fonts. <u>Left</u>: attributed to the New England Glass Company, Cambridge, Mass., or to the Boston and Sandwich Glass Company, Sandwich, Mass., ca. 1840-50. The vertical mold seam on the upper part of the font is definitely visible. <u>Right</u>: probably the New England Glass Company, Cambridge, Mass., ca. 1850-55. The mold seam on this lamp has been eliminated, perhaps as a result of the improvements claimed in J. Magoun's patent no. 5,303. (Corning Museum of Glass: Photo, Raymond F. Errett.)

probably dating from about 1860-70, illustrate candleholders, chamber sticks, plates, sugar bowls, and salts bearing lacy designs. French and even Swedish factories continued to produce lacy designs during the third quarter and into the fourth quarter of the nineteenth century.

Despite the evidence that the production of lacy pressed glass continued in some instances well beyond 1850, broader, more simple patterns of pressed glass began to be made about 1840. This stylistic trend undoubtedly resulted partly from the effects of President Jackson's financial policy, the closing of banks in 1837, and the subsequent depression that lasted for the next several years. The need for economy in the production of molds through the simplification of designs seems to have occurred at the same time that a change in taste took place, not only in pressed glass but also in cut-glass designs. The development of pressing technology and the exploitation of interchangeable parts to create different products using a limited number of molds were undoubtedly economic factors influencing, to some degree, this change in style. Stylistic change seems to have occurred first in the production of lamps, candleholders, and vases. The Greek revival influence continued to be very strong and is evident in the columnar standards and classical bases on lamps and candleholders and in the use of the acanthus leaf as a decorative motif on lamp standards and fonts. The use of colored glasses, especially translucent blue, green, and white, became much more common during this period. Frequently, variations among the final products were achieved by pressing different elements of the product in different colors (Fig. 13).

Technical improvements in pressing, often patented, aided in producing more refined products. For example, Joseph Magoun, of the New England Glass Company, was granted a patent on September 25, 1847, for a mold that eliminated the appearance of vertical mold marks on the upper, undecorated portion of lamp fonts (Fig. 14). Magoun's patent was for a solid circular section at the top of the mold for forming the font, thus eliminating the vertical joints previously required. Magoun was also granted a patent for an improved glass press on December 6, 1845. It was one of the first practical

improvements in the press itself and consisted of a sliding
frame that received the cap plate of molds of various sizes
and designs and at the same time provided for the frame, plate
toggles, and rest block of the toggles to be adjusted with
respect to the mold, or bedplate, upon which it was placed.
Several years earlier, on August 21, 1841, Hiram Dillaway, a
young mechanic who had been hired in 1827 to establish a
mold-making department at the Boston and Sandwich Glassworks,
had been granted the first patent for multiple pressing of
objects. Specifically, it was for a mold designed to press ten
stoppers for decanters or bottles at one time by forcing the
glass through a central cylinder or fountain into individual
stopper molds radiating from it.

Many efforts were devoted to increasing the productive
powers of the press, including the development of power
presses to supersede manually operated ones. On January
31, 1854, and on August 25, 1863, William O. Davis was
granted patents for improved presses. In the latter patent he
stated: "The chief object which I have in view in my present
invention, as well as in the former one, is to secure an
accurately vertical movement of the piston rod and plunger by
relieving the piston rod from all side strain or pressure and the
bed plate of the press from the pressure of the piston rod and
the plunger." In short, his invention brought about a more
nearly vertical stroke of the piston rod, or plunger, which was
highly desirable to obtain uniform walls in pressing wineglasses,
decanters, and the like. On May 13, 1873 Jonathan Haley of
Pittsburgh was granted a patent for a power press. His in-
vention utilized a series of cranks "driven by a rotary shaft
carried by and in the frame of the press and arranged to
connect with and derive motion from the prime mover," and
included a reciprocating plunger and an arrangement in
combination "with the bedplate of the press, of sliding mold-
guides, arranged to be shifted at will from one side of the
bedplate to the other, under the plunger, whereby the press
is made a double press, admitting of one, or two more, work-
men working at one press at the same time." Washington
Beck of Pittsburgh was granted a patent on May 4, 1875, for
what he claimed was the first practical power press, although

on March 29, 1864, Frederick McKee and Charles Ballinger of
the McKee firm in Pittsburgh had invented a steam-operated
glass press. Numerous other individuals developed improved
presses; for example, on August 25, 1891, Daniel C. Ripley
of Pittsburgh registered his patent for a glass press operated
by either air or steam power. It was designed to enable the
power to be applied and controlled precisely in proportion to
the amount of glass in the mold. All of these improvements
aided in increasing the production of pressed glass, making a
greater variety of products available to more and more people
at all economic levels at a price they could generally afford.

A result of increased production and increased demand for
reasonably priced glass was the development of services of
pressed-pattern glass (Fig. 15). Among the earliest of these
patterns--broad and simple in concept--were Ashburton
(Fig. 15), Argus, and Excelsior. Ashburton continued to be a
favorite pattern throughout most of the century and was produced
by numerous glasshouses, including the New England Glass
Company, the Boston and Sandwich Glass Company, and some
Midwestern glass firms. While most of these patterns were
made in colorless flint glass of good quality, at least until
after the Civil War, a few were produced in colors, and some
were stained and/or gilded. Though plates do not usually
seem to have been a part of these services, practically every
other form of tableware was included. An 1868 New England
Glass Company catalog[13] of pressed-pattern glass indicates
the wide variety of patterns produced. At the Crystal Palace
Exhibition in New York, 1853, the New England Glass Company
exhibited an extensive selection of wares, mostly cut and
engraved, but also included were "130 pieces pressed sharp
diamond pattern glass-ware, consisting of bowls, tumblers,
champagnes, wine and jelly glasses."[14]

A Catalogue of 700 Packages Flint Glass Ware Manu-
factured by the Cape Cod Glass Works to Be Sold at the New
England Trade Sale, Wednesday, July 13, 1859 at 9 1/2
O'clock . . . New Granite Warehouse, 43 Summer Street,
Boston[15] lists a number of pressed glasswares in patterns.
Included are creamers, butters, and 6-inch nappies on feet,
as well as lamps, cone-shaped with handles in "Punty and

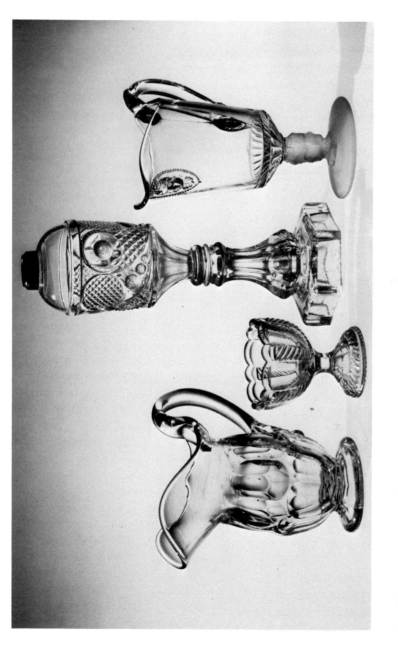

Fig. 15. American pressed-pattern glass. Left to right: Creamer in Ashburton pattern, probably New England Glass Company, Cambridge, Mass., 1840-70; Salt in cable pattern, Boston and Sandwich Glass Company, Sandwich, Mass., 1855-65; Fluid-burning lamp in "Horn of plenty" or "comet" pattern, probably Boston and Sandwich Glass Company, Sandwich, Mass., 1855-70. H. 10 1/8"; Cream pitcher in "Three-face" pattern, Duncan and Miller, Washington, Pa., ca. 1890. (Corning Museum of Glass: Photo, Raymond F. Errett.)

Star" pattern; butters and 6-inch nappies of "Feather and
Diamond" pattern; 6-inch "Star and Bee" nappies and butters;
3-, 4- and 5-inch "Comet" nappies; as well as 4-inch "Punty"
nappies. Whether these nappies are cup plates, or small
dishes referred to today as honey dishes, is uncertain. The
catalog also offered for sale many packages of "Shell,"
"Steamboat," and "Rope-Bottom Cone" salts. A wide variety
of pressed-pattern glass also appears in a List of Glass Ware,
Manufactured by Cape Cod Glass Company,[16] which dates
from about 1863. Among the patterns listed are "No. 64 Cape
Cod Pattern, No. 94 Rose Leaf Pattern, No. 96 Utica Pattern,
No. 95 Star and Punty, No. 19 Mirror Pattern, No. 22 Huber
Pattern, No. 200 Gaines Pattern, No. 400 Zuoaves Pattern,
No. 150 Mt. Vernon Pattern and Mt. Washington." In
addition, numerous miscellaneous wares are listed. Many of
these same patterns were made by other glass factories, both
in the East and the Midwest. The several catalogs cited are
only a small indication of the number of patterns and the vast
quantities of pressed-pattern glass made in American glass-
houses in the second half of the nineteenth century.

The quality of both designs and glass was remarkably
consistent until about 1865. From about 1840 to the mid-
1850s designs were fairly simple; after the mid-1850s they
became somewhat more decorative. Following the Civil War
and throughout the balance of the century, patterns degenerated
and became more elaborate and less distinctive. After the
perfection of a new soda-lime glass formula by William
Leighton, Jr., of the Hobbs-Brockunier Glassworks in Wheeling,
West Virginia, in 1864, the quality of most pressed glass
made in the balance of the century was inferior to that
produced earlier. To the uneducated eye this new lime glass
looked like flint glass, but it was actually of inferior quality.
It could, however, be made for one third the cost of flint
glass, an important factor to many glass manufacturers.

Numerous commemorative and novelty wares, often of a
sentimental nature, were produced by pressing during the last
third of the nineteenth century. At the time of the Centennial
Exposition in Philadelphia, Gillinder and Sons, a Philadelphia
firm that had erected a glasshouse on the Centennial grounds,

produced their Pioneer pattern, popularly called Westward Ho today. It depicted a noble American Indian in a kneeling position as the handle on covers of compotes and sugar bowls and a band of western scenery around the bowl. Both features were emphasized by a matte finish produced by acid.

During the 1870s a number of patents were granted for methods of producing decorative glasswares by means of pressing or a combination of pressing and blowing techniques. On June 14, 1870, Daniel C. Ripley was granted a patent for a mold producing twin-fountain oil lamps by these operations. Benjamin Bakewell, Jr., of Bakewell, Pears and Bakewell in Pittsburgh, was granted a patent on September 29, 1874, for manufacturing glass articles "by pressing glass of different colors, one upon or above another, in a mold, or molds, so as to form an article made up of two or more colors." This type of glass is sometimes referred to as "double glass." Its scarcity today indicates that it was manufactured in relatively limited quantities, perhaps because of difficulties encountered in producing it. On November 23, 1875, Thomas B. and James F. Atterbury were granted a patent for producing a cameo effect in glass. Despite some inconsistencies in the patent description, their process apparently fused an opal glass medallion and a glass plate together in the pressing operation. Atterbury spoke of "a medallion set in glass, made and united to the article in which it is set by the one operation of pressing, substantially as described."

Other decorative techniques used in the last third of the nineteenth century to further enhance and popularize pressed-glass tablewares included sand blasting, staining, gilding, and engraving of simple floral and geometric patterns on surfaces left plain in the pressing operation. In the early twentieth century, much pressed glass was decorated by spraying the hot glass immediately after it had been pressed with solutions of stannous or iron chloride to create a thin, shimmering iridescent film in imitation of the more expensive iridescent glass produced by such firms as Tiffany and Steuben. This type of glass is generally called carnival glass today. Despite the general deterioration of designs and quality in pressed glass in the late nineteenth century, there were some

well-designed and well-made pressed-glass pieces including some novelty wares. Among these may be cited the "Atterbury duck," patented by Thomas Atterbury in 1887, and the "Caryatid," or "Madonna," candleholder, patented by Henry Whitney of the New England Glass Company, May 10, 1870.

Regardless of the design and quality of the glass, pressed glass served both functional and decorative purposes in almost every household, including many where the cost of more expensive, handmade glassware would have been prohibitive. Continued improvements of glass presses and molds have resulted in today's gigantic, highly automated machines that produce, either by pressing or by a combination of pressing and blowing, the tremendous quantities of utilitarian glassware required by the demands of our present-day civilization.

APPENDIX

U.S. PATENTS RELATING TO THE MANUFACTURE OF

PRESSED GLASS

Patent number	Date issued	To whom/Location	Purpose
4,179	9/9/1825	John P. Bakewell Pittsburgh	Glass furniture (knobs)
4,553	11/4/1826	Henry Whitney and Enoch Robinson Cambridge, Mass.	Making glass doorknobs
4,892	10/6/1827	John Robinson Pittsburgh	Making pressed-glass doorknobs
4,901	10/16/1827	Phineas C. Dummer Jersey City, N.J.	Improvements in molds for pressing glass
4,902	10/16/1827	G. Dummer, P. C. Dummer, and Js. Maxwell Jersey City, N.J.	Improvement in the combination of molds for glass
5,112	5/14/1828	Thos. & John P. Bakewell Pittsburgh	Making glass furniture knobs
5,290	12/1/1828	Deming Jarves Boston	Improvement in the mode of pressing melted glass into molds
5,501	6/11/1829	Elijah Skinner Sandwich, N.H.	Manufacture of glass commode knobs
5,496	6/13/1829 (actually issued 5/13/1829)	Deming Jarves Boston	Manufacture of glass knobs and screws
6,004	5/28/1830	Deming Jarves Boston	Molds for glassmakers
6,198	10/19/1830	Deming Jarves Boston	Manufacturing glass knobs
6,262	11/26/1830	Jonathan McGann Kensington, Pa.	Manufacture of glass bottles, decanters of all kinds, and other pressed hollow glassware, with the necks smaller than the cavity of inside diameter of the vessel

Patent number	Date issued	To whom/Location	Purpose
6,817	10/3/1831 (actually issued 10/31/1831)	Spencer Richards Cambridge, Mass., and Attleborough, Mass.	Glass doorknobs
7,781	11/19/1833	Theodore T. Abbott Canton, Mass.	Glass knobs
2,226	8/21/1841	Hiram Dillaway	Mold for multiple pressing of stoppers
4,297	12/6/1845	Joseph Magoun East Cambridge, Mass.	Improvement in pressing glass in molds
5,302	9/24/1847	Joseph Magoun	Glass molding and pressing
5,303	9/25/1847	Joseph Magoun	Improvement in pressing lamp fonts
5,875	10/24/1848	Joseph Magoun	Glass molding
10,470	1/31/1854	W. O. Davis Pittsburgh	Glass press
15,548	8/19/1856	Henry W. Adams New York City	Mold for pressing glass fountain lamps
29,017	7/3/1860	Andrew J. Sweeney	Improvement in molds for glass goblets
30,093	9/18/1860	George W. Scollay	Improvement in glass molds
34,345	2/11/1862	J. S. Atterbury, T. B. Atterbury, and James Reddick Pittsburgh	Improvement in the manufacture of hollow glassware
34,555	3/4/1862	J. S. Atterbury, James Reddick, and T. B. Atterbury Pittsburgh	Improvement in molds for glassware
35,429	6/3/1862	J. S. Atterbury, T. B. Atterbury, and James Reddick Pittsburgh	Improvement in the manufacture of hollow glassware in bas relief
35,430	6/3/1862	J. S. Atterbury, T. B. Atterbury, and James Reddick Pittsburgh	Improvement in the manufacture of hollow glassware

Patent number	Date issued	To whom/Location	Purpose
39,698	8/25/1863	William Otis Davis Pittsburgh	Improvement in glass presses
42,143	3/29/1864	Frederick McKee and Charles Ballinger	Glass-pressing machine
50,437	10/17/1865	Atterbury Bros.	Manufacture of drinking glasses
51,386	12/5/1865	William T. Gillinder Philadelphia	Improvement in blowpipes
60,203	12/4/1866	Henry J. Leasure and James S. Gill	Cooling glass press
64,312	4/30/1867	Robert E. Haines	Glassware mold
71,216	11/19/1867	J. H. Reighard	Glass mold
75,604	3/17/1868	David Turpie	Glass mold
75,577	3/17/1868	Daniel C. Ripley	Manufacture of glass
79,737	7/7/1868	Hiram Dillaway	Glassware mold
79,738	7/7/1868	Hiram Dillaway	Cooling glassware molds
79,786	7/7/1868	Michael Sweeney	Glass pressing machine
83,210	10/20/1868	Daniel C. Ripley	Manufacture of glassware
90,040	5/11/1869	Alonzo E. Young	Glassware mold
91,118	6/18/1869	Robert D. Haines Boston	Improved sectional mold for glassware
104,205	6/14/1870	Daniel C. Ripley Birmingham, Pa.	Improved mold for glass lamps
114,140	4/25/1871	Hobbs, Brockunier, and Leighton	Manufacture of lamp shades
114,569	5/9/1871	William C. King Pittsburgh	Improvement in machines for operating glass molds
4,571	9/26/1871 (reissued)	William C. King Pittsburgh	Improvement in machines for operating glass molds
124,364	3/5/1872	Henry J. Leasure	Improvement in glass presses
134,071	12/17/1872	William C. King Pittsburgh	Improvement in glass presses

Patent number	Date issued	To whom/Location	Purpose
138,750	5/13/1873	Jonathan Haley Pittsburgh	Glass presses
139,993	6/17/1873	James S. Atterbury and Thomas B. Atterbury	Improvement in methods and molds for manufacturing glassware
145,144	12/2/1873	Andrew H. Baggs Bridgeport, Ohio	Improvement in the manufacture of glassware
155,403	9/29/1874	Benjamin Bakewell, Jr. Pittsburgh	Improvement in the manufacture of glassware
156,569	11/3/1874	John H. Hobbs, William Leighton, Jr., and Charles W. Brockunier Wheeling, W. Va.	Improvement in stemmed glassware
159,519	2/9/1875	William Leighton, Jr. Wheeling, W. Va.	Improvement in hollow pressed glassware
162,791	5/4/1875	Washington Beck Pittsburgh	Improvement in glass presses
170,218	11/23/1875	Thomas B. Atterbury Pittsburgh	Improvement in the manufacture of glassware
206,569	7/20/1878	H. Sellers McKee	Molds for decorating glassware
216,134	6/3/1879	David Barker	Glass molds
219,240	9/2/1879	Washington Beck and Henry Feurhake Pittsburgh	Processes of preparing glass molds
234,300	11/9/1880	William Libbey Boston	Mold and process for the manufacture of glassware
234,564	11/16/1880	William Haley Pittsburgh	Mold for pressed glassware
260,819	7/11/1882	Philip Arbogast	Manufacture of glassware
341,141	5/4/1886	Jonathan Haley	Ornamental pressed glassware and process for making same
344,500	6/29/1886	Henry C. Schrader Wheeling, W. Va.	Mold for hollow glassware
364,298	6/7/1887	Daniel C. Ripley Pittsburgh	Manufacture of glassware

Patent number	Date issued	To whom/Location	Purpose
452,722	5/19/1891	Louis Schaub	Glassware
458,191	8/25/1891	Daniel C. Ripley Pittsburgh	Machine for forming glassware
477,336	6/21/1892	Daniel C. Ripley Pittsburgh	Manufacture of glassware
485,032	10/25/1892	Jonathan Haley	Ornamental pressed glassware
582,949	5/18/1897	Julius Proeger Greensburg, Pa.	Method of and apparatus for forming glass articles

NOTES

1. Deming Jarves, Reminiscences of Glass Making (Boston: Eastburn's Press, 1854), pp. 93-94.
2. Pellatt, Curiosities of Glass Making (London: D. Bogue, 1849), p. 121.
3. U.S. Patent no. 4179. See appendix for other patents referred to in this paper, as well as additional patents relating to the subject. I am indebted to C. S. Janes, Jr., of Corning Glassworks, for providing copies of many of these patents and to Albert Christian Revi, whose informative article "The Development of the Pressed Glass Industry in America," Glass Industry 41 no. 5 (May 1960): 268-73, 296-99, provided much of the data relating to patents cited in this paper.
4. Pellatt, Curiosities of Glass Making, p. 121.
5. [James Boardman], America, and the Americans (London: printed for Longman, Rees, Orme, Brown, Green, & Longman, 1833), pp. 83-84.
6. Royall, Mrs. Royall's Pennsylvania or Travels Continued in the United States, 2 vols. (Washington, D.C.: by the author, 1829), 2:125.
7. Record book of the Boston and Sandwich Glass Company, present ownership unknown, quoted by Ruth Webb Lee, Sandwich Glass (2d ed.; Framingham Centre, Mass.: by the author, 1939), p. 98.
8. Bill of lading, New England Glass Company to William E. Mayhew and Company, Baltimore, July 26, 1828, Maryland Historical Society, Baltimore, MS300. All bills of lading or invoices to Mayhew referred to in this paper are in this same collection.
9. The light-blue glass toddy plate bearing the profiles of Victoria and Albert is in the collection of the Corning Museum. Catalog, Launay Hautin & Cie, Paris, Collection des Dessins Représentant Exactement les Cristaux, Compris dans le Tarif Général de Launay, Hautin & Cie, seul Dépot des Manufactures de Baccarat, St. Louis, Choisy et Bercy (Paris: de Thierry frères, 1840: Collection, Corning Museum of Glass.)
10. Prices of Glassware Manufactured by McKee and Brother (Pittsburgh: W. S. Haven, [1859]: Collection, Corning Museum of Glass.)

11. Catalog, Bakewell, Pears and Bakewell Company: see esp. the page illustrating the "6 in. Rochelle Comport & Cov." reproduced in Ruth Webb Lee, Early American Press Glass (36th ed.; Wellesley Hills, Mass.: Lee Publications, 1960), pl. 23. (Catalog, Collection of Thomas C. Pears, Jr.)

12. Catalog of pressed-pattern glass, title page lacking, Meyr-Neffen Company, Bohemia, ca. 1860-70. (Collection, Corning Museum of Glass.)

13. Catalog of pressed-pattern glass, title page lacking, New England Glass Company (Boston: printed by the New England Lithographic Steam Printing Co., 1868: Collection, Corning Museum of Glass.)

14. C. R. Goodrich, ed., Science and Mechanism: Illustrated by Examples in the New York Exhibition, 1853-54 (New York: G. P. Putnam, 1854), p. 220.

15. Corning Museum of Glass, library, acc. no. 11272, TP868/c237, gift of Mrs. Elizabeth Bowker.

16. Original in the collection of the Sandwich Glass Museum, Sandwich Historical Society, Sandwich, Mass.

JOHN HENRY BELTER: MANUFACTURER
OF ALL KINDS OF FINE FURNITURE

Clare Vincent

THE title, from a label on a parlor table in the Museum of the
City of New York, underlines the appropriateness of including
John Henry Belter in a volume on technology and the decorative
arts. For technology implies machines, machines lead to
manufacturing, and Belter is an example of a genuinely creative
cabinetmaker content to be known to his patrons and to posterity
as a manufacturer.

Belter is best known as the maker of a type of mid-
nineteenth-century parlor set characterized by generous propor-
tions, sinuous curves, and deep, yet often delicate, carving.
Belter's furniture was designed as a personal adaptation of
the style variously called rococo revival, Victorian rococo, or
second rococo, combined with certain elements of the Gothic
revival. The furniture, called "pressed work" by Belter, is
constructed in part of laminated rosewood and is really an
elegant form of plywood.

A fine center table from the parlor set made for the New
York home of Mr. and Mrs. Carl Vietor (Fig. 1) illustrates
the characteristics of Belter's more elaborate furniture.[1] The
paper label, from which the title of this article is taken,
identifies the table as the work of Belter and dates the piece
between 1856 and 1861. The decoration of the table consists
of S-scrolls and C-scrolls combined with grapes, pomegranates,
roses, and pendent morning glories, all of which surely have
their genesis in English pattern books. These naturalistic
motifs are combined within free, serpentine-scrolled elements
(arabesques or "arabaskets" as Belter once called them) that
are unlike anything published in England. They are instead
peculiar to Belter's designs and to those of the American
cabinetmakers who used Belter's multilayered constructional
methods.

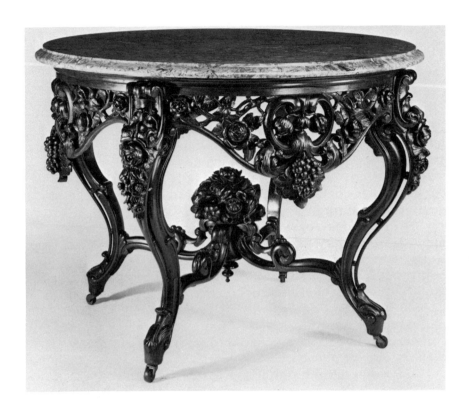

Fig. 1. John Henry Belter, center table. New York, 1856-61. Carved and laminated rosewood, with green-veined marble top; H. 28 1/4". (Museum of the City of New York, Gift of Mr. and Mrs. Ernest Gunther Vietor.)

Belter was born in 1804 in South Germany and served his apprenticeship in Württemberg.[2] The date of his emigration is thought by his descendants to have been 1840. In 1844 his name first appeared in Doggett's New York City Directory as a cabinetmaker at 40 1/2 Chatham Street, now Park Row. From 1846 until 1852 Doggett placed him at 372 Broadway. In 1853 Trow's New York City Directory listed a new address at 547 Broadway, and the 1854 edition of the same directory listed the name J. H. Belter and Company for the first time and recorded the opening of his factory at Third Avenue near East 76th Street.[3] In 1856 the directory noted a move to 552 Broadway for the shop and evidenced the entry of J. H. Springmeyer, a brother-in-law, into the business. In 1861, when two more Springmeyers, William and Frederic, joined the business, the firm was a 722 Broadway. After Belter's death in September 1863, the Springmeyers continued the furniture business under the name of J. H. Belter and Company until 1865, when they took the name of Springmeyer Brothers.[4]

Belter's construction methods are of great interest to the furniture historian, as well as the historian of technology, for to create his distinctive designs he used wood in ways that transcended the traditional limitations of the material. A slipper chair in the Metropolitan Museum of Art (Fig. 2),[5] with its lacy pattern of intertwined grapevines and oak leaves framed by the flowing scrolls or arabesques that were Belter's original contributions as a designer, provides a striking example of the way in which the demands of design literally commanded developments in production technology. The typical rail and stile construction of the preceding centuries would plainly have been unequal to supporting the openwork pattern of this chair.

Belter's methods can be examined in two ways: from existing United States patents and from surviving examples of his furniture. For the construction of chairs and sofas, there are two patents. Belter's patent for an "Improvement in the Method of Manufacturing Furniture," dated February 23, 1858, is useful not only in determining what new process Belter introduced but also in documenting the complete method by which he made laminated and bent wood chair backs. Figures

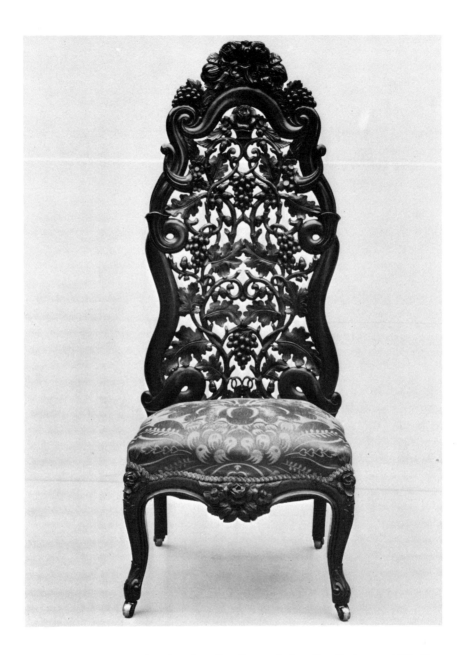

Fig. 2. John Henry Belter (attributed), slipper chair. New York, ca. 1850-55. Laminated, bent and carved rosewood; H. 44 1/4", W. 18 1/2", D. 17 1/2". (Metropolitan Museum of Art, Gift of Mr. and Mrs. Lowell Ross Burch and Miss Jean McLean Morron.)

1 and 2 of the patent drawing (Fig. 3) show that Belter replaced the usual rail and stile with a back composed of laminated wooden panels (A,B,C,D). These panels, when bent to the desired shape and glued together in overlapping, cross-banded layers, produced a sturdy back that could be pierced, carved, or upholstered. Belter explained that the panels, or staves as he called them, shown in figure 8 of the patent drawing (Fig. 3), were each composed of two layers of wood. The innermost layer, made of a desirable wood, was placed in a vertical position. Behind this layer of veneer was placed a second layer with the grain running at right angles to the first (Fig. 3, figure 9). The two layers were glued and bent in a wedge-shaped clamp (Fig. 3, figures 10, 11, 12). The edges were trimmed with a special kind of plane (Fig. 3, figure 13), and notches were cut in the top and the bottom ends. The notches were then secured on knife edges attached in perpendicular fashion to the large circular caul (Fig. 3, figures 14, 15, 17). A number of these staves were placed to fit around the circular core of the caul (Fig. 3, figure 14).

A second vertical layer was then glued and molded into a stave with its own cross-banded pieces (Fig. 3, figure 9), somewhat wider than the first layer, to allow for the bending process in the large caul. The staves of the second layer were placed outside the first layer of veneered staves, glued, and forced into place by the slots cut on their edges. The second layer of staves was placed so that they overlapped the seams between the staves of the first layer. Any number of layers could be built up in this manner and finished with a vertically grained veneer of desirable wood on the outermost layer. But the layers had to be added rapidly so the glue did not dry.

The whole cylindrical construction of staves was then compressed between the core and the outer mold and left to dry for twenty-four hours. The outer mold was removed in sections, revealing a varrellike structure that was cut into eight pieces, four above and four below (Fig. 3, figure 14). The vertical (Fig. 3, figure 6) and horizontal (Fig. 3, figures 4, 7) profiles of a single piece can be seen in the patent drawing.[6]

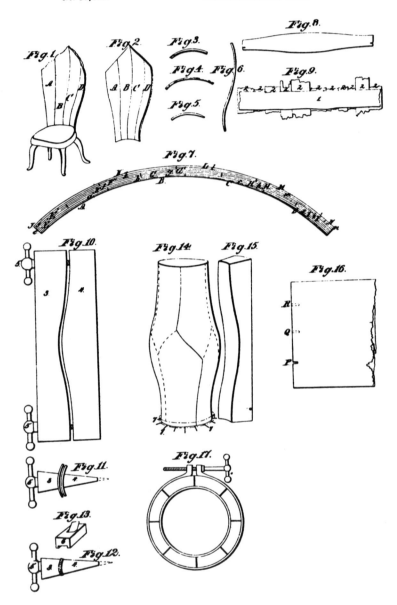

Fig. 3. John H. Belter, "Improvement in the Method of Manufacturing Furniture." U.S. Patent no. 19,405, Feb. 23, 1858. (Photostat, United States Bureau of Patents.)

As mentioned, the outermost layer, which would in fact become the exterior surface of the reverse side of the chair back, consisted of a vertically grained veneer of a desirable wood. Although the seams of this outermost layer need not correspond to the seams of the staves beneath, they would nevertheless have occurred as hairline cracks at regular intervals along the whole laminated cylinder. The distance between them would necessarily have been governed by the width of the board from which the veneer was cut. The rotary cutter used to peel long sheets of veneer, without a seam, from a log in turnip fashion was a much later invention,[7] and the veneer it produced has a distinctive grain pattern by which it can be easily identified.

From the illustration (Fig. 3, figure 14) showing how the whole laminated cylinder was cut apart, it is obvious that within a set of chairs, some of the hairlines could be expected to fall in the center of the backs, while others might be found in an off-center position. Smaller side chair or slipper chair backs might fit within a single sheet of veneer and show no trace of a seam, while larger armchairs would require at least two sheets of veneer to span the width of the back. The presence of hairline seams does not, therefore, have the significance sometimes implied.[8] The presence of a seam does not negate the attribution of a piece to Belter. In fact, the reverse side of an armchair (Fig. 4) bought from Belter by Mrs. Samuel Milbank of New York City clearly shows a central seam between sheets of rosewood veneer with matching grains. This grain pattern was obtained by sawing or cutting a board in two and opening it up like a book. In Belter's time, with the machinery available, there was no way of avoiding such joints, even if indeed it had been considered desirable to do so.

Seven layers are shown in the patent illustration (Fig. 3, figure 7). Seven are often found on Belter's products. He suggested rosewood for the exterior and oak, hickory, or black walnut for the interior layers. The patent states that the described process may be used to construct any type of furniture by simply changing the form of the clamps and cauls. The aesthetic and practical advantages of the method were expressed by Belter himself.

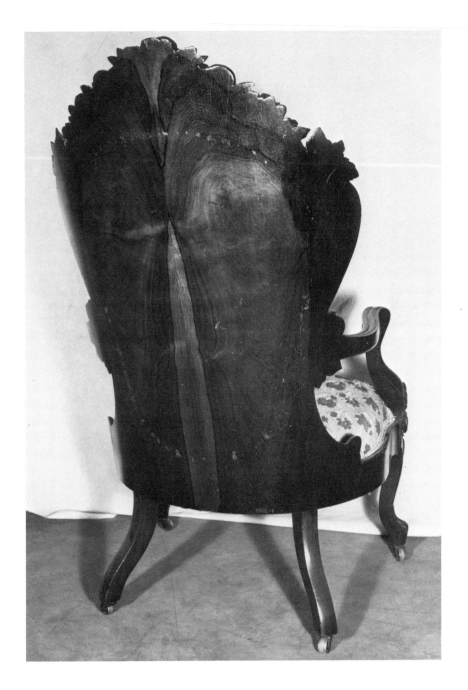

Fig. 4. John Henry Belter, armchair. New York, before 1855. Laminated
and bent rosewood back; H. 48". (Collection of Edward M. Foote, Jr.)

This work is more graceful in appearance and
better adapted in form to its intended use than
ordinary pressed work, and is much stronger and
stiffer. The dishing form in effect adds to the
thickness of the material.

When a transverse strain is applied to my
pressed work in any direction whatsoever, the
force tends to compress a portion or portions of
the material and to extend another or others,
thus greatly increasing its ability to withstand
such strains according to laws well recognized.
The pressed work made in the ordinary manner
of sheets simply glued together without being
formed into staves is capable of being curved
or bent in one direction only.

My work is capable of resisting with great
power transverse strains applied in any direction
and tending to break it along any line. In the
method of construction I have described the whole
assumes exactly the form desired without splitting
or wrinkling and with all the joints mathematically
close and perfect.[9]

Belter's remarks about "dishing" have remained something
of a puzzle. I have searched for a number of years for a chair
with a vertical profile matching the one shown in the patent,
and I have found that only the back of the patent model, now
in the Smithsonian Institution (Fig. 5),[10] displays the S-curve
and concave shape shown in the patent drawings. If Belter
did make chairs in the manner described in the patent, in
actual practice his clamps and cauls must have been far less
adventurously curved than those in his drawings.

The next step in finishing a chair back is explained in an
earlier patent by Belter, "Machinery for Sawing Arabesque
Chairs," dated July 31, 1847.[11] The machine, a single movable
saw, was used by Belter to obtain the basic pattern of openings
for his pierced, lacy, decorative carvings. It was a variety of
jigsaw that allowed the chair back to be fixed in position,
pierced, and then sawed in any direction to meet the require-
ments of an irregular and complicated design.

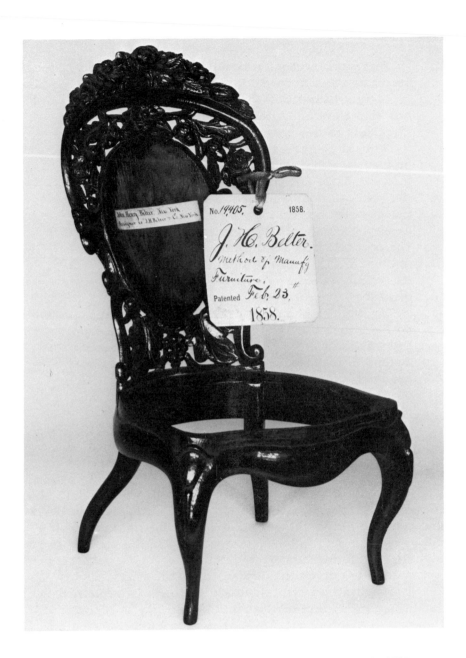

Fig. 5. John Henry Belter, patent model of an armchair. New York, 1858.
Laminated, bent and carved rosewood; H. 11 13/16". (Smithsonian Institution,
National Museum of History and Technology.)

Chair backs were attached to the seat rail in an irregular but unobstrusive pattern, so that on each side the outermost veneer gradually blended with and became a part of the seat rail. The arms and legs of the armchairs were generally carved from a single piece, and the seat rails were attached to the sides. When the shaped and pierced carcasses were assembled, hand carving produced the elaborate scrolls, grape and rose, oak leaf and acorn, cornucopia, or floral designs, together with fine finger moldings. Where a high relief pattern of decoration was called for, extra pieces of rosewood were glued to the concave side of the chair back. The quality of the carving of signed and well-documented pieces is almost always good, but it may never be possible to distinguish Belter's own work from that of his assistants.

In 1856 Belter's patent bed established him as the designer and inventor of a distinctively different type of bed. Few examples of the bed still exist. Their scarcity is certainly due partly to the impracticality of their size in a modern house. Also perhaps Belter's beds were not as often imitated by competitors as were his parlor sets.

The patent, "Bedstead," dated August 19, 1856,[12] is, in its simplest terms, for a laminated structure of only two pieces held together by a notched internal frame (Fig. 6, figures 2, 3). Standard rail and stile construction was given up for a kind of wrap-around look that, except for its decoration, is not far removed from the effect of the molded chairs of the 1930s and 1940s designed by Marcel Breuer or Charles Eames. The process of lamination was not the subject of the patent, for Belter was definitely not the inventor of plywood or even of bent plywood.[13] He was quite careful to make this clear in the text of his chair patent. "I do not claim the simple pressing of veneers and glue between dies or cawls, one of which is convex and the other concave; nor do I claim the so gluing of veneers together that the grain of each stands at right angles to that of the next." In the bed patent he stated: "I am aware that veneers glued together with the grain of each layer standing at right angles to the next have been long in use for the purpose of combining strength and lightness. This I do not claim nor do I claim the described method of producing it."[14]

Fig. 6. John H. Belter, "Bedstead." U.S. Patent no. 15,552, Aug. 19, 1856.
(Photostat, United States Bureau of Patents.)

Belter did go on to describe at length the method he used to produce the wood for his bed, even though it was not part of the patented process. In this case the process was a simpler one than the stave method he invented for chairs. It is in fact much closer to the modern method of manufacturing plywood.

> The veneers from which the parts A A are formed
> may as well be a little thicker than ordinary, say
> about 1/16 inch thick. The glue should be of the
> very best quality, pretty thin and hot. The sheets
> to form one surface being spread on the table, and
> liberally covered with glue, each successive layer
> should be treated in the same manner, taking care
> to lay the veneers in each layer so that the grain
> shall run at right angles to the grain in the last.
> Any odd number of layers may be used, but I prefer
> nine, and the whole mass if [sic] sheets should
> then be immediately pressed between hot "calls,"
> I.J, which bend it to the form required. When the
> "calls" I J, are firmly pressed to their places, the
> superfluous glue will exude at the edges of the
> sheets, and after remaining seven hours or more,
> under pressure the "calls" may be carefully
> separated but the compound sheet must be allowed
> a few days to become thoroughly dry. After this
> period the work may be finished by ordinary tools,
> gluing on more wood to form a sufficient thickness
> for the carved portion when necessary.[15]

Belter says little about how his cauls were made, either here or in the chair patent, but from the fact that they were heated, it seems probable that they were metal rather than wood. The planklike effect of the representation of the bed veneers in the cauls (Fig. 6, figure 5) may simply be a way of visually distinguishing the core of the mold from the exterior. Of the preparation of the wood veneer, whether steamed or merely wet from thin, hot glue, or of the composition of the glues used, Belter says nothing.

In the case of Belter's patent bed, one mold (Fig. 6,
figure 5) turned out the head and half of the sides of the bed,
and another the foot and the other half of the sides. The two
halves were held together by an internal frame made in a
single piece (Fig. 6, figure 3) and used in place of slats.
This was, in fact, the invention covered by the patent. The
joint uniting the halves of a side was strengthened, if desired,
by the addition of a rail across the top of the side and by
casters placed on either side of the joint (Fig. 6, figure 4).

In his paragraph on the advantages of the invention,
Belter shows the amusing, but really completely functional,
reasons for his design.

> Bedsteads as ordinarily constructed are necessarily
> composed of several parts secured together in a
> manner which requires considerable time and in
> some cases peculiar wrenches or other instruments
> to effect either their junction or their separation.
> This is an evil more particularly apparent when it
> becomes necessary to separate the parts very
> hurriedly in case of fire. One object of my inven-
> tion is to surmount this difficulty, and allow the
> parts to be immediately separated without tools.
> Again the ordinary bedstead contains deep and
> intricate recesses about the joints and fastenings
> which are difficult of access and notorious as
> hiding places for bugs. A second object of my
> invention is to avoid the necessity for these
> recesses. Again the thickness of posts and other
> parts in ordinary bedsteads intrudes upon what
> would otherwise be valuable space either on their
> interior or exterior faces. A third object of my
> invention is to avoid this evil. And again an
> ordinary veneered bedstead is liable to contain
> empty spaces between the veneer and the solid
> in which spaces young bugs may be concealed.
> These spaces result from inequalities in the "calls"
> as the large molds are termed which press the veneer
> upon the solid wood. Whenever a depression exists

in the "calls" the solid wood having little or no
ability to yield does not adapt itself thereto, and
an empty space M is the result as shown in Fig. 7.
A fourth object of my invention is to avoid this
evil.[16]

Fire, bedbugs, space saving, solidity--what better answer to
those critics of the nineteenth century who charge that crafts-
men of the period were concerned solely with piling decoration
upon decoration? Belter's patents reveal a constant concern
for achieving the simplest, lightest, and most delicate
structure that could carry the decoration demanded.

Although the patent is for a structure of two pieces,
Belter notes that it can be made as well in four. He notes
further that he often made the larger pieces in several sections
and glued them together with a tapering scarf. He says that
the "strength of such a scarf is very nearly or quite equal to
the other portions and I do not term such a scarf a 'joint' in
the ordinary acceptation of a term. In general when I make
the bedstead proper in only two parts I prefer to manufacture
each of the parts in three pieces and then glue them together
as described."

I have found no example of a two-piece bed, but a good
example of a four-piece structure can be seen in the collections
of the Brooklyn Museum (Fig. 7).[17] The bed bears a stamp
"J.H. Belter, Patent, August 15, 1856, N.Y." The device
holding the four pieces together is somewhat different from
that described in the patent. In this case the two separate
side pieces are attached to the head and foot by means of
interlocking end pieces, and the internal frame is dispensed
with. The bed can still be dismantled quickly without the
aid of a tool, an advantage that Belter stressed in the patent
for the two-piece bed.

The Brooklyn Museum also has a bureau (Fig. 8)[18] that,
although not of matching design, was apparently used with
the bed. The quality of the carved decoration on the mirror
with its high relief doves and putto and on the relatively
quiet, indeed rather flat, rococo scrolls of laminated wood
on the drawers, serves as a warning to those who identify

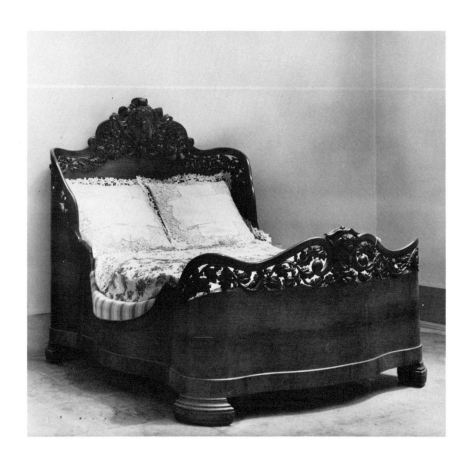

Fig. 7. John Henry Belter, bedstead. New York, after 1856. Laminated, bent and carved rosewood; H. 62 1/2", W. 58 1/2", L. 83". (Brooklyn Museum, Gift of Mrs. Ernest Vietor.)

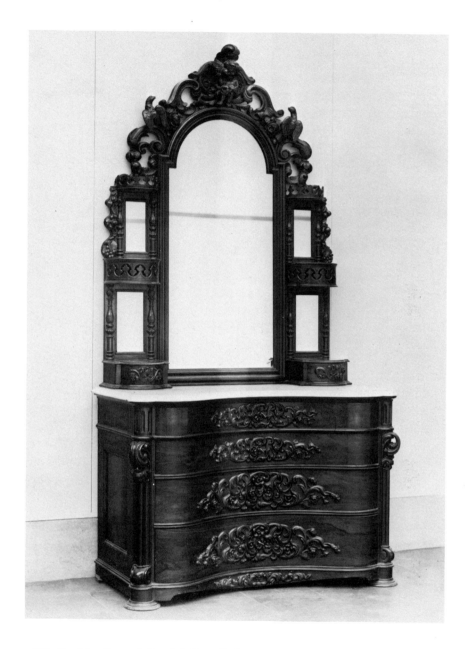

Fig. 8. John Henry Belter (attributed), bureau. New York, after 1856. Laminated, bent and carved rosewood, with white marble top; H. 95", W. 49 1/2", D. 25". (Brooklyn Museum, Gift of Mrs. Ernest Vietor.)

Belter or Belter factory products on the basis of crisp,
well-defined carving. There is no absolute proof for the
attribution of the bureau since it is neither signed nor
stamped. It does come from the Vietor collection, not only
the source of the bed but also the source of the parlor set
accompanied by the labeled Belter center table (Fig. 1).
Thus, the probability that the bureau is Belter's work seems
rather strong.

In general outline, though not in structure, the bureau
is very much like the one illustrated in Belter's patent for
a "Bureau Drawer" (Fig. 9, figure 5). Dated January 24, 1860,
the document describes Belter's special method of drawer
construction. The sides of the patent drawer are made of a
single strip of laminated wood molded in cauls of the proper
shape (Fig. 9, figure 1) and joined together with a glued
scarf. The drawer bottom is also made of laminated wood,
and the molded sides are glued to it with two of the bottom
edges projecting. These projecting edges fit into grooves
cut into the sides of the bureau, eliminating the need for
dust boards between the drawers and cleats within the bureau
to support the drawers. The inventor observed that this
economical, space-saving construction was possible because
of the imperviousness of laminated construction to warping
and swelling in damp weather. The patent also includes an
ingenious system of locking the various drawers from one
keyhole.

In all his practicality and attention to detail, Belter
never lost interest in the aesthetic aspects of his inventions.
If the one-piece chair back was built to carry Belter's
arabesques freely and uninterruptedly, the patented bureau
drawer was made to carry out Belter's idea of a design that
was unified in construction and decoration.

In addition to the several features and advantages
before enumerated my bureau is superior in appear-
ance to any other in use by reason of the absence
of stretchers and of key hole and locks. The sides
of the whole series of drawers may if I choose be
constructed from a single broad sheet of pressed

Fig. 9. John H. Belter, "Bureau Drawer." U.S. Patent no. 26,881, Jan. 24, 1860. (Photostat, United States Bureau of Patents.)

work--sawing them apart at such heights as may
be required. By this means the whole front may
be made to exhibit a degree of unity hardly prac-
ticable or possible where stretchers are required.[19]

To minds educated by the Bauhaus and conditioned to an
almost total lack of decoration, Belter's notion of unity seems
lost under the layers of scrolls, leaves, and flowers that
covered his furniture. But it was perhaps this very idea of
constructional unity that enabled Belter to succeed better
than his rival designers in creating decorative designs that,
while partaking of more than an ample amount of the Victorian
"horror vacuui," managed on the whole to weld decoration
and structure into a cohesive whole.

In his own time, Belter's work was both much admired
and much copied. Although his techniques required consider-
able specialized skill and a certain investment in equipment,
there is no longer any question that other cabinetmakers in
New York and perhaps in Philadelphia used similar methods
of laminating and bending wood. Thus, the mere presence
of multilayered wood in a chair back or sofa cresting is plainly
not a reliable indication of Belter's authorship.

Unfortunately no design or pattern book from Belter's
workshop has survived, nor did he issue trade catalogs. It
is hard, therefore, to attribute specific decorative designs,
much less specific pieces of furniture, unless they are either
labeled or documented. Surviving furniture does confirm
Enrest Hagen's assertion that Belter invented a generic type
of furniture. Hagen said that "those heavy over-decorated
parlor suites with round perforated backs [were] generally
known as 'Belter Furniture' from the original inventor J. H.
Belter, 372 Broadway."[20] The point I wish to make at present
is that although Belter's competitors certainly used similar
construction methods, it is still somewhat difficult to say to
what extent they copied or pirated his designs. We know
from the evidence provided by the patent jigsaw for making
chair backs, dated 1847, as well as from certain very well-
documented examples of parlor furniture, that Belter's style
was fully developed before 1855.

A simple and probably rather early version of the arabesque appears on an armchair in the collection of Edward Foote, Jr. The chair was bought by Foote's great-grandmother, Mrs. Samuel Milbank, between 1844, when Belter is first listed as a cabinet-maker in the New York directories, and 1855. Mrs. Milbank was a prominent New Yorker whose enthusiasm for Belter prompted her to furnish her house at 13 East 24th Street with two parlor sets and a bedroom set, consisting of bed, bureau, wardrobe with pier mirror, and sewing table, from Belter's establishment. In 1855 she gave her daughter, Elizabeth, a third parlor set on the occasion of Elizabeth's marriage to William Cauldwell, which brought the grand total of her purchases from Belter to thirty-five pieces.[21] Another chair from the Milbank collection provides evidence that Belter also made more elaborate pierced designs in the period before 1855.[22] A similar suite sold to Col. B. L. Jordan on September 5, 1855, for $1,305.75 survives with its original invoice in a private New York collection. In addition a rose and grape-leaf pattern center table in the collection of the Newark Museum may be dated between 1852 and 1856 on the basis of the address of the Belter shop printed on its paper label.[23] The Newark Museum's table and the Milbank chairs are similar to a parlor set now in the Chicago Historical Society that was purchased for the Chicago row house of Tuthill King in 1851.[24]

To the best of my knowledge, no pieces with patterns identical to these can be attributed with any certainty to Belter's competitors. A comparable chair, belonging to a parlor suite, with openwork designs of grape and oak leaves and a pedimentlike cresting reminiscent of Renaissance revival design can be firmly dated 1859 and assigned to the firm of Joseph Meeks and Company.[25] The suite was made as a gift for Joseph W. Meeks's daughter, Sophia Teresa, on her marriage to Dexter W. Hawkins.

Another chair that is undoubtedly the work of one of Belter's contemporaries can be found in the collection of the Detroit Historical Museum, the gift of Edith Klein, a grand-daughter of the cabinetmaker. Its laminated rosewood scrolling is the work of Charles Klein, a New Yorker found in Trow's New York City Directory as early as 1853. He was last listed

in 1874, and he died sometime before March 25, 1879.[26] But Klein's rather pleasant rococo scrolls are far too conventional to allow him any conceivable part in the formation of Belter's style.

The most serious problem lies in the relationship between Belter and Charles A. Baudouine. Baudouine is listed in Longworth's Directory published for the year 1829 as a cabinet-maker at 508 Pearl Street. Thus, he was in business for about fifteen years before Belter opened his shop at 40 1/2 Chatham Street. A directory for the years 1852-53 gives his business address at 335 Broadway and his home address at 21 West 16th Street. In the next year he moved the business to 475 Broadway. Trow's New York City Directory published in 1854 listed him as a cabinetmaker, and the next volume, published in 1855, contained the last listing of any business address for Baudouine. Thereafter, until his death in 1894, he appeared only at various home locations on 23rd Street and, later, Fifth Avenue.[27] Among the papers in Baudouine's estate is an inventory dated July 3, 1864, valuing his personal worth at $83,218, certainly an indication of a successful business career.

The greater part of what we know about Baudouine has been supplied by the memoirs of Ernest Hagen. Hagen was an employee of Baudouine's for about two years beginning in 1853. In his notebook, Hagen referred to Baudouine as the leading New York cabinetmaker of the time, employing about seventy cabinet-makers in his workshops. He went on to say that his former employer made parlor suites with "round perforated backs . . . made of 5 layers of veneer glued up in a mould in one piece, which made a very strong and not heavy chair back only about 1/4 inch thick, all the ornamental carved work glued on after the perforated part of the thin back was sawed out and prepared." Hagen said this process was patented by Belter and that Baudouine infringed on the patent or rather avoided legal difficulties that would have resulted from infringement by "making the backs of 2 pieces with a center joint."[28] The sketches that accompany Hagen's remarks (Fig. 10) remain a mystery. Perhaps Hagen had in mind only the outer veneer on the reverse of the chair back when he drew his diagram. But

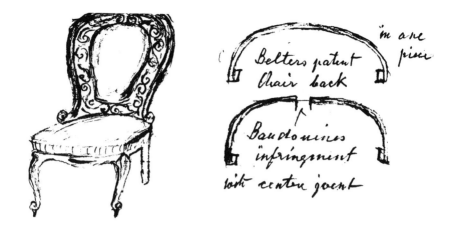

Fig. 10. Ernest Hagen, "Baudouines infringement" on "Belters patent chair back." From "Personal Experiences of an Old New York Cabinetmaker," Brooklyn, 1908, p. 8. (R. T. Haines Halsey Collection, Winterthur Museum Libraries.)

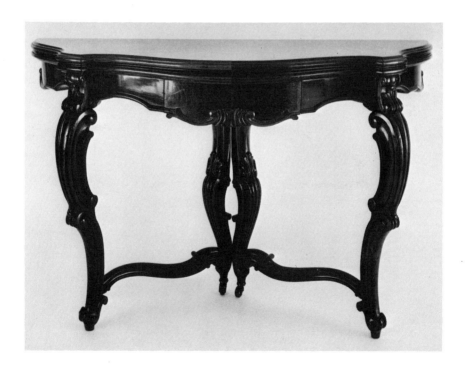

Fig. 11. Charles A. Baudouine, card table, one of a pair. New York, 1852. Carved rosewood; L. 46". (Munson-Williams-Proctor Institute.)

I have shown that some of Belter's own chairs would also have had a seam or joint at the center because of the limitations of the material.

If the diagram is meant to show the full thickness of the chair back, shown in section, we are forced to believe that Baudouine made chairs with a seam or joint running through the entire molded back. Such a structure, if it held together, would seem to negate most of the advantages obtained by laminating the wood in the first place. Not surprisingly, no chair of this sort has ever been found.

It must be remembered that Belter's patent is incontro-vertibly dated February 23, 1858. That date is at least three years after the time Hagen described Baudouine as avoiding an infringement of it and two to three years later than Baudouine's retirement from business. I am thus forced to question the reliability of Hagen's memory. We may reasonably trust Hagen's assertion that Baudouine made laminated rosewood parlor suites. Perhaps also Baudouine may have pirated some of Belter's decorative designs, providing extra cause for his former employee's feeling that some sort of infringement occurred, but Hagen's description of Baudouine's constructional methods is probably inaccurate.

With Hagen's remarks in mind, furniture historians have gone in search of a Baudouine parlor suite of laminated rose-wood. Curiously, not one has been discovered that can be identified with any certainty. One set proposed as the work of Baudouine, the cornucopia suite in the Museum of the City of New York, seems entirely improbable, since there is no evidence connecting it in any fashion with Baudouine.[29] On the contrary, the chairs and sofa are part of the Vietor gift and were accompanied by the center table with the label of John Henry Belter.[30] Therefore there are better than average reasons for attributing the entire suite instead to Belter.

In fact, the only labeled examples of Baudouine's work that have come to light are a pair of card tables now in the collection of the Munson-Williams-Proctor Institute at Utica (Fig. 11). Called a multiform table in the original bill,[31] presumably because the two elements could be used either separately or together, the tables are of solid construction

with a single layer of rosewood veneer. They are labeled with the stenciled mark "C.A. Baudouine. 335/ Broadway/ New York," which indicates the years 1849 to 1854.[32] As in the case of the chair by Charles Klein, the table may be described as a pleasant, if unexceptional, example of the rococo revival style. While it is unfair to judge any man on a single example of his work, the tables or table provide no evidence that the designer ought to be compared in creativity with Belter. It is obvious, therefore, that more documented examples of Baudouine's work must be found before any sensible conclusions can be drawn.

The names of the Philadelphian George Henkels[33] and the New York cabinetmaker Alexander Roux[34] have also been suggested as makers of parlor suites of the Belter type. In neither case is there sufficient evidence to warrant such attributions. If we were once to ready to attribute all laminated rosewood furniture to John Henry Belter, we are now too hasty in attributing too much to other makers when sufficient evidence is lacking. In fact, the evidence now available suggests that extreme caution is indicated in attributing laminated rosewood furniture in the rococo revival style to any specific maker.

It does seem perfectly correct to assert that Belter made substantial contributions to both furniture construction and furniture design. Although he did not invent the basic technique of laminating and pressing wood, he developed the technique for the bending of wood into forms that approach the fluidity of metallic shapes. He was also the creator of a number of open and lacelike combinations of fruit, flowers, foliage, and scrolls, framed by free-form arabesques. His structural methods proved ideal for supporting these designs.

NOTES

1. See V. Isabelle Miller, Furniture by New York Cabinetmakers: 1650-1850 (New York: Museum of the City of New York, 1957), p. 82, no. 141.

2. J. H. Belter, Register of Deaths, vol. 38, Department of Health, Bureau of Records and Statistics, City of New York; John Henry Belter III to Mrs. H. J. Sicard, Oct. 8, 1929, Arthur J. Belter Collection, New York City.

3. [John Doggett], The New York City Directory, 1844-1845 (New York: John Doggett, 1845), p. 35; H[enry] Wilson, Trow's New York City Directory, 1853-1854 (New York: John F. Trow, 1853), p. 58; Wilson, Trow's New York City Directory, 1854-1855, p. 61.

4. J. H. Belter, Register of Deaths, vol. 38. See also the "Obituary of John H. Belter," New York Times, Sept. 25, 1863; In the Matter of the Estate of John H. Belter, Dec., Objection to the Account of the Executor, Mar. 25, 1870, New York County, New York, Surrogate's Court.

5. See Berry B. Tracy and Marilynn Johnson, 19th-Century America: Furniture and Other Decorative Arts (New York: Metropolitan Museum of Art, 1970), no. 123.

6. John H. Belter, "Improvement in the Method of Manufacturing Furniture," United States Bureau of Patents, Washington, D.C., U.S. Patent no. 19,405, Feb. 23, 1858.

7. See Andrew Dick Wood and Thomas Gray, Plywoods: Their Development, Manufacture and Application (Edinburgh and London: W. and A. K. Johnston, 1942), p. 5; John Rodd, The Repair and Restoration of Furniture (London: Batsford, 1954), pp. 94-95.

8. See Marvin D. Schwartz, Victoriana: An Exhibition of the Arts of the Victorian Era in America (New York: Brooklyn Museum, 1960), n.p.; Elizabeth A. Ingerman, "Personal Experiences of an Old New York Cabinetmaker," Antiques 84, no. 5 (Nov. 1963): 576; Celia J. Otto, "The Rococo Style in Nineteenth-Century American Furniture," Antiques 88, no. 3 (Sept. 1965): 324-26.

9. Belter, "Improvement in the Method," n.p.

10. See Robert Bishop, Centuries and Styles of the

American Chair: 1640-1970 (New York: E. P. Dutton and Co., 1972), p. 331, no. 548.

11. United States Bureau of Patents, Washington, D.C., U.S. Patent no. 5,208.

12. United States Bureau of Patents, Washington, D.C., U.S. Patent no. 15,552.

13. See Clare Vincent, "John Henry Belter's Patent Parlour Furniture," Journal of the Furniture History Society 3 (1967): 97-98.

14. Belter, "Improvement in the Method," and "Bedstead," n.p.

15. Belter, "Bedstead," n.p.

16. Belter, "Bedstead," n.p.

17. See Schwartz, Victoriana, no. 51.

18. Illustrated by Helen Comstock, American Furniture (New York: Viking Press, 1962), p. 105, fig. 649.

19. United States Bureau of Patents, Washington, D.C., U.S. Patent no. 26,881.

20. Hagen, "Personal Experiences of an Old New York Cabinetmaker, Brooklyn, October, 1908," R. T. Haines Halsey Collection, Winterthur Museum Libraries. See also Ingerman, "Personal Experiences of an Old New York Cabinetmaker," pp. 576-80, see esp. 578.

21. Untitled ms. by Mrs. Edward M. Foote, Sr., collection of Edward M. Foote, Jr., Connecticut, n.p. See also Caroline Cauldwell Foote, "A Victorian Cabinetmaker," Christian Science Monitor, Aug. 19, 1933, p. 5.

22. See Joseph Downs, "John Henry Belter & Company," Antiques 56, no. 3 (Sept. 1948): 168.

23. The Newark Museum, Eva Walter Kahn Bequest Fund, 1967.

24. The Chicago Historical Society, gift of Mrs. George High, granddaughter of Tuthill King. See Vincent, "Belter's Patent Parlour Furniture," pl. 26A and pp. 92-93.

25. John N. Pearce, Lorraine W. Pearce, and Robert C. Smith, "The Meeks Family of Cabinetmakers," Antiques 85, no. 4 (Apr. 1964): figs. 13, 16. The Meeks suite is now in the Metropolitan Museum of Art.

26. Wilson, Trow's New York City Directory, 1853-1854,

p. 385; Wilson's Business Directory of New York City, 1874–
1875 (New York: John F. Trow, 1874), p. 125; Last Will and
Testament of Charles Klein, Mar. 25, 1879, New York County,
New York, Surrogate's Court, Liber 265, pp. 248–49.

27. Longworth's American Almanac, New York Register
and City Directory (New York: Thomas Longworth, 1829),
p. 80; Henry Wilson, The Directory of the City of New York
for 1852–1853 (New York: John F. Trow, 1852), p. 58; Wilson,
Trow's New York City Directory, 1854–1855, p. 54; H[enry]
Wilson, Trow's New York City Directory for the Year Ending
May 1, 1856 (New York: John F. Trow, 1855), p. 59; Last
Will and Testament of Charles A. Baudouine, Feb. 2, 1895,
New York County, New York, Surrogate's Court, Liber 524,
p. 213. See also Wilson's New York City Directory for the
Year Ending May 1, 1895 (New York: John F. Trow, 1894).

28. Ingerman, "Personal Experiences," pp. 578–79.

29. Otto, "The Rococo Style in Nineteenth-Century
American Furniture," p. 326.

30. See Miller, Furniture by New York Cabinetmakers,
p. 82, no. 142; and Downs, "John Henry Belter," p. 167,
fig. 4.

31. Comstock, American Furniture, p. 105, no. 650.

32. Tracy and Johnson, 19th-Century America, no. 133.

33. Robert C. Smith, "Rococo Revival Furniture, 1850–
1870," Antiques 75, no. 5 (May 1959): 473.

34. D[avid] B. W[arren], "The Belter Parlor at Bayou Bend,"
Museum of Fine Arts, Houston, Bulletin, n.s., no. 3 (May
1971): 32, fig. 2, 33–34; David B. Warren, "A Victorian Parlour
(Museum of Fine Arts Houston)," Burlington Magazine 113,
no. 825 (Dec. 1971): 741 and fig. 56.

THE INTRODUCTION OF CALICO CYLINDER PRINTING IN AMERICA: A CASE STUDY IN THE TRANSMISSION OF TECHNOLOGY

Theodore Z. Penn

THE mechanization of calico printing is a significant example of change from slow, hand-manufacturing methods to rapid, machine production during the industrial revolution. Automation of the printing process also illustrates translation of the intermittent, reciprocating motions of the hand-printing process into the continuous, rotary motion that came to characterize many mechanized manufacturing methods.[1] Adapted to a number of other nineteenth-century manufacturing processes as well, the principle of rotary motion opened up new possibilities in machinery design that are still being explored and debated today. The introduction of cylinder-printing textile machinery in America offers an opportunity to study the transmission of technology between the United States and Great Britain in the early decades of the nineteenth century. Finally, the mechanization of the printing process gives us a unique view of the methods of gathering technical information used by early American entrepreneurs and the practices and ethics of some of the businessmen of the time.

The development of cylinder printing in England during the last half of the eighteenth century was called the "grand improvement" in the art of calico printing.[2] Although patents for printing by cylinders had been granted as early as 1743 and 1764, the credit for perfecting the process is universally accorded to Thomas Bell, a Lancashire printer who filed for his first patent in 1783.[3] Like copperplate printing, which had been developed thirty years earlier, cylinder printing employed the intaglio technique; that is, the design was incised into the copper cylinder, rather than being carved in relief as in the case of wood blocks. In the process of cylinder printing, the

surface of the cylinder was inked, and all the excess color was then removed, leaving ink only in the incised design. When cloth was pressed into these ink-filled lines, the inked design was transferred to it.

A cylinder-printing machine, in its simplest form, consists of a drum (analagous to the bed or table in the process of hand printing) and an engraved cylinder (analagous to the wood block or copperplate in hand printing), which presses against the drum. Early engraved cylinders measured three to four inches in diameter and were "mounted upon a strong iron shaft, or arbor." Originally, the cylinder itself was dipped into a trough of coloring material. Bell was "probably the first" to fit a metal blade, called a doctor, to the cylinder to remove all excess ink. The doctor was positioned so that the excess ink would fall back into the color trough as it was scraped from the printing cylinder. Later, a second cylinder, wrapped with a woolen cloth and then dipped in the ink trough, was placed beneath the printing cylinder.[4] The cloth-covered cylinder took up the ink from the trough and passed it evenly onto the printing cylinder. The drum was covered with a cloth belt, which equalized the pressure between the drum and printing cylinder and forced the calico into the ink-filled lines of the design (Figs. 1, 2).

Experiments were carried on using printing machines with four, five, or six colors in the early nineteenth century, but they were unsatisfactory because of the difficulty in maintaining registration between the cylinders. The prevalent use of wood for the frames of these machines was one source of the problem (Fig. 3). Changes in temperature and humidity could cause the wood to expand or contract enough to throw the cylinders out of register. To print properly, the engraved cylinder had to be forced against the backing drum under high pressure. Wood, a compressible material, could not resist these pressures without deforming enough to reduce the pressure or alter the registration. The difficulty of securing proper registration also had an effect on the designs used by early printers, for one way they tried to work around the problem was to use tight patterns with short repeats, which made the effects of misregistration on their prints less visible. As the processes of patternmaking

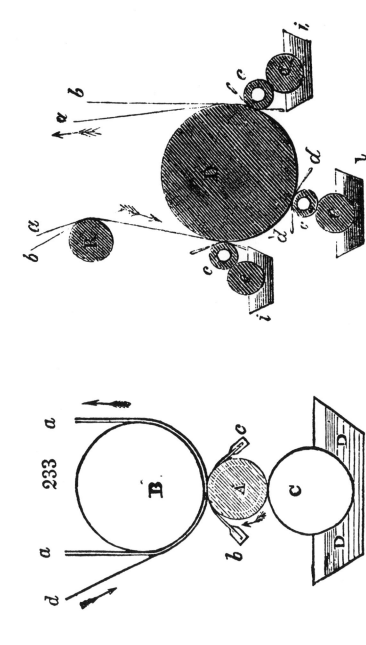

Fig. 1. Calico printing in one color. From Andrew Ure, A Dictionary of Arts, Manufactures, and Mines, 2 vols. (New York: D. Appleton & Co., 1844), 1:223, fig. 233. (A) engraved cylinder, (B) backing drum, (C) inking cylinder, (D) ink trough, (a) backing cloth, (b) color doctor, (c) lint doctor, (d) cloth being printed. (Old Sturbridge Village: Photo, Donald F. Eaton.)

Fig. 2. Calico printing in three colors. From Charles Tomlinson, ed., Cyclopaedia of Useful Arts, 2 vols. (New York: George Virtue & Co., 1854), 1:279, fig. 408. (Old Sturbridge Village: Photo, Donald F. Eaton.)

and founding improved in the first quarter of the nineteenth
century, mechanics began to use more iron for machine frames,
for iron did not change its dimensions appreciably with
fluctuation in temperature and humidity and was not easily
compressible (Fig. 4).

Other difficulties in cylinder printing can also be attributed
to limitations in the machine-building process. The most
important problem was that of turning the diameters of cylinders
and drums to the close tolerances required for satisfactory
printing. The slide lathe, with its mechanically held turning
tools, provided a partial answer when it came into common use
in English and American shops during the second decade of the
nineteenth century. With this equipment, a mechanic could
produce geometrically correct cylinders. As long as mechanics
worked only with hand-held turning tools, it had been extremely
difficult to produce cylinders of essentially the same diameter
along their entire length (Fig. 5). Even with the help of the slide
lathe, it remained nearly impossible to achieve tolerances
within a few thousandths of an inch. Calipers and rulers, the
commonly used measuring devices then as now, simply lacked
that degree of precision. The difficulty in turning a part to the
desired diameter caused a smudging problem in early printing
machines. The greater the error in the intended size of the
machines' components, the more severe the smudging.

The printing cylinder and the backing drum were each fixed
to their own shafts so that when the axes were parallel, the
cylinders and drum were also parallel. A ring gear was fastened
to the drum, and its pitch diameter--the imaginary circle, the
radius of which falls halfway up each gear tooth, which forms
the center line at which mating gears intersect--had to coincide
exactly with the diameter of the drum. Likewise, the pitch
diameter of the pinion gear, fastened on the axis of the cylinder,
had to coincide exactly with the diameter of the cylinder.[5]
When these two sets of diameters did not match, the ratio of
the diameter of the cylinder to that of the drum was different
from the ratio of the pinion to the ring gear. When the ratios
were not matched, something had to slip, since the cylinder
and pinion were firmly fastened to the same shaft and the drum
and ring were both fixed to another axis (Fig. 6). The gears

could not slip, so the slippage had to occur between the
cylinder and the drum. When movement took place there, the
print was invariably smudged. Handicapped as they were by
the lack of accurate measuring devices, early printers had to
wait for better gear-forming equipment and the perfection of
shop measuring techniques to solve the smudging problem and
to achieve fine lines in their designs.

The first cylinder-printing machine of record in the United
States was imported from England by Joseph Siddall in 1809.
It is not clear whether Siddall had the machine sent over,
whether he went to England to acquire it, or, indeed, whether
he was an English emigrant who brought it along with him.
Siddall joined in partnership with John Thorp in 1809 to operate
a bleaching and calico-printing works in Germantown, Pennsyl-
vania, under the name of Thorp, Siddall and Company. Although
almost nothing is known of the training and work of either Thorp
or Siddall, there is some evidence that Thorp was English and
that he had begun work in the Philadelphia area blocking out
prints by hand.[6]

The first lot of cloth printed by Thorp and Siddall arrived in
Philadelphia in October 1810. With the new machine, it was
claimed, one man and two boys could print "ten thousand yards
of cloth, or fifty thousand children's handkerchiefs, in a single
day." Nothing is known about the quality of these prints, but
the machine must have operated fairly well to achieve such
relatively high rates of production. If the produce was limited
to children's handkerchiefs, the firm's output could have consisted
of very simple patterns printed in a single color.

The firm of Thorp, Siddall and Company continued to
operate until at least 1826, and John Thorp was still listed
as a calico printer in the Philadelphia directory of 1837.
Relatives of each of the partners worked for the company or for
other textile manufacturing firms, and one of them eventually
played a role in establishing the large-scale multicolored
printing of fancy calicoes in New England. That person was
Thorp's nephew, also named John, who was working in Providence
as early as 1812 and took out a patent for a hand and power
loom in March of that year.[7] He later assisted Silas Shepard of
Taunton, Massachusetts, in building a power loom, worked with

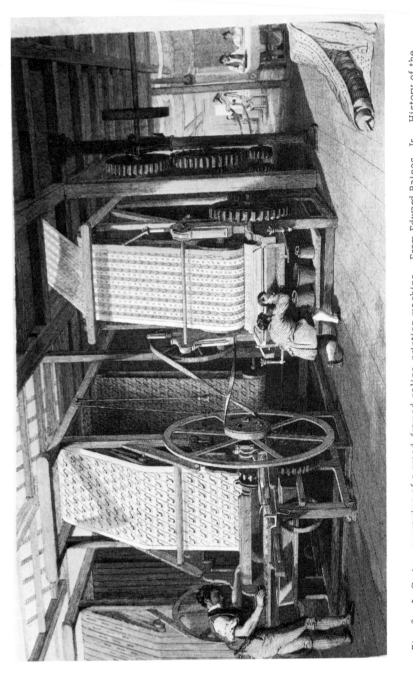

Fig. 3. J. Carter, engraving of a wood-framed calico-printing machine. From Edward Baines, Jr., History of the Cotton Manufacture in Great Britain (London: H. Fisher, R. Fisher, & P. Jackson, [1835], unnumbered plate opposite p. 267. (Old Sturbridge Village: Photo, Donald F. Eaton.)

Samuel Crocker and Charles Richmond in the construction of
one of the earliest successful cylinder-printing works in New
England, and still later did much of the basic development
work leading up to the modern process of ring spinning. We
will return to him again.

Meanwhile, Thomas Siddall was granted a patent for a
power loom in July 1814. He was very likely related to Joseph
Siddall. Thomas Cooper, who described the loom in his
Emporium of Arts and Sciences in 1814, mentioned that he had
seen it in operation "at the Calico Printing Works five or six
miles from Philadelphia," presumably Thorp, Siddall and
Company.[8] The Siddalls and Thorps were clearly drawing on the
same pool of technical information, for Siddall's loom showed
elements of Thorp's 1812 patent, and the younger Thorp would
later demonstrate that he had a good understanding of the
operation of cylinder-printing machinery.

Very little is known about the development of cylinder
printing in America between 1810 and the early 1820s. The
Thorps and Siddalls continued to manufacture various sorts of
roller prints in Philadelphia. Other firms in the Philadelphia
and Baltimore area may have experimented with cylinder machines,
but New England textile manufacturing firms, experimenting with
the technique between 1821 and 1828, put the printing industry
on a solid footing in this country. One of the New England firms
that played a major role in the industry was the Taunton Manufac-
turing Company of Taunton, Massachusetts.

This company was organized in 1823 by Samuel Crocker and
Charles Richmond of Taunton, with the backing of Boston
capitalists. Both men had been engaged in various iron-working
and textile-making ventures in Taunton, and the company was
initially incorporated "for the purpose of rolling copper and iron,
and manufacturing nails, . . . and also for the purpose of
manufacturing cotton and wool." The Taunton printing company
was a consolidation of several smaller firms. By a deed of
August 1822, Crocker and Richmond had sold half of their interest
in four companies to a group of Boston businessmen composed of
Israel Thorndike, Harrison Gray Otis, Edmund Dwight, William
Eliot, and John McLean.[9] On May 30, 1823, the directors of
the Taunton company voted:

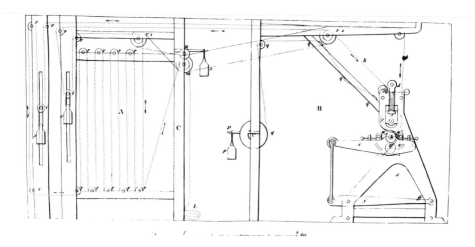

Fig. 4. Engraving of an iron-framed, single-color American printing machine. From Arthur L. Porter, The Chemistry of the Arts, 2 vols. (Philadelphia: Carey & Lea, 1830), 2:pl. 67. (Old Sturbridge Village: Photo, Donald F. Eaton.)

Fig. 5. J. LeKeux, engraving illustrating metal turning by hand-held and machine-held tools. From Robertson Buchanan, Practical Essays on Millwork, with additions by Thomas Tredgold and George Rennie (London: John Weale, 1841), p. 396. (Old Sturbridge Village: Photo, Donald F. Eaton.)

>to make the experiment of an establishment for
>the printing of cottons, . . . and that the Agents
>be authorized to make such contract with any
>person or persons skilled in the business as they
>may think proper, also to purchase a suitable
>site for the necessary buildings and to do what-
>ever may be requisite for commencing the same
>and to continue it until further orders.[10]

The Taunton company was one of three major New England
textile manufacturers that decided to enter the cylinder-printing
field between 1821 and 1824. The others were the Dover
Manufacturing Company of Dover, New Hampshire, and the
Merrimack Manufacturing Company of Chelmsford (now Lowell),
Massachusetts. By late 1821 or early 1822, the directors of
the Taunton and Dover firms must have been aware of plans by
the Merrimack company to build a complex of mill buildings and
printworks. Although the Merrimack company was the first to
plan a calico-printing works, it was a new firm, and all of its
facilities, including the waterpower systems, spinning and
weaving mill, and printworks, had to be built from the ground up.
On the other hand, the companies at Taunton and Dover had only
to add printeries to their existing plants, although both of them
expanded their spinning and weaving capabilities as well.[11]

The first printing at both Dover and Taunton, as the two
firms sought to implement their plans, was done by blocks.
The block printing process was well understood in this country,
having been practiced successfully in the Philadelphia area
since the middle 1770s and in the Providence area since the
1790s. The Columbian Reporter and Old Colony Journal referred
to block prints on December 3, 1823, when it noted that the
Taunton Manufacturing Company had begun turning out pieces of
calico. Although the Taunton firm hoped to get a cylinder-printing
machine in operation by the summer of 1824, they did not achieve
this goal until 1825.[12]

From two main sources the Taunton management acquired the
knowledge, equipment, and skills necessary to enter the field.
It turned first to John Thorp of Providence, whose family had
been involved in cylinder printing in Philadelphia since 1809.

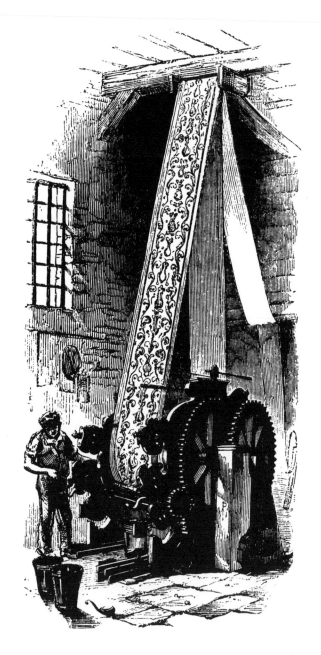

Fig. 6. Engraving of a cylinder-printing machine showing the relation of the pinion gears to the ring gear. From Charles Tomlinson, ed., Cyclopaedia of Useful Arts, 2 vols. (New York: George Virtue & Co., 1854), 1:279, fig. 410. (Old Sturbridge Village: Photo, Donald F. Eaton.)

Later, through a trade of information, it was able to import English machinery as well as workmen to install and operate it.

Although information is lacking on Thorp's exact role in the building of the printworks, he was apparently one of the major sources of technical information available to the Taunton company. Thorp had arrived in Taunton in the winter of 1812 to work with Silas Shepard, the major machine builder and mechanic for the various firms that later joined in the Taunton Manufacturing Company. Shepard himself had worked with Crocker and Richmond from the time the Taunton cotton mill was built in 1806. He was especially interested in the problem of weaving by power, and in 1816 he and Thorp had taken out a joint patent on an upright power loom. Thorp's activities for the next few years are unknown, but in 1823 he was described as being "lately from a manufactory of this kind in England," and had been appointed superintendent of the Taunton Manufacturing Company printworks.[13]

Thorp continued in this job for about two years, while the company constructed its printworks and attempted to build workable cylinder-printing machinery. Shepard, as chief mechanic for the Taunton company, had charge of the firm's extensive machine-building shops and had overall responsibility for the construction, maintenance, and supervision of spinning, weaving, and mechanical equipment in all of the company's mills. Thorp's role was probably to work with Shepard in overseeing the part of the machine-building operation that related to cylinder printing. Company records show that the Taunton shops were very large for the period; besides a blacksmith shop large enough to contain four fires, the firm had its own "Air Furnace" with all the patterns and flasks necessary to operate the same.[14]

Thorp severed his relationship with the Taunton Manufacturing Company in the summer of 1825. His subsequent encounter with the Dover Manufacturing Company offers some evidence of behavior that may have caused problems at Taunton. In September 1825 he and his father applied for work at Dover, which was looking for a superintendent for its new printworks. In their interviews and correspondence, the Thorps proved so secretive about their knowledge of cylinder printing that John

Williams, the Dover agent, finally decided against hiring them. He feared that they would not teach anything of value to other employees and that if they left the company would lose their knowledge and be set back severely: "We might retrograde faster than we advanced to the point where he [Thorp] found us. It is highly important that the knowledge and experience which every person brings to the institution should be retained by it, that its influence may be seen and felt long after such persons have left it." Arthur L. Porter, the firm's chemist, put it even more strongly when he wrote, "There is little appearance of candor and trust in these Gentlemen."[15] Williams had seriously considered hiring Thorp, and the Dover company's interest in him is good evidence of Thorp's ability to demonstrate at least some technical expertise.

Thorp was without doubt a highly skilled builder of textile machinery. It is questionable, though, whether he or any other American had mastered the technology required for the successful building of cylinder-printing equipment. At any rate, Taunton and other firms soon turned to Britain for machinery and skilled workmen, and Thorp himself did not remain long in this field. Shortly before applying for the position at Dover, he had taken an advertisement in the Manufacturers' and Farmers' Journal offering for sale one-, two-, and three-color cylinder-printing machines and seeking a "small privilege either in the neighborhood of Providence or Boston" where he could establish himself as a machine builder. In addition to printing machinery, he was prepared to manufacture cylinders "engraved for the spring trade," engraving machinery, and "Draughts, Models and Machinery of every description" relating to textile printing. He continued to manufacture textile machinery but seems to have soon switched his interests to equipment for spinning. Within a few years he was living in Providence, where he took out a series of patents basic to the concept of ring spinning, a technique that became very important later in the nineteenth century.[16]

Following Thorp's departure, the Taunton Manufacturing Company sent one of its directors as an agent to England to learn more about the technology of cylinder printing. The success of his trip was reflected in a vote of the directors in October 1826

that the "sum of one thousand dollars be granted to Mr. Charles Richmond for his services and exertions in England in behalf of the Company."[17] Richmond had gone to England in 1825 to acquire information about calico-printing machinery and to try to purchase some of the English machinery itself. Unlike many other Americans who had crossed the ocean to learn about calico printing and other English technology, Richmond took something of value with him to exchange. In trade for the parts of a cylinder-printing machine, he gave Henry Houldsworth, an English manufacturer of fine cotton textiles, an invention that was not his property and that was probably the most significant machine developed by the American textile industry in the first quarter of the nineteenth century.

Richmond, in fact, took two textile machines to England in 1825. The first was the Taunton speeder, or tube-roving frame, which had been developed by George Danforth. It had been perfected in the shops at Taunton with the aid of Silas Shepard, and although Danforth held the patent, it was intended to be for the "mutual benefit of Danforth, Crocker & Richmond," and Silas Shepard. Richmond patented this machine in England with Joseph C. Dyer, but Dyer later induced the Taunton associates to sell their interest in the British patent and kept the financial rewards for himself. Secondly, and even more important, Richmond took along a model and a copy of the specifications for Aza Arnold's patented compound motion, which, when fitted to a cotton speeder, was often simply referred to as the Arnold speeder.[18] He did this without Arnold's knowledge and with no rights of his own to the Arnold patent.

One of Richmond's business associates, Shepard, many years later denied that Richmond had taken a model of Arnold's patent to England. He wrote: "I have no recollection that the Arnold speeder was ever used in Taunton--or any knowledge that Mr. Richmond ever carried it to England." Indeed, the pirating of the compound motion was a secret the Taunton firm carefully guarded. Shepard himself may never have known about Richmond's actions, or he may have simply denied them later. Arnold apparently did not discover what Richmond had done with his patent for a number of years. He had no legal recourse, because British patent law protected those taking out the papers and did not

require proof that the invention was original. Arnold learned
"through a former partner" of Richmond's that "the model which he
[Richmond] carried to England in 1824-5 was made in Taunton."[19]

Zachariah Allen, the Providence engineer, textile manufac-
turer, and historian of the textile industry, believed that
Richmond had simply sold a model of the compound motion to
Henry Houldsworth, but this was not the case. Richmond
traded both the model and patent specifications to Houldsworth
in exchange for the parts of a cylinder-printing machine. J. D.
Van Slyck, in New England Manufacturers and Manufactories,
detailed the switch: "To obtain this improvement and secure a
patent right to the sale of it in Great Britain, Mr. H. Houldsworth,
a Manchester machinist, afforded the desired facilities procuring
and exporting the roller printing machine." Thus Richmond
acquired the latest in English cylinder-printing machinery in
exchange for a patent that did not belong to him. Zachariah
Allen had been in Manchester in 1825 to study English textile
technology. He saw Richmond in Manchester at that time and
apprised Arnold of that fact more than thirty-five years later.
Writing in the 1860s or 1870s in an unpublished history of the
manufacture of textiles, Allen's recollections of the events
that transpired in Manchester in 1825 helped document the
exchange:

> A model of the apparatus invented by Mr. Arnold
> was taken to Manchester early in the year 1825
> as the writer has reason to believe from personal
> knowledge obtained at that time whilst residing
> several weeks in Manchester for the special
> purpose of obtaining information in the subject
> of cotton manufacture. Mr. Richmond then stated
> to the writer that he had brought out with him also
> a model of the "compound motion" invented by Aza
> Arnold and that he disposed of it there.

Arnold came to believe that Richmond had also had an English
speeder fitted with a compound motion and brought it back with
him.[20] The purpose of this maneuver remains unknown, unless
it represented an attempt to obscure Arnold's right to the patent.

The compound motion, fitted to a speeder, enabled the machine to be adjusted to wind a finer-size roving with less damage to the roving than any machine previously in use. It simplified the task of adjusting the mechanism to the point that it could be accomplished by "any intelligent workman." Ironically, Andrew Ure, in his history of the cotton industry, attributed the invention of the compound motion to Henry Houldsworth in 1826. Nevertheless, Ure accurately assessed the value of this complex device when he referred to it as the mechanism "which affords perhaps the most refined specimen of the automatic equating principle to be found in the whole compass of science and art.[21]

Richmond returned to Taunton in 1825 with the knowledge he had gathered about cylinder printing in Manchester and with the parts of a printing machine he had acquired from Henry Houldsworth. Very likely he recruited skilled labor at the same time. Although the Taunton Manufacturing Company was probably the first to successfully introduce cylinder printing in New England, that early success must be viewed as relative, for the company continued to be plagued by a host of technical and financial problems. Competition from other New England firms proved stiff, and the surviving records of the Taunton company imply that expected profits were never realized. Aside from continuing financial problems, there was the difficulty of finding, hiring, and keeping the necessary technical personnel to operate the specialized printing machinery. In 1827 the directors voted: "That the Agents be requested forthwith to take measures for ascertaining whether a superintendent in all respects qualified to take charge of the Printing Works, can be procured in England." At the same time the directors also decided to look for an English printer to "take charge of the printing machines" and to take the necessary measures to procure the latest styles of prints "so as not to be anticipated in the market." These efforts must have proved temporarily successful, for two years later the directors' minutes noted: "The improvement in the style and execution of prints is obvious, and together with the increased rapidity of production affords a favorable prospect for the opening market."[22]

By 1832, though, the company was again looking for an

Englishman to manage the printworks. Business declined from
this date, and in January 1833 the directors of the company met
in Boston and voted to sell the "print works, bleachery, water
privilege, land, buildings, and machinery connected therewith."
In April 1833 Samuel Crocker purchased the printery and bleachery
in association with some of his former partners. That same year
the new corporation, organized under the name of the Bristol
Printworks, was granted a charter by the Massachusetts
legislature. The printing company continued to operate under
this name until it suffered severe losses in the "panic and
financial crash of 1837." The business never recovered, and
in 1845 it was finally brought to a close when the mills passed
into new hands.[23]

The transmission of the cylinder-printing process to America
actually represents the third wave of textile-manufacturing
technology to reach America from Britain. The first of these
focused on the introduction of spinning technology, begun by
Samuel Slater in 1790, and the second was based on the
importation of weaving technology in the second decade of the
nineteenth century by Francis Cabot Lowell, William Gilmore,
and others. The development in the 1820s of the textile mill
that spun, wove, bleached, dyed, and printed cloth represented
a combination of mechanical and chemical technology new to the
American experience. Taunton's success in introducing cylinder
printing in New England was heavily dependent not only on
British technology but also on the importation of "skilled and
other workmen" from the printing establishments of England and
Scotland. Calico printing, in fact, was dependent to a "greater
degree probably than . . . almost any other branch of industry
upon the imported skill of British workmen, either as designers,
engravers, or printers."[24]

The study of calico printing offers an unusual view of the
transmission of technology between the United States and
Britain. The story of the methods used by the Taunton Manufac-
turing Company to acquire an English cylinder-printing machine
is particularly novel, because it involves a two-way flow of
information. Normally the United States drew on Britain for
technological ideas and technically trained personnel in the
first quarter of the nineteenth century. Aza Arnold's compound

motion was one of a very few American inventions that was important enough to swim against the current and make a basic contribution to British textile technology. The exchange worked to the advantage of both Charles Richmond and Henry Houldsworth. Richmond used the parts he received from Houldsworth to successfully introduce large-scale multicylinder fancy calico printing in New England, while Houldsworth used the compound motion he acquired from Richmond to become a successful manufacturer of fine cotton goods.

NOTES

1. Other examples of the transition in systems of motion can be found in the replacement of the up-and-down saw by the circular saw in sawmills, the substitution of the rotary carding machine for hand cards, and Richard Arkwright's principle of drawing textile fibers by rollers, which essentially replaced the reciprocating action of the thumb and first finger of the hand spinner.

2. Edward Baines, Jr., History of the Cotton Manufacture in Great Britain (London: H. Fisher, R. Fisher, & P. Jackson, [1835]), p. 265.

3. Stuart Robinson, A History of Printed Textiles (London: Studio Vista, 1969), p. 26; William Bagnall, "Sketches of Manufacturing Establishments in New York City, and of Textile Establishments in the Eastern States," ed. Victor S. Clark, 4 vols., typescript, Baker Library, Harvard Business School, 3:1783-84.

4. Alonzo Potter, The Principles of Science Applied to the Domestic and Mechanic Arts, and to Manufactures and Agriculture (Boston: Thomas H. Webb & Co., 1842), p. 167; George S. White, Memoir of Samuel Slater, the Father of American Manufactures, Connected with a History of the Rise and Progress of the Cotton Manufacture in England and America (Philadelphia: printed at no. 46, Carpenter Street, 1836), p. 396; Robinson, History of Printed Textiles, p. 261.

5. Erik Oberg and F. D. Jones, Machinery's Handbook for Machine Shop and Drafting-room (New York: Industrial Press, 1953), p. 649.

6. J. M. Edmunds, comp., Manufactures of the United States in 1860; Compiled from the Original Returns of the Eighth Census (Washington, D.C.: Government Printing Office, 1865), p. xviii; Victor S. Clark, History of Manufactures in the United States, 1607-1860 (Washington, D.C.: Carnegie Institution, 1916), p. 548; William R. Bagnall, The Textile Industries of the United States (1893; reprint ed., New York: Augustus M. Kelley, 1971), p. 583; J. Thomas Scharf and Thompson Westcott, History of Philadelphia, 1609-1884, 3 vols. (Philadelphia: L. H. Everts & Co., 1884), 3:2317; J. Leander Bishop, A History of American

Manufactures from 1608 to 1860, 3 vols. (Philadelphia: Edward
Young & Co., 1868), 1:164; John Howard Brown and E. M.
Norriss, eds., Lamb's Textile Industries of the United States,
2 vols. (Boston: James H. Lamb Co., 1911), 2:164; J. G.
Dudley, "A Paper on the Growth, Trade, and Manufacture of
Cotton," Bulletin of the American Geographical and Statistical
Society 1, no. 2 (Jan. 1853): 171.

7. Bagnall, "Sketches of Manufacturing Establishments,"
3:1783-84; Bishop, History of American Manufactures, 2:164;
Scharf and Westcott, History of Philadelphia, 3:2316-17;
Edmunds, Manufactures of the United States in 1860, p. xviii;
Desilvers Philadelphia Directory and Strangers Guide for 1837
(Philadelphia: Robert Desilver, 1837), p. 237; Dudley, "Growth,
Trade, and Manufacture of Cotton," p. 171; Edmund Burke, comp.,
List of Patents for Inventions and Designs . . . from 1790 to 1847
(Washington, D.C.: J. & G. S. Gideon, 1847), p. 80.

8. Burke, List of Patents for Inventions, p. 80; Thomas
Cooper, "Weaving," Emporium of Arts and Sciences, n.s. 3,
no. 3 (Oct. 1814): 459.

9. Directors Records, Taunton Manufacturing Company
(hereafter TMC), Jan. 24, 1823. Unless otherwise noted, all
records of the Taunton Manufacturing Company referred to in
this paper are on deposit at the Baker Library, Harvard Business
School; TMC, Bristol County Registry of Deeds, Taunton, Mass.,
Aug. 1, 1822, vol. 112, pp. 185-88. The smaller firms that
were unified in the new company consisted of the Whittenton
Manufacturing Establishment, the Hopewell Manufacturing
Establishment, the Cobb Slitting Mill, and the White Mill.

10. Directors Records, May 30, 1823, TMC.

11. Bagnall, "Sketches of Manufacturing Establishments,"
3:2164.

12. Columbian Reporter and Old Colony Journal (Taunton,
Mass.), Dec. 3, 1823; Zachariah Allen, Diary, 1821-24,
Mar. 20, 1824, Zachariah Allen Papers, Rhode Island Historical
Society, Providence (hereafter Allen Papers); Dudley, "Growth,
Trade, and Manufacture of Cotton," p. 171.

13. Dudley, "Growth, Trade, and Manufacture of Cotton,"
p. 171; J. D. Van Slyck, New England Manufacturers and
Manufactories, 2 vols. (Boston: Van Slyck & Co., 1879), 1:2;

Zachariah Allen, "Historical, Theoretical, and Practical Account of Textile Fabrics," p. 28, Allen Papers; Burke, List of Patents for Inventions, p. 81; Columbian Reporter, Dec. 3, 1823.

14. TMC, Deeds, vol. 112, p. 187.

15. John Williams to William Shimmin, with postscript by Arthur L. Porter, Sept. 9, 1825, letter no. 99; J. Williams to William Payne, Sept. 1825, letter no. 102; J. Williams to Samuel Torrey, n.d., letter no. 103; letterbook no. 1, Dover Manufacturing Company, New Hampshire Historical Society, Concord, N.H. My thanks to Caroline Sloat, researcher at Old Sturbridge Village, for bringing the information on the Thorps in the Dover Manufacturing Company records to my attention.

16. Manufacturers' and Farmers' Journal (Providence, R.I.), Aug. 1, 1825; Burke, List of Patents for Inventions, p. 90. John Thorp was granted "spinning machine" patents on the following dates while residing in Providence, R.I.: Nov. 25, Dec. 31, 1828; Jan. 23, June 13, 1829. See the Journal of the Franklin Institute for the year 1829 for these patent specifications.

17. Directors Records, Oct. 13, 1826, TMC.

18. Samuel Shepard to Zachariah Allen, Apr. 24, 1862; Aza Arnold to Allen, June 12, 1862; Miscellaneous Correspondence, Allen Papers.

19. Silas Shepard to Allen, Apr. 24, 1862; Aza Arnold to Allen, Sept. 4, 1861, Miscellaneous Correspondence, Allen Papers.

20. Van Slyck, New England Manufacturers, 1:3; Aza Arnold to Allen, Sept. 4, Dec. 20, 1861, Miscellaneous Correspondence; Allen, "Practical Account of Textile Fabrics," p. 88, Allen Papers.

21. Ure, The Cotton Manufacture of Great Britain Investigated and Illustrated, 2 vols. (London: H. G. Bohn, 1861), 2:55. For other assessments of the importance of the compound motion, see John L. Hayes, American Textile Machinery (Cambridge: University Press, John Wilson & Son, 1879), p. 37; and Allen, "Practical Account of Textile Fabrics," p. 87, Allen Papers.

22. Directors Records, Oct. 24, 1827; Feb. 10, 1829, TMC.

23. Directors Records, Feb. 15, 1832; Stockholders Records, Jan. 21, Apr. 17, 1833, TMC; Bagnall, Textile Industries, p. 428;

Samuel Hopkins Emery, <u>History of Taunton, Massachusetts from Its Settlement to the Present Time</u> (Syracuse, N.Y.: D. Mason & Co., 1893), p. 649.

 24. Emery, <u>History of Taunton</u>, p. 649; Nathan Rosenberg, ed., <u>The American System of Manufactures</u> (Edinburgh: University Press, 1969), p. 242.

STYLISTIC CHANGE IN PRINTED TEXTILES

Florence M. Montgomery

THE patterning of textiles developed through two centuries in
Europe and America from crude wood-block stamping in
vegetable colors to a continuous, mechanized process depen-
dent on synthetic coloring agents and sophisticated chemistry.
European interest in printed textiles was stimulated in the
seventeenth century by beautiful palampores from India, cotton
hangings of bedspread size with exotic flowers stemming from
trees. Their brilliant colors were produced with metallic
mordants, which, when dipped in a madder bath, developed
into various shades of red, purple, and brown. Blue was the
most troublesome color to achieve because of the insolubility
of indigo "not only in water but in any other known fluid."[1]
But rich blues were attained by dyeing the cotton in an indigo
vat after the madder colors had been protected with wax or
paste to resist the indigo. Yellow came from weld, an
especially fugitive dye, which could be combined with blue
to produce green. The methods of producing these textiles,
the rage of Europe for both dress and furnishing materials,
were slow and laborious.[2]

European printers, in an endeavor to produce rich, color-
fast cloths by cheaper, faster methods, used carved wood
blocks to print the mordants. By the 1780s English manufac-
turers were producing handsome furnishing chintzes in a full
range of madder colors, although blue and yellow still required
painting by hand. As in textile manufacture today, changes in
fashion were governed not by designers at the printworks but
by the dictates of London merchants, or linen drapers. It was,
however, up to the printworks to produce the new patterns,
which were brought out twice annually in a prescribed range of
colors, as cheaply and as quickly as possible. Arborescent
patterns, including floral sprays and exotic birds, were

fashionable in both England and France in the 1780s for
furnishing. By the 1790s dark-ground, striped patterns with
dense foliage and flowers were the mode. In the last years
of the century, neoclassical medallions were fashionable; a
few years later pillars with flowery capitals reigned supreme.
Copyright laws were unknown, and novelty was the important
factor in satisfying the fashion conscious.

In the early eighteenth century, block printing was brought
to America. Although colonial printers advertised in newspapers
that they printed linens and calicoes in "durable colors" and
"colors to hold washing," their work can no longer be identified,
and most printers confined their work to what was known as
job printing. Their colors were fugitive, and patterns usually
lacked the effects of three-dimensional shading from dark to
light in a flower or leaf, an effect created by a fitted series of
blocks. Only a few fine, colorfast eighteenth-century American
examples are known, among them the unique floral stripe in the
Winterthur Museum stamped by Thomas Bedwell and John Walters,
who worked in Philadelphia just before the Revolution. More
important are two remarkable bedspreads, dated about 1790,
printed by John Hewson, another Philadelphian.[3] The full-blown
flowers in the central urn and the rich, densely shaded inner
and outer borders in Hewson's work contrast to the little butter-
flies and floral sprigs with birds perched in their midst. The
only other eighteenth-century American textile printer whose
work has been identified is Archibald Hamilton Rowan, a
Delaware printer from Ireland whose pattern book is in the
Winterthur Museum Library.[4] His designs, mostly for dress
materials and handkerchiefs, clearly show his familiarity with
the sprigged dress chintzes produced at a Scottish printworks
about 1795[5] and his acquaintance with small-scale leafy
patterns in the drab style produced with the new dye stuff
called quercitron.

Drab-style prints are easily recognized by the complete
absence of reds and purples in favor of yellow, buff, brown,
and olive--in fact, drab colors. Instead of dyeing the
mordanted cloth in madder, a concoction made from the bark
of the North American quercitron oak was used. This style
can be dated quite precisely from 1799, the year in which

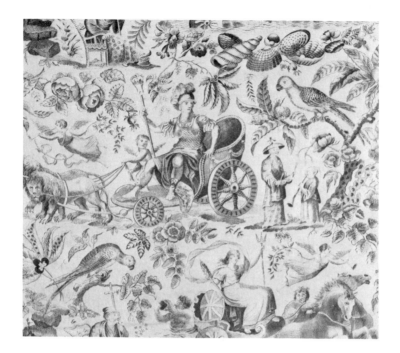

Fig. 1. Cotton textile, copperplate-printed in red. England, ca. 1800.
W. 24". (Winterthur 59.79.1.)

Fig. 2. Cotton textile, roller-printed in red. England, 1810–15. W. 38 1/2".
Same subject as figure 1 with a reduced repeat. (Winterthur 58.77.5.)

Edward Bancroft's English patent and exclusive right to
manufacture and sell the drug expired.[6] With the turn of
the century many other color fashions appeared that were
soon adopted by American printers.

A parallel development to polychrome wood-block printing
was initiated in 1752 when copperplate printing was invented
in Ireland. It is interesting that transfer printing on pottery,
a related technique, was also invented about this time. In
copperplate printing the technique governed the appearance of
the prints--the repeat was considerably larger and the drawing
finer than in wood-block prints, but copperplate prints were
limited to single colors, generally red, purple, or blue. This
intaglio process, similar to that used by paper printers, made
it possible to print about a yard of material at a time. Two
well-known, high-quality patterns were printed by Robert
Jones at Old Ford in 1761 and 1769.[7] From Jones's sophisticated
patterns of hunters, shepherds, birds, and ruins, and some
500 other designs identified from pattern books discovered in
the 1950s by Peter Floud and Barbara Morris, it is now possible
to appraise the high quality of English copperplate-printed
textiles of the period 1760 to 1785.[8]

The high cost of engraving the plates caused the quality of
copperplate patterns to decline considerably after about 1785.
They lost their strength of design and grandeur of scale, and a
uniformity of tone replaced the dynamic balance between
dominant motifs and subordinate details. No examples of
American copperplate printing for furnishings are known.

In order to increase the market for English printed textiles,
less expensive production methods were sought. All the
mechanical and chemical developments of the late eighteenth
century and early nineteenth century contributed to a reduction
of manufacturing costs. Peter Floud has described two
mechanical improvements in the textile printing press that
link copperplate printing to cylinder printing, the next major
development.[9] These inventions concerned the adaptation of
the paper printer's press for use by textile printers who aimed
to print entire rolls of cloth rather than single sheets of paper.
Other attempts were made to color and print wood blocks
mechanically and to reduce the blocks to a manageable weight

in order to print larger areas. It is sufficient to say that each
new invention speeded cloth printing to a degree, but not
until the invention of rotary machines did the continuous
printing of cloth become a reality.

Honors for the invention of cylinder printing go to Thomas
Bell, a Scotsman. His machine was patented in 1783, two
years before James Watt first applied steam power to cotton
spinning, but about twenty years elapsed before the new
technique became commercially successful and was generally
applied at Lancashire printworks. After several abortive
early efforts, cylinder printing was well established in America
soon after 1825. Despite strict British prohibition "during
these years, the best foreign machinery was imported surrep-
titiously from England and skilled workers were brought over."[10]

Figures 1 and 2 offer a striking comparison between a
plate-printed textile (Fig. 1) and a cylinder-printed example
(Fig. 2), which has a vertical repeat much reduced in size.
Both examples show the allegorical figure of Minerva seated
in a chariot drawn by lions and preceded by the Angel of Fame.
Jumbled together with Minerva are Chinese figures, seashells,
huge birds, flowers, and Britannia drawn by sea horses.
Mercifully some of these details are deleted from the more
compressed example of figure 2, for a roller with the entire
vertical repeat of figure 1 would have been heavy and cumber-
some to handle.

The first roller prints produced were apparently limited to
monochrome, small-scale dress patterns. As early as 1805 a
union, or mule, machine was invented that combined a finely
engraved metal roller, usually inked in red, with coarser
wooden relief-cut rollers that printed other colors less precisely.
By 1815, with the refinement of this machine, larger motifs
suitable for draping long windows and high-post beds were
produced. Characteristic of several English prints are a
variety of honeycomb or net patterns, some of which appear to
have three colors, an effect created by overprinting; i.e.,
portions of the design produced by a metal roller were covered
with color from a wooden, relief-cut roller.[11] Designers
relied heavily on overprinted effects to add richness to their
work while obviating the cost of engraving a second metal

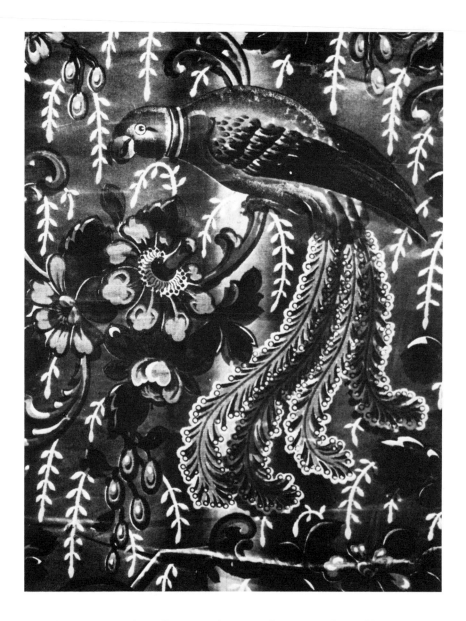

Fig. 3. Cotton textile, roller-printed in rose, brown, purple, and blue with an ombré or shaded background. Bloomfield Calico Printworks, West Bloomfield (Montclair), N.J., 1827-53. (Genesee Country Museum, Mumford, N.Y.)

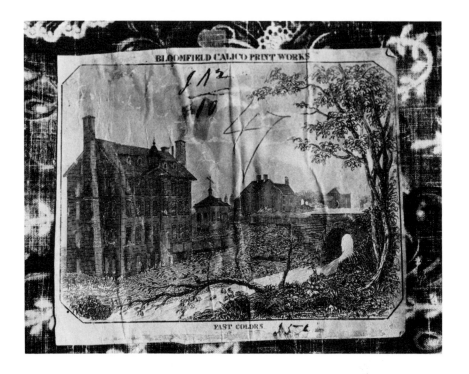

Fig. 4. Printed paper label of Bloomfield Calico Printworks pasted to back of chintz shown in figure 3. (Genesee Country Museum, Mumford, N.Y.)

roller. To produce a variety of prints, the primary metal
cylinder and the wooden rollers could be inked in different
colors.

Late eighteenth-century advances in metallurgy had their
effect on roller printing. For instance, with increased facility
in the tempering of steel, the technique of die-and-mill
engraving was possible. Jacob Perkins, an American inventor,
first developed the die-and-mill process for printing counterfeit-
proof bank notes, and the principle was adapted about 1808 by
Joseph Lockett of Manchester to engrave background or cover
rollers completely filled with fine repeating patterns. Cylinders
with floral or pictorial patterns could be printed over these
backgrounds.[12] Edward Baines, author of The History of the
Cotton Manufacture in Great Britain, described die-and-mill
work:

> The pattern intended to be engraved is so arranged
> in the first place by a drawing made to agree with
> the circumference of the copper cylinder, as that
> it will join and appear continuous when repeated.
> This is then carefully followed by the engraver,
> and cut or sunk on a small steel cylinder, about
> three inches long and one thick, so softened or
> decarbonized as to admit of being easily cut. The
> steel is then tempered or hardened, and by means
> of pressure against another cylinder of softened
> steel, a facsimile is made in relief, that is, raised
> upon the surface. The second cylinder is then
> hardened in the same way, and it becomes hard
> enough to impress the whole engraving, even to
> the most delicate lines, on the copper cylinder,
> when pressed against it in a machine. The small
> cylinder originally engraved is called the die: the
> second cylinder, which is in relief, is called the
> mill. The latter is successively applied to the
> whole circumference of the copper cylinder, which
> is thus entirely covered with the pattern, as finely
> wrought as if it had been directly produced by the
> tool of the engraver.[13]

Cover rollers, with tiny vermiculate, leafy, geometric, or "cracked-ice" overall patterns, had the advantage of concealing any misregistry of pattern cylinders, the imprecise edges of surface printed areas, and marks of the doctor blade, which skimmed the color off the roller and tended to scratch it if not properly sharpened. With a variety of background rollers and colorways (cylinders inked in different color combinations), many different colors and patterns could be offered at little additional expense.

Two of America's most persistent and able inventors, Thomas Jefferson and Charles Willson Peale, may be credited with the germ of an idea for a mechanical device widely used in the cotton-printing industry until about twenty-five years ago. The polygraph, or stylograph, was invented by Peale and adapted by Jefferson to copy his letters.[14] The polygraph has been described as "a very ingenious double writing desk, with duplicate tables, pens, and inkstands. The pens are connected together at an invariable distance by a system of jointed parallelograms, with two fixed centres, such that the pens are always parallel. Whatever movement is impressed upon one is simultaneously by the connecting linkwork communicated to the other pen."[15]

In due course, the polygraph evolved into the rotary pantograph machine, which greatly reduced the hand labor of cutting patterns on cylinders. With this device a worker traced on a flat metal plate a pattern that was simultaneously recorded by other arms on a roller mounted above him. Rather than scratching the metal roller itself, the tracing points incised the varnished surface of the roller, which was subsequently etched in an acid bath. With proper adjustment the scale of the flat pattern could be reduced on the cylinder from five to nine times, making the patterns look finer and richer, and the cost of engraving a roller was said to be cut from $23 to $2.25. Most prints made with the pantograph have motifs arranged in half-drop repeats, which gave variety to the finished goods. This machine was invented in 1843 by Milton D. Whipple, an American. It was introduced at the Merrimack Mills and was later used at the Cocheco Printworks, Dover, New Hampshire, where an English engraver,

named Rigby, "seeing the advantages of the machine, quietly
made sufficient sketches of the machine for his purpose, and,
returning to England, introduced it under his own name, where,
with some modifications, it is still in use."[16]
 Having arrived at this new and wondrous process of
mechanically tracing and chemically etching patterns, it
remains to describe some of the color fashions popular in
the nineteenth century and to endeavor to explain how they
were produced. In Lancashire, about the year 1801, an entirely
new technique called discharge work was discovered which
was considered "one of the beautiful facts in the chemistry of
calico printing."[17] First applied to the printing of bandana
handkerchiefs with white spots on a colored ground, it was
soon adopted for furnishing prints with fine dotted effects.
When other colors are added, discharge prints are difficult
to identify, and the techniques become very complex. Edward
Baines described the process:

> In this system the parts intended to be kept
> white are printed with acid,--lemon juice, or
> citric acid, being chiefly used for this purpose.
> The cloth is then wholly immersed in the mordant,
> and quickly dried; or, being first impregnated
> with the mordant, the design or pattern is printed
> in acid, which removes it.[18]

 Peter Floud has described the developments during the
period 1810 to 1850 in the use of metallic dyestuffs, which
preceded the discovery of artificial alizarine and aniline,
or coal-tar, dyes. Unfortunately, although these new dye-
stuffs were more easily controlled and less bulky to handle,
they upset the color harmony of the older vegetable palette
with startling, harsh results. A wide range of new "mineral
colors were developed in the fibre--Iron buff, Prussian blue,
Antimony orange, Manganese bronze, and the yellow and
orange chromates of lead."[19]
 The neutral, or lapis, style, used to brilliant effect in
printing, was characterized by a juxtaposition of bright red
next to blue, even in dotted effects, without intervening areas

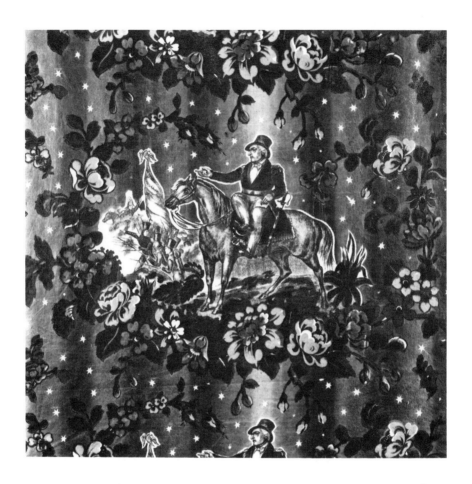

Fig. 5. Cotton textile, roller-printed in tan, blue, and pink with an ombré or shaded background. America, 1846–50. W. 26". The design shows Zachary Taylor at the battle of Palo Alto. (Winterthur.)

of white.[20] It was made possible by using a resist paste
combined with a mordant, thereby combining two steps in
printing. Rainbow-color styles were achieved through the
use of a single engraved roller inked from a partitioned color
trough, which permitted the simultaneous printing of vertical
stripes in several colors.[21]

Mid-nineteenth-century critics deplored the bad designs
and vulgar colors found in most printed patterns. The Journal
of Design and Manufactures stated that "the manufacturer of
fabrics ornamented on the surface cannot be content with
harmonious blending of colour, but is compelled to be most
uncomplimentery in his colouring." Elsewhere the author
expressed the wish that "a more studied attention to the
harmonies of colour" prevailed. Scientific principles and
theories of color harmony were understood by the mid-nineteenth
century and were taught in schools of design. These are
spelled out at length in Christopher Dresser's book, Principles
of Decorative Design, published about 1873. The author wrote
of the three primary colors--red, blue, and yellow--the
secondary colors of purple, green, and orange, and so on.
The Journal of Design cited these theories as a basis for
criticism in observing (with reference to samples of spring
goods), "Cold light green and lilac . . . are tints that cannot
harmonise together"; "green requires red as its contrast"; and
"blue requires orange as its equivalent."[22]

Although American examples of these various styles can
no longer be identified, there is no question that printers
here understood the chemistry of textile printing as practiced
in England. The color book of Edmund Barnes, Dover, New
Hampshire, dated 1829, and the eleven color books of Samuel
Dunster, who worked at various Rhode Island, Pennsylvania,
and New Hampshire printworks, give receipts that parallel
these processes and include small swatches of printed cloth
as well.[23]

To turn to the development of American machine printing,
according to J. G. Dudley:

> Block printing was also commenced very early in
> Philadelphia, by an Englishman of the name of Thorpe.

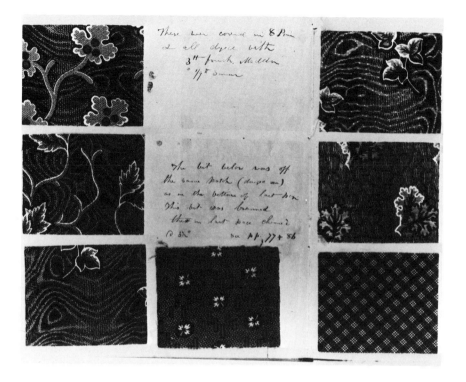

Fig. 6. Samuel Dunster, roller-printed swatches from dye-receipt book. Cocheco, N.H., 1852. Five of the patterns resemble silk moiré dress goods. (Rhode Island Historical Society Library, Providence, R.I.)

Somewhere between 1820 and 1824, Mr. John
Thorpe, a nephew of the above-named gentleman,
built an establishment for the firm of Crocker and
Richmond, at Taunton, Mass. Their first printing
was done by hand.

The first cylinder machine for printing calicoes,
I believe, was put in operation at this place. The
model of this machine, together with some engraved
copper cylinders, was imported from England, in
1825, by Wm. J. Breed, now living in Providence,
R. I. At the time he made this importation, all such
exports were strictly prohibited by the English
Government, and it was very difficult even for
skillful workmen to get away.[24]

Although it may have been experimental, as early as 1824
a two-color printing machine was in operation in Cranston,
Rhode Island, and by 1836 the Hudson Calico Printworks
employed "forty-two block hand printers and three of them
three colors. The machines were all of the best models in
England, whence they had been recently imported."[25] Not
only were machines brought from England but men to work
them, along with chemists and designers.

D. Graeme Keith in his article, "Cotton Printing," listed
the numerous printworks established during the first half of
the nineteenth century along the rivers of New England and the
Middle Atlantic states. In 1836 these printworks produced
120,000,000 yards of calicoes. By 1860 "the product of
printed cloths in the same States amounted to 271,000,857
yards, or an average of 5,228,000 yards a week."[26]

To judge by surviving examples in American collections,
handsome and expensive English furnishing prints continued
to be sold in this country, but, as far as we know, few
American printers competed in this de luxe print category.
According to Horace Greeley, writing in 1872:

The quantity [of calicoes] produced in the United
States nearly equals the production of England,
though the quality of both English and French

Fig. 7. Cotton textile, roller-printed in brown, rose, green, and purple
chintz with a printed label. Printed label probably of the Eagle Printing
Company, Belleville Village, N.J., 1835-45. (Mrs. Samuel Schwartz,
Paterson, N.J.)

Fig. 8. Printed paper label probably of the Eagle Printing Company, Belle-
ville Village, N.J., 1835-45. (Mrs. Samuel Schwartz, Paterson, N.J.)

calico is superior. The consumption of calico in
the United States is greater in proportion to the
population, than that of any other country in the
world. Calico-printing in our country is more
remarkable for mechanical power and speed than
for taste.

On the other hand, the catalogs of trade exhibitions such as
those held annually at the Franklin Institute state that the
prints exhibited were "strikingly like English work" and "equal
to any in England." Two mid-nineteenth-century pieces of
fairly good quality floral chintz from Marqueston and Company,
who received medals at New York fairs, were labeled "Premium
Furniture Prints" and might be considered comparable to
English goods.[27]
 Probably typical of the American product is a furnishing
print with the label of the Bloomfield Calico Printworks
(Figs. 3, 4), which was in business from 1827 to 1853 in
West Bloomfield, now part of Montclair, New Jersey.[28] It is
coarsely printed in a technique related to rainbow prints with
vertical color bands fading into each other. A similar ombré,
or shaded, background is seen in a Mexican War scene
(1846-48) of Zachary Taylor at the battle of Palo Alto (Fig. 5).
In all likelihood this and two other Mexican War subjects,
with scenes taken from popular prints published by Nathaniel
Currier and others, were printed in America.[29]
 According to Victor S. Clark's History of Manufactures in
the United States, during the decade 1820-30 and later inexpensive
printed goods of American manufacture supplied "the people who
create the volume of consumption," that is, the middle class
mass market.[30] Typical of many cotton dress prints are five by
Samuel Dunster (Fig. 6) with moiré grounds and leafy patterns
clearly intended to look like silk. Apparently his firm was seeking
to produce inexpensive cottons that gave the appearance of the
richer material without its high cost.
 Characteristic of numerous furnishing prints found in
America is one with a paper label, almost certainly of
American origin (Fig. 7), showing an eagle perched on a globe
marked America (Fig. 8). Since the owner bought this piece

in New Jersey, it is not unreasonable to attribute it to the
Eagle Printing Company of Belleville Village, New Jersey.
Although this pattern and numerous related ones in American
collections follow an English fashion chronology, the printing
is coarser. All are printed on loosely woven cloth in a limited
range of dark, somewhat muddy colors, in this case brown,
rose, green, and purple. Washed examples, without glaze,
show that colors in these prints are not entirely fast. The
Centennial Exhibition catalog of 1876, written when these
prints were no longer in fashion, described the type as having
"impossible peacocks and birds of paradise--whose plumage
was anything but terrestrial."[31]

These furniture prints have long been a puzzle. Possibly
they were cheap English work not recorded in the London
Patent Office Design Register, and therefore not mentioned by
English design historians. However, from the evidence, both
written and pictorial, cited in this paper, it would appear
that American textile printers competed with imported goods by
manufacturing cheap fabrics for the large, middle class market.
Dunster's dress patterns imitating expensive silk moirés and
satins are probably typical of dress goods, aside from the
thousands of unidentified small-patterned calicoes seen now
in patchwork quilts. The labeled furnishing prints (Figs. 3, 7)
can be related stylistically to quantities of others, several
with American subjects. Characteristic of all are the loosely
woven cloth, poor engraving, and muddy, fugitive colors.
Because of the frequency with which they are found in America,
I am tentatively prepared to call them American. Many more
pattern books must be examined and many more printed labels
discovered before these attributions can be made with certainty.

NOTES

1. Charles O'Neill, The Practice and Principles of Calico Printing, 2 vols. (Manchester: Palmer and Howe, 1878), 2:192.
2. For an account of the Indian technique, see P. R. Schwartz, "French Documents on Indian Cotton Painting," in John Irwin and P. R. Schwartz, Studies in Indo-European Textile History (Ahmedabad: Calico Museum of Textiles, 1966), pp. 75-124.
3. For illustrations see Florence M. Montgomery, Printed Textiles, English and American Cottons and Linens, 1700-1850 (New York: Viking Press, 1970), figs. 164, 166, and frontispiece.
4. For illustrations see Montgomery, Printed Textiles, figs. 61-64.
5. Francina Irwin, "Scottish Eighteenth-Century Chintz and Its Design," Burlington Magazine 107, no. 751 (Oct. 1965): 510.
6. Peter Floud, "The Drab Style and the Designs of Daniel Goddard," Connoisseur 139, no. 562 (June 1957): 234-39.
7. For illustrations see Victoria and Albert Museum, English Printed Textiles (Large Picture Book No. 13) (London: Her Majesty's Stationery Office, 1960), figs. 4, 5.
8. Catalogue of a Loan Exhibition of English Chintz at the Victoria and Albert Museum (London: Her Majesty's Stationery Office, 1960); Peter Floud and Barbara Morris, "English Printed Textiles," Antiques 71, nos. 3-6 (Mar., Apr., May, June 1957); 72, no. 3 (Sept. 1957).
9. Floud, "The English Contribution to the Development of Copperplate Printing," Journal of the Society of Dyers and Colourists 76, no. 7 (July 1960): 431.
10. Victor S. Clark, History of Manufactures in the United States, 2 vols. (New York: McGraw-Hill, 1929), 1:431.
11. Edward Baines, History of the Cotton Manufacture in Great Britain (London: H. Fisher, R. Fisher, & P. Jackson [1835]), p. 271; for illustrations see Montgomery, Printed Textiles, figs. 322-23.
12. John Lord Hayes, American Textile Machinery

(Cambridge: At the University Press, J. Wilson & Son, 1879),
p. 45; Baines, History of the Cotton Manufacture, p. 267; for
illustrations see Montgomery, Printed Textiles, figs. 336-39.

13. Baines, History of the Cotton Manufacture, p. 267.

14. Dumas Malone, Jefferson the President, vol. 4 of
Jefferson and His Time (Boston: Little, Brown & Co., 1970),
p. 419.

15. Andrew A. Lipscomb, ed., The Writings of Thomas
Jefferson, Monticello Edition, 20 vols. (Washington, D.C.:
Thomas Jefferson Memorial Association of the United States,
1904), 18:177.

16. Hayes, American Textile Machinery, p. 45.

17. Edward Andres Parnell, A Practical Treatise on Dyeing
and Calico Printing (New York: Harper & Brothers, 1846), p. 306.

18. Baines, History of the Cotton Manufacture, p. 275.
For illustrations of discharge prints dating from about 1800, see
Peter Floud, "Richard Ovey and the Rise of the London 'Furniture-
Printers,'" Connoisseur 140, no. 564 (Nov. 1957): figs. 7, 8.

19. Floud, "The English Contribution to the Chemistry of
Calico Printing before Perkin," CIBA Review 1 (1961): 8-14;
Edmund Knecht and James Best Fothergill, The Principles and
Practices of Textile Printing (3d ed.; London: Charles Griffin
& Co., 1936), p. 10.

20. For illustrations see Montgomery, Printed Textiles,
pl. 8 and figs. 153, 154.

21. For illustrations see Montgomery, Printed Textiles,
figs. 334, 335.

22. Journal of Design and Manufactures, 6 vols. (London:
Chapman & Hall, 1849-52), 1:4, 44, 76; Christopher Dresser,
Principles of Decorative Design (London, Paris, and New York:
Cassell, Petter & Galpin [after 1872]), chap. 2 "Colour,"
pp. 30-49.

23. Color book or dye-receipt book of Edmund Barnes,
Providence, Rhode Island, Cooper-Hewitt Museum of Design,
New York. Eleven color books or dye-receipt books were made
by Samuel Dunster between 1828 and 1858, Rhode Island
Historical Society Library, Providence, Rhode Island. Places
Dunster worked include La Grange, Philadelphia County,
Pennsylvania; Philip Allen and Sons Printworks, Coventry,

Rhode Island; Sprague's, Cranston, Rhode Island; Clays
Printworks, Johnston, Rhode Island; and Cocheco Printworks,
Dover, New Hampshire.

24. Dudley, "A Paper on the Growth, Trade, and
Manufacture of Cotton," Bulletin of the American Geographical
and Statistical Society Bulletin 1, no. 2 (Jan. 1853): 171.
Theodore Z. Penn kindly brought this article to the writer's
attention. For a description of machine printing in Philadelphia
in 1810, see J. Leander Bishop, A History of American Manufac-
tures from 1608-1860, 2 vols. (Philadelphia: Edward Young &
Co., 1864), 2:164.

25. D. Graeme Keith, "Cotton Printing," The Concise
Encyclopedia of American Antiques, ed. Helen Comstock,
2 vols. (New York: Hawthorn, 1958), 1:195; Bishop, History
of American Manufactures, 2:404.

26. Bishop, History of American Manufactures, 2:404;
Horace Greeley, Leon Case, Edward Howland, et al., The
Great Industries of the United States (Hartford: J. B. Burr &
Hyde; Chicago and Cincinnati: J. B. Burr, Hyde & Co.,
1872), p. 470.

27. Greeley, Great Industries, p. 470; for illustrations
see Montgomery, Printed Textiles, figs. 413, 414.

28. Henry Whittemore, The History of Montclair Township
(New York: Suburban Publishing Co., 1894), p. 36. Mrs.
Samuel Schwartz, long interested in the early textile industry
of New Jersey, kindly identified this firm for the writer.

29. Esther Lewittes, "The Mexican War on Printed Cottons,"
Antiques 40, no. 4 (Oct. 1941): 212.

30. Clark, History of Manufactures in the United States,
1:547.

31. Phillip T. Sandhurst, et al., The Great Centennial
Exhibition (Philadelphia and Chicago: P. W. Ziegler & Co.
[1876]), p. 322.

WALLPAPER: TECHNOLOGICAL INNOVATION AND CHANGES IN DESIGN AND USE

Catherine Lynn Frangiamore

DURING the 1840s industrialization began to transform the business of producing wallpaper in America. For seventy years, relatively simple hand printing of wallpaper, closely related to textile block printing, had been practiced in workshops scattered among American cities. These workshops were soon to be replaced by new, larger factories using mechanized industrial techniques.

Machine-made papers became so cheap that all but the very poorest could afford wallpapers. An appetite for pattern was fed and stimulated by manufacturers, and the popular preference for a patterned wall was reflected in wallpaper industry statistics of soaring production.[1] Quite simply, technological innovation made possible the widespread use of wallpapers, which became an important feature of nineteenth-century interiors at every economic level. In the 1880s, writing in the Decorator and Furnisher, Marion Foster Washburne summed up the popular opinion of the public to which an eager wallpaper industry catered. In "About Walls and Wallpapers," she proclaimed: "next to whiteness, bareness is objectionable."[2]

But the wallpapered American interior long predated the wallpaper industry's own technical revolution of the 1840s. Wallpaper is known to have been in the stock of a Boston merchant as early as 1700, and by the 1730s advertisements for wallpapers were appearing in American newspapers with some regularity. Historic restorations and museum period rooms generally fail to reflect the frequency with which wallpaper was apparently used in the middle class American home by the last quarter of the eighteenth century. By 1783 a Philadelphia merchant could offer a selection of 2,500 pieces. By 1799, a New York dealer advertised "4000 elegant Paper Hangings . . . for

the Southern Market." Just after the turn of the century, in
1801, a New York manufacturing firm advertised 10,000 pieces
of its own make in addition to imported papers. These figures
indicate that wallpaper was available, and therefore probably
used, in some quantity, even before the industrialization of
the 1840s. After the introduction of machine printing, the
quantities of paper hangings offered in newspaper advertisements
made significant jumps: advertisements of 1845 have been
found offering 50,000 pieces of paper hangings and twenty-four
tons of hanging paper.[3]

This paper will provide an introduction to one aspect of
current research on wallpaper use and production at the Cooper-
Hewitt Museum. The primary aim of this research is to provide
more precise information to American restoration projects about
the dates of samples found in early houses and to document the
styles of wallpapers appropriate to rooms of given dates, although
by itself stylistic analysis of pattern types is often inadequate
for establishing dates of wallpapers.

A general movement, paralleling furniture styles, can be
traced in wallpaper. The styles for hanging papers were
frequently derived from textile patterns. For eighteenth-century
England, large-scale floral papers, frequently with flocking,
and sombre architectural papers in shades of grey are particularly
notable. For France, eighteenth-century styles seem best
represented by the subtle, though vividly colored, arabesque
patterns developed to new heights by the Reveillon factory
(Fig. 1). In the early nineteenth century, bright, strongly
colored, even gaudy, Empire styles vied with the well-known
scenic papers for attention (Fig. 2). Gothic, rococo, and
Renaissance revival styles were outstanding in the middle years
of the century. Japanese- and Moorish-influenced fashions,
often rendered in metallic golds, maroon, black, olive, and
yellows, provided some of the most distinctive wallpapers of
the 1870s and 1880s. From the turn of the century, art nouveau
patterns stand out. This listing of some outstanding styles, of
course, represents an oversimplification of the patterns that
were being used to paper American houses. All through the
eighteenth and nineteenth centuries multiplicities of styles
were available to the decorating householder. Styles overlapped
and paralleled each other in bewildering variety.

Fig. 1. Jean Baptiste Reveillon (attributed), wallpaper. Paris, 1765–89.
Block-printed in colors over light-blue ground color, on joined sheets of
laid paper; H. 45", W. 20 3/4". A long repeat length and delicacy in
handling many shades of color in this arabesque pattern represent high-
style French production of the last quarter of the eighteenth century. The
Reveillon firm took the lead in refining techniques for block printing in
color. (Cooper-Hewitt Museum, Smithsonian Institution.)

Fig. 2. A. P. Mongin, a portion of <u>Les Jardins Français</u>, scenic wallpaper. Printed by Zuber and Cie, Alsace, 1800-1825. Block-printed on joined sheets of paper and mounted on a folding screen; H. 6', W. 6'. Nonrepeating panoramic papers produced in France during the first half of the nineteenth century represent a high point in the development of block printing in color. Their survival in more than two hundred American houses attests to their popularity here. (Cooper-Hewitt Museum, Smithsonian Institution.)

In attempting to date wallpapers, it is necessary to contend with the problems presented by different levels of taste and wealth among consumers. As is true today, what one customer might have considered old-fashioned, another might have thought pretty. Geometric, striped, and simple floral patterns persisted throughout shifts in fashions at the top of the social scale. When (as it frequently does), stylistic analysis fails as a dating tool, physical traces of datable technological innovations in wallpaper production sometimes provide a chronological range for wallpapers. Because English and French papers were imported in quantity through the eighteenth and nineteenth centuries, information about styles and processes of production in England and France, as well as in America, is obviously required. Indications of datable technological innovations in both foreign and domestic wallpaper samples give but one important clue in cataloging wallpapers. The paper itself, the coloring matter, and the way patterning has been applied can contribute information in this identification process. In particular, detailed and practical study, utilizing laboratory analysis, needs to be done to establish the sequence for the introduction of new pigments to the coloring of wallpapers.

Actual production of the paper itself was not normally considered part of the paper stainer's craft during the eighteenth century. Rather, he received the blank, uncolored material from a paper mill, which supplied him with a special class of paper known as hanging paper. This paper has been described as "made from the coarsest and cheapest rags and woolen stuff,"[4] but by modern standards it was high-quality, strong paper. The fact that it was not always bleached a snowy white was of little consequence, since a coating of ground color was almost always brushed over the paper before it was printed. Grounding was one of the first steps in transforming this stock hanging paper to paper hangings.

Although paper mills had been established as early as 1690 in America,[5] it seems probable that in a country which had a sparse supply of rags for papermaking and imported large quantities of foreign paper, foreign hanging-paper stock was sometimes decorated by eighteenth-century American paper stainers. The earliest written record I have located mentioning

American production of papers specifically for hangings is a
1791 diary reference to paper mills at Watertown, Massachusetts.
These mills were described as "employed in the making of paper
for the blocks and stamps used for hangings, etc."[6]

During the eighteenth century, the sizes of handmade papers
were limited by the sizes of the molds in which they were made,
and the size for wallpaper sheets does not seem to have been
uniform. Secondary sources variously described standardly
produced "sheets 30 inches long," sheets 22 inches by 32 inches,
and sheets 16 1/2 inches by 12 1/2 inches for a French paper of
about 1700. Early in the eighteenth century, these sheets would
have been printed individually and hung one by one on a wall.
By mid-century, the sheets would have been pasted together to
form a roll before any coloring was applied. The standard length
of a "piece" of joined wallpaper sheets seems to have been
firmly established by English excise officials during the eighteenth
century at twelve yards. Horizontal seams in a length of wall-
paper are rather sure signs of an eighteenth- or early nineteenth-
century date. By the mid-nineteenth century, standardized sizes
for machine-made hanging papers reportedly varied from country
to country.[7]

Consideration of the printing processes for decorating the
paper requires a jump backward in time. The first documented
example of English printed paper used to decorate a wall was
found to be in the Masters Lodgings, Christ's College, Cambridge,
attributed to the surprisingly early date of 1506.[8] The sample
was block printed in black ink and is one of the types that more
frequently survive as linings in early trunks and wooden boxes.
Samples of sixteenth- and seventeenth-century English and
French printed and marbleized wallpapers have survived, and
flocked papers and canvases have been documented in this early
period, but it was not until the eighteenth century that wallpaper
enjoyed widespread popularity.

The single sheets of late seventeenth- and early eighteenth-
century French papers, called Domino papers, preserve examples
of early printing and coloring techniques. In these papers, the
pattern outlines were printed in black from wood blocks, and
colors were filled in freehand or with the aid of stencils in
watercolors (Fig. 3). By the mid-eighteenth century this procedure

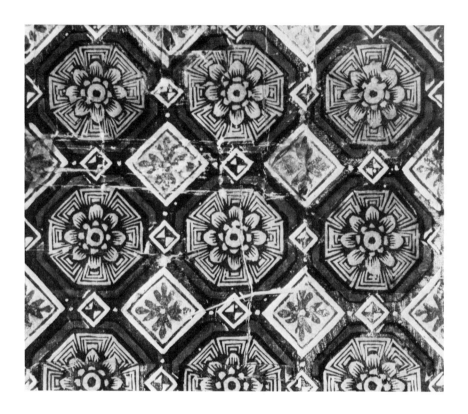

Fig. 3. Domino paper, France, ca. 1720. Printed from wood blocks in black ink with stenciled washes of red and blue, on single sheets of laid paper; (fragment) H. 11 1/4", W. 13". The technique of printing only the pattern outlines on single sheets of paper, which had to be pasted one by one to a wall, and of brushing in color as a second step represents an early stage in the development of wallpaper-making technology. (Cooper-Hewitt Museum, Smithsonian Institution.)

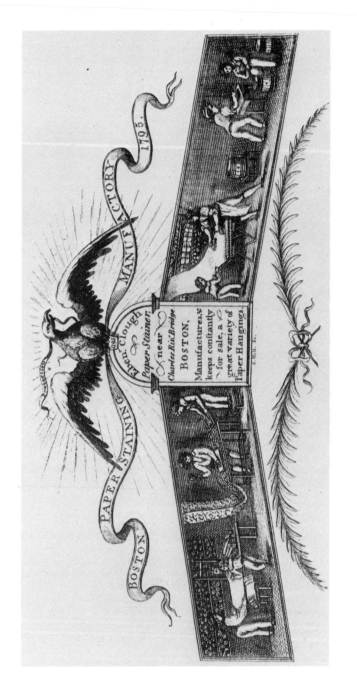

Fig. 4. S. Hill, billhead printed for Ebenezer Clough. Boston, 1795. From Nancy McClelland, Historic Wall-Papers (Philadelphia and London: J. B. Lippincott Co., 1924), p. 268. Stages in the production of wallpapers are shown, right to left: far right, color mixing; center right, applying the ground color by hand with brushes; center left, printing from a hand-held block using a hammer to make the impression; left, rolling the finished paper. (Photo, George Cowdery.)

had been replaced by color printing, in which a separate block
was carved for each color. The colors were distemper mixed
with water and glue size, giving the thick-bodied, opaque,
chalky appearance still favored in the finest wallpapers.
Occasionally the colors were oil-based pigments that gave a
glossy finish and were, unlike the distemper colors, waterproof.
By the mid-eighteenth century both English and French paper
stainers practiced printing in distemper colors from wood blocks
carved with raised printing surfaces (Fig. 4). Mica or colored
wool or silk flocking was added to many eighteenth-century
papers. From the seventeenth century through the nineteenth,
the silk or woolen shavings were spread over a surface pattern
printed in adhesive varnish. A relatively simple device of the
1880s for distributing flocking over the areas of a paper with
pattern printed in an adhesive was a flexible trough. Boys
beating on the bottom of the trough, which was filled with flock,
effected the even spreading of the material.[9]

After 1765 Jean-Baptiste Reveillon, most famous of the
Parisian paper stainers, brought the art and craft of block printing
in distemper colors to new heights of refinement, and French
attainment far outstripped English. Prior to the American
Revolution, more advertisements for English than French wall-
papers appeared in America, and more English examples have
survived from the earlier period. After the Revolution, in the
period coinciding with the preeminence of Reveillon and his
followers, French imports to America were more numerous. The
popularity of French scenic papers during the first half of the
nineteenth century is well known: refinement of skill in the
color block-printing technique is epitomized in these ambitious
productions involving hundreds of individually carved blocks
(Fig. 2).

Imported French and English papers supplied American
markets, but wallpaper was also printed in America during the
eighteenth century. The earliest documentation yet located for
American printed wallpaper is the 1756 advertisement of a dyer
and scourer "lately from Dublin," one John Hickey, who announced
in the New York Mercury, December 13, 1756, that he "stamps or
prints paper in the English manner and hangs it so as to harbour
no worms." This service was but one among many offered by

Hickey; the rest involved the dyeing, printing, and scouring
of textiles.

On June 6, 1765, the New York Gazette reported as a news
item from London that "a new manufactory for Paper Hangings is
set up at New York, which is an article in great demand from
the Spanish West Indies." On December 12 of the same year,
the Boston Newsletter reported that "John Rugar produced several
patterns of Paper Hangings" made in New York "at a numerous
meeting of the Society for promoting Arts &c." also in New York.
In the Annual Register, London, 1766, a similar report appeared
of the presentation of "paper Hangings of domestic manufacture . . .
in 1765, to the Society of Arts Manufactures, and Commerce
instituted in New York . . . which were highly approved and,
when offered for sale were rapidly bought up." These reports,
which probably all refer to John Rugar's activities, seem to
document a larger-scale, more specialized attempt to produce
paper hangings than John Hickey's sideline of stamping papers,
which was advertised as an adjunct to Hickey's primary business
of decorating textiles. In 1769 Plunkett Fleeson, a Philadelphia
upholsterer who had been in business since 1739, first announced
that he had for sale "American Paper Hangings . . . manufactured
in Philadelphia . . . not inferior to those generally imported."[10]

From this point on, newspaper advertisements urged the
purchase of American-made paper hangings as a patriotic gesture.
American manufacturers advertised that their papers were as
good if not better than imports. However, one vendor of imported
wallpapers contended in his advertisements that "paper hangings
manufactured in America are generally very different [from imported
papers] and the colours too faint and pale. Those made in France
are of a fixed and substantial nature."[11] Documentation for the
existence of paper-hanging manufactories in Philadelphia, New
York, Boston, Albany, New Bedford, New Haven, Hartford,
Springfield, Baltimore, and Providence gives evidence of wide-
spread American production of wallpapers during the late
eighteenth and early nineteenth centuries. As far afield as
Steubenville, Ohio, the painter Thomas Cole designed wallpapers
for his father's wallpaper factory between 1821 and 1823.[12]
Indications that regional specialities were developed during the
early period are provided by advertisements describing "Hartford

stile" paper hangings and Boston and Philadelphia papers.[13]
With the coming of industrialization in the 1840s, production
became centralized around New York, Philadelphia, and Boston.
During the later period, wallpapers sent out from these three
main centers functioned as style carriers, bringing the latest
East Coast fashions to all parts of the country. Still later,
Midwestern wallpaper centers developed nearer the source of
supply of wood-pulp papers.

Machines for making endless paper were the important
technological innovations of the early nineteenth century that
made possible the industrialization of wallpaper making. In
1799 the Fourdrinier machine was first patented in England, and
after further experimentation, an improved Fourdrinier machine
was patented in 1807. Using a continuous belt of moving wire
screen to form the paper, it was one of the most successful of
early papermaking machines. In 1809 another important English
machine for making endless paper was patented; this one was
developed by John Dickinson, using a cylinder to form the paper.

In 1817 Thomas Gilpin first produced machine-made paper
in America, in the Gilpin mill on the Brandywine River in
Delaware. Gilpin's machine, patented in 1816, was probably
derived from Dickinson's cylinder machine. The Gilpin mill
was producing some quantity of machine-made paper by 1820, and
in 1822 another American, John Ames of Springfield, Massachu-
setts, patented improvements on the Gilpin machine. In 1827 the
first Fourdrinier machine was imported to the United States.[14]

Evaluating the immediate impact of this series of inventions
on the wallpaper business and determining just when endless
paper was first used for American-made wallpapers is difficult,
since factory records have not been located. In France there is
evidence that the Zuber factory in Alsace began using continuous
paper by 1820. In England tax laws requiring the marking of the
individual wallpaper sheets with excise stamps prohibited the
use of the newly developed endless paper. Not until after 1830
could endless, machine-made paper be used legally in English
wallpaper factories.[15]

The wallpaper industry has been cited as a logical early
user of the new endless paper. Yet in America paper mills
continued to make paper by hand, and all the old, nonmechanized

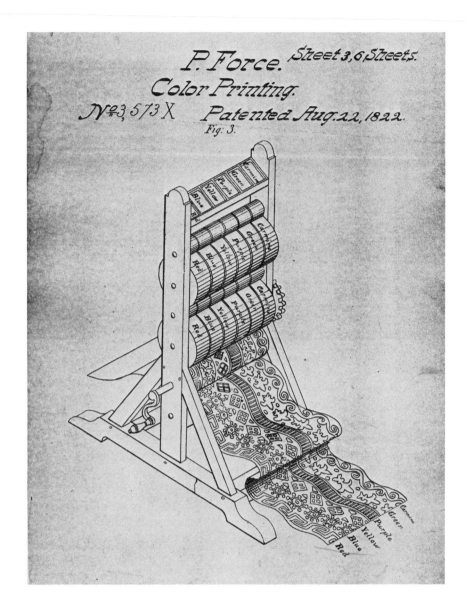

Fig. 5. Peter Force, color printing, U.S. patent no. 3,573X, Aug. 22, 1822. This illustration (third sheet of six) accompanied Force's patent for grounding wallpapers and for printing patterns from an engraved wooden roller. (United States Patent Office.)

mills did not really disappear until about 1870. It is all but
impossible to draw a cutoff date for the use of joined sheets
of paper for American-made wallpaper. As late as 1829, of
sixty paper mills in Massachusetts, only six were using
machinery.[16] There was doubtless a transition period of mixed
use of handmade and machine-made papers in the wallpaper
industry between 1820 and 1840--and probably later.

The basic and dramatic transformation of the paper industry
by Fourdrinier and cylinder machines was a necessary
prerequisite for the mechanization of wallpaper manufacture.
In the 1820s, an ever increasing number of devices for speeding
up wallpaper production and for making more efficient uses of
the abundant, cheaper paper began to appear. As they had
traditionally copied textile pattern designs, wallpaper manufac-
turers attempted to imitate the new textile-printing machines
during the early nineteenth century. English, French, and
American patent records give evidence for the development of
adaptations of calico-printing machines to wallpaper production.
These machines, which used engraved copper cylinders, were
not commercially successful for wallpaper probably because
thick distemper wallpaper colors could not be carried in engraved
grooves as successfully as could the thinner pigment bodies
used for textile printing, nor did the grounded paper receive
the coloring matter carried below the metal surface as readily as
the more absorbent and pliant textiles.

The Zuber factory in Alsace claimed to have used engraved
copper rollers for wallpaper printing from 1827 on.[17] This use
was probably limited to detail work. In England, the 1830s
witnessed numbers of experiments in adapting textile cylinder
printing to wallpaper production. Americans too tried to adapt
textile roller-printing machines to wallpaper. The United States
patent records preserve a series of five charming illustrations of
hand-cranked machines for printing wallpapers using engraved
wooden rollers, patented by Peter Force in 1822 (Fig. 5).[18]

The 1839 experiments of an English firm, Potters of Darwin
in Lancashire, led to the development of the first commercially
successful printing machine for wallpaper. In 1841 the Lancashire
firm made a steam-powered machine with an efficient system for
feeding color to cylinders that printed from raised, rather than

engraved, surfaces. This invention successfully applied the old principle of printing from the raised surfaces of wood blocks to a machine with a curved printing cylinder.

The standard wallpaper-printing cylinder as adopted in wallpaper manufactories had a wooden core with the raised printing surface formed by tapping into that core strips of brass, which formed cloisonlike raised outlines of shapes--little walls into which felt was tightly stuffed to carry the colors for the solid areas of patterning. Lines and dots were printed by appropriately shaped brass pieces (Fig. 6). Such cylinders were used on a machine very like those still used today for large-volume wallpaper printing. At the center of the machine is a large revolving drum, or giant cylinder, upon which the blank paper rides while it engages in sequence a series of smaller cylinders, each of which has a raised surface to print one color of the pattern. Each printing cylinder is coated with its individual coloring by a roller-fed belt from a trough that holds the appropriate color (Fig. 7).

The machine as developed by Potters in 1841 ushered in the real era of machine printing for English wallpaper. Earlier experiments with engraved cylinder printing and earlier mechanical improvements in machines for block printing should not be confused with the more significant developments of the 1840s. The Zuber factory installed one of the English, Manchester-made machines in 1850. It quickly superseded hand-powered machines used by the French firm Leroy, which had begun printing in one or two colors with raised surface cylinders in 1843. Thus 1850 marks the beginning of full-scale machine printing in France.[19]

American records, both factory and patent records, for the crucial 1830-45 period have not been found. Therefore we are limited in our ability to document and assess three divergent descriptions of the introduction of machine printing to American wallpaper that appear in nineteenth-century industrial history and trade publication sources. In a generally well-researched history of the wallpaper industry written in 1895 by the president of the National Wallpaper Company, Henry Burn, 1844 is cited as the crucial year for the American industry. "In that year the first machine for printing wallpaper was imported from England and introduced into the Howell factory . . . it printed only a

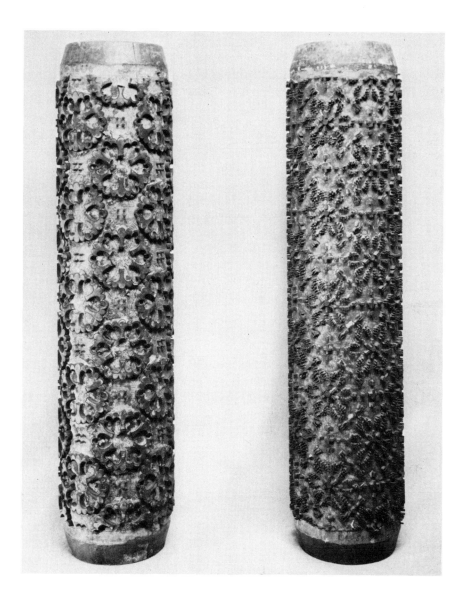

Fig. 6. Raised printing surfaces shown on rollers used for printing two separate colors in the same pattern. L. 21 1/2", Diam. 5 1/4". The surfaces on the left-hand roller were formed by tapping small cloisonlike "walls" of brass into the wooden core of the cylinder. The metal outlines were then stuffed with felt to carry solid areas of color. Similar rollers were used on machines like those shown in figure 7. (Cooper-Hewitt Museum, Smithsonian Institution.)

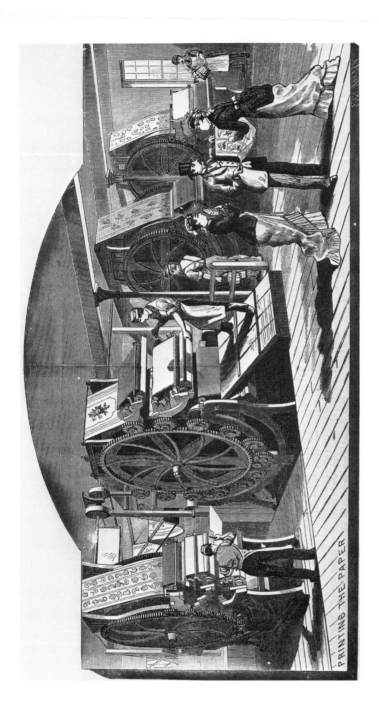

PRINTING THE PAPER

Fig. 7. "Printing the paper," as illustrated in a drawing of the factory of Christy, Shepherd, and Garrett, New York. From Scientific American 43, no. 4 (July 24, 1880): cover. (Photo, courtesy of the Science and Technology Research Center, New York Public Library, Astor, Lenox, and Tilden foundations.)

Fig. 8. Wallpaper, America, 1840-50. Machine-printed on ungrounded, continuous (machine-made) off-white paper with grey veining, light-blue and red patterning; H. 27", W. 20". A repeat length of about 18" is the result of fairly typical mid-nineteenth-century roller sizing. The relatively transparent coloring and dark outlining of the printed shapes are earmarks of the machines' roller. (Cooper-Hewitt Museum, Smithsonian Institution.)

single color." In her book of 1924, Nancy McClelland cited this same 1844 importation of a machine to Philadelphia by the Howell firm as marking the beginning of machine production in American wallpaper.[20]

Earlier nineteenth-century works on American industrial history cite development in 1843 of machines "for printing two colors" by the J. R. Bigelow Paper Hangings Manufactory in New England. Thus, it is possible that the first commercially important American machine printing of wallpaper could have been performed with an American-made machine.[21] Yet a third date, 1835, and a different firm, that of Josiah Bumstead of Boston, is offered in another set of wallpaper trade histories as the originator of American machine printing. The 1835 machine is described as "a machine to print wallpaper in one color, which though crude, was a vast improvement to the hand process for rapid work."[22] Research has yet to turn up contemporary descriptions of, or patent records for, any of these machines--Bumstead's of 1835, Bigelow's of 1843, or that imported by Howell's in 1844--that give meaningful descriptions of the machines, telling whether they were mechanized block-printing devices, machines for printing from engraved cylinders, or the machine that proved successful for wallpaper production, one which used raised-surface printing cylinders. Further research may yield more precise information. At this point, it seems probable that the 1835 machine was one of the earlier, commercially insignificant forms of printing machinery for wallpaper.

The 1840s stand as the decade marking the beginning of commercially significant machine printing of wallpaper. Old papers found during the course of restoration projects that bear the impression of the raised-surface cylinders used on wallpaper-printing machines cannot be safely dated before 1841. The little metal outlines with felt filling left a distinct impression--an outline of thicker coloring around edges of shapes--and when combined with traces in colored areas of the directional movement of the cylinders, their mark (Fig. 8) indicates a date of no earlier than 1841 for English papers, 1850 for French, and, very probably, the mid-1840s for American wallpapers.

Although a series of refinements in wallpaper production

followed these initial improvements, the development of endless paper and the introduction of steam-powered machinery using printing cylinders with raised surfaces stand as the two most crucial technological improvements in wallpaper production. Machine processes for grounding and for making striped paper were among the earliest improvements in wallpaper production (Fig. 9). The most important later refinements included devices for rapid drying of more quickly printed papers, embossing and gilding processes, and combining the steps of grounding, printing, and embossing in a series performed by machine. During the second half of the century, the previously abandoned engraved-cylinder process was readopted to print on smoother, more suitable paper surfaces, in oil-based pigments. The washable papers produced, called "sanitary" papers, were very popular in England as well as in America. Photographic and lithographic patterning processes were developed and patented as well.[23]

The introduction of wood pulp for papermaking was of great subsequent importance in lowering the price of wallpaper and increasing its use. The process was first worked out practically in England early in the 1850s and introduced to America in 1855. By the 1880s the bulk of commercial hanging paper stock had been greatly cheapened by the introduction of wood pulp, straw, and other less expensive ingredients. The brittle, browned wood-pulp papers of the nineteenth century, familiar in cheaply made books, are easily differentiated from rag pulp papers. There were numerous compositions for making wall coverings with patterns embossed in high relief, such as the thick linoleum-like wall covering with the brand name "Lincrusta." Among the patents that provide documentation for dating wallpapers found in late nineteenth-century houses is an 1877 patent for "Ingrain" paper. It is a patent for making paper from mixed cotton and woolen rags, dyed before pulping, which gave a thick paper with textured, "ingrain" coloring instead of surface-color coated wallpaper.[24] Similar papers were called oatmeal papers in the trade.

In summarizing the major effects of technological improvements on wallpaper design in the nineteenth century, it is no surprise that, as in textile production, designs for cylinder-printed

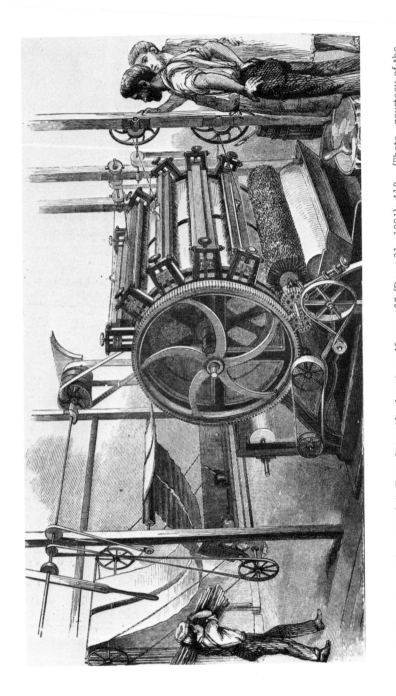

Fig. 9. "Laying the ground." From Scientific American 45, no. 27 (Dec. 31, 1881): 418. (Photo, courtesy of the Science and Technology Research Center, New York Public Library, Astor, Lenox, and Tilden foundations.)

Fig. 10. Japanese-influenced wallpaper, America, 1880-95. Machine-printed in maroon, yellow, light green, black, and brown on olive ground, on continuous paper; H. 19", W. 17 1/2". Japanese-derived styles, called Japanesque in the trade literature, were popular at this time. During the 1880s color printing by machine in twelve or even in sixteen colors was not uncommon. Small-scale patterns like this were compatible with the construction techniques for making wallpaper-printing rollers. (Cooper-Hewitt Museum, Smithsonian Institution.)

wallpapers were strictly limited by roller sizes. Machine
production required shorter pattern repeats, usually under
eighteen inches, to fit cylinders that were seldom larger than
six inches in diameter. The construction technique for making
the printing cylinders, substituting metal outlines filled with
felt for carved wooden printing surfaces, also contributed to
the reduction of pattern size and scale (Fig. 10). Large areas
of felt could not be relied on to hold within metal walls over
too large an expanse; so a smaller scale of design and smaller
areas of solid coloring than were possible in wood-block printing
were required (Fig. 11). Small-scale patterns came to dominate
machine-made wallpapers.[25] Coloring materials for the cylinder
machines had to be thinned down from the thick-bodied distempers
of block prints and chemically adapted to dry more quickly in
the almost simultaneous process of application of ground colors
and printing of patterns. These thinner, more transparent colors
brought a different look to the machine-printed papers, as did
the introduction of new synthetic pigments.

Technological innovations were so intoxicating that in some
cases design considerations were totally subordinated to
celebration of the new talents of the machines. Papers were
bespangled, gilded, and embossed. Sometimes one overburdened
sample on a single sheet of paper boasted embossed patterning,
printed fill-patterning with overlaid dominant patterning, and,
on top of all, accents in metallic colors or mica.

The speed, quantity, and reduced cost of production
apparently encouraged and created new markets in spiraling
growth patterns. By the twentieth century, wallpaper fashions
had become seasonal. New lines were brought out spring and
fall. Some city laws required yearly renewals of apartment
house walls, and this helped bolster the seasonal wallpaper
market.[26] Patterns were seldom carried in a manufacturer's
line for more than a very brief period.

In reaction to the development of machine-printing technology
there were decided changes in block printing. On the one hand,
mechanical devices were introduced to speed the block-printing
process and reduce costs. On the other hand, particularly in
France and in papers produced for the carriage trade, block
printers worked to clearly differentiate their products from

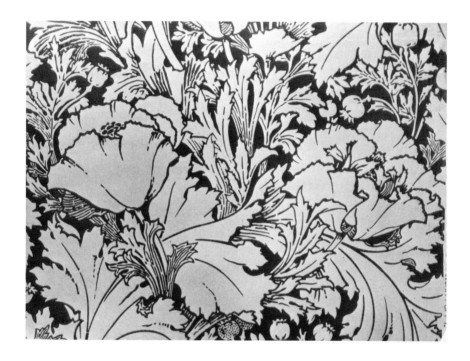

Fig. 11. <u>The Manora Poppy</u>, art nouveau style wallpaper. America or England, 1895-1905. Machine-printed in tan on ungrounded cream yellow paper; H. 15 3/8", W. 22". The large, light areas forming flowers and leaves show the reserved, light-colored paper. In conformity to the requirements of roller construction, the darker, printed areas require only small printing surfaces. This sample is an unused remnant from The Manse, Deerfield Academy, Deerfield, Massachusetts. (Cooper-Hewitt Museum, Smithsonian Institution.)

machine-made designs. Using enormous numbers of thick
chalky colors, they strove for refinements in painterly effects
of realistic shading and delicacy in their block prints, as well
as for elaboration unattainable in machine printing.

Thoughtful critics of design reacted both against the block
printers' overelaborations and strivings for painterly realism
and against the hasty, ill-designed, overelaborated productions
of the machines. They called for careful consideration of the
problems of designing patterns for covering flat surfaces. From
the mid-century on, in opposition to the tide of commercial
production, a group of reform-conscious English designers,
including leading architects of the day, grappled thoughtfully
and creatively with the problems of flat pattern design. These
problems had been emphasized by the horrors of machine produc-
tion. In reaction, these designers (William Morris, C. F. A.
Voysey, E. W. Godwin, Lewis F. Day, Christopher Dresser,
and so on) created brilliant examples of repeating patterning
during the second half of the century, and their influence was
strongly felt in America.

A negative effect of the increased use of wallpaper made
possible by the technological innovations during the nineteenth
century is still felt today: extreme reaction against its overuse
(Fig. 12). A generation of architects raised in houses covered
in a multiplicity of patterns turned away from wallpaper. Their
preference for the unadorned "honest" white wall, a preference
derived from their overall architectural philosophy, was reinforced
by a reaction against the excesses of the previous generation.
The popular image of wallpaper was not helped by fading expanses
of poor quality wallpaper, which quickly browned from the acids
in the wood pulp paper from which it was made.

The widespread use of wallpaper made possible by nineteenth-
century production technology transformed the interior spaces of
many examples of architecture that are of increasing interest to
us today. Architects frequently planned these interior spaces
for patterned walls--often for wallpaper. The proper understanding
of these rooms as interior spaces, as well as their restoration as
backgrounds for the other decorative arts, requires a recognition
of wallpaper as a major architectural accessory of the nineteenth-
century interior. Whether in mansions designed by architects or

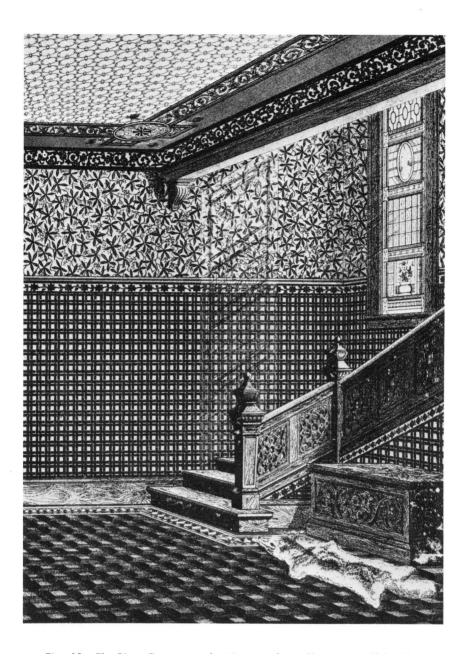

Fig. 12. The Birge Company, advertisement for wallpapers, Buffalo, New York. From <u>Decorator and Furnisher</u> 5, no. 3 (Dec. 1884): opp. 92. The small scale of the patterns is typical of machine production, and the use of many patterns on walls and ceiling epitomizes the basic result of technological innovation in wallpaper production: increased use of wallpaper during the nineteenth century. (Photo, courtesy of the Art and Architecture Division, New York Public Library, Astor, Lenox, and Tilden foundations.)

in the most ordinary row houses of factory workers, wallpaper
dominated many American rooms. Its widespread use, in
combinations of multiple patterns, was a direct result of
cheapened, increased production of new machine technology.

NOTES

1. In 1850 the annual output of wallpaper was valued at
$107,040. In 1900 this figure had risen to $10,663,209.
J. Leander Bishop, A History of American Manufactures, 3 vols.
(Philadelphia: Edward Young & Co., 1868), 2:420; U.S. Bureau
of the Census, Twelfth Census of the U.S. Taken in the Year
1900, Manufactures, Part 1, vol. 7 (Washington, D.C.:
Government Printing Office, 1902), p. 12. In 1840 two million
rolls of wallpaper were produced in America; in 1890 one hundred
million rolls were produced. "Wallpaper," Decorator and
Furnisher 16, no. 6 (Sept. 1890): 193.
2. Marion Foster Washburne, "About Walls and Wall
Papers," Decorator and Furnisher 10, no. 4 (July 1887): 124.
3. Walter Kendall Watkins, "The Early Use and Manufacture
of Paper-Hangings in Boston," Old-Time New England 12, no. 3
(Jan. 1922): 109; advertisement of William Poyntell, Pennsylvania
Journal, Aug. 16, 1783; advertisement of A. S. Norwood, New York
Gazette and General Advertiser, Feb. 15, 1799; advertisement of
Cornelius and John Crygier, Republican Watch Tower (New York),
July 20, 1801; advertisement of G. P. Gratacap, New York Evening
Post, Mar. 31, 1845; advertisement of Cyrus W. Field, New York
Evening Post, Apr. 1, 1845. The 1845 advertisements were
brought to the author's attention by David Kiehl.
4. Lyman Horace Weeks, A History of Paper-Manufacturing
in the United States, 1690-1915 (New York: Lockwood Trade
Journal Co., 1916), p. 99.
5. Harry E. Weston, "A Chronology of Papermaking in the
United States," The Paper Maker (Wilmington, Del.), no. 2
(1944): 9.

6. Watkins, "Paper-Hangings in Boston," p. 119.

7. Weeks, History of Paper-Manufacturing, p. 99;
Watkins, "Paper-Hangings in Boston," p. 110; Nancy McClelland,
Historic Wall-Papers (Philadelphia: Lippincott, 1924), p. 30.
Additional measurements of paper sizes in examples of Cooper-
Hewitt wallpapers printed on joined sheets give the following
figures: 1780, French paper by Reveillon (1931-45-28): 17 1/4" x
21 1/2"; 1804, American pattern possibly New York (1973-8-1):
23 1/2" x 20". Although variant measurements have been found,
one nineteenth-century source reported sizes for machine-made
paper as follows: "Of the American paper, each piece is 18"
wide and 8 yards long, . . . French . . . 18" wide and 9 yards
long . . . English . . . 21" wide and 12 yards in length."
American Builder and Journal of Art 1, no. 3 (Dec. 1869): 231.

8. Alan V. Sugden and John L. Edmondson, A History of
English Wallpaper, 1509-1914 (London: Batsford, 1925), opp.
p. 40, with illustrations.

9. The process of flocking as carried out in the Frederick
Beck & Co. factory, New York City, is illustrated in Scientific
American 45, no. 22 (Nov. 26, 1881): cover.

10. The Annual Register, a Review of Public Events at Home
and Abroad 8 (London: Dodsley, 1766), p. 55. The report in
Dodsley's Annual Register adds that additional samples from the
same manufacturer were presented to the same society the
following year and approved. Pennsylvania Gazette (Philadelphia),
Oct. 19, 1769.

11. Morning Chronicle (New York), Mar. 10, 1803.

12. Documentation for the existence of Boston, Philadelphia,
and New York paper-hanging manufactories is copious in secondary
sources, including Nancy McClelland's Historic Wall-Papers,
the Watkins article cited above, and period newspapers and
directories. Hartford paper stainers are discussed by Phyllis
Kihn, "Zecheriah Mills," Connecticut Historical Society Journal
26, no. 1 (Jan. 1961): 21ff. Newark, N.J., city directories of
the 1840s advertise the local paper-hanging manufactory of
William P. White and William M. Shaw. New Bedford manufac-
ture is known from labels on bandboxes, for example the Cooper-
Hewitt bandbox 1968-71-1 labeled by Joseph L. Freeman and
described on the label of about 1835 as "at the Paper-Hanging

Manufactory of John Perkins . . . New Bedford." McClelland
lists the Howell factory in Albany as well as Baltimore paper
stainers. For Providence, the 1800 venture of Robert Newell
and Samuel Thurber in the manufacture of paper hangings is
mentioned in Edward M. Stone, Mechanics Festival (Providence:
Knowles & Anthony, 1860), p. 114. The 1820 census report
for Rhode Island includes documentation for "Two paper-staining
manufactories, the business of one of which is dull, from the
markets being overstocked with French papers, and the other,
from the same cause, is not in operation"; Weeks, History of
Paper-Manufacturing, p. 143. The Springfield factory of
McKay & Dixey is mentioned in an advertisement in the New York
Daily Gazette, Aug. 14, 1790; Thomas Cole's wallpaper designing
is recorded by Louis L. Noble, The Course of Empire, Voyage of
Life, and Other Pictures of Thomas Cole (New York: Lampert
& Co., 1853), p. 25.

 13. Kihn, "Zecheriah Mills," p. 28.

 14. I have relied on Weeks, History of Paper-Manufacturing,
for this summary of early nineteenth-century developments in
papermaking machinery, esp. pp. 173-76.

 15. Jean-Pierre Seguin, "Des Siècles de Papiers Peints,"
in Musée des Arts Décoratifs, Trois Siècles de Papiers Peints
(Paris: Union Centrale des Arts Décoratifs, 1967), p. 114;
Sugden and Edmondson, History of English Wallpaper, p. 124.

 16. Weeks, History of Paper-Manufacturing, p. 199.

 17. Sugden and Edmondson, History of English Wallpaper,
p. 139, gives the 1827 date. Seguin, "Des Siècles de Papiers
Peints," p. 114, suggests around 1820 for the introduction of
engraved-cylinder printing at Zuber.

 18. U.S. Patent no. 3,573X, Aug. 22, 1822, class 101,
printing, subclass 187. In the patent specifications, Peter
Force suggests that motive power other than hand turning the
crank could be substituted.

 19. Sugden and Edmondson, History of English Wallpaper,
p. 140; Seguin, "Des Siècles de Papiers Peints," p. 116. Seguin
gives 1849 as the date when Zuber had a power-driven wallpaper-
printing machine.

 20. Henry Burn, "American Wallpapers," in One Hundred
Years of American Commerce, ed. Chauncey M. Depew (New York:

D. O. Haynes & Co., 1895), p. 506; McClelland, Historic Wall-Papers, p. 274.

 21. Bishop, History of American Manufactures, 3:305. The same 1843 date used by Bishop was used by Horace Greeley to date the beginning of machine-printing in American wallpaper; Greeley, et al., The Great Industries of the U.S. (Hartford: J. B. Burr & Hyde; Chicago and Cincinnati: J. B. Burr, Hyde & Co.; 1872), p. 463.

 22. "Wallpaper," p. 192. The same date and "a Boston firm" are mentioned in a generally garbled promotional booklet by William R. Bradshaw, Wallpaper, Its History, Manufacture and Decorative Importance (New York: for the Joseph P. McHugh Co., 1891), p. 10. In "Early Wall Paper Machinery," Wallpaper News and Interior Decorator 38, no. 2 (Aug. 1911): 30, the writer stated that in 1893 he had "obtained from William Campbell and Co., the Old New York Manufacturers, the following date which they had preserved as authentic: 'In 1835 a machine was invented in America to print wallpaper in one color. . . . It was a machine but was operated by hand. . . . The first wallpaper ever made in New York by machinery was in 1839.'"

 23. Claire Crick, "The Origin and Development of Wallpaper" in Historic Wallpapers in the Whitworth Art Gallery (n.p.: Whitworth Art Gallery & Wall Paper Manufacturers, 1972), p. 13. A particularly vague patent for a photographic process for making wallpaper is described in Archibald W. Paull, U.S. Patent no. 140,533, July 1, 1873.

 24. Weston, "Chronology of Papermaking," p. 10; James S. Munroe, U.S. Patent no. 204,446, June 19, 1878.

 25. G. T. Robinson, "The Year's Advance in Art Manufactures, No. VIII Household Decoration--Wall Papers," Art Journal 11 (London, 1883): 355.

 26. Wall-Paper News and Interior Decorator 26, no. 6 (June 1908): 13.

CRAFTSMEN AND MACHINES:
THE NINETEENTH-CENTURY FURNITURE INDUSTRY

Polly Anne Earl

THE notion of craftsmanship is a kind of romantic filter through
which the artisans and material remains of our past are often
viewed. The craftsman is usually seen as an independent,
quasi-artist using hand skills to produce objects that combine
a useful function with artistic merit.[1] Much of our modern
affection for craftsmen and craftsmanship is rooted in a
nostalgia that recalls a seemingly simpler time before the
so-called industrial revolution of the nineteenth century befouled
our historical landscape with smoke, steam, railroads, machines,
and their attendant social problems. A more practical look at
the past shows many of the attributes of craftsmanship are not
what they seem, and many of our truisms about the industrial
revolution are questionable. If they indicate anything clearly,
the few firsthand historical records available show the complexity
of the transition from hand to machine work.

Part of our definition of craft work is derived from general-
izations about the economic characteristics of early American
businesses. Far from being individualistic proprietors of
simple firms, many master craftsmen, especially in cities, were
masters, not of their crafts, but of the business skills necessary
to survive in the bewilderingly complex world of colonial trade
and finance. They were organizers and managers who had to
deal with rapidly fluctuating currencies, to contract for labor
and supplies, to oversee what was sometimes considerable
specialization and subdivision of productive processes, and to
arrange transportation, insurance, and sale of the finished
product.[2]

Even if the craftsman is accepted as an entrepeneur, crafts-
manship is still viewed as the mastery of hand skills and hand
processes. According to this approach, craftsmanship ended

abruptly with the introduction of machinery. David Pye, an
English historian of design, has advanced a somewhat different
viewpoint. He has defined craftsmanship as "workmanship
using any kind of technique or apparatus, in which the quality
of the result is not predetermined, but depends on the judge-
ment, dexterity, and care which the maker exercises as he
works."[3] This definition liberates the idea of craftsmanship
from the strictures of historical time and economic organization
and focuses on the central problem of process. To Pye, crafts-
manship, whether hand or machine processes are involved, is
the "workmanship of risk" and its antithesis, automation, is
the "workmanship of certainty." Yet from the beginning of
productive work, men have sought to introduce elements of
certainty in their techniques. For instance, printing, as Pye
has pointed out, is a process whose results are at least
partially predetermined. In a similar manner the adz is a hand
tool that is "partly self-jigging" because each stroke follows
the plane of the previous stroke. Any die or jig or pattern used
in a process is an example of development toward a workmanship
of certainty, and dies, jigs, and patterns were used from very
early times in all kinds of decorative arts processes.

From this point of view the distinction between hand and
machine labor in craftsmanship, while it may have social
implications, is not a rigid line in a technical sense.[4] To
determine the parameters of craftsmanship in the nineteenth
century, we need an investigation of the relationship between
the craftsman and the machine. We need information on the
kinds of machines used, when they were introduced, and how
they were employed. Only this view of technology from the
inside out will yield an understanding of the relationships
between process and product, between new capabilities and
new designs and forms. Too often this kind of specific infor-
mation about processes is unavailable. Chauvinistic boosters
of America wrote at great length in the nineteenth century about
the glories of mass production achieved through the introduction
of machinery, but usually they had limited practical knowledge
of how this machinery operated.[5] And since mechanics and
artisans only rarely recorded their work experiences, we are
left with few reliable sources as to how work was actually

organized, how the subdivision of labor evolved, and how new
machinery was actually integrated into productive processes.
Some general information is available in technical dictionaries
and artisans' handbooks that can be combined with the manu-
script returns for the census of industry after 1850, which do
provide listings of machinery and power used.[6]

Since nineteenth-century observers singled out woodworking
as an area of particular American superiority in the application
of new machines,[7] the early furniture industry is an appropriate
place to look at the introduction of machinery. Furniture
historians have concluded that "by 1840, with a rapidly
expanding market, there had been a definite change from
individual assembly of furniture to the mass production of
parts, which were shaped with the aid of lathes and scroll
saws powered by steam-driven machines."[8] Usually the
introduction of power-mechanized processes is associated by
furniture historians with the popularity in the 1830s and 1840s
of the pillar and scroll style. And often the pillar and scroll
style is linked with the adoption of the band saw, which
Robert Bishop says was in common use by 1840.[9]

The assertion that the simple curves and surfaces of the
pillar and scroll style were immediately adapted to machine
replication is contradicted by the technical literature of the
period, which shows that powered saws, especially band saws,
were introduced quite slowly into general use in the furniture
industry. A review of the outstanding machinery exhibited at
the American Centennial Exposition states that band saws were
shown in England as "novelties" in 1855. And an expert on
shop practice in the furniture industry, writing in 1870, dated
the rapid introduction of the band saw in America from 1865 on.
The wide commercial use of a band saw like the 1884 model
produced by the Williamsport Machine Company (Fig. 1) required
high-grade steel to prevent the blade snapping and a heavy iron
frame to prevent vibration.[10] Circular saws were in use much
earlier, widely by the 1840s and 1850s, although they too were
subject to strain and metal fatigue. Since they were most
efficient at heavy cutting, both circular and band saws presup-
posed a steam or water power source strong enough to drive
them at their optimum speeds. For the average cabinetmaker

Fig. 2. Patent unstrained scroll saw. From Illustrated Descriptive Catalog of Labor Saving Patent Wood-Working Machinery (Cincinnati: J. A. Fay & Co., 1893), p. 202. (Eleutherian Mills Historical Library.)

Fig. 1. Thirty-six-inch band saw. From Catalogue of the Williamsport Machine Co., Ltd. (Williamsport, Pa.: n.p., 1884), p. 38. (Eleutherian Mills Historical Library.)

the cost of the necessary power plant, with its required shafting and belting, rather than the cost of the saws, may have ruled out the installation of power machinery. Instead, many cabinetmakers obtained rough stock, veneers, moldings, and turnings from lumber mills and even sent out their own smaller work to be mill sawn.[11] Lumber and builders' supply mills, which produced a generic product marketable without style considerations and which generally worked heavier stock than cabinet shops, adopted power saws earlier than furniture concerns did.

Band saws were recommended for curved work, which could not be cut with a circular saw, and rotary motion was generally preferable to reciprocating, which led to wear and vibration. But reciprocating scroll or jig saws were highly adaptable to furniture work because their blades could be unhooked and perforated work inserted. The magnitude of labor savings introduced by these machines is illustrated by an 1898 report asserting that it took 110 hours with hand processes to work irregular shapes on side boards compared to 4 hours using mechanized band and jig saws. The J. A. Fay and Company's 1893 scroll saw showed the kind of bracket work commonly cut on these machines (Fig. 2). Another versatile feature, on an 1884 Williamsport Company scroll saw, was a tilting table, also used on band saws, which allowed the work to be cut on an angle. It is important to note that neither of these machines dispensed entirely with the skill of the operator, since the work had to be controlled in the saw by the operator's hand. In fact, one authority stressed the application and dexterity necessary on the workman's part in using a jig or scroll saw in order to follow the lines of the work.[12]

The 1884 Williamsport scroll saw cost $110,[13] and much of its cost undoubtedly went into the pulleys, brakes, eccentrics, and so on that adapted the machine to its power source. Simpler, human-powered machinery could do the same job at considerably less expense, especially in shops where limited markets or unstructured labor division resulted in less emphasis on quantity output and high-speed production. Human-powered machinery was the only option for shops without steam or water power. Because of its simplicity and because human-powered machinery

Fig. 3. Velocipede scroll saw. From <u>Patent Foot and Hand Power Wood-</u>
<u>working Machinery</u> (Rockford, Ill.: W. F. and John Barnes Co., 1904),
p. 32. (Eleutherian Mills Historical Library.)

does not accord with our preconceptions about industrialization
in the nineteenth century, this class of invention has escaped
the attention of most historians of technology and furniture.
Yet it was made and used in quantity in the nineteenth century.
In 1876 the Sorrento Wood Carving Company of Boston advertised
that it used a treadle-powered jig saw and drill[14] in making its
patterns. As late as 1904 the W. F. and John Barnes Company
recommended its patent velocipede scroll saw to all branches
of the furniture trade. This saw included a boring attachment
and sold with a dozen blades for only $20 (Fig. 3).

Machinery like this could of course be used to produce
any type or style of furniture. Far from being particularly useful
for the pillar and scroll style, one of its virtues was its
versatility. It was even recommended for styles more usually
associated with an antimachinery bias. The Illustrated Wood-
worker in 1879 suggested that the top, bottom, and side pieces
of a vaguely Eastlake bookcase (Fig. 4) be cut out with a band
or jig saw. It is extremely difficult to find accounts linking
manufacture of specific pieces of furniture with specific machines,
but the Illustrated Woodworker's instructions for making a side-
board (Fig. 5) called for shaping the fronts with a "Barnes foot
scroll saw."[15]

An examination of the pattern of power and machine usage
in furniture shops in two rapidly industrializing areas at mid-
century also indicates the relatively late adoption of powered
machinery and the probable prevalence of human-powered
machinery. In addition, such a survey illustrates the economic
considerations of location, size, and market that enter into
when and why firms purchased machinery. New Castle County,
Delaware, was perhaps typical of an industrializing satellite
area on the eastern seaboard. From an earlier specialization
in flour milling, the county and its primary city, Wilmington,
had developed by mid-century a diversified industrial base of
ironworks, tanning, carriage making, railroad car manufacture,
and iron ship building. Due to its proximity to Philadelphia,
the earliest center of American steam technology, New Castle
County was technically in advance of many areas of the country.[16]
The other area, Cincinnati, Ohio, was the archetype of a
vigorous, growing western town. With river connections to the

Fig. 5. Sideboard. From the Illustrated Wood-
Worker 1, no. 9 (Sept. 1879): opp. 128.
(Winterthur Museum Libraries.)

Fig. 4. Library bookcase. From the Illustrated Wood-
Worker 1, no. 4 (Apr. 1879): 64. (Winterthur Museum
Libraries.)

expanding markets in the South and West, Cincinnati could dispose of the vastly increased output of machine production, and the city seized on machine technology in its meat packing, its steamboat and locomotive industry, and its furniture factories.[17] By 1850 the Cincinnati furniture industry was a preview of what Grand Rapids would become.

Surprisingly, the two areas represent opposite poles in their adoption of powered machinery. New Castle County furniture shops had no power machinery in 1850, nor did they have any in 1860. And as late as 1870 not a single cabinet-maker in the county, or in the state, listed any steam or water power. This lack of power, especially steam power, was not specific to the furniture trade. In general, up to 1870 New Castle County craft businesses, with the exception of the rapidly expanding heavy iron sector, did not use power. Nevertheless power woodworking machinery was available in New Castle County because by 1870, 70 percent of the lumber-milling firms in the county, which made blinds, sashes, doors, and so on, had power and used circular saws, jig saws, planers, mortisers, and boring machines. One significant factor in the failure of New Castle County cabinetmakers to adopt power may have been the small scale of their operations. In 1870 the average capital of furniture firms (in 1850 dollars) was $2,082, actually a drop from the 1850 average of $2,700. Average output and employment in 1870 were correspondingly low, $2,636 and 3.1 hands per firm respectively.[18]

In Hamilton County, Ohio, where Cincinnati is located, in 1850 27.8 percent, or seventeen, of the area's sixty-one furniture firms employed steam, water, or horse power. The firms employing power had an average capital of $19,612, compared to an average capital of $8,093 for all furniture firms in the area. These firms with power, which represented less than a third of the total furniture firms in the Cincinnati vicinity, accounted for almost 70 percent of the total capital invested in the industry. By 1870 54.5 percent of Hamilton County's furniture factories had adopted steam power to run circular saws, scroll saws, crosscut saws, mortisers, planers, borers, lathes, and tenoning machines. Cincinnati's relatively greater use of steam power supports Peter Temin's and Nathan Rosenberg's

observations on the faster adoption of steam power in western areas that lacked the seaboard's swift-flowing streams.[19]

Aside from warning of the dangers of generalizing about the pace of industrialization in an entire industry, the significance of the statistics on steam-powered factories in Cincinnati and Wilmington lies not in greater use of power in the western city, but rather in the relatively late adoption of steam power even in the country's major center of steam-powered furniture production. In 1870 Ohio employed more steam power in the furniture industry than any other state in the union, but Ohio's furniture output was eclipsed by that of New York, Pennsylvania, and Massachusetts.[20] The conclusion is inescapable that as late as 1870 an important proportion of America's furniture output was manufactured in relatively small shops without the aid of steam power.

But we need not assume that these furniture firms without steam power operated without machinery. Wheel, foot, hand, and pole lathes were used by cabinetmakers from the inception of the craft. The human-powered lathe belongs to that class of machinery so ubiquitous in furniture manufacture that it was deemed unworthy of notice by most commentators. Lathes were particularly necessary in chair factories, and a lathe fitted with a Blanchard type tracing element could reproduce the form of an irregular chair leg or arm. These lathes required operation by particularly skilled operators. More common in the furniture industry was the simple human-powered lathe (Fig. 6),[21] which often lacked the self-acting mechanisms of larger, heavier, metal turning lathes.

Another human-powered machine commonly in use in furniture work was the mortising machine, which cut the hole, or mortise, for the basic kind of joint used in uniting two pieces of wood. Large, heavy, steam-powered mortisers combining mortising and boring tools were used in railroad car shops where the large size of the stock required a powerful machine. More often in furniture factories mortising machines were light and foot-pedal-powered like the 1893 Fay model (Fig. 7). The Cincinnati census for 1870 records a number of firms without steam power using mortising machines, and they may very possibly have used machines exactly like the

No. 3 Lathe.

Price $35.00.

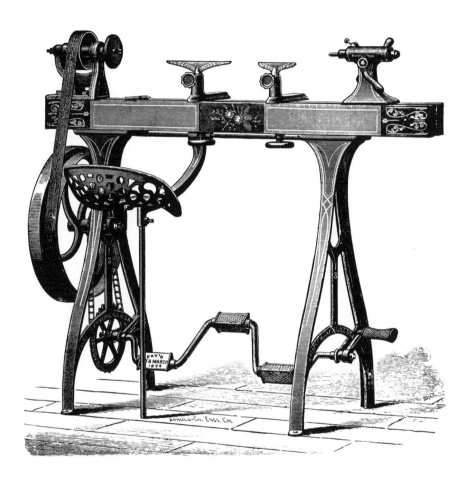

Fig. 6. Lathe. From <u>Patent Foot and Hand Power Woodworking Machinery</u> (Rockford, Ill.: W. F. and John Barnes Co., 1904), p. 34. (Eleutherian Mills Historical Library.)

Fay model since the Fay Company was located in Cincinnati.
Mortising machines, derived from Isambriel Brunel's 1796
block-making machines for the British navy,[22] were one of
the earliest human-powered machines whose widespread
adoption in American cabinetmaking can be reliably dated.

Patent records reveal a cluster of mortising machine
patents in the 1830s, and technically oriented journals took
special notice of mortising machines in the 1830s and 1840s.
The Mechanics Magazine in 1835 pictured a mortising machine
(Fig. 8) that was awarded a silver medal at the first annual
fair of the Mechanics Institute. According to the editors, this
remarkably simple machine, which cost less than thirty dollars,
could make sixteen mortises in a minute at any angle,[23] but
without any visible mechanical means of altering the angle,
that kind of adjustment obviously depended on the skill of
the workman manipulating the work. The light wood construction
of this earlier machine contrasts sharply with the more rigid,
shock-resisting metal frames of later mortisers. This machine
may not have worked as effeciently as its backers boasted, but
the early genesis of much nineteenth-century woodworking
machinery probably lay in just such light, almost jerry-rigged
mechanisms.

Victorian fondness for ornamentation in the decorative arts
(which may have had considerably more value as allusion and
symbol to its original beholders than to modern eyes) demands
mention of one final piece of machinery, the carving machine,
which was introduced, apparently, in furniture factories in the
last half of the century. The English type of carving machine,
invented about 1847 and called the Jordan machine, copied a
form by means of a tracer and revolving cutters, but the work
table moved rather than the cutters. Carvings done on the
Jordan machine still required hand finishing. This cumbersome
arrangement was apparently abandoned in American machines
(Fig. 9), which used templates cut out in the form of the design
to be created. The work table moved, but only vertically to
bring the work into contact with the cutter. With his hands the
workman then moved the work (Fig. 10), with the template on
top of it so that the cutter cut along the edges of the template,
reproducing the desired ornamentation. An enormous variety of

Fig. 8. Mortising machine. From Mechanics Magazine 8, no. 1 (July 1836): 7. (Eleutherian Mills Historical Library.)

Fig. 7. Patent prize foot mortising machine. From Illustrated Descriptive Catalog of Labor Saving Patent Wood-Working Machinery (Cincinnati: J. A. Fay & Co., 1893), p. 146. (Eleutherian Mills Historical Library.)

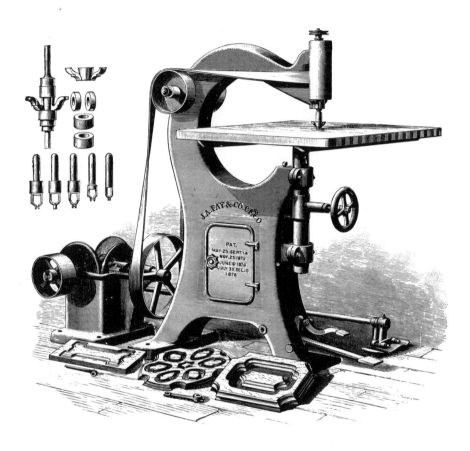

Fig. 9. Patent carving and edge-molding machine. From <u>Illustrated</u>
<u>Descriptive Catalog of Labor Saving Patent Wood-Working Machinery</u>
(Cincinnati: J. A. Fay Co., 1893), p. 112. Note the finished carvings
at the base of the machine. (Eleutherian Mills Historical Library.)

shapes and designs could be copied depending on the template selected, and the shape of the edge molding could be altered by the replacement of the cutter. Cutters, like templates, were sold in a great variety of designs. This machine was probably used to produce the carving on the paneled doors and drawers of an 1882 Sugg and Beiersdorf bedroom suite (Fig. 11), whose designs are very similar to those shown with the machine. Only a small amount of hand finishing was needed for this kind of panel carving.[24]

The so-called hand-carving machine (Fig. 12) was actually a powered machine taking its power from above by means of belting, but without any supporting work table, its operation required a considerable degree of manual dexterity. Designs could be traced on the wood to be cut, or the machine could be used for completely unprogrammed designs.

This sampling of the machinery used in the furniture industry emphasizes the fact that mechanization did not suddenly arrive with the advent of any particular style. Instead machine processes infiltrated the industry. The furniture craftsman had never worked without patterns, lathes, and other devices to modify the margin of error in production. Throughout the nineteenth century he added to his stock of error-reducing machines, but many of the new machines still required skill and sensitivity for their correct and optimum operation. Much more intensive study is needed before the impact of the new machinery and its rate of integration into the sequencing of productive processes in a shop can be analyzed with finality, but it is clear that in many ways the relationship between the craftsman, the machine, and the material remained unstructured and variable.

The twentieth century has seen the introduction of truly automated machinery in many industries. The aim of nineteenth-century machinery was not automation but output. With the exception of the machine tool industry, nineteenth-century machinery was not general-purpose machinery; it was specialized machinery evolved to replace specific hand processes. British visitors observed that "the determination to use labour saving machinery has divided the class of work usually carried on by carpenters and the other wood trades into special manufactures,

In Paneling, Carving, Surface and Edge Molding doné on the J. A. Fay & Co.
Patent Carving Machine.

DIRECTIONS FOR OPERATING.

For paneling or cutting designs in the solid wood (Fig.
C), prepare a template (Fig. B) of the form desired. Place
this template over the piece to be carved with openings
between (Fig. A) for the escape of chips, and to allow a view
of the work as it progresses. The template must be as much
smaller than the panel to be cut as the outside cutting edge
of cutter extends beyond the line of directrix.

Fig. 10. Samples of carving work. From Illustrated Descriptive Catalog of
Labor Saving Patent Wood-Working Machinery (Cincinnati: J. A. Fay & Co.,
1893), p. 113. (Eleutherian Mills Historical Library.)

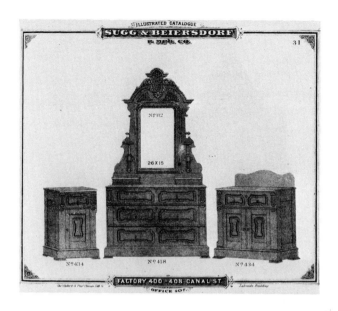

Fig. 11. Dresser and night stands. From Sugg & Beiersdorf Furniture Manu-
facturing Co. (Chicago: Charles Shober & Co., [1875]), p. 31. (Eleutherian
Mills Historical Library.)

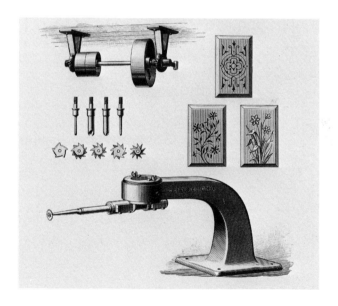

Fig. 12. Hand-carving machine. From Illustrated Descriptive Catalog of
Labor Saving Patent Wood-Working Machinery (Cincinnati: J. A. Fay & Co.,
1893), p. 118. (Eleutherian Mills Historical Library.)

where only one kind of article is produced, but in numbers or quantity almost in many cases incredible. As a general rule the machinery employed is of a coarse description, and the work it produces may not in every case come up to our notions of finish; but it is produced cheaply and quickly."[25] American production processes may have slighted finish, but evidence exists that furniture machines were efficient where time and cost were involved. In 1898 the machine-made parts of a sideboard could be assembled in 18 hours compared to the 210 hours needed to assemble handmade parts, which fitted less precisely.[26]

The new machinery led to a vastly increased production of furniture at lower prices,[27] and machine replication of involved designs brought an increased variety of ornamentation into the average home. To take two examples of machine replication, perhaps the relative ease with which templates for carving machines could be changed and patterns for tracing lathes could be replaced is somehow related to the rapid succession of revival styles in the late nineteenth century. Certainly the band saw facilitated the output of curved forms and the carving machine encouraged incised and relief decoration, two qualities that Nikolaus Pevsner has attributed to typical Victorian designs.[28] Although inventions have a disturbing way of coming to fruition when their time is ripe (as the railroad did when Americans needed to cross the plains), it is neverthe-less unlikely that the machines came into being because of Victorian styles or the styles because of the machines.

The wide adoption of simple, human-powered machinery as one aspect of the mechanization of the furniture industry and the uneven introduction of power in the industry warn against generalizations about the timing, the pace, and the character-istics of industrial revolution. We are reminded that industrial evolution is a useful catch-all, too, and that most revolutions, upon examination, are based on a background of evolution.

NOTES

1. Examples of the romantic view of the craftsman are Edward H. Pinto, The Craftsman in Wood (London: G. Bell & Sons, 1962); Eric Sloane, A Museum of Early American Tools (New York: Wilfred Frank, 1964); George Sturt, The Wheelwright's Shop (Cambridge: At the University Press, 1923); Edwin Tunis, The Colonial Craftsman (Cleveland: World Publishing, 1965).

2. For information on a large-scale operation using much subdivision of labor run by a craftsman see Nancy McClelland, Duncan Phyfe and the English Regency (New York: William R. Scott, 1939); Charles Cornelius, Furniture Masterpieces of Duncan Phyfe (New York: Doubleday, Page & Co., 1922); for information on the substantial late eighteenth-century furniture trade between the North and the South, see Katherine W. Gross, "The Sources of Furniture Sold in Savannah: 1789-1815" (M.A. thesis, University of Delaware, 1967); for cabinetmakers' problems with wholesalers and for the large amount of subcontracting between craftsmen, see Kathleen M. Catalano, "Cabinetmaking in Philadelphia: 1820-1840" (M.A. thesis, University of Delaware, 1972); and Nancy A. Goyne, "Francis Trumbull of Philadelphia: Windsor Chair and Cabinetmaker," Winterthur Portfolio 1 (1964): 221-41.

3. Pye, The Nature and Art of Workmanship (Cambridge: At the University Press, 1968), p. 4.

4. Pye, Nature and Art of Workmanship, pp. 4, 6, 18, 10.

5. For an example of the patriotic approach to technological innovation, see Horace Greeley et al., Great Industries of the United States (Hartford: J. B. Burr & Hyde Co., 1872); Eighty Years Progress of the United States . . . by Eminent Literary Men (New York: New National Publishing House, 1864); a modern, popular example of the same genre is The Editors of Life, America's Arts and Skills (New York: E. P. Dutton & Co., 1957).

6. In 1850-70 categories of information listed in the census of industry were: name, occupation, capital, power (and machinery in 1870), number of employees, wages, quantities, types, and values of raw materials, and quantities, types, and values of products. The manuscript returns for Delaware and

Pennsylvania cited hereafter are available on microfilm at the
Eleutherian Mills Historical Library, Greenville, Delaware;
returns for Ohio cited hereafter are available on microfilm at
the Winterthur Museum Libraries, Winterthur, Delaware.

7. Nathan Rosenberg, ed., The American System of
Manufactures: The Report of the Committee on the Machinery
of the United States 1855, and the Special Reports of George
Wallis and Joseph Whitworth, 1854 (Edinburgh: University
Press, 1969), pp. 27, 58, 167, 169-71, 344, 346.

8. Metropolitan Museum of Art, 19th-Century America:
Furniture and Other Decorative Arts (New York: Metropolitan
Museum of Art, 1971), p. xiv; Thomas H. Ormsbee, Early
American Furniture Makers: A Social and Biographical Study
(New York: Tudor, 1930), p. 89 dates the end of the era of
handwork at 1850.

9. Celia Jackson Otto, "Pillar and Scroll: Greek Revival
Furniture of the 1830s," Antiques 81, no. 5 (May 1962): 507;
Bishop, Centuries and Styles of the American Chair 1640-1970
(New York: E. P. Dutton & Co., 1972), pp. 313, 315. The
American source for pillar and scroll designs was John Hall,
The Cabinetmaker's Assistant (Baltimore: by the author, 1840).

10. Joseph M. Wilson, History, Mechanics, Science,
vol. 3 of The Masterpieces of the Centennial International
Exhibition (Philadelphia: Gebbie & Barrie, 1877), pp. 107-9;
"The Endless Band Sawing Machine," Journal of the Franklin
Institute, 3d ser. 59, no. 1 (Jan. 1870): 6-11; J. Richards,
"Wood-Working Machinery," Journal of the Franklin Institute,
3d ser. 60, no. 3 (Sept. 1870): 174-76; Charles Singer, ed.,
A History of Technology, 5 vols. (Oxford: Clarendon Press,
1958), 4:437.

11. T. Antisell, Handbook of the Useful Arts (New York:
George P. Putnam, 1852), p. 552; J. Richards, On the Arrangement,
Care, and Operation of Wood-Working Factories and Machinery:
Forming a Complete Operator's Handbook (London & New York:
E. & F. N. Spon, 1885), p. 53; Catalano, "Cabinetmaking in
Philadelphia," pp. 25-27; Elizabeth A. Ingerman, "Personal
Experiences of an Old New York Cabinetmaker," Antiques 84,
no. 5 (Nov. 1963): 576.

12. Carroll D. Wright, Thirteenth Annual Report of the

Commissioner of Labor, 1898: Hand and Machine Labor, 2 vols.
(Washington, D.C.: Government Printing Office, 1899), 1:280;
J. Richards, "Woodworking," Journal of the Franklin Institute,
3d ser. 64, no. 1 (July 1871): 27; 3d ser. 60, no. 4 (Oct.
1870): 235-37; D. K. Clark, The Exhibited Machinery of 1862:
A Cyclopaedia of the Machinery Represented at the International
Exhibition (London: Day and Son, 1864), p. 213; Richards,
Wood-Working Factories and Machinery, p. 109.

 13. Williamsport Machine Company, Improved Wood-Working
Machinery (Williamsport, Pa.: n.p., 1884), p. 40.

 14. Patterns Published by the Sorrento Wood Carving Company
(Boston: n.p., 1876), p. 8.

 15. "Our Illustrations," Illustrated Woodworker 1, no. 4
(Apr. 1879): 50; "Our Illustrations," Illustrated Woodworker 1,
no. 9 (Sept. 1879): 130.

 16. For Wilmington's industrialization, see Carol E.
Hoffecker, "Nineteenth-Century Wilmington: Satellite or
Independent City?" Delaware History 15, no. 1 (Apr. 1972):
3-18; for early steam technology, see Carroll W. Pursell, Jr.,
Early Stationary Steam Engines in America: A Study in the
Migration of a Technology (Washington, D.C.: Smithsonian
Institution Press, 1969).

 17. Sidney D. Maxwell, The Manufactures of Cincinnati
(Cincinnati: Robert D. Clarke & Co., 1878), p. 8; Carl W.
Drepperd and Lurelle van Arsdale Guild, New Geography of
American Antiques (Garden City, N.Y.: Doubleday & Co.,
1948), p. 146; J. L. Oliver, The Development and Structure
of the Furniture Industry (Oxford: Pergamon Press, 1966),
pp. 55-56.

 18. Manuscript Census of Industry, New Castle County,
Delaware, 1850, 1860, 1870. The lack of powered machinery
was not a New Castle County aberration, for in 1850 only 12.6
percent of Philadelphia County furniture firms had any nonhuman
power. Manuscript Census of Industry, Philadelphia County,
Pennsylvania, 1850.

 19. Manuscript Census of Industry, Hamilton County, Ohio,
1850, 1870. For descriptions of some of the larger Cincinnati
furniture factories, see Charles Cist, Sketches and Statistics
of Cincinnati in 1850 (Cincinnati: William H. Moore & Co.,

1851), pp. 201-8. Temin, "Steam and Waterpower in the Early Nineteenth Century," Journal of Economic History 26, no. 2 (June 1966): 199, 203, 204; Rosenberg, Technology and American Economic Growth (New York: Harper Torchbooks, 1972), pp. 63, 67.

20. Ninth Census: The Statistics of the Wealth and Industry of the United States (Washington, D.C.: Government Printing Office, 1872).

21. Robert S. Woodbury, History of the Lathe to 1850: A Study in the Growth of a Technical Element of an Industrial Society, Society for the History of Technology Monograph Series No. 1 (Cleveland: Society for the History of Technology, 1961), p. 13; Taylor Chair Company, The Taylor Chair Company, 1816-1966 (n.p.: Taylor Chair Co., 1966), p. 11; Richards, Wood-Working Factories and Machinery, pp. 131, 136.

22. Manuscript Census of Industry, Hamilton County, Ohio, 1870; Andrew Ure, Dictionary of Arts, Manufactures, and Mines: Containing a Clear Exposition of Their Principles and Practice (2d ed.; London: Longman, Orme, Brown, Green and Longman, 1840), p. 145.

23. M. D. Leggett, comp., Index of Patents Issued from the United States Patent Office from 1790 to 1873, Inclusive, 3 vols. (Washington, D.C.: Government Printing Office, 1874), 2:940-42. Of 184 patents for mortising machines in 1873, 37 were issued in the decade of the 1830s, more than any other decade. "First Annual Fair of the Mechanics Institute," Mechanics Magazine 6, no. 5 (Nov. 1835): 252, 268; "Morticing Machine," Mechanics Magazine 8, no. 1 (July 1836): 7-10; "Description of American Patents," American Repertory 2, no. 1 (Aug. 1840): 69; 2, no. 3 (Oct. 1840): 224; 3, no. 5 (June 1841): 389. Jacob Bigelow, who is credited with coining the word technology, mentioned mortising machinery in The Useful Arts Considered in Connection with the Applications of Science, 2 vols. (Boston: Marsh, Capen, Lyon and Webb, 1840), p. 152, but not in his earlier edition of the same book under a different title, Elements of Technology, Taken Chiefly from a Course of Lectures Delivered at Cambridge (2d ed.; Boston: Hilliard, Gray, Little and Wilkins, 1831).

24. Charles Tomlinson, ed., Cyclopaedia of Useful Arts,

Mechanical and Chemical, Manufactures, Mining and Engineering, 2 vols. (London: George Virtue & Co., 1854), 1:334; Clark, Exhibited Machinery of 1862, p. 225; George Dodd, Curiosities of Industry and the Applied Sciences (London: George Routledge & Co., 1854), p. 24; "Machinery for Carving," Journal of the Franklin Institute, 3d ser. 9, no. 6 (June 1845): 413-14.

 25. Rosenberg, The American System of Manufactures, p. 167.

 26. Wright, Hand and Machine Labor, 1:280.

 27. Eighty Years Progress, p. 250.

 28. Pevsner, High Victorian Design: A Study of the Exhibits of 1851 (London: Architectural Press, 1951), p. 49.

ART AND INDUSTRY: REFLECTIONS ON THE ROLE OF THE AMERICAN MUSEUM IN ENCOURAGING INNOVATION IN THE DECORATIVE ARTS

Jay E. Cantor

WRITING in Harper's Monthly in September 1868, an anonymous critic extolled the wonders of machine production as observed at the Gorham manufactory in Providence, Rhode Island. Technological sophistication had, in the critic's estimation, replaced the crude handwork of but a few decades earlier. He located the crucial phase of factory production in the design room and sought to describe the responsibility of the designer: "to perfect utility until it becomes elegance; to produce forms novel and pleasing, because they are perfectly convenient; to devise ornaments which shall truly harmonize with the object they are intended to adorn; always to keep a little in advance of the public taste, so as to educate while delighting it--these are the constant aims of the designer of an establishment like this."[1]

In a few sentences, this critic summarized the mid-nineteenth-century attitude toward design, in which form and ornament were considered distinct entities capable of being united for profitable appreciation.[2] Although it was impossible for most manufacturers and consumers to consider a form acceptable without some ornament, it was precisely in the realm of ornament that the manufacturer got into trouble. New materials and techniques and the large vocabulary of ornament made available to manufacturers through the increased publication of books on historical and contemporary design constituted an embarrassment of riches. Instead of focusing on the appropriateness to machine-made forms of historical ornament surviving from hand processes, designers created a riot of ornamental approaches in an attempt to compete with hand processes at the level of style. Ornamental references were thus frequently external to the form of the object or to its

functional requirements, a fact reforming critics deplored
since the late 1840s.[3] Early critics often concentrated on
the symbolic appropriateness of a particular style and were
more concerned with the search for an expressive national
style than with style as the logical product of new manufac-
turing methods. Thus, while the lavish naturalism of the
Victorian rococo was by 1868 being replaced by a more severe
classical vocabulary, the style of mass-produced objects
still followed the lead of luxury goods, and the problems
implied by machine production were largely ignored.

The Harper's critic suggested that well-designed objects
should inform and presumably improve taste, but where in a
country without museums could the average citizen encounter
choice objects and contemplate the felicities of their form
and appropriate ornament? The answer was clear; he may
"avail himself of those free museums and galleries of art,
the shop windows."[4] Not everyone, however, approved of the
indiscriminate displays of leading commercial establishments,
and it was with the conviction that there was a failure of taste
in contemporary life--on the part of manufacturers, artisans,
and consumers--that the first museums in America numbered
among their charter goals "the application of arts to manufacture
and practical life."[5]

In the 1870-80 decade, a quickening of artistic life led to
the creation of museums in New York, Boston, Philadelphia,
Cincinnati, and Washington. All were significantly influenced
by the South Kensington Museum in London, which had arisen,
phoenixlike, from the ashes of England's industrial design
reputation after its poor showing at the Crystal Palace exhibition
of 1851. America's industry had looked to England for design
leadership and suffered accordingly. The cure was to be found
in strengthening the national artistic heritage and in extending
the appreciation of the constituents of good design through
objects displayed in museums.

The application of art to industries was also a practical
goal for the business and industrial leaders who were trustees
of museums. Good design was equated with high profits, and
in strengthening American industrial activity they hoped to
counter the continuing influx of foreign goods. The contemporary

attitude was well summarized by a writer in <u>The Crayon</u> who
noted: "In matters of taste, the public is a child that must
be instructed by precept as well as example."[6] There was,
of course, something ironic in the assumption that industrial
leaders whose own taste was open to question could act as
arbiters to the masses, and the speculative dilettantism that
resulted was a target of later reforms. In the process of
stimulating and exercising their own taste, the trustees made
taste a significant attribute of the upper classes in America
and thus introduced a wedge further separating the interests
of the wealthy from the ordinary citizen. What finally turned
the trustees from their democratic purpose was not so much a
dissatisfaction with the possibility of wedding art and industry
but rather the sudden expansion in the quality of private (and
subsequently public) collections, which outreached all expec-
tations. Drawing on these new accumulations of fine arts,
within a few decades the museum became the very treasure
house that had once been considered impossible in America.
As museum collections improved, other more practical functions
subsided.

The Metropolitan Museum of Art, chartered in April 1870,
opened its doors in rented quarters with a loan exhibition
culled from private collections. This inaugural project revealed
a great cache of art already in private hands. The loan
collection included paintings and objects of decorative art,
and by 1880 a critic writing in <u>Harper's Monthly</u> could attribute
a decided increase in the quality and availability of artistic
pottery and porcelain--made and sold in America--to the inspired
example of this loan exhibition.[7] In addition to the stimulus
provided by the opening of the museum, there was in the 1870s
and 1880s a broadening of interest in the decorative arts inspired
by a number of concurrent phenomena, including the Centennial
Exposition and the example of the aesthetic movement and reform
ideas emanating from England, which were conveyed to America
by numerous periodicals and books dealing with domestic taste.
The effort to find rewarding and respectable employment for
women spread the interest in art decoration, needlework, china
painting, and similar activities, and organizations such as the
Society of Decorative Art in New York pursued art and social

betterment with missionary zeal. The emphasis of such groups was largely on handcraft, although some manufacturers were inspired to institute competitions for industrial design. The general public likewise was stimulated toward serious interest in applied art through such activities as the Society of Decorative Art's loan exhibitions held in 1877 and 1878. Naturally the organization and operation of these activities was in the hands of the same class of citizens that controlled the museum. The artisan working for industry still had to be reached.

As plans for the first wing of the Metropolitan Museum in Central Park progressed, the trustees appointed a special committee including Robert Hoe, manufacturer of printing presses, and Henry Marquand, railroad financier and brother of an important jewelry maker, to deal with industrial art activities. Their report was significant in its orientation:

> One of the primary objects of an art museum is
> the development and fostering of fine art as
> applied to industries. While they believe that
> the general public should be educated and their
> tastes improved by the exhibition of fine works
> of art of a high order, it seems equally important
> that the artisan and student should have a prac-
> tical acquaintance with the origin and formation
> of the materials in use, and the various methods
> employed in their manipulation.

For this purpose, they recommended the acquisition of the art and industry exhibits from the Centennial that were still housed in Memorial Hall in Philadelphia. In addition to the exhibits from Germany, France, Denmark, Norway, and Sweden, they urged the acquisition of a display prepared by the American Institute of Mining Engineers. The resulting collection of raw materials and materials in different stages of manufacture would be supplemented by models or samples of tools and machinery used in production. Included among the areas of concern were to be gems, gold and silver work, bronzes and other metalwork, and household decorations, including

paper hangings, pressed leather, furniture, textiles, fabrics,
bookbindings, laces, dyes, and stained glass. Hoe and
Marquand clearly intended to correct a failure they had observed
in the museum's operation.

> Your Committee believe that the valuable aid and
> assistance which men of science and members of
> the Institute of Engineers may give, and the good
> will which may be gained for the Museum from a
> large class of citizens not heretofore especially
> interested in our undertaking, will add materially
> to our strength and usefulness.
> It may possibly appear to some of the Trustees
> that such collections as it is proposed to incor-
> porate into the Museum do not lie strictly within
> its sphere of operation but in Europe and especially
> in England at the South Kensington Museum they are
> now considered of a necessity, and to be at the
> foundation of successful education in Art Industry.
> Your Committee earnestly advise that some arrange-
> ment be made to secure the aforesaid collections of
> the American Institute of Engineers for the Metro-
> politan Museum of Art, and would at the same time
> recommend that one member of the Institute should
> be made a Trustee of the Museum.[8]

Although a sign proclaiming "this room will be devoted to the
collection of industrial art"[9] was placed in the large space
below the main gallery of the new building, this grand scheme
remained largely unrealized. The only process exhibit actually
installed was one surveying the "art of electrotyping."
In addition to exhibits, the creation of an industrial art
school based on the South Kensington example was urged. This
project fared better than the industrial art exhibits. In explaining
the decision to found a school, the trustees noted:

> With some exceptions, our artisans show great lack
> of artistic taste and knowledge, and are practically
> destitute of originality in design. As a natural

Fig. 1. Free Industrial Art School of the Metropolitan Museum of Art Recently Opened at No. 31 Union Square. Daily Graphic (New York), 1880. (Photo, the author.)

> consequence, bad forms, improper treatment and
> handling of material, false construction and taste-
> less decoration, found in most of our industrial
> work, show few signs of improvement. It is as
> easy to make a tasteful as a tasteless work, if
> those who originate and execute are made familiar
> with forms of beauty and truth, and are taught the
> principles of design, adaptation and construction.

This statement was a reiteration of ideas that had been current
in design reform circles for several decades, and its adoption
by the museum was typical of the secondhand philosophy
dominating industrial art activity. In January 1880 the museum
circulated a prospectus for its industrial art schools among
employers and workmen, suggesting the practical advantages
of the enterprise and citing the examples of France, England,
and Germany, which had begun educating workmen and
apprentices in design. The effect of an improved standard of
taste and the enrichment of manufactures was duly noted.[10]

The schools opened in rented rooms on Union Square, and
classes started in drawing and design related to wood- and
metalwork (Fig. 1). The museum stipulated that students have
some skill in drawing, but familiarity or skill in handling
materials was not required. The problems of design were seen
as external to, although conditioned by, materials.

In announcing a gift of $50,000 to endow the schools, the
trustees remarked that "technical schools for the teaching of
artisans are essential to the progress of American industrial
art. The time has certainly arrived when America should cease
to be dependent upon foreign production of beautiful works in
any and every department of industry; when American youths
should have the facilities for learning how to produce beauty
which German, French, and especially English youths have in
technical schools."[11] It was in fact the English approach that
was most consistently favored in America. This program relied
heavily on drawing and a highly regimented course of twenty-
three stages through which the student had to progress, his
move to the next being conditioned by the satisfactory completion
of the preceding. Beginning with outline drawings of inanimate

Fig. 3. Industrial Art Schools of the Metropolitan Museum, New York City, cover for 1886–87 brochure. (Photo, the author.)

Fig. 2. A. Shults, Art Student Copying Designs. Wood engraving from Harper's New Monthly Magazine 60, no. 360 (May 1880): 876. (Photo, the author.)

and then animate subjects, the program concluded with figure
drawing, modeling, and painting. Only in the last two stages
were problems of original design considered.[12]

A dependence on drawing did not appear misplaced to the
Metropolitan's trustees (Fig. 2), for they stated "the mechanic
who can design as well as do his work, is worth more to him-
self and to his employer than one who can only follow a director
or do that which he has seen done. If American industrial art
is to rank with that of European countries, it can only be by
having educated artisans." This attitude forms an interesting
contrast to the ideas held by advanced designers such as
Louis C. Tiffany who thought primarily in terms of materials.
Candace Wheeler reports a conversation in which Tiffany,
having noticed the absence of a needlewoman from the workrooms
of Associated Artists, was informed that she was taking a
watercolor lesson at the academy. "Don't you think it will be
an advantage to her embroidery," Mrs. Wheeler inquired?
Tiffany responded, "No--I would rather have her think in
crewels."[13]

The Metropolitan's schools involved a serious drain on the
museum's resources, constituting in the early days nearly a
fifth of the museum's total expenditures. The courses of
instruction varied from year to year, depending on the number
of students. Generally classes were offered in drawing and
design, modeling, and carving. For a few years, carriage
drafting, underwritten by a committee of the Carriage Builder's
National Association, was included, and in one year a course
was offered in plumbing. At its most prosperous moment in the
mid-1880s (Fig. 3) the schools' program included color compo-
sition, freehand and life drawing, sculpture, modeling,
architectural draftsmanship, chasing and repoussé work in
metal, perspective, anatomy, and decorative design, decorative
clay modeling, cabinet drawing, interior design, and a mechan-
ical class. At this time the museum proudly reported that a
number of its former pupils had found "lucrative employment
in different departments of industry."[14] In addition, an arrange-
ment was made in the spring of 1885 for the exhibition and sale
of student designs at the rooms of D. W. Granbury and Company
of 20 John Street, New York. Prize competitions were introduced,

and the entire curriculum became increasingly academic,
especially after Arthur L. Tuckerman, architect of the second
wing of the museum building, became the head of the school
in 1887. An article published in Art Age, November 1888,
illustrates the degree of conventionalism the art schools had
achieved in their short career. The prize-winning vase design
was typical of high-style classical conventions that had
prevailed since the 1860s, and it is interesting to note that the
submissions for the competition could be "rendered at will
either by drawings in line or wash, black and white or color,
by clay models, metal, wood or any other suitable material."[15]

Despite the apparently flourishing state of the schools in
these years and the boost to their resources by a number of
grants, the museum's interest had begun to flag. Other art
schools pursuing essentially the same goals were in operation
and were, according to the museum's own account, more
successful. The problem of industrial design education was
passing from the museum's hands. Public schools were beginning
industrial design and technical programs that undercut the
museum's activities, and it was acknowledged that much of the
work produced at the museum schools was of an inferior grade.
Training had to be deeper and more sustained. Since the
museum's energies were increasingly directed toward the
accumulation and refinement of its collections, in 1895 the
trustees finally conceded "that the funds of the Museum devoted
to purposes of education can be more usefully employed in
promoting the study of the collections in the Museum."[16] This,
in itself, was no easy task since displays like the Edward C.
Moore collection (Fig. 4), which was intended for the aid of
artisans and designers, were installed in an inconvenient
fashion. Not surprisingly in the same year that the trustees
abandoned the schools, the Hewitt sisters founded a Museum
of the Arts of Decoration in association with the Cooper Union,
a museum that was truly designed for the use of student, designer,
and craftsman.[17]

The Metropolitan schools did not die as quietly as readers
of the annual report might assume. They had in fact been the
center of controversy when, in 1887, John W. Stimson, the
director, resigned in protest over what he termed "crass

philistinism," the enemy of art, which took the form of
dilettantism on the part of the trustees. The other mortal
opponent of the schools' artistic survival was, according to
Stimson, the hayseed provincialism encouraged by the
speculative energies of a "Boston book monopoly," which
promoted Walter Smith's <u>Art Education, Scholastic and Industrial</u>,
a book largely devoted to perpetrating the South Kensington
method of instruction, which Stimson considered a "mental
straight jacket." To combat these enemies, Stimson invoked
William Morris's concept of the democracy of art and Viollet-le-
Duc's notion that art must live within its own age. Stimson
proposed the creation of the New York Institute of Artist-Artisans,
where he claimed "sincere Art students and honest Artist-Artisans
might flee for <u>practical</u> help and Principles instead of hollow
Parade."

Such was the failure of the Metropolitan's own stated goals.
By trying to improve taste from above, the museum had failed to
provide abiding principles to which design could aspire. More
importantly, the museum had made taste its point of departure.
Stimson pleaded for art education as a function of organic,
vital activity and personal inspiration, and he received broad
support for his program.

> Our <u>Ideal is to create</u> the "Artist-Artisan" whom we
> believe to be "the Coming Man," i.e. a balanced
> temperament and development which <u>harmonises</u>
> <u>instead of alienates mutually allied and essential</u>
> truths. Without loosing sight of respective roles,
> the Artist is made broader and more helpful by
> acquaintance with <u>practical media</u>. The Artisan
> is made more plastic and efficient by becoming
> <u>more artistic and sympathetic</u>.

Among Stimson's supporters were E. C. Moore (Tiffany and
Company), Cottier and Company, Richard Watson Gilder (editor
of the <u>Century Magazine</u>), Janette Gilder (editor of <u>The Critic</u>),
Candace Wheeler (Associated Artists), Augustus Saint-Gaudens,
Julian Alden Weir, William Merrit Chase, and Thomas W. Dewing.
Shares for the institute were subscribed by leading manufacturers

and associations.[18] Yet even this program appears to have
been fairly short-lived and supported by makers of the finest
trade goods and specialized objects rather than firms catering
to a broad audience.

Not until the early twentieth century, when a number of
museum men emerged who were concerned with putting their
occupation on a more professional footing, was the problem
of industrial art again taken up by the museum. There had,
of course, been affiliations between arts and crafts groups
and museums in other cities,[19] but the Metropolitan and New
York City in general seemed little concerned with reform
through the revival of handicraft. Although firmly committed
to the decorative arts, the museum had clearly become entrenched
in the past. Furthermore both the historical decorative arts
and traditional craft production had become associated with
upper class taste in distinction to machine production, which
was the clear demarcation of class. As late as 1912 when an
exhibition of German applied art became available for American
museums, an exhibition that included some of the most advanced
contemporary design associated with the Deutsche Werkbund,
the Metropolitan refused to take the exhibition, claiming "it
could not run the risk of coming thus into close contact with
anything commercial."[20]

The fate of artistic industrial design seemed to hover
between the historicism of the museum, the indifference of
the industrial community to craft and design, and the hostility
of the craft community toward mechanization and the dehuman-
ization of modern life. The result of this impasse was summarized
effectively in an article entitled "Industrial Art: The Opportunity
of America," which appeared in Good Furniture magazine in 1914.
"We are," wrote William Laurel Harris, "a great industrial
nation, but we have no industrial art."[21] This condition was
reinforced by wartime isolation. Pleas for cultural nationalism
were balanced by the realization of the extent to which America
had depended on Europe for fashion, design, and finished
products--often made with American raw materials. The path
for both the duration of the war and the revitalization of America's
industrial arts seemed clear--American manufacturers must
improve the quality of native design, and consumers must cease

Fig. 4. Installation view, the Edward C. Moore collection. Metropolitan Museum of Art, 1891.

Fig. 5. Raymond Hood, installation view of business executive's office, "The Architect and the Industrial Arts," Metropolitan Museum of Art, 1929.

to find European goods more desirable than analogous American products.

At this point the Metropolitan cautiously stepped back into the arena. Between 1909 and 1920, in an effort to make the collections more readily available to designers as well as scholars, study rooms associated with each curatorial department were established for the closer inspection of museum objects. The museum also attempted to measure the extent of its past influence beginning in 1917 with the inauguration of an annual series of contemporary industrial design exhibitions. This ambitious program was largely the work of Henry Watson Kent, who had come to the museum as secretary to the president. Kent had strong convictions about the practical functions of the museum and its responsibility to encourage art in the trades.[22] To further this work, he arranged the appointment in 1918 of Richard F. Bach, who had been librarian of the Avery Architectural Library at Columbia University, as associate in Industrial Arts. Bach was to be a kind of industrial ombudsman, inaugurating training programs for shopkeepers and salespeople and contacting manufacturers to keep abreast of technical advances and to suggest how they could best use the museum's resources. Simultaneously, Grace Cornell was giving talks on design illustrated by the museum's collections. This series of study hours on practical subjects grew to include programs for salespeople, buyers, homemakers, young girls, and teachers.

Bach felt the Metropolitan must become a laboratory for good design effected through the confidence of manufacturers. His ambition was national in scope, and he noted that the factory was too often seen as a business venture and not as the "workbench of national taste." The museum was no longer to be a patron or big brother but a partner in progress. He was greatly concerned about mundane production and was interested in reaching a popular audience through industrial art. His efforts were encouraged by John Cotton Dana of the Newark Museum Association, who had been actively involved in the industrial art of the New Jersey community. Picking up where the Metropolitan's plumbing course left off, Dana had shown bathroom fixtures in a 1915 exhibition of "New Jersey Clay Products." To Dana, Bach addressed some of his misgivings

about the effectiveness of the Metropolitan's first "Manufac-
turers and Designers" exhibition in 1917. Praising the beauty
of the show, he noted:

> It is, however, almost entirely an exhibit of
> articles de luxe. It couldn't very well be other-
> wise, I suppose. The manufacturer of things for
> ordinary people needs only to make ordinary things
> and doesn't waste any time sending his designers
> to the Museum or upsetting his machinery to get
> new patterns. He still has to be reached.
> It ought to be exhibited down town where shoppers
> (ordinary shoppers) would see it. The ordinary
> shoppers might begin to want such things. Then
> the manufacturer would begin to make them. Then
> the Metropolitan would really have something to
> do (perhaps).[23]

The education of the shopper seems to have become, once
again, an incentive for museums. In Newark, Dana was quick
to realize this, and in 1928 he organized a show entitled
"Inexpensive Articles of Good Design--Objects from the 5 & 10."
In the following year he showed a collection of objects costing
fifty cents. In the meantime, Bach's ambition of an exhibition
downtown was in a measure realized with the "Art in Trade"
exposition of 1927 and the "International Exposition of Art in
Industry" of 1928--shows at Macy's for which the museum
provided some assistance and support.[24]
Under Bach's guidance, the exhibitions at the museum were
expanded and improved. In 1922 the designer's name appeared
on labels for the first time. But until 1924 the criterion for the
inclusion of objects in industrial design shows was that their
design be based on the study of objects in the museum's
collections. While discouraging exact reproduction, the museum
in effect fostered ludicrous situations by exhibiting talcum
powder cans whose design was based on the ornament of Chinese
vases.
For its eleventh industrial art exhibition, the Metropolitan
undertook a unique project, substituting the architect and the

room setting for the individual object taken from active stock.
"The Architect and the Industrial Arts: An Exhibition of
Contemporary American Design" opened February 12, 1929.
Its scheduled run of six weeks was extended to seven months
during which 186,361 people viewed the installation, nearly
172,000 more than had seen the previous exhibition. The
settings and furniture were designed for the exhibition by
Armistead Fitzhugh, Raymond Hood, Ely J. Kahn, John W. Root,
Eliel Saarinen, Eugene Schoen, Leon V. Solon, Joseph Urban,
and Ralph T. Walker. The results were somewhat predictable
since the designers' taste had already been manifest in their
ongoing practice. Frank Lloyd Wright, who was offered a
share in the principal space, never answered the museum's
letter. The museum explained the concept of the show as "an
illuminating exposition of what might result in the realm of
design if the designer himself were to occupy a position of
authority."[25]

In spite of the fact that the best of twentieth-century
furniture design has been the work of architects rather than
furniture designers, it appears that the museum cast its lot
with the wrong camp of architects. The architects involved
were stylists in the modern (and moderne) idiom who appropriated
a grammar of machine-influenced ornament in contrast to the
organic approach of modern functionalism. Historical and exotic
style currents lurked just below the surface, and the end product
looked more mechanical than machined. One has only to compare
Raymond Hood's (Fig. 5) suite of aluminum office furniture for
a business executive with the tubular steel furniture designed
in the preceding years by Ludwig Mies van der Rohe and Marcel
Breuer to see how far the museum was from what is considered
classic modern design.

It was not the Metropolitan but rather the Museum of Modern
Art that became the principal spokesman for advanced modern
design. Founded in 1929, the Modern characteristically included
in its charter application the purpose of "encouraging and
developing the study of modern arts and the application of such
arts to manufacture and practical life." Perhaps with malice
aforethought, this museum parroted the Metropolitan's words of
six decades earlier. In many ways, the Museum of Modern Art

came closer to succeeding where the Metropolitan failed in fulfilling its charter goals--largely because its problem was different. The Modern looked, not to the salons of France, but to the workrooms of Germany where the modern style had been perfected. Its task was to find an audience, and the museum became a showroom of modern design objects, domestic, scientific, and technical, in the approved taste of the functional style. The objects it promoted seemed once and for all to function democratically and to appeal universally, not only because of the economy made possible by machine production but also because of their intrinsic quality of design and the direct relationship between the form of the object and the method of production. It is interesting to read in Philip Johnson's introduction to the "Machine Art" show, the Modern's inaugural industrial art exhibition, which Johnson organized, the suggestion that the show had been "assembled from the point of view that though usefulness is an essential, appearance has at least as great a value."[26]

At the Metropolitan the functional style was making inroads. The exhibition of 1934, under the economic pressure of the depression, carried the stipulation that objects be produced in quantity or as models for large-scale production (Fig. 6). Bach's work had been given full departmental status in 1929 as the Department of Industrial Relations, suggesting its propagandistic function. Significantly, the museum made no acquisitions from its industrial design shows, although the decorative arts department had obtained a number of contemporary high-style Art Deco pieces from the influential Paris exposition. The Metropolitan's industrial design shows ceased with the advent of World War II, but the center of activity had by then clearly shifted to the Museum of Modern Art.[27]

Many of the industrial design objects shown by the Metropolitan could be classed as dated period work. Personal and idiosyncratic when viewed against the more universal and astylistic furniture of functional modernism, they represented the ultimate failure of an attempt to deal with machine production and to improve contemporary design by consulting the past. The 1929 show in particular indicated the way designers had appropriated the machine look as motif but had been unable to accept

Fig. 6. Installation view, "Contemporary American Industrial Art," Metropolitan Museum of Art, 1934.

Fig. 7. Philip L. Goodwin Galleries for Architecture and Design, Museum of Modern Art. (Photo, Museum of Modern Art.)

Fig. 8. "The Museum of Modern Art Got One from Us," advertisement for George Kovacs, New York from the New York Times Magazine, Oct. 27, 1968. (Photo, the author.)

the fundamental neutrality implied by machine production. Yet were all these exhibits so much wasted energy? Do they speak any less convincingly for the aspirations and concomitant failures of their age? And, most difficult of all for the art historian and the museum worker, will these objects not seem beautiful, original, and dynamic at some later date? Certainly functional modern, which has achieved a state of design perfection, has become not a little boring and cliched. Characteristically, designers have turned to new avenues, seeking new materials to manipulate, new spatial situations to control, and new design problems to solve. Counterrevolutionary? Perhaps. A new reaction to machine tyranny? Also a possibility. And where is the museum in relation to this design reorientation?

The Museum of Modern Art, having been the standard bearer of significant modern design for the past several decades has, for the most part, slipped into the complacency of middle age. Its permanent modern design collection is a chronologically arranged hall of fame (Fig. 7), a closed world of perfect design cut off from both the concept of craft and insight into mechanical techniques that stand behind the forms. The viewer has little point of relationship with these objects except as discrete forms without functional reality. When the museum becomes didactic in the investigation of new design imperatives as it did in the 1972 exhibition, "Italy: The New Domestic Landscape," the results are either overbearing or impenetrable.

The Modern has finally become a tastemaker, or perhaps a taste barometer, for that limited group of individuals who find its taste desirable. With its educational function largely suspended, the gap between the museum and the marketplace has narrowed. It has, in a real sense, become the ultimate consumer, standing, as did the readers of Harper's in 1868, outside the shopwindow looking in (Fig. 8). And has the taste of the manufacturer or the public improved? Probably not. The public clamors for an even greater mélange of historical styles than the nineteenth century ever dreamed of, and the manufacturer seems to pursue, as he did in 1868, the improbable attempt at wedding those strange bedfellows, art and industry.

NOTES

1. Research for this paper was begun with documents in the archives of the Metropolitan Museum of Art, but its conclusion has been based on between-the-lines reading of official accounts in the published annual reports of the museum. During the course of this project, the museum's archives were closed to outside researchers. The published histories of the Metropolitan Museum: Winifred E. Howe, A History of the Metropolitan Museum of Art (New York: Metropolitan Museum of Art, Gilliss Press, 1913); and Calvin Tomkins, Merchants and Masterpieces: The Story of the Metropolitan Museum of Art (New York: E. P. Dutton & Co., 1970), contain brief factual accounts of some of the museum's industrial art activities that should be consulted for additional details. Summary statements about other American museums have been based on annual reports of the Cincinnati Museum Association; the Pennsylvania Museum and School of Industrial Art; and the United States National Museum; Walter Muir Whitehill, Museum of Fine Arts, Boston: A Centennial History, 2 vols. (Cambridge, Mass.: Belknap Press of the Harvard University Press, 1970), vol. 1; and Neil Harris, "The Gilded Age Revisited, Boston and the Museum Movement," American Quarterly 14, no. 4 (Winter 1962): 545–66; For quotation, see "Silver and Silver Plate," Harper's New Monthly Magazine 37, no. 220 (Sept. 1868): 433–48.

2. Nikolaus Pevsner, Studies in Art, Architecture and Design, 2 vols. (New York: Walker & Co., 1968), 2:38–96.

3. Pevsner, Studies in Art, 2:38–96; see also Gillian Naylor, The Arts and Crafts Movement: A Study of Its Sources, Ideals and Influence in Design Theory (Cambridge: M.I.T. Press, 1971). Both of these volumes deal with the situation in England, but contemporary documents suggest similar attitudes prevailed in the United States. See B. Silliman, Jr., and C. R. Goodrich, eds., The World of Science, Art, and Industry Illustrated from Examples in the New York Exhibition, 1853–1854 (New York: G. P. Putnam & Co., 1854); and George C. Mason, The Application of Art to Manufactures (New York: G. P. Putnam, 1858).

4. "Silver and Silver Plate," p. 436.

5. New York State Laws of 1870, Chapter 197, An Act to Incorporate "The Metropolitan Museum of Art," Passed April 13, 1870.

6. "Public Taste," The Crayon 6, no. 3 (Mar. 1859): 100.

7. "The Metropolitan Museum of Art," Harper's New Monthly Magazine 60, no. 360 (May 1880): 863-78.

8. Hoe and Marquand, "Resolution to the Executive Committee of the Board of Trustees," Feb. 18, 1878, Metropolitan Museum of Art archives.

9. Howe, History of the Metropolitan Museum, p. 201.

10. The Metropolitan Museum of Art, Annual Reports of the Trustees of the Association from 1871 to 1902, report for the year ending May 1, 1880 (New York: Metropolitan Museum of Art, 1902), pp. 166-68 (hereafter Annual Reports).

11. Annual Reports, year ending May 1, 1881, p. 196.

12. Walter Smith, Art Education, Scholastic and Industrial (Boston: James R. Osgood & Co., 1873), p. 110-20.

13. Annual Reports, year ending May 1, 1881, p. 196; Candace Wheeler, Yesterdays in a Busy Life (New York: Harper & Brothers, 1918), p. 235.

14. Annual Reports, year ending Dec. 1885, p. 316.

15. "Art Schools of the Metropolitan Museum," Art Age 8, no. 64 (Nov. 1888); 72-73.

16. Annual Reports, year ending Dec. 1893, pp. 576-77.

17. Eleanor Garnier Hewitt, The Making of a Modern Museum (New York: Wednesday Afternoon Club, 1919); "Designed for Use: The Cooper Union Museum," Museum News 39, no. 6 (Mar. 1961): 12-19. See also the proceedings of the Sixtieth Anniversary Jubilee in Chronicle of the Museum for the Arts of Decoration of the Cooper Union 2, no. 9 (Aug. 1957): 283-304.

18. Walter Smith was a distinguished contemporary writer on the industrial arts and the state director of art education for Massachusetts. In addition to his book on art education cited above see also Walter Smith, Industrial Art, vol. 2 of The Masterpieces of the Centennial International Exhibition (Philadelphia: Gebbie & Barrie, 1876); John Ward Stimson, New York Institute for Artist-Artisans Report, 1888-89 (New York: New York Institute for Artist-Artisans), pp. 10, 11. Stimson's educational philosophy and teaching program is further detailed in his book, Principles

and Methods in Art Education, Introductory Suggestions to Art
Students and Teachers with Chats by Principal John Ward Stimson
(New York: New York Institute for Artist-Artisans, 1892).

19. David Hanks, "The Role of the Art Institute of Chicago
in the Arts and Crafts Movement," 1972, Ms. in author's
possession.

20. John Cotton Dana, The New Relations of Museums
and Industries (Newark, N.J.: Newark Museum Association,
1919), p. 9.

21. Harris, "Industrial Art: The Opportunity of America,"
Good Furniture, the Magazine of Good Taste 4, no. 1 (Oct.
1914): 1.

22. See Kent, What I Am Pleased to Call My Education,
ed. Lois Leighton Comings (New York: Grolier Club, 1949).

23. Richard F. Bach, "The Museum and Industrial Art,"
Metropolitan Museum of Art Bulletin 13, no. 9 (Sept. 1918): 79.
See also Bach, "The Museum as a Laboratory," Metropolitan
Museum of Art Bulletin 14, no. 1 (Jan. 1919): 2-4; Bach to Dana,
Mar. 31, 1917, Metropolitan Museum of Art archives.

24. The Metropolitan also published four industrial art
monographs during these years: Richard F. Bach, Museums and
the Industrial World (New York: Gilliss Press, 1926); Gregor
Paulsson, Swedish Comtemporary Decorative Arts (New York:
Gilliss Press, 1927); Richard F. Bach, Museum Service to the
Art Industries, an Historical Statement to 1927 (New York:
Gilliss Press, 1927); Robert W. DeForest, Art in Merchandise:
Notes on the Relationships of Stores and Museums (New York:
Gilliss Press, 1928).

25. Henry Watson Kent, "The Motive of the Exhibition of
American Industrial Art," Metropolitan Museum of Art Bulletin 14,
no. 4 (Apr. 1929): 97. See the discussion of this show in relation
to the museum's interest in Parisian fashion in Penelope Hunter,
"Art Deco and the Metropolitan Museum of Art," Connoisseur 179,
no. 722 (Apr. 1972): 273-81.

26. A. Conger Goodyear, The Museum of Modern Art: The
First Ten Years (New York: by the author, 1943), pp. 15-16;
the Museum of Modern Art's activities in the industrial arts are
discussed in the preface of Arthur Drexler and Greta Daniel,
Introduction to Twentieth Century Design from the Collection of

the Museum of Modern Art, New York (New York: Museum of
Modern Art, 1959); Philip Johnson, "History of Machine Art,"
in Machine Art (New York: Museum of Modern Art, 1934), n.p.
 27. The Metropolitan Museum held fifteen exhibitions in
its national series and one international exhibition ("Rugs and
Carpets") in the years between 1917 and 1940. The fourteenth
exhibition in 1937 was devoted to a single material, silver.
The total attendance at these exhibitions, excluding 1918, for
which no record was kept, was 450,221. The highest daily
attendance was for the 1934 exhibition, which averaged around
2,200 visitors a day.

MUSEUMS AND TECHNOLOGICAL UTOPIANISM

George Basalla

THE study of the craft and results of historical research reveals
that in writing history the historian is never able to rid his
work of value judgments and assumptions that reflect his times,
training, and personal beliefs. Scientific, or purely objective,
history is a remote goal pursued by men who, in choosing,
ordering, and interpreting the cold facts, impose upon them a
framework of meaning which has its own subjective elements.
The historical profession, aware of its inherent limitations,
is marked by an ongoing struggle between historical schools
or individual interpreters who see the "bare facts of history"
from different perspectives and consequently offer divergent
evaluations of the same set of events.[1]

What is true of a work of written history is also true of a
historical museum. Its collection of objects is chosen, ordered,
and interpreted by another group of men who, likewise, reflect
their personal value systems in the museums and exhibits they
present to the public. What is lacking in museum circles is a
consistent, critical appraisal of the assumptions, or ideologies,
embodied in museum exhibitions of historical artifacts.

The practice of scholarly book reviewing by academic
historians leaves much to be desired, but even this weak
critical procedure scarcely exists in the museum field, where
exhibits are far more often announced or described than they
are criticized or evaluated. Some museum exhibits are reviewed
in metropolitan papers by journalists and critics, and the
journal Technology and Culture began a series of critical
reviews of technical museums several years ago.[2] Of course,
there are physical limitations to be considered; an exhibit
cannot be sent out to a reviewer as readily as a book can.
Nevertheless, the museum profession has shown a lack of
interest in encouraging critical appraisal of its work. Possibly

the lack of an adequate critical-review apparatus within the
museum world is attributable to the fact that museum adminis-
trative organization is often based on a business or industrial
model of management. In the museum, as in business,
institutional loyalty may be more highly rewarded than is
searching criticism. Whatever the ultimate reason, the result
is that the uninformed general public is presented with, and
readily accepts as the highest historical truth, museum exhibits
that may embody viewpoints already abandoned, or severely
criticized, by other historians.

As a historian interested in the social implications of
science and technology, my specific concern is to discover
the ideology underlying the majority of exhibits in technical
museums. For two reasons the matter is especially important.
First, the social consequences of a particular interpretation
of technology and its history may have direct repercussions on
the current social scene. And second, an object or process of
technology implies to the uncritical viewer a degree of con-
creteness that further acts to mask the assumptions motivating
its display in the first place. A public that all too easily
accepts the myth of the superior objectivity of a value-neutral
science and technology does not expect to find subjectivity
creeping into the halls of museums of science and technology.
All of this, plus the fact that the history of technology is one
of the newer fields of historical research, calls for a closer
examination of the values and assumptions that permeate
technical exhibits in museums.

The origins and nature of the basic philosophy of the
technical museum were first discussed by Professor Eugene S.
Ferguson in his article: "Technical Museums and International
Exhibitions."[3] The great technical museums of London, Paris,
Vienna, Munich, Washington, D.C., and Chicago can be
traced back to the famous nineteenth-century exhibitions of
trade and industry that began in 1851 at the Crystal Palace in
London and continued throughout the century. These "tourna-
ments of industry"[4] pitted the industrial nations against one
another in friendly rivalries, celebrated the machine and its
varied products, and, above all else, gave prominence to
the notion that quantifiable technical progress was to be equated

with social progress and human betterment. The naive
enthusiasm for technology and the huckster ethos and
uncritical spirit of the older international industrial exhibitions
are still with us. These features are easily identified in the
world's fairs and international expositions promoted in our own
day by optimistic financial speculators. And, they reappear
in more subtle forms in some of our best-known technical
museums. The personnel of these institutions might not like
to be identified with, say, the most recent New York World's
Fair, yet the fair and the technical museum share a common
origin and philosophical outlook.

Progress was the hallmark of the nineteenth-century
international exhibition. In any given exhibition the relative
progress achieved by competing nations could be measured by
counting the number of medals awarded each. A further
refinement of measurement could be made by taking into account
the awards in specific categories--say locomotives, firearms,
machine tools, or processed foods. Finally, this score card
of progress could be brought up to date in a few years when
the next exhibition revealed the latest positions in the inter-
national race for industrial supremacy.

The international rivalry, somewhat subdued, persists in
world's fairs and expositions. It is not to be found in museums,
which tend to celebrate the achievements of the national
culture they represent without drawing up an international
score card. In these institutions, progress appears in a
somewhat different form. The development of modern machines
or technological processes is depicted in a progressive and
unilinear evolutionary fashion. One learns from their exhibits
that each technological device emerged clearly from its
predecessor, that there were no wrong turns or dead ends in
the development of technology, and that the final form of the
technological object was somehow miraculously foreordained
in its most primitive ancestor. At each step along the way a
quantitative measure--size of cylinder bore, horsepower,
speed--records the steady progress made manifest in the steam
engine, automobile, or whatever chances to be on display.

The deep significance of the idea of progress to the
creators of the modern technical museum is nicely illustrated

in some remarks made concerning the outlook of Oskar von Miller, the founder of Germany's great repository of technological artifacts, the Deutsches Museum. In 1955 the president of the German Federal Republic summed up von Miller's philosophy in these words: "He believed in Progress, he wanted to make manifest the march of Progress, the place and nature of its advance out of the past."[5]

One result of this uncritical belief in technological progressivism is that technical museums often tend to be a mixed bag. Rarely are they satisfied to concentrate on a given historical period; instead, they mix historical exhibits with some glimpses of "what-we-have-now," or "how-we-do-it-now." Of course, what is implied is that the current processes or the modern machines represent the finest in man's history. At times technical museums seem to have adopted the General Electric slogan as their own: "Progress is our most important Product."

Technological progressivism is not only bad history; it fosters an outlook that is all the more dangerous to society because it takes the appearance of a truism when in fact it is a highly debatable proposition. What I have in mind is the assumption that technological progress and social progress are inexorably linked, that a society based on 500-horsepower engines is inherently better, and its citizens are happier, than one based on 20-horsepower engines. This is a formula which equates cultural superiority and personal satisfaction with the conquest of nature by more and more complex and powerful machines. That formula, devised by ethnocentric industrial nations who chose to use the machine as their cultural yardstick, is the working philosophy of too many technical museums.

The technical museum's promotion of current machines and technical practices has its defenders in the museum world. Charles R. Richards in his 1925 book The Industrial Museum argued that in nonindustrialized societies technological operations are not "hidden from common observation." Anyone can watch the potter, spinner, or metalworker as he pursues his craft. However, where the crafts have been replaced by highly sophisticated technological procedures, the "processes

of production" underlying civilization are "hidden behind
factory walls where only the specialized factory worker
enters." More recently, the director emeritus of the American
Museum of Natural History, A. E. Parr, made the same point
when he wrote that museums of science and technology were
assigned the task of showing us "what goes on in the trades
and professions we do not practice ourselves."[6]

The technical museum, according to Richards and Parr,
supplies us with experiences and knowledge offered by no
other institution in our society. It has become a surrogate
for the public performances of the blacksmith or cabinetmaker
of an earlier day who, acting in the modern spirit of Williams-
burg or Sturbridge, worked openly before the curious onlooker.
Apart from taking note of the overly romanticized portrait
of the artisan as actor and teacher implied here, one can
offer at least three responses. First, in the words of George
Brown Goode, "a factory in actual operation is the best place
to study most modern industries."[7] Why settle for a surrogate
when local industrial plants offer public tours? Second,
modern machinery and processes can be displayed without
relying upon the ideology of technological progressivism.
For example, an exhibit of power technology need not present
the waterwheel and steam engine as merely so many faltering
steps along the path to the latest nuclear-powered electric
generating plant. The earlier power sources can, and should,
be studied and exhibited as devices functionally related to
the times and people that produced them. The third, and final,
response raises the question whether technical exhibits, of
the historical or modern sort, really do show what went, or
goes, on in the industrial setting, a point that will be reviewed
later in this essay.

Having discussed the historical and ideological foundations
of the technical museum, we can now determine its essential
features and look at some specific examples of its philosophy
made concrete in exhibits. In essence the technical museum
is a place where the machine, or the industrial process, is
put on display. Its exhibition involves the removal of the
technological object from its physical and social matrix,
stripping it of the many links to the factory or the community

at large that formed its natural surroundings. The precedent
for this mode of display probably comes from the art museum.
Aesthetic objects can be appreciated and understood, to a
large extent, apart from the social context in which they
were produced. The same cannot be said of the technological
artifact.

Visits to some of the better known technical museums in
the United States have led me to conclude that once the
machine has been lifted out of its social and physical setting
it is exhibited in one of three different ways: cornucopia,
aesthetic object, or item of romantic, sentimental, or
humorous interest. Each of these introduce their peculiar
distortions of technology, its historical development, and
its meaning to society.

The technological cornucopia is filled to overflowing, not
with the gifts of the harvest, but with the fruits of the assembly
line. The machine, as horn of plenty, is the engine of the
GNP, the producer of consumer goods and services. It spills
out automobiles, telephones, fabrics, washing machines,
television sets, and the many other things identified with
the good life in America. The source of the manufactured
goods, like the source of the bountiful harvest in the ancient
cornucopia, is mysterious. The appliances tumble out all
gleaming, ready to serve us, but we are given no indication
of the social, environmental, or human costs involved in their
production and use. The modern horn of plenty features the
production of goods in a social vacuum. We are expected
to applaud the machine and its products without interesting
ourselves in what it means to condemn a portion of our people
to work on an automobile assembly line or in a steel mill.

The Franklin Institute of Philadelphia and the Museum of
Science and Industry in Chicago provide many examples of
the machine as cornucopia. The commercial firms who built
the exhibits were unashamedly selling their products. As an
example, in Chicago go to the Petro Chemical Theater and
see an "unusual musical skit show[ing] the almost endless
variety of oil-based chemicals in our daily lives." And, do
not miss the "Inferno," an oil-fired flame that "could supply
enough hot water for five families to stand under their showers

for the rest of their lives."[8] If you can turn your attention
away from these perennially drenched and steaming families
at the petroleum exhibit, you will certainly find one of the
many historical exhibits that are scattered throughout the
museum. It is one of the boasts of the Chicago museum that
"historic experiments" and the productive machines they
made possible have been placed side by side under one roof.[9]
What is missing, of course, are the workers who tended those
machines in an industrial environment and the cultural and
ecological consequences of the machine's operation.

The supreme example of the machine as cornucopia can
be found in New York City at Sixth Avenue and Fifty-fourth
Street in The Mill, sponsored by Burlington (Textile) Industries.
Academic and museum people have probably never heard about
this exhibit, but the general public has. The Mill has attracted
more visitors than either the New York Stock Exchange or the
United Nations!

Burlington Industries promises you the opportunity to see
and hear a working textile mill.[10] It only takes 8 1/2 minutes
and you need not walk because a moving walkway carries you
along at the right speed for viewing. After a quick look at
some three-dimensional, stylized representations of raw
materials, the visitor enters the heart of The Mill where he
finds white floors, white machines, and a mirrored wall.
The amplified sounds of textile machines initially hide the
fact that the moving machines, strung with brilliantly colored
threads, are not producing fabric. In this technological
paradise there are no human beings, or models of them, to
spoil the effect of complex machinery working by itself to
give mankind the gifts of Burlington Mills. Those gifts are
conveniently seen in a fifty-five-hundred slide audiovisual
presentation at the end of the exhibit. Appropriately, as one
leaves the building he is offered a button bearing the legend,
"I have been through the Mill."

The National Museum of History and Technology in
Washington, D.C., has not adopted the cornucopia entirely
as its model for the presentation of the artifacts of an
industrial civilization, but glimpses of it can be found
there in the exhibits of steel and petroleum. The technical

museum generally has been so closely identified with the horn of plenty theme that when the Nixon administration decided to educate the American people regarding the complexities of productivity, it inspired and financed the installation of a temporary exhibit entitled: "If We're So Good, Why Aren't We Better?" in the lower level of the museum. Productivity might not be of central concern to the Smithsonian but it was to the White House, which was willing to spend nearly one-half million dollars to get its point across in one of Washington's most popular tourist attractions.[11] "If We're So Good, Why Aren't We Better?" is by no means a one-sided plea for hard work and more consumer goods. It does mention the drawbacks of expanding industrialism, including environmental and social problems. Nevertheless, one leaves the exhibit with the overall impression that a bigger GNP means a better USA even if it is difficult to balance the choices in a constantly expanding market.

In the Museum of History and Technology's permanent exhibit halls the cornucopia image of the machine has been replaced by the machine as aesthetic object. Rooms are filled with clean, shining machines working away, not to fill the appliance store or supermarket, but simply to reveal their intrinsic beauty. The aesthetic aspects are stressed to the point where emotions usually reserved for a painting or piece of sculpture are now directed toward the machine. The artifacts are accurately and abundantly labeled as to their historical significance, yet in the presence of the machine one's sense of history is overwhelmed by the beauty of the contrivance. The machine's strength, grace, interrelated complexity, and elegance predominate.

Countless artists, engineers, and mechanics have offered their testimonials on the aesthetic qualities of the machine. I do not dispute them, but I claim that an exhibition technique and philosophy that emphasizes these qualities brings with it its own misreading of history. The machine as aesthetic object operates in a social vacuum; it is depicted as a thing-in-itself set apart from any association with human and physical environment. When a museum display stresses the indepen-dence of the machine from societal concerns, social and

economic history suffer accordingly. Cornucopia and aesthetic
object are polar opposites; yet they share a common feature--
distortion of social reality.

In discussing the various models of machine display, it
is clear that in any given institution it is possible to find
more than one of the models functioning simultaneously. I
have been trying to isolate the dominant model characterizing
a museum without calling attention to the subsidiary ones.
This is not easy to do in the case of the third approach, the
machine as a historical artifact of romantic, sentimental,
and humorous interest, because this approach is found in
varying degrees of intensity in virtually every technical
museum. The unstated philosophy of the third model runs
somewhat like this: these are the contraptions that grandma
and grandpa used in the good old days; they sure look crude,
but by golly they worked, and they helped to make America
what it is today. The viewer's expected, and actual, response
is twofold: (1) weren't they ingenious way back then; (2) aren't
we lucky to have come so far along the way toward the good
life? Here, as in the other two approaches to the machine,
historical veracity takes a back seat.

The way in which the machine can be sentimentalized and
become a source of amusement is exemplified in a recent
Smithsonian exhibit of the works of Rube Goldberg, cartoonist-
inventor of unnecessarily complicated and silly machines. In
a book published independently of, and prior to, the Smithsonian
exhibit, Goldberg was said to portray himself as fighting "a
one-man insurrection against needlessly multifarious gadgetry
of the machine age that enslaves man instead of freeing him
from non-rewarding labor."[12] Goldberg's critical attitude
toward technology was softened and the comic elements were
highlighted in the museum's exhibit, entitled: "Do It the Hard
Way: Rube Goldberg and Modern Times." It was played for
laughs the whole way--isn't it amusing that we Americans go
to so much trouble to make life complicated?--and in the
process the artist's satirical picture of modern technology was
lost.[13]

Whatever the prevailing model--cornucopia, art object,
or sentimental and fun item--the visitor is rarely given a

criticism of technology. He is left with the strong impression that progress in the design of these productive, beautiful, and pleasant machines spells progress for mankind, that more powerful and efficient machines mean a better life for the fortunate people who chose to build them. Furthermore, there is the implication that if we only continue the process of industrialization begun by our inventive and foresighted ancestors, then our descendants will move ever more rapidly toward the goal of the ideal society-Utopia. Technical museums, therefore, are purveyors of technological utopianism. They help to broadcast the idea that current technical or social problems are likely to be resolved through expanding mechanization because mankind's progress is directly linked to the mechanisms he contrives to meet his needs. As the tool exhibit at the Chicago Museum of Science and Industry proclaims: "Universal Prosperity and Permanent World Peace through Tools."[14]

A forecast of the future made by General Motors at the 1939 World's Fair shows just how wrong a narrow technical focus can be in extrapolating the elements of a future utopia. This is GM's Futurama picture of the urban scene twenty years hence, in 1960:

> Here is an American city replanned around a highly developed modern traffic system and even though this is 1960, the system as yet is not complete. Whenever possible the rights of way of these express city thoroughfares have been so routed as to displace outmoded business sections and undesirable slum areas.
>
> The city of 1960 has abundant sunshine, fresh air, fine green parkways, recreational and civic centers--all the result of thoughtful planning and design.
>
> There are approximately 38,000,000 motorcars in this America of 1960--almost a third more than in 1939--motorcars which have created more and more jobs for more and more men.
>
> Here you see a close-up view of one section

of the great metropolis of 1960. The traffic
system is the result of exhaustive surveys of
the highway and street problems of the past.
Modern and efficient city planning--breath-
taking architecture--each city block a complete
unit in itself. Broad, one-way thoroughfares--
space, sunshine, light and air.[15]

Not only was this vision of the city of tomorrow hopelessly
unrealistic from a social and physical standpoint, the General
Motors prognosticators were far off the mark in their prediction
of the number of automobiles that would use the utopian high-
ways of 1960. They gave a figure of 38 million; in 1960 there
were over 61.5 million registered passenger cars in the United
States. The technological utopian thinking of today will lead
us into the same pitfalls as it did in 1939. The fault is with
the basic outlook and uncritical reliance upon technological
utopianism, not with the specific predictive methods employed.

This criticism of the technological utopianism that infuses
so many exhibits in museums of science and industry should
not be misconstrued. I am not a technophobe arguing that the
road to hell is paved with good inventions. I do believe that
industrial societies should develop a much more critical
attitude toward the machine, an attitude encouraging the public
to examine carefully each new technological innovation instead
of welcoming each technical change unthinkingly as another
step along the glorious highway of progress. An ideology that
was relevant to mid-nineteenth-century industrializing nations
has simply outlived its usefulness in our day.

Technological utopianism is to be criticized on two counts.
First, it is a distortion of the record of the development of
technology. As the study of the history of technology grows
in intellectual sophistication, it becomes increasingly clear
that the idea of progress cannot provide the central core
around which all of the history of technology can be conveniently
arranged. The best historians of technology are finding it
necessary to study technology within a complex social matrix
for which there exists no one simple explanatory device.
Second, technological utopianism, with its promise of neat

technological solutions to social problems, is a panacea that
diverts society from its real task of trying to cope with difficult
social, political, and ethical problems on a human, not
mechanical, level. The solution of these problems might
involve the use of a machine, but it is unrealistic to suppose
that any technological device alone has the power to transform
a troubled society into a utopian one.

Whether museums will it or not, they are educational
institutions. By making public the artifacts they have chosen
to collect, they bring their conceptions of history, as well as
their societal and aesthetic values, to their visitors.[16] The
attractive and effective displays of modern museums permit
them to reach levels of popular education untouched by other
means. Tens of millions of American families visit technical
museums annually, and public school systems regularly
incorporate museum visits into the child's normal educational
program.[17] I am concerned about the utopian message this
captive audience has been receiving about machines, industry,
and economic growth.

Duncan F. Cameron recently criticized the science museum
for being nothing "more than three-dimensional textbooks."[18]
A more pertinent criticism of these institutions was offered in
1970 by a group of scientifically oriented political activists
who chose the Boston Museum of Science as their target. After
criticizing the museum for the disproportionate amount of display
space allotted to the promotion of NASA's rockets and capsules,
they moved on to the other exhibits. This is what they found:

> A strobe light exhibit contains a plug for the
> manufacturer--a local defense contractor.
> Another exhibit shows the benefits of power
> steering. (For that you paid four bucks?
> [admission fees]). . . . The Bell System's
> huge exhibit has zero technical content and
> merely encourages people to use telephones. . . .
> The more you see, the more obvious it is that
> most exhibits are nothing more than hypes
> [advertisements] for the companies contributing
> to them.[19]

The complaint of this radical group acquired greater significance in light of a 1961 Business Week article entitled: "Industry's Softest Sell: Museum Exhibits." This article reveals that large industrial firms--Bell Telephone, Union Carbide, General Motors--willingly invest in costly museum exhibits because they see them as an opportunity for "exposure" of their name, "low-keyed image building," and a possible source of recruitment of "younger museum visitors for jobs sometime in the future."[20]

Some reality does intrude into those technological paradises we call technical museums. Its intrusion, however, is not part of an overall philosophy but the result of the failure of the machine. The visitor approaches a diorama or model prominently displaying a button or crank that supposedly actuates it. The button is pushed, or the crank spun, with hope of producing some motion that will instruct or amuse. Nothing happens; the mechanism is broken. Or, on some other occasion, the mechanism behaves in a wholly unintended erratic or insane fashion. At those moments the museum visitor is face to face with the limitations of technology. The mechanical failures are not to be blamed on a lack of museum maintenance or excessive visitor use; mechanical breakdowns are a normal part of technology. We meet them every day in our lives.

Two firsthand museum experiences have impressed upon me the high rate of mechanical failures in technical exhibits. In 1970 the Museum of Modern Art ran a show entitled "Information" which featured media technology. About one-half of the tape recorders, projectors, and so on wore "OUT OF ORDER" signs when I visited the exhibit. More recently the Smithsonian's exhibit on productivity featured a huge wall-mounted pinball machine illustrating the chances of achieving success or failure by adopting different strategies in business and labor. The mechanism utilized heavy, bowling-ball size, metal spheres. At times these spheres would be hurled out beyond the pinball bumpers and come crashing down dangerously close to the viewers clustered at the guard rail. When a Washington Post reporter visited the same exhibit she noted: "Not everything in the show works. Last week it was the film on typewriters, some ball bearings and the multiple

television screens used to illustrate the mass availability of television."[21]

The widespread use of mechanically actuated devices in museums is in itself a reflection of an attitude that assumes the more gadgets the better. Yet one wonders about their effectiveness. Julius Rosenwald, founder of the Chicago Museum of Science and Industry, promised that his institution would not become a "technical Coney Island."[22] His critics say that is exactly what it is. The London Science Museum found that a large majority of its school-age visitors "tend to flit from one thing to another, stopping to press buttons or turn handles and treating the Gallery more as an amusement arcade than as a source of scientific information."[23] A museum with a large number of action exhibits apparently encourages buttonpushing as an end in itself.

Any discussion of realism in the technical museum calls to mind the "world famous coal mine"[24] of the Chicago Museum of Science and Industry. A. E. Parr, mentioned earlier as an exponent of the idea that technical museums should portray modern technological operations, has written: "We do not visit the miners in the pits, we see the coal mines in facsimile in Chicago."[25] Having visited working coal mines, I feel qualified to remark on the differences between the two. The roomy, dry, clean corridors lined with coal through which one can walk comfortably upright in the Chicago facsimile present a sharp contrast to the damp, low-ceilinged shafts of a working mine that are filled with noise, coal-dust laden air, and little light. If the visitor gathers his impression of coal mining from the Chicago museum he will never understand why coal miners throughout history have fought so vigorously with their employers and the government about working conditions in the pits. Nor would he know how coal operations scar the countryside outside the mine and create the wretched villages we call coal-mining towns.

In criticizing the idealization of technology in technical museums and urging the creation of more realistic and historically accurate displays, I leave myself open to some obvious complaints. What would you have us do, say the museum people, recreate the industrial slums of Manchester,

England, with their diseases, filth, and stench? Hire young
children to work twelve to fourteen hours a day in a recon-
structed textile mill? Expose the museum visitor to the
dangers of coal mining and steelmaking or the odors of the
paper industry? The obvious answer to all of these questions
is no. However, technical museums can accomplish much if
they begin to question the assumptions upon which they have
operated for so long, and if they begin to see themselves as
perpetuators of a romantic and utopian myth of technology and
its social consequences.

Technical museums are by no means the only American
museums to sacrifice realism to romanticism in their exhibits.
A. E. Parr has found that the animal habitat displays of
European natural history museums stress an "earthy realism"
not to be found on this side of the Atlantic. Our natural
history museums cultivate "a lighter spirit of almost romantic
sentimentalism" in their exhibits. In American museums
"death is beautiful, and scavenging a polite and fastidious
meal that would pass the scrutiny of any meat inspector,"
said Parr.[26] The idealization of nature, I would add, does
not have so great and so immediate social, economic, and
political ramifications as the idealization of technology and
its history.

There are animal bodily functions and examples of disease
and decay that need not be reproduced in an animal habitat
group in order to satisfy my search for versimilitude. The
habitat group, even of the romantic sort, with its environmental
setting and ecological connotations, might well serve as a
model for the technical museum. The machine's habitat is a
factory or industrial plant, and it includes the men and women
who work there as well as their living conditions in the
community adjacent to the plant. Nor does the machine's
influence stop there. The products of technology exert their
own influences, and these need to be evaluated within a wide
social setting. The habitat, when used in connection with the
machine, means more than the trivial identification of the
device with the architecture, fashions, and surroundings of
the era it represents. I am asking that the social matrix of
the machine be reproduced to the fullest extent possible, that

technology be displayed for what it is—a human venture with triumphs and failures and with widespread and mixed repercussions upon society.

A reevaluation of the nineteenth-century philosophy of progress and the use of the habitat group as a theoretical model for display are my first suggestions for the improvement of technical museums. In keeping with these ideas I would encourage the development of working museums founded on historical industrial sites. Thus the "ecology of the machine" would be preserved without the need to recreate the entire industrial environment through words, pictures, or models. By means of conducted walking tours in the area, the workers' community, or at least some of their homes, might be seen. In many cases, of course, plant expansion and urban growth have destroyed any traces of these. If so, then other means models, or contemporary illustrations, could be used. Finally, the working museum should concentrate on industrial or craft processes, leaving modern practices where they belong—in the factory. Museum visitors should be encouraged to visit the many firms offering tours of their establishments. A working coal mine, even one that is especially fitted out to receive visitors, is far superior to one reconstructed deep beneath the basement of a museum located in a large city. And, if museums serve inner city children who are unlikely to venture out to industrial sites, they have a special responsibility to portray realistically the mine or factory they reconstruct on their premises.

These suggestions carry with them an implicit criticism of the large museum of science and industry. Like the international exhibitions that spawned them, they attempt to cover far too much under one roof, and their breadth of scope has been determined by an uncritical progressivistic philosophy. They are places where the public may be amazed, amused, and encouraged to buy a manufacturer's products, but where historical truths will always be at a disadvantage.

In conclusion, my recommendations are not foreign to the museum world in general even if they have not been central to the thinking of technical museum people, at least not central in the terms in which I have presented them.

Historical museums with objects from preindustrial times have made real efforts to integrate their artifacts into a broad cultural and social setting. Here I have in mind the examples of Williamsburg, Sturbridge, and Plimoth Plantation.[27] The machines of the industrial age, however, pose special problems of interpretation, not the least of which is the technological utopianism that, acting as a hidden hand, has shaped so many displays in technical museums.

NOTES

1. My analysis of this topic has been substantially improved by the incorporation of suggestions made by two of my Delaware colleagues: professors Eugene S. Ferguson and Edward P. Alexander. See also M. M. Postan, "Fact and Relevance in Historical Study," Historical Studies 13, no. 51 (Oct. 1968): 411–25.

2. Thomas W. Leavitt, "Towards a Standard of Excellence: The Nature and Purpose of Exhibit Reviews," Technology and Culture 9, no. 1 (Jan. 1968): 70–75; Eugene S. Ferguson, "Hall of Power Machinery, Museum of History and Technology," Technology and Culture 9, no. 1 (Jan. 1968): 75–85; W. David Lewis, "Corning Museum of Glass," Technology and Culture 10, no. 1 (Jan. 1969): 68–83. Exhibit reviews are a continuing feature of Technology and Culture.

3. Ferguson, "Technical Museums and International Exhibition," Technology and Culture 6, no. 1 (Winter 1965): 30–46.

4. Merle Curti, "America at the World Fairs, 1851–1893," American Historical Review 55, no. 4 (July 1950): 833–56.

5. Professor Theodor Heuss, May 7, 1955. His words are recorded in The German Museum in Munich, a 16–mm film distributed by the German consulate.

6. Charles R. Richards, The Industrial Museum (New York: Macmillan Co., 1925), pp. 1–2; Albert Eide Parr, "Marketing the Message," Curator 12, no. 2 (June 1969): 77.

7. Ferguson, "Technical Museums," p. 44.

8. Quoted from an unpaginated, undated brochure by the Standard Oil (Indiana) Foundation, Learning about Petroleum Is Fun at the Museum of Science and Industry.

9. Unpaginated, undated handbook of exhibits, Museum of Science and Industry; Chicago, Illinois.

10. Unpaginated, undated brochure by Burlington Industries, Have You Been through the Mill? See also the seven–column advertisement for the exhibit in the New York Times, Nov. 25, 1970, p. 19.

11. Washington Post, Jan. 7, 1973.

12. Clark Kinnaird, ed., Rube Goldberg vs. the Machine Age (New York: Hastings House, 1968), p. viii.

13. The National Museum of History and Technology, Do It the Hard Way: Rube Goldberg and Modern Times, undated, unpaginated. Daniel J. Boorstin's contribution to this pamphlet, "Rube Goldberg: Wit and Prophet," is more critical than is the exhibit.

14. Wilkie Brothers Foundation, Tools That Created Civilization, undated, unpaginated brochure.

15. General Motors, Futurama, undated, unpaginated booklet distributed at New York World's Fair, 1939.

16. Duncan F. Cameron, "The Museum, a Temple or the Forum," Curator 14, no. 1 (Mar. 1971): 16.

17. Sidney R. Galler, et al., "Museums Today," Science 161, no. 3841 (Aug. 9, 1968): 548-51.

18. Cameron, "The Museum," p. 17.

19. "Point of View," Science 170, no. 3954 (Oct. 9, 1970): 145.

20. "Industry's Softest Sell: Museum Exhibits," Business Week (Sept. 30, 1961): 32-33.

21. Washington Post, Jan. 7, 1973.

22. Ferguson, "Technical Museums," p. 42.

23. Joyce A. M. Brooks and Philip E. Vernon, "A Study of Children's Interests and Comprehension at a Science Museum," British Journal of Psychology 47, no. 3 (Aug. 1956): 175-82.

24. So designated in the handbook of the Museum of Science and Industry.

25. Parr, "Marketing the Message," p. 77.

26. A. E. Parr, "Realism and Romanticism in Museum Exhibits," Curator 6, no. 2 (June 1963): 174-84.

27. Edward P. Alexander, "A Fourth Dimension for History Museums," Curator 11, no. 4 (Dec. 1968): 263-89.